IN TRIBUTE TO

THE NATIONAL SCULPTURE SOCIETY

ON ITS 100TH ANNIVERSARY

TO ALL THOSE WHO LABOR

IN BEHALF OF THE HUMAN FIGURE,

AND, SHINING THROUGH IT,

THE HUMAN SPIRIT

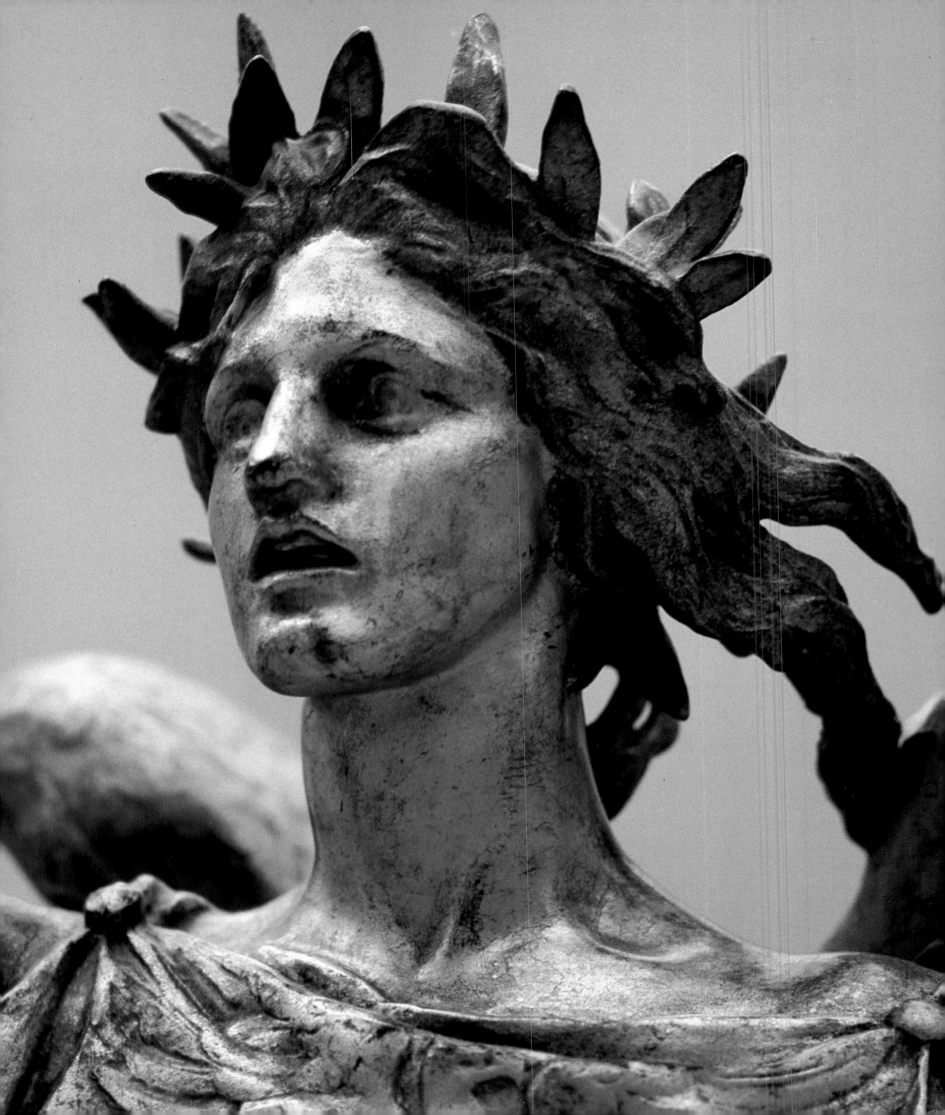

MASTERS OF AMERICAN SCULPTURE

THE FIGURATIVE TRADITION
FROM THE AMERICAN RENAISSANCE
TO THE MILLENNIUM

DONALD MARTIN REYNOLDS

ABBEVILLE PRESS PUBLISHERS

NEW YORK LONDON PARIS

FRONT COVER: *Mount Rushmore*, by Gutzon Borglum.
See pages 88–89.

BACK COVER: Detail of *Robert Gould Shaw Memorial*,
by Augustus Saint-Gaudens and Charles F. McKim.
See page 140.

FRONTISPIECE: Detail of *Liberty, Sherman Monument*,
by Augustus Saint-Gaudens. See page 121.

TITLE PAGE: National Sculpture Society Seal, National
Sculpture Society, New York. See page 231.

Manuscript Editor: Walton Rawls
Project Editor: Ann ffolliott
Designer: Nai Chang
Production Editor: Abigail Asher
Picture Editor: Laura Straus
Desktop Project Manager: Barbara Sturman
Production Supervisor: Matthew Pimm

First edition

CIP
Reynolds, Donald M.
 Masters of American sculpture : the figurative tradition
from the American renaissance to the millennium / Donald
Martin Reynolds. —1st ed.
 p. cm.
Includes bibliographical references and index.
ISBN 1-55859-276-8
1. Sculpture, American. 2. Human figure in art.
3. Sculpture, Modern—19th century—United States.
4. Sculpture, Modern—20th century—United States.
I. Title.
NB210.R49 1993
730'.0973'0904—dc20 93-24578

CONTENTS

ACKNOWLEDGMENTS

This book commemorates the one hundredth anniversary of the National Sculpture Society, and I am honored to have been asked by the society to write it. It is impossible to acknowledge all those who have helped me in this work, but some people deserve special mention.

Joseph Veach Noble, chairman of the Board of Trustees at Brookgreen Gardens, not only suggested the title, *Masters of American Sculpture*, but he and Marcel Jovine, past president of the National Sculpture Society, were also the prime movers of the book from its concept to its publication. I am singularly indebted to Stanley Bleifeld, the society's president, for his unstinting support as he leads the National Sculpture Society into its second century, and to sculptor Judith Weller, who was instrumental in moving the project forward in its initial stages.

There are a number of important sculptors who do not appear in the book due to limitations of space, which I regret. Their exclusion is in no way a commentary on their contribution to the figurative tradition. Moreover, the weight I have given to individual sculptors and to specific works relates not only to their artistry but also to the unique insight or the substance that I feel each one imparts to the reader.

I owe a great debt to Gwen Pier, executive director of the National Sculpture Society, and her dedicated staff, who not only facilitated my research in the society's archives but also were enormously helpful in countless ways on a day-to-day basis. Theodora Morgan, editor emeritus of *Sculpture Review*, the society's magazine, which she faithfully edited for thirty-six years, read the manuscript and made useful suggestions.

I was blessed with experienced and gifted editors at Abbeville Press. Walton Rawls, who has a long list of credits to his name in the publishing field, edited the manuscript and provided me with indispensable direction, while Sarah Key and Ann ffolliott, with care and sensitivity, brought the book to term.

Special thanks are due Laura Straus and her efficient staff for the demanding and critical task of preparing the photographs. I am grateful to David Finn for opening his photographic archive to me, waiving all fees, and for the photographs he took for the book.

Abigail Asher, production editor, shepherded the book through the increasingly tortuous terrain of computer technology, Matthew Pimm handled the many production challenges with care, and Barbara Sturman assured the text, captions, and illustrations the harmony intended in the design.

Nai Chang's design for the book uniquely captures the power, drama, and substance of the vast and engaging subject of the figurative tradition in American sculpture. The field is richer for his labors.

I am especially indebted to that contingent of supporters over the years who have done much to make my work possible: James Beck, Howard McParlin Davis, Margot Wittkower, and Charles Sarner—and, as always, Nancy Zlobik Reynolds, my wife, companion, and helpmate, who keeps me ever mindful of the important things on the journey we all share.

INTRODUCTION:
THE FIGURATIVE TRADITION

From earliest times, the human figure has symbolized the unknown forces that govern the universe and served as the vehicle for those powers mankind ardently reveres. In one form or another, the figure has been at the center of ritual throughout the world since prehistoric times and the medium through which the human and the divine communicated.

The human figure embodies the universe of human existence and experience. It personifies all that is human and is therefore the one form in art with which we totally, uniquely, and immediately identify—physically, emotionally, and intellectually. Its attraction lies in the fact that it is the complete expression of the beauty, mystery, and dignity of the human person, the quintessential form of life. "In figurative sculpture," the distinguished sculptor Walker Hancock says, "because we are human, we enter into the stone or bronze by empathy and share its formal strength or beauty."[1]

The figurative tradition occupies a unique place not only in the history of art but also in the entire sweep of human history. It has always been the most accurate barometer of civilization's attitude toward humanity and the most sensitive measure of society's respect for human dignity. Moreover, the full potential of figurative art is realized when the dignity of humanity is expressed through the eloquence of the human figure.

The ancient Greeks were the first to establish standards of beauty for the human figure based on the perfection of its physical development.[2] At first, it served to embellish the Greeks' temples, but when they freed the human figure from its role as an adjunct or embellishment to architecture, the Greeks imbued it through gesture, composition, and modeling with the wide range of feelings and emotions that we identify uniquely with human expression—which has not changed substantially since that time.

The body's physical design is a perpetual marvel of proportion, flesh, and organization.[3] We wonder at nature's systems that coordinate the body's functions; the relationship of motion to the body's skeletal and muscular structures; the skin[4]—our largest sensory organ—through which we feel, love, and hate; reproduction—the thread to sustain life; and the nervous systems that maintain the internal environment of the body. Moreover, through modern medicine, we are constantly confronted with the indivisibility of body, mind, and spirit.

By the human body, and shining through it the human spirit, we are introduced to the glories and mysteries of humanity. Yet, even in our sophisticated age of science, the human capacity to create symphonies, poetry, and all forms of art and, through science, to pierce the cloud of unknowing[5] that surrounds our universe remains a mystery.

OPPOSITE LEFT
John Bernard Flannagan
(1895–1942)
Figure of Dignity—
Irish Mountain Goat, 1932–33
Granite, horns cast aluminum,
on concrete plinth
53¾ × 14⅛ × 8¾ in.
(136.5 × 35.9 × 22.2 cm)
The Metropolitan Museum
of Art, New York; Gift of
Alexander Shilling Fund, 1941

OPPOSITE RIGHT
John Bernard Flannagan
(1895–1942)
Jonah and the Whale, 1937
Stone, 30 × 11 × 5 in.
(76.2 × 27.9 × 12.7 cm)
Virginia Museum of Fine Arts,
Richmond; Gift of Curt Valentin

For a large part of the world since the Middle Ages, the human body has been a metaphor for the universal community of mankind. Medieval theologians audaciously taught that all human beings are united by divine grace—that is, the Creator's love for his creatures. When his creatures learned to express that love to one another through constructive acts, they enhanced the community of mankind, which the theologians called the Mystical Body.[6] Through destructive acts, people cut themselves off from that community, thereby diminishing the body and, consequently, each of its members. Through that analogy of the human figure, those medieval thinkers taught respect for the human person, which was for them a conflation of matter and spirit, unique in the universe to human beings.

John Donne, in the early seventeenth century, contributed to the perpetuation of that medieval idea of a mystical body, in lines from one of his most beautiful *Devotions:*

No man is an island, entire of itself; every man is a piece of the continent, a part of the main; if a clod be washed away by the sea, Europe is the less, as well as if a promontory were, as well as if a manor of thy friends or of thine own were. Any man's death diminishes me, because I am involved in mankind. And, therefore, never send to know for whom the bell tolls. It tolls for thee.[7]

John B. Flannagan was one of those who extended the idea of communion to all of nature. He said in 1942 that his sculpture "partakes of [a] . . . kinship with all living things and [a] fundamental unity of life."[8]

Historically, or to be more accurate, prehistorically, mankind's first images of the human figure are found in the art of the caveman.[9] They are fetishes or fertility figures, and their union of naturalism and idealization is the earliest expression of that trait possessed by humans alone—the ability to make symbols.[10]

Mythically, however, the origins of the human figure go back to creation and the first maker of symbols. It has been said that ever since the First Sculptor formed man out of the clay of the ground and breathed life into him (*Genesis* 2:7), the human figure has been the central theme of art, and people's yearning for immortality its underlying principle. It should likewise be noted that this act of creation is the first distinction between art and craft. It is when the sculptor breathes life into his or her figure that it becomes art. It should be underscored, however, that this distinction in no way minimizes the importance of skill. In fact, to the contrary, it illustrates the reality that without skill there is no art.[11]

The history of figurative art records the pendulum's swing from naturalism to idealism. Sculpture that successfully balances those two poles of expression tends to have a longer life. Sculpture from the American Renaissance to the present is no exception.

While few works become world-class pieces, many less ambitious works are worthy of study, not only because they are interesting as sculptural form

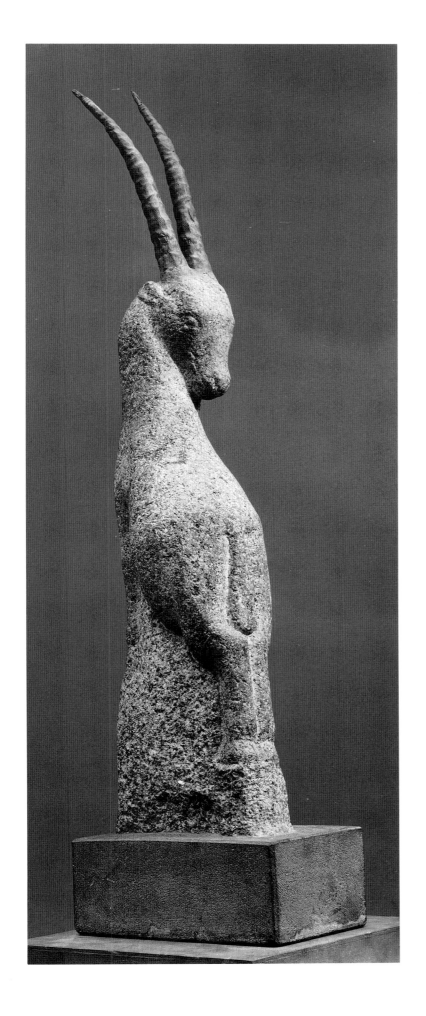

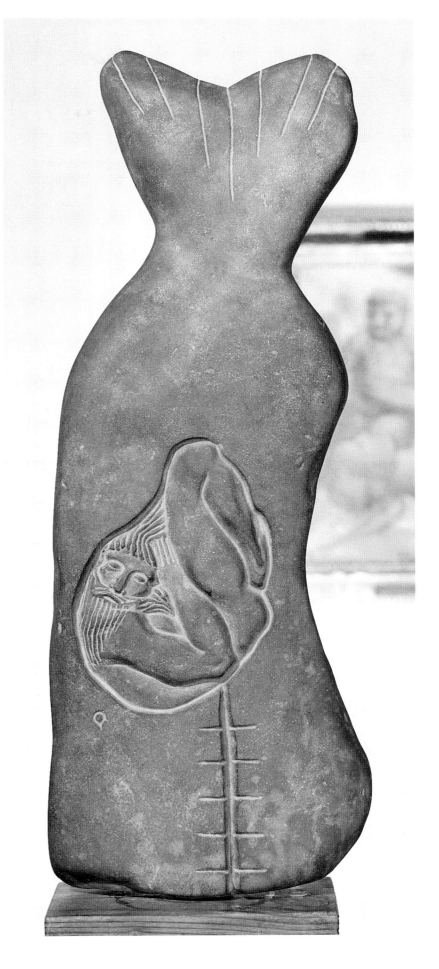

but also because they are rich in the human element, which is the foundation of figuration. What is most important, they hold useful insights for those who will take the time to look within. Because that leitmotif is a unifying theme throughout this book, many lesser-known works of real worth are discussed. Moreover, while the contributions of the major masters of American sculpture have been well covered in monographs and biographies, I have included many other sculptors whose works surround us and inspire us but whom we hardly know.

This book is an extensive chronicling of the figurative tradition from the American Renaissance to the present, not a balanced history of the period. I have therefore presented several hundred artists and works in a general treatment that begins with the great sculpture programs produced in the Beaux-Arts tradition around the time of the Columbian Exposition of 1893 and have proceeded to the present to discuss both major and minor sculptors and their works within traditional categories of art history. Most of the sculptors discussed here were or are members of the National Sculpture Society, because most of the sculpture produced from 1893 until World War I was produced by its members. Furthermore, the society has continued to be the strongest force for the figurative tradition in America.

The study begins with a discussion of the Beaux-Arts tradition, the single most pervasive force in the history of American art. And it shows how that force was rooted in the classical tradition, which is enjoying a resurgence in figurative art today. Through an analysis of major Beaux-Arts projects and programs, the principles of the tradition that shaped American sculpture at the end of the nineteenth century are clarified and illustrated.

It is most significant to American culture that the Beaux-Arts tradition gave form to America's public monuments, which are one of the primary means by which we communicate our traditions, beliefs, and values from generation to generation. In my discussion of public monuments, therefore, I have analyzed their foremost role as embodiments of human values. The examples I have selected show the enormous range and variety of America's monuments, illustrating their importance not only as works of art but especially as essential components of our culture.

The European influences that shaped America's portrait tradition are discussed to illuminate its foremost achievements from the American Renaissance to the twentieth century. I have analyzed America's historical portraits in bronze of the Beaux-Arts period as well as the intimate portraits that depart from academic models and which account for some of the most memorable pieces of sculpture in any culture. And I have explored the ongoing dialogue between Europe and America in the twentieth century and its effect on the variety of traditional and avant-garde approaches to portraiture in America.

Medallic art has been a much neglected medium, and yet it accounts for some of our richest sculptural treasures. The combination of a revolution in figuration and technological advances in medallic art in nineteenth-century France produced a renaissance in the medium that attracted some of America's most gifted sculptors. I have tried to select the work of those expatriates

and their followers that best illustrates the richness in variety and scope of America's medallic art. Moreover, I have shown that the roles of key benefactors, collectors, and organizations illustrate the importance of their continued support of medallists and their work today.

As an extant human link to our primordial roots, North American Indian cultures are of unique importance to American sculpture. To make that clear, I have presented a broad selection of Indian sculpture in different styles from the nineteenth century to the present, by non-Indian sculptors as well as by descendants of the first Americans, ranging from anthropologically accurate records of different physical types and Indian lifeways to romantic idealizations of the "noble savage."

Although traditionally genre sculpture has not enjoyed the status of high art, few people today are convinced that that distinction is valid. The practitioners of genre, which is best described as everyday people doing everyday things, have often captured profound insights that are of value to all ages. The works I have selected illustrate the power of the genre tradition in American sculpture and express some of those timeless insights. Some of these works also show that the line between genre and categories such as portraiture and equestrian statuary is often unclear and sometimes even meaningless.

Over the years, scholars and specialists have shown that the traditional techniques of making sculpture—modeling and carving—underwent profound change at the turn of the century, and by the 1930s open-form metalwork contributed further to shaping sculpture of the twentieth century. Sculptors trained in the Beaux-Arts method were influenced by the works of ancient Greece and Rome, and the Renaissance, Mannerist, and Baroque periods. They modeled their figures in clay, which were cast in plaster to be then either cast in bronze or transferred by means of a pointing device into stone. The system involved a body of artisans, those who made the molds and did the pointing, casting, and carving. The successful American sculptors at the end of the nineteenth century were either trained at the Ecole des Beaux-Arts in Paris or learned from those who were.

The advent of direct carving in the United States in the second decade of the twentieth century eventually destroyed the Beaux-Arts studio system, and even though it opened up new avenues of sculptural expression, it drove a wedge between the human figure and figurative sculpture. Then, sculptors casting figures from life, often fully clothed, further rejected anatomical integrity and the classical nude, which had been the linchpin of the figurative tradition since antiquity. Meanwhile, a growing contingent of modelers and carvers remained faithful to the anatomically conceived figure, and its members continue today to perpetuate that noble tradition in ever-growing numbers.

I have concluded this study with a sculptor's reflection on the fruits of a century of abstraction and a look to the twenty-first century as we approach the millennium.

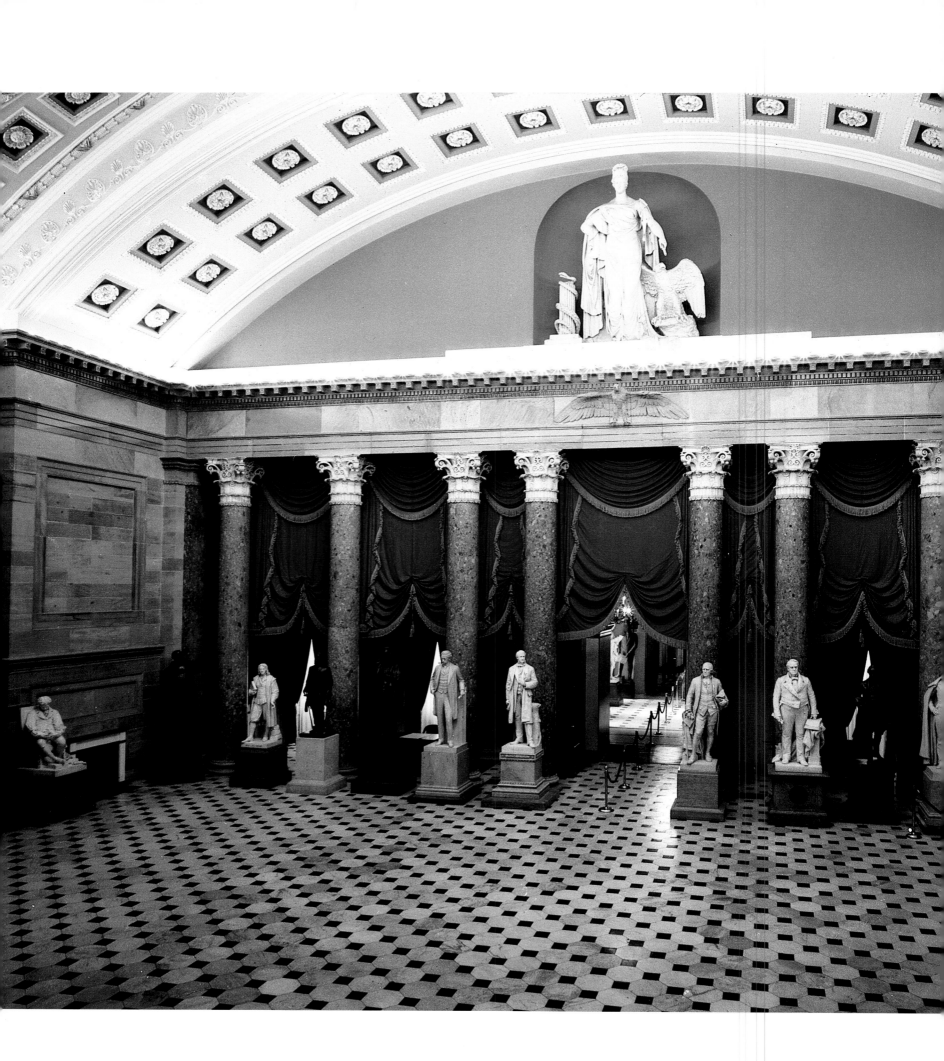

CHAPTER ONE
BEAUX-ARTS SYMBIOSIS

ARCHITECTURE AND THE HUMAN FIGURE

The nation's Golden Age of figurative sculpture was the American Renaissance, when the sister arts of painting, sculpture, and architecture were united in a grand flowering likened to the Italian Renaissance of the fifteenth and sixteenth centuries, thus its name.[1] While the period extended from the country's Centennial celebration of 1876 in Philadelphia to World War I, the sculptural potential of the human figure was most fully realized in the classical style of the great civic and private building enterprises, public monuments, and urban designs that enshrined America's values, ideals, and history in the decades immediately before and after the Columbian Exposition of 1893.

Ideologically not unlike Italian Renaissance art of the fifteenth and sixteenth centuries, which was infused with the Neoplatonic thought of Renaissance humanism, civic art's mission in the American Renaissance was to penetrate the visible world and reveal the ideal, the substance of divine truth, thereby encouraging the public to lives of virtue and ultimately elevating the spiritual life of the nation. That was based on the conviction that both the individual and society could be improved by art.[2] In celebrating the virtues of honesty, loyalty, commitment to high purpose, patriotism, duty as an expression of conscience, and brotherly love, what Adeline Adams called "moral earnestness" characterized the transcendent and didactic "spirit of American sculpture" (the name of her 1923 book) of the period, as Daniel Robbins reminds us.[3] And this ideal was most fully expressed in the great collaborations of civic art.

THE EARLY DAYS

Collaboration in the arts celebrating lofty themes of high moral purpose did not begin in this country with the American Renaissance, but until then

Statuary Hall,
United States Capitol
Washington, D.C.

qualified American artists were in short supply. Thomas Jefferson, for example, had appointed the English architect Benjamin Henry Latrobe in 1803 to complete the interiors of the Capitol in Washington, D.C., and his work was hailed as "a superb visible expression of the ideals of a country dedicated to liberty."[4] While the work was neither conceived by Americans nor executed by American artists, it was a glorious example of artistic collaboration of the highest order, which would inspire succeeding generations of American artists. Latrobe's crowning achievement was the Hall of Representatives, with Corinthian capitals fashioned after the Choragic Monument of Lysicrates in Athens, at Jefferson's insistence.[5] The sculpture program, as numerous scholars have shown, consisted of a statue of Liberty by Giuseppe Franzoni, which stood above the Speaker's desk, with a colossal bald eagle, emblem of the United States, in the frieze beneath Liberty. Flanking the entrance were personifications of the foundations of the new Republic—Art, Science, Agriculture, and Commerce—and above, Clio, the muse of history, with stylus and slate, recorded the events within the great hall while riding in her winged chariot, its wheel the face of a monumental clock, reminding the lawmakers that time is fleeting but that history triumphs over time. The entire ensemble is supported by a globe encircled with signs of the zodiac, symbol that the law is for all seasons.[6]

For the axial lunette in the Supreme Court room, Latrobe designed a seated figure of Justice holding her scales, flanked by a winged figure on one side holding the Constitution and on the other side an American Eagle guarding the law.[7] He invented classical columns to celebrate the agricultural basis of the new nation: corn and tobacco. For the lower vestibule of the Senate, the column shafts are bundles of cornstalks and the capitals are ears of corn, their husks revealing full ripe kernels. In the small rotunda of the north wing, Latrobe designed capitals composed of the flowers and leaves of the tobacco plant. To give them a classical pedigree, he elongated the tobacco leaves in two alternating rows, shorter and longer, a design that was inspired by the capitals of the then-famous Temple of the Winds, second century B.C., in ancient Athens.[8]

Because America's sculptors at the time were woodcarvers and stonecutters lacking the necessary training and experience to execute Latrobe's designs, Jefferson insisted that Latrobe recruit sculptors and carvers from Italy to do the work.[9] With them came the Neoclassical style in vogue at that time in Europe, which shaped aesthetic taste in America for two generations.

EXPATRIATES CAPTURE COMMISSIONS

At first, government commissions for statuary and architectural decoration went to the European-trained immigrant artists. Then, in the 1820s and 1830s, Americans began to go to Italy to learn sculpture from the Italian masters and from the international community of sculptors there. They could also be close to the great statues of ancient times, the marble quarries, and the many marble carvers who could execute their works.

Some of those first American expatriates were successful in capturing coveted commissions for the United States Capitol, particularly Horatio Greenough, who had settled in Florence, and Thomas Crawford, who set up his studio in Rome. Greenough executed a statue of George Washington for the Capitol rotunda. It was installed in 1841 but removed soon after amid criticism from legislators, and the statue is now in the Smithsonian Institution. He also executed *The Rescue* group, a frontiersman defending his family from a hostile Indian. Erected in 1853 on the east front steps of the central portico of the Capitol, it is now in storage.[10]

Crawford did the 19½-foot-high bronze statue of *Freedom* atop the Capitol dome, personifications of *Justice* and *History* over the east portico of the Senate wing, and *The Progress of Civilization* group for the pediment over the Senate portico. All were erected in 1863, during the Civil War. In spite of the economic pressures of war, President Lincoln insisted that these public works proceed as symbols that the Union would survive. Crawford was also commissioned to do two sets of bronze doors, one for the House and one for the Senate, both modeled in the 1850s.[11]

THE "UNVEILED SOUL"

Hiram Powers, who settled in Florence, became America's best-known expatriate Neoclassical sculptor, and he established a figure style that was both universal and timeless. Internationally acclaimed in their own time, Powers's ideal nudes have appeal for the twentieth century as well. Art historian Fred Licht has noted, "Powers's concern for a very delicate transcription of the human form animated by a tender silhouette is already remarkably close to the serenity of Maillol."[12]

Powers's sculpture was a unique blend of the practical and the theoretical. The foundations of his art are to be found in the writings of Emanuel Swedenborg and in the teaching, example, and influence of his father, a Vermont farmer who "valued himself on the curve of his ox bows and yokes" and was delighted that he could "*strike* with the blacksmith."[13] His father's genius with his hands and mastery of materials were transformed by Powers into the invention of new tools and techniques in finishing marble and a revolutionary method of modeling and carving in plaster.

The laborious process of making a marble statue in Powers's day took from a year to a year and a half. It involved modeling a clay figure, casting it in plaster (called the original plaster because replicas were made from it), then copying the original plaster in marble by means of a pointing process. It was a frustrating process to sculptors because the clay figure that came from their hands was destroyed when it was cast in plaster. Powers invented a way of modeling and carving directly in plaster that eliminated the need for the clay model. His original plaster was therefore his original conception. Besides being technologically innovative, his invention was iconographically revolutionary because it preserved the sculptor's conception as material fact in the original plaster at a time when the sculptor's original model had traditionally been lost in the casting.[14]

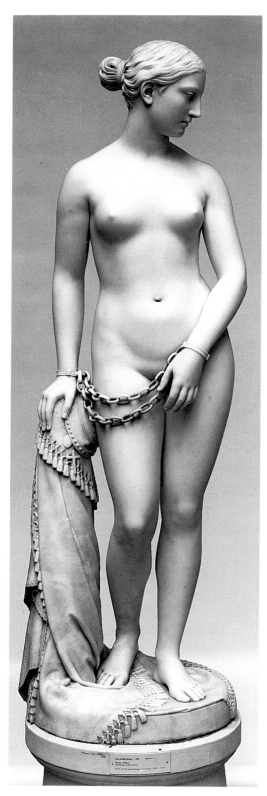

Hiram Powers (1805–1873)
Greek Slave, 1845–47
White marble, 65 × 19½ in.
(165.1 × 49.5 cm)
The Corcoran Gallery of Art,
Washington, D.C.; Gift of
William Wilson Corcoran

Powers's inventive and practical nature extended to the marble itself. Powers rediscovered the Serravezza quarries, first opened by Michelangelo in the sixteenth century. The white statuary marble from Carrara was often flawed, which usually would not be discovered until a statue was well along. Imperfections could mean that a statue had to be discarded, which was very costly to the sculptor. Powers went into the hills himself in search of a solution. He found it in the quarries near Pietra Santa, where the Serra and Vezza rivers come together. The white Serravezza marble, as it was therefore called, was pure, with a fine grain resembling porcelain. Its porosity and color approximated human flesh, making it the ideal material for statuary when naturalism was the goal. In stepping "out of the beaten path . . . by using the Serravezza stone," and by developing special tools to carve and finish it, contemporary critics noted, "the artist has had the creative vigor to reproduce, in its indescribable symmetry, its matchless grace, its infinite beauty, that chief marvel of the earth, the human body . . . and shining through it the human soul."[15] Powers's most famous ideal nude was the *Greek Slave*, which he made in six versions.

In a letter to his friend the English poet Elizabeth Barrett Browning in 1853, Powers wrote that "the legitimate aim of art should be spiritual and not animal" and that "the nude statue should be an unveiled soul."[16] Powers got that notion from the writings of Emanuel Swedenborg, the eighteenth-century Swedish scientist-turned-mystic, who taught that at death we shed our earthly body and exist in a spiritual one, through which our soul shines as if unveiled—in its radiant splendor.

Powers's marble nudes were material equivalents to Swedenborg's "spiritual body" and the means by which he attempted to unveil the beauties of the human body and its animating spirit, the human soul.

Powers's nudes did not capture the innocence of prehistoric man, nor did they evoke some golden age of prelapsarian bliss. They did succeed, however, in reconciling the sensual and the spiritual through Powers's remarkable manipulation of marble, a union that had been eclipsed by eons of civilization. He gave contemporary society, to which erotic gratification was taboo, works of art with which it could celebrate the mysterious forces of nature in a way that was appropriate to its world and to its time.

Looking ahead to the end of the twentieth century, Powers's reconciliation of sense and spirit in the "unveiled soul" is echoed in such works as Frederick Hart's nudes in the *Ex Nibilo* relief on the National Cathedral in Washington, D.C., which attests to the timeless nature of Powers's unique brand of Yankee Classicism.[17]

THE BEAUX-ARTS

By the mid-nineteenth century, Paris was replacing Florence and Rome as the center for training artists, and Americans began attending the prestigious Ecole des Beaux-Arts, France's state school for artists, with its distinguished library and collection of plaster casts of the great works of art from ancient times and the Renaissance.

Beaux-Arts education was grounded in history and technology combined with a studio system in which students learned to analyze and solve architectural and building problems.[18] A thorough analysis of the problem would dictate an appropriate solution, which was expressed in the plan. Because architecture was an ancient art, understanding historical styles was fundamental. While students were taught to master all styles, including Romanesque, Gothic, and Byzantine, it was the classical—ancient, Renaissance, and Baroque—that dominated the curriculum, because it was the most extensively published, best understood, and most widely used. Moreover, its reliance on the cube made it a modular system most suitable for monumental public enterprises. When the French Academy was founded in the seventeenth century, artists were trained to create great public works for the aggrandizement of the monarchy. The American expatriates who studied at the Ecole absorbed that rich tradition of the grand design, which in their hands shaped the American Renaissance.

While all the arts were integrated to achieve a total expression, it was the architect who was the principal creator, designer, and orchestrator of the great enterprises of the American Renaissance, which shaped the destinies of sculpture and painting until the aftermath of World War I.[19]

Richard Morris Hunt was the first American to study architecture at the Ecole, 1846–53, followed by Henry Hobson Richardson, 1859–62, and Charles Follen McKim, who attended from 1867 to 1870.[20]

In Richardson's Trinity Church of 1873–77, according to Henry-Russell Hitchcock, the union of the arts to create a unified decorative scheme for the interior of the church reached a level of sophistication heretofore unknown.[21] John La Farge's modeling of opalescent tones in the small stained glass windows in the west front; the Pre-Raphaelite north transept windows of Morris and Burne-Jones of England; and La Farge's wall murals in tones of dull terracotta, muted golds and blue-greens, stenciled patterns, and small pictorial panels produce what Hitchcock calls an interior illumination of "low burning intensity." For Hitchcock, Richardson's orchestration of light and color in Trinity to produce a unified decorative scheme marks the beginning of a new era, a collaboration between architect and artists that became the hallmark of the American Renaissance.

The following year, La Farge collaborated with Augustus Saint-Gaudens, who had studied at the Ecole and who had assisted him in the Trinity decorations, on the chancel of St. Thomas Church in New York City, designed by Richard Upjohn—unfortunately destroyed by fire in 1905. Then, in 1879, the two collaborated on the interiors for Cornelius Vanderbilt II's house by architect George B. Post, which was the first collaboration of noted artists and architects on a residential commission.[22] Other artists included sculptor Philip Martiny, the French sculptor René de Quèllin, and painter Will H. Low. That structure was razed in the 1920s to make way for the Bergdorf-Goodman department store, but a remnant of its Beaux-Arts decoration survives and has been traced by James Dennis in his study of the architectural sculptor Karl Bitter. Post had enlarged the mansion in 1893, and the Austrian-trained Bitter,

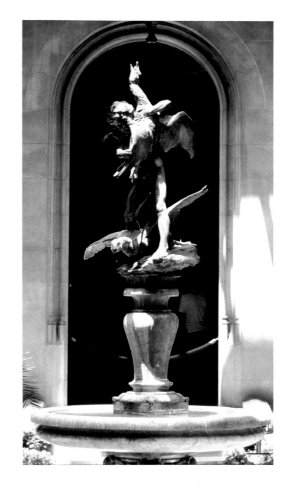

Karl Bitter (1867–1915), sculptor
Richard Morris Hunt
(1827–1895), architect
Boy with Swans, 1895
Marble, under lifesize
Biltmore Estate, Asheville,
North Carolina

who had been discovered by Richard Morris Hunt and was one of the most accomplished sculptors in the Beaux-Arts tradition, executed six panels in high relief of groups of children engaged in various activities such as playing musical instruments. Two of the panels survived the destruction of the mansion and can be seen today at the entrance to the Sherry-Netherland Hotel at 59th Street and Fifth Avenue, across the street and northeast from where the mansion once stood.[23] At that time, Bitter was also creating pieces for Hunt's famous Biltmore, in North Carolina, and his celebrated bronze doors for Trinity Church in New York City were completed in 1893–94. The doors rank among the finest ecclesiastical sculpture in the United States in conception and execution, and they are superb examples of the eclecticism that characterizes the Beaux-Arts tradition. Designed to fit the main portal of Richard Upjohn's building of 1846, the doors are lancet in shape, but for their scheme of the Fall, Redemption, and Last Judgment, they rely on Ghiberti's second set of Early Renaissance doors for the Baptistery in Florence. Yet James Dennis,

Karl Bitter (1867–1915), sculptor
Richard Morris Hunt
(1827–1895), architect
Main Door, 1894
Bronze, 8 × 12½ ft. (2.4 × 3.8 m)
with tympanum
Trinity Church, New York

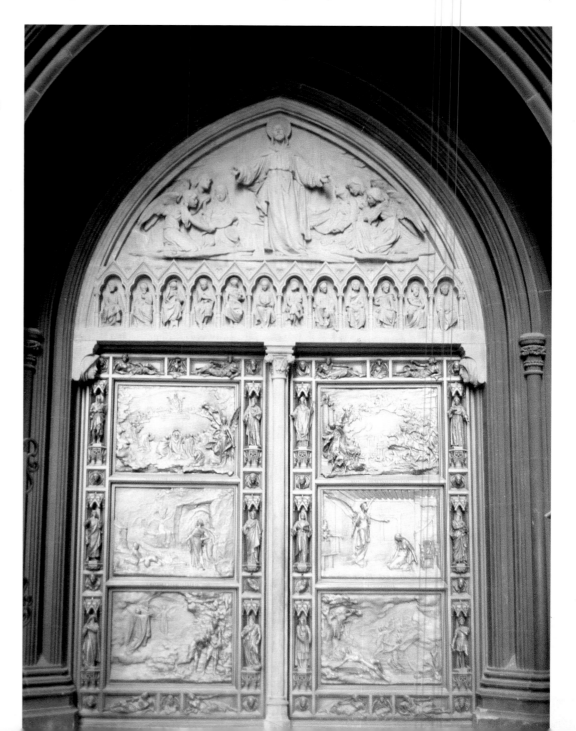

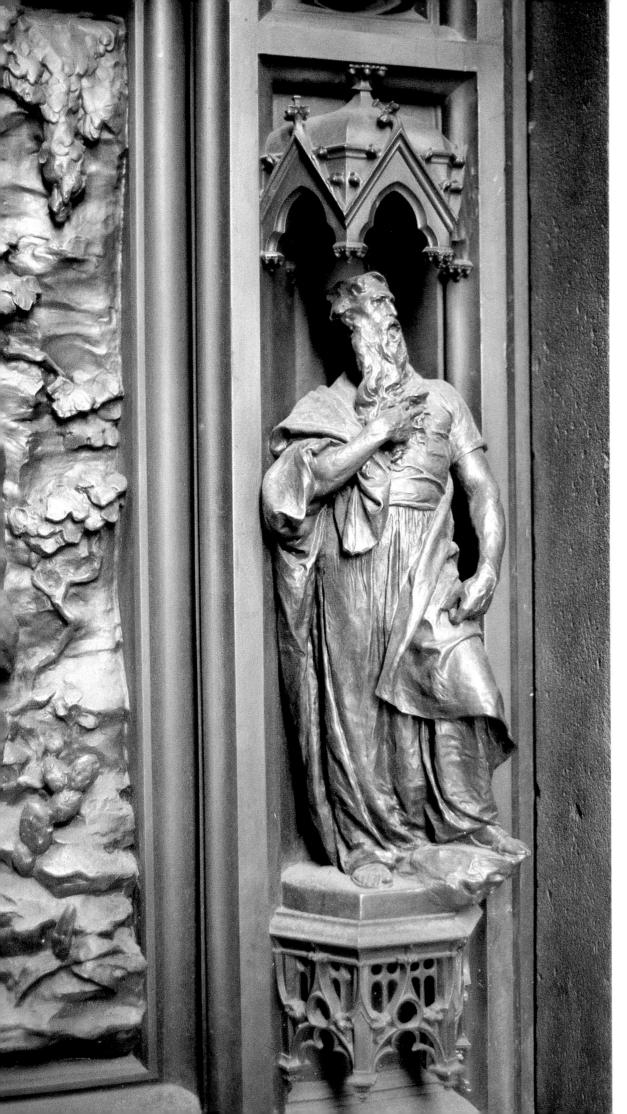

Karl Bitter (1867–1915), sculptor
Richard Morris Hunt
(1827–1895), architect
Two Details of Main Door: Moses
(LEFT) and portrait of Richard
Morris Hunt (RIGHT), 1894
Trinity Church, New York

in his illuminating study of Bitter's architectural sculpture, shows that Bitter's modeling and composition, with dramatic diagonals and grand circular movements, depart from the linearity of Early Renaissance reliefs and rely on a Baroque sense of space and movement for their remarkable life and immediacy. Moreover, for his freestanding figures flanking the relief panels, Bitter drew inspiration from familiar works of the great Renaissance masters. His figure of Moses, for example, is an ingenious conflation of the upper torso of Michelangelo's *Moses* in the Church of St. Peter in Chains in Rome, and the contrapposto of Donatello's *St. John* on the exterior of Or San Michele in Florence. In Renaissance fashion, Bitter includes a bust of the architect of the doors, Richard Morris Hunt, as well as his own self-portrait.

"A PALACE FOR THE PEOPLE"

McKim, Mead & White's success with the Villard houses won them the commission for the Boston Public Library (1887–98), which brought the civic exuberance of the American Renaissance to the people. As scholars have noted, the artistic glories that heretofore had been available only to such wealthy patrons as the Vanderbilts and Villards now belonged to everyone in what the trustees called "a palace for the people."[24]

Besides being a palace for the people, the building had to house the largest public circulating library in the world, and it had to share a site on Copley Square with a medieval melange of Romanesque, Gothic, and nondescript structures. In McKim's solution, he echoed the massive Romanesque arcuation of Richardson's Trinity Church to the east in his design for the Copley Square façade with a long row of deeply set arched windows for the reading room, set above a high basement flanking an entrance of three triumphal arches. It was symbolic that the architectural and artistic collaboration that began in Richardson's church reached maturity in McKim's library.[25]

For this treatment, which Leland Roth chronicles in his monograph, McKim drew from the great arches of the Roman Colosseum (70–80 A.D.)

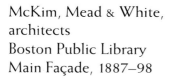

McKim, Mead & White, architects
Boston Public Library
Main Façade, 1887–98

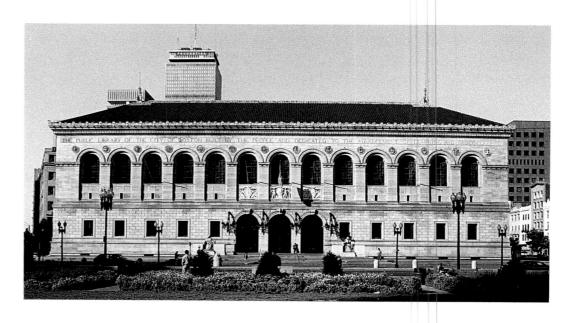

and the deep funerary niches of Leon Battista Alberti's transformation of the church of S. Francesco in Rimini of 1450. The strong horizontal composition acted as a foil to the Gothic spire of the Old South Church and recalled the cinquecento façade of the Library of St. Geneviève in Paris (1843–50) by Pierre-François-Henri Labrouste. The library's light pink granite rested as comfortably as possible with the red brick and yellow terracotta of the Gothic Revival Museum of Fine Arts across the way.

For the interiors, Roth shows that McKim assembled leading artists of the day, both Americans and Europeans, to create the noblest international collaboration of the arts yet achieved in America. Augustus Saint-Gaudens executed the seals of Massachusetts, Boston, and the library over the triumphal arches at the entrance, his brother Louis did the pair of lions for the stair hall, and Daniel Chester French modeled the bronze doors for the entrance. The English artist Edwin Austin Abbey and the American expatriate painter John Singer Sargent worked together in Abbey's studio in Gloucester, England, where Abbey painted a mural of the Holy Grail for the library delivery area, and Sargent devised a series of murals for the third-floor hall showing the development of religion. Pierre Puvis de Chavannes, the French painter, whose murals re-created the look of the monumental fresco style of the Renaissance, painted the murals for the grand stair hall, while a host of other artists and craftsmen enriched the interiors with a myriad of tones and shades created with mosaics and paintings and variegated marbles from here and abroad.

It became apparent when the doors opened in 1895 and the public first laid eyes on McKim's program of art and architecture that here was the wave of the future for civic buildings—monuments to human values enshrined in dignity and beauty. Here was a style of civic art adaptable to commerce, industry, and the home as well as to city planning. In closing the west end of Copley Square with the library building, McKim created a Renaissance-like piazza, as McKim scholars have pointed out, a device that was most fully developed in the Columbian Exposition in Chicago in 1893, with the Court of Honor.[26] Indeed, the promise for public art and architecture that the Boston Public Library showed was realized in the Columbian Exposition.

THE CITY BEAUTIFUL

During that period, according to scholars, as the country experienced increasing prosperity, the gap between the rich and the poor increased, and with the rise of the great industrial trusts and robber barons, the nation's leaders in government, commerce, and industry were too often governed by corruption and expediency rather than by virtue and justice. So, the humanitarian themes central to the great collaborative art programs of the American Renaissance did not ring true to a sizable segment of society: the working poor. As a matter of fact, to them those great artistic collaborations were monuments to their poverty. Had not their labor made them possible?[27] Moreover, in spite of the American Renaissance in the arts, the sociological

and technological problems of tenements, transportation, sewage, and the like continued to plague the country.

In his insightful and comprehensive study of the City Beautiful Movement, William H. Wilson has shown that there were people, however, who were interested in those problems, even if at first not for humanitarian reasons. They organized themselves into village improvement societies, a movement that Wilson traces to pre–Civil War New England. The first of those societies was the Laurel Hill Association, which was founded in 1853, in Stockbridge, Massachusetts, by Mary Hopkins, who wanted to do something about summer visitors' complaints about the village's poor sanitation and lack of adornment.[28] From the outset, then, the movement addressed sociological, technological, and aesthetic issues.

The village improvement movement spread throughout New England and westward, until by 1895 a society had been established as far west as Pasadena, California, and the movement by then had extended to large towns and cities and was addressing broader issues. After all, it was a logical step from beautifying streets and parks, restoring civic buildings, and improving sanitation and public services to comprehensive town planning, civic responsibility, and efficiency in government.[29]

It has been shown that the greatest impetus to the movement came from a book by the self-taught urban designer Charles Milford Robinson, who was by training a journalist and poet. *The Improvement of Towns and Cities; or, the Practical Basis of Civic Aesthetics,* published in 1901, was a comprehensive guide to civic improvement that combined utility and aesthetics and covered every aspect of the community.[30] Prefiguring his book in a series of articles in the *Atlantic Monthly* in 1899, Robinson used the phrase "City Beautiful" to describe the growing movement. In addition to a system of boulevards and parks, which were central to his overall theory of the City Beautiful, public sculpture, murals, and artistic street furniture were essential components of civic improvement and urban planning.

It was in the Chicago Exposition of 1893 that the real potential of the City Beautiful Movement took tangible shape in what became known as the White City, which set before the nation what the fair's director Daniel Burnham called "a great truth, the need of design and plan for whole cities."[31] The Chicago Exposition has been correctly called a culmination rather than the beginning of the City Beautiful Movement, because it crystallized on a grand scale the sanitary and aesthetic aims of the movement.[32]

THE COLUMBIAN EXPOSITION

To celebrate the 400th anniversary of Columbus's discovery of America, it was decided to have a great world's fair. As Secretary of State Seward wrote in 1867, "They advance human knowledge in all directions, ancient prejudices are broken down, nations are fraternized, generous rivalries in the peaceful fields of industry are excited, the tendencies to war are lessened, and a better understanding between capital and labor is fostered. . . . Such exhibitions have

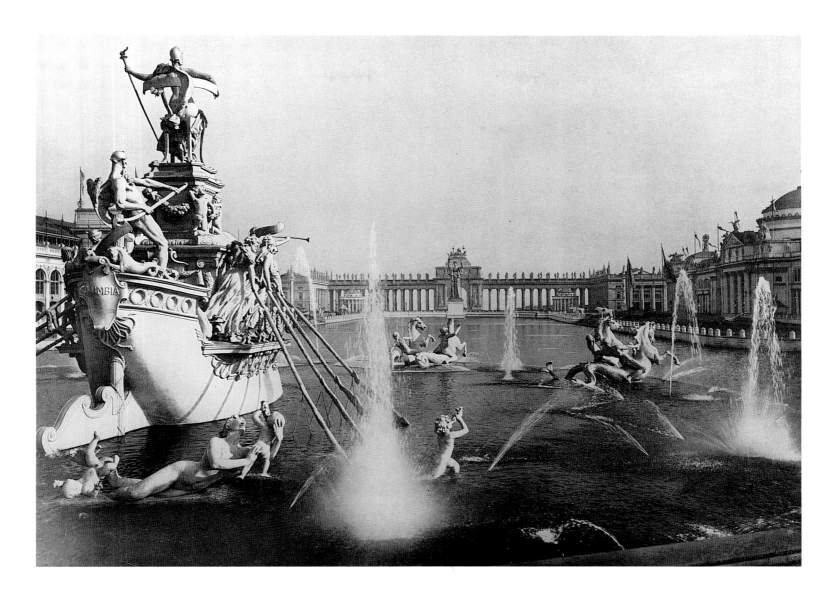

become national necessities and duties."[33] Historians are agreed that the first world's fair, the London Exhibition of 1851 in the Crystal Palace, to promote British industry, established the international exposition as the major vehicle for expressing the nationalist spirit and for promoting trade and international relations. Others were then held in Paris in 1855, 1867, 1878, and 1889, in London in 1862, in Vienna in 1873, and in Philadelphia in 1876.

Congress selected Chicago over bids of various states to be the host for the great world's fair. The noted landscape designer Frederick Law Olmsted was commissioned to select and design the site, working with Burnham & Root, one of the leading architectural firms of Chicago. And Augustus Saint-Gaudens was supervisor of sculpture. The location chosen was a marshy undeveloped site in Jackson Park, and John Wellborn Root, as the general designer, conceived the idea of a lagoon flanked by the exhibition buildings. That idea evolved into dividing the fair into four zones, which were determined by their activities, an innovative idea that influenced the future of urban planning. The zones were the Court of Honor, the formal area to the south for the main exhibits and the architectural, sculptural, and decorative

Frederick William MacMonnies (1863–1937)
Barge of State, World's Columbian Exposition, 1893
Chicago

heart of the fair; an informal lagoon in the center; an area to the north for the state and national pavilions; and the midway to the west for amusements.

Root's partner, Daniel Hudson Burnham, was in charge of directing the entire operation. Burnham's organizational and administrative abilities made him the ideal partner for Root, the designer, notes William Wilson. Root died of pneumonia in 1891, however, leaving Burnham in full control, which has caused some historians to wonder whether the architecture and plan would have been different if Root, who had been a master of the Romanesque, had lived. Burnham selected leading Eastern architectural firms for more than half of the major buildings, and most of the monumental sculpture was assigned to New York City sculptors, which angered Burnham's fellow

Richard Morris Hunt
(1827–1895)
Elevation of Administration Building,
World's Columbian Exposition,
1891–93
Pencil, wash on blue line
drawing on paper
The American Architectural
Foundation, Washington, D.C.

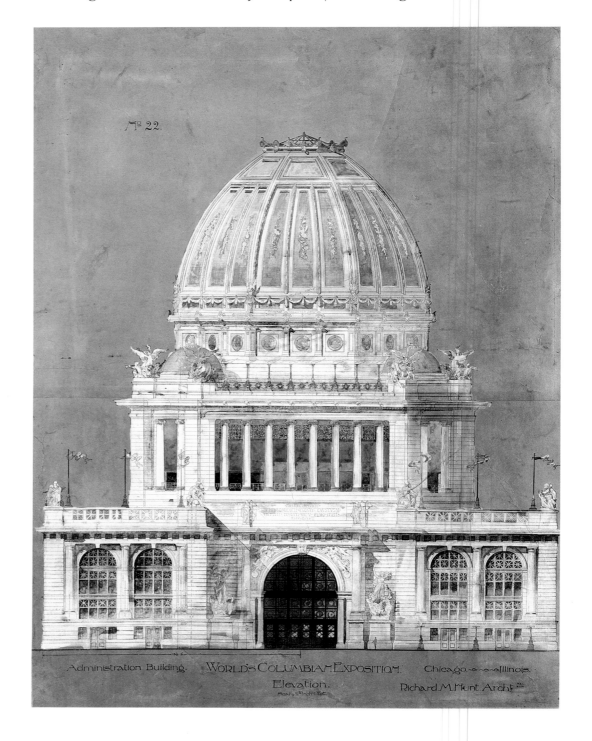

Chicagoans. Moreover, three of New York City's architects—Richard Morris Hunt; McKim, Mead & White; and George B. Post—were assigned the key buildings in the Court of Honor. To achieve unity of overall design, while providing individual architects sufficient independence, the Eastern architects chose the classical style.

The Court of Honor consisted of a complex of classical temples, arcades, and a peristyle surrounding a basin 350 feet wide and 1,100 feet long and would serve as a model for civic centers after the great fair in cities like Cleveland and San Francisco. Richard Morris Hunt's French Renaissance Administration Building, with Frederick MacMonnies's colossal fountain, the *Barge of State*, in front of it, faced Daniel Chester French's 65-foot-high gilded personification of the *Republic* at the opposite end of the long basin. Hunt's building was set against the elaborate peristyle with its roof of statues by Theodore Baur, its water gate emblazoned by the sculpture of Bela Lyon Pratt, and its triumphal arch capped by a colossal quadriga with figures by French and horses by Edward Clark Potter.

McKim, Mead & White's Agriculture Building, with its Pantheon-like dome, and George B. Post's Manufactures Building, whose façade called to mind the triumphal arch of Septimius Severus, faced each other midway along the basin like giant Roman temples.

THE PARIS EXPOSITION OF 1889

The entire ensemble in name and plan, Richard Guy Wilson has noted, was meant to rival the Court of Honor at the Paris Exposition in 1889 on the Champ-de-Mars, the great fair to commemorate the centennial of the French Revolution.[34] Gustave Eiffel's 986-foot-high tower was the centerpiece of the Paris Exposition, and extending from it was the Court of Honor composed of exhibition halls surrounding a long rectangular split-level lagoon with fountains whose multitude of sprays were varied and ever changing. Across the lagoon and facing the Eiffel Tower was the Dôme Central of the Industrial Palace. Directly in front of it and on axis with the Eiffel Tower was sculptor Jules-Felix Coutan's monumental fountain sculpture, a ship representing the City of Paris, bearing France, who illuminates the world with her torch of learning. She is surrounded by more than twenty colossal figures including Science, Industry, Agriculture, and the Arts, mermaids, and allegories of modern life.

In Chicago, in place of the Eiffel Tower was Richard Morris Hunt's Administration Building, and MacMonnies's *Columbian Fountain* or *Barge of State* directly in front of it was fashioned after Coutan's *City of Paris*. At the opposite end of the basin was Daniel Chester French's 65-foot-high gilded statue of the *Republic*, which recalls Eugène Delplanche's colossal statue of *France* atop the 214-foot-high Dôme Central. And the liberal use of statuary, murals, and staff are indebted to the Paris Exposition.[35]

Richard Morris Hunt, one of the 150,000 Americans who attended the Paris Exposition, called it an architectural failure, because it lacked

monumentality. The Americans would not make the same mistake in Chicago. The fair would be a marvel of architecture and ornament, an unprecedented collaboration of the fine arts. It would bring before the American people the largest collection of public sculpture in the classical style ever assembled. More than thirty sculptors were involved in creating the statuary and architectural ornament for the fair. Augustus Saint-Gaudens called it the greatest assemblage of artists since the Renaissance, as the Saint-Gaudens authority John Dryfhout recalls, which both crystallized and expressed the ideas of the City Beautiful Movement and marked the greatest application of the Beaux-Arts tradition to urban planning in America up to that time.[36]

The classical style was selected because the architects and artists were familiar with it; it was the most adaptable to varied spaces, the most suitable for town planning, and it provided the best vehicle for the arts, especially for sculptural ornament.[37]

THE WHITE CITY

The Chicago fair was called the White City because all the main buildings were sheds of wood and iron skeletons clad with staff, an impermanent material made of a mixture of plaster and horsehair, jute, or other fibrous material to hold the plaster together which was cast in gelatin molds and was easily worked and tinted. The gleaming white plaster inspired the name "White City."

While it was indeed a white city, it was also a richly colorful one, William Wilson explains. Architectural details were picked out in rich polychromy, and great masses of color acted as a foil to the radiant white façades and colossal statuary, especially in the Court of Honor. French's gilded *Republic* stood tall in the Great Basin facing Hunt's lofty black dome of the Administration Building with its gilded ribs. Gardeners maintained an extraordinary array of colorful flower beds interspersed among the grassy green lawns throughout the grounds. Louis Sullivan's Golden Doorway to the Transportation Building was set within a colorful façade, and at night the buildings with their impressive displays of sculptural ornament were outlined against the sky in a profusion of electric lights, creating a grand show that held the promise of the future for civic centers across the country.[38]

Here was living proof that cities could be beautiful. And the fair was a perfect blend of beauty and utility, a hallmark of the City Beautiful Movement. It demonstrated on a scale heretofore never dreamed of what actually could be done in terms of technology wed to the classical tradition, contemporary critics noted. There were some 200 buildings housing exhibits and displays of 79 countries and 38 states spread over 686 acres, compared with the Paris Exposition of 228 acres. Innovations in transportation included a moving sidewalk and elevated railways, and the massive illumination of the entire complex was a preview of the century to come. The Paris Expo of 1889 had been the first world's fair to be lighted at night, but the Chicago Fair was the greatest. Sanitation workers kept the streets immaculate, security

was efficient, there were an unprecedented number of restrooms, and 27 million visitors to the fair had an abundance of filtered drinking water.

Having a Women's Building reflected the large and continuing role women had in the village improvement movement, Wilson makes clear; Jeanne Weinmann chronicles how Sophia G. Hayden, a female Boston architect, was selected to design the building, while the murals of Mary MacMonnies and Mary Cassatt were featured in the building's decoration.

The Administration Building

Hunt's Administration Building was to be the formal entrance to the fair for those who arrived by train at the railway terminal just west of the building. It should therefore convey a monumental and exuberant welcome. Hunt's great dome—which at 266 feet 6 inches high was 57 inches higher than the U.S. Capitol building and 52 feet 6 inches higher than the Dôme Central of the Paris Exposition—reporters noted was reminiscent of Brunelleschi's famous dome for the Cathedral of Florence and soared above a giant Ionic colonnade inspired by the tomb of Mausolus at Halicarnassus. It was supported by 60-foot-high Doric pavilions forming the base of the building.

The theme for the sculpture program was chaotic nature harnessed by man and brought into the service of society, and the institutions, values, and virtues by which that is accomplished. Hunt chose Karl Bitter, the Austrian-born-and-trained sculptor, whom he had employed on numerous other commissions. Bitter's baroque exuberance in his treatment of the human figure produced an appropriate blend of nature and allegory that captured the pageantry and dignity the architect felt were appropriate to his building and at the same time would be a fitting welcome to the fair.[39]

In the basin in front of the Administration Building, Brooklyn-born Frederick MacMonnies, who had studied in Paris and there distinguished himself with exotic nymphs and historical portraits, created one of the most popular sculptures of the fair, the *Columbian Fountain,* or *Barge of State.* A personification of Columbia was enthroned on an exotically conceived galleon-like barge surrounded by a confection of colossal seminude allegories. Winged Fame strides forward at the prow, her trumpet in the right hand and her wreath of victory in the left, guiding Columbia. Bearded and aged Time, with both hands on the tiller and muscles bulging, steers the barge while four females on either side, allegories of the arts, sciences, and industries, draped in flowing gowns, dip their paddles into the water and propel the barge with much greater ease than Time steers it. Surrounding the barge are a host of spirited nymphs, tritons, dolphins, and sea horses playing amidst the animated jets of water. MacMonnies's debt to Coutan's fountain sculpture of the 1889 fair in Paris was evident to many, but in no way diminished the enthusiasm the public felt for his colossal group.[40] The remarkable contemporary views of those pieces illustrated and described by Stanley Applebaum provide the reader with a comprehensive guide to the architecture and sculpture of the fair.

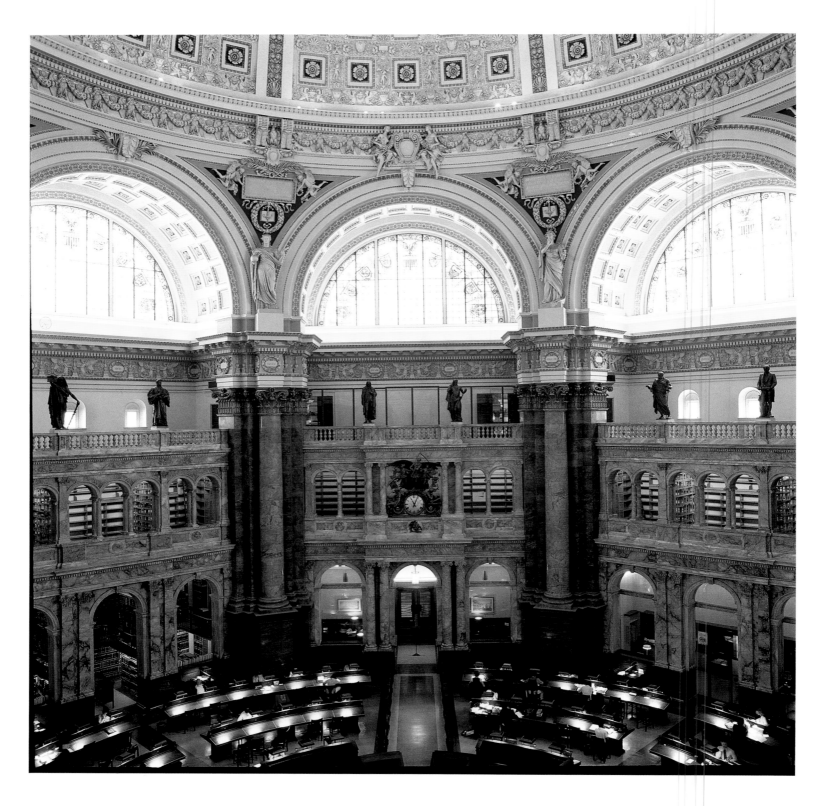

Reading Room,
Library of Congress
Washington, D.C.

THE LIBRARY OF CONGRESS

The first great decorative program for a civic building following the Columbian Exposition of 1893 was designed for the Library of Congress and was executed between 1892 and 1897.[41]

When the Library of Congress was founded in 1800, the year the national government was moved to Washington, it was housed in the Capitol

building. It remained there until the opening of the present building, which was designed by Paul J. Pelz of the Washington firm of Smithmeyer and Pelz, Architects, and was completed by Edward Pearce Casey. Casey had graduated from Columbia University with degrees in engineering and philosophy. He then worked for McKim, Mead & White and attended the Ecole des Beaux-Arts for three years. In 1892, the year he won the library commission, he set up his office in New York City, the fast-growing cultural center of the nation.[42]

While Pelz's original design for the building was modified, it retained the style of the Italian Renaissance, Helen-Anne Hilker has noted. Casey was responsible for the execution of the art and decoration of the building, a collaboration that reflected his Beaux-Arts training and experience with McKim, Mead & White. The library's comprehensive plan of sculpture, murals, and mosaics, developed under Pelz and executed with modifications under Casey, remains the most elaborate of any library in the United States, and it was a model for countless civic buildings and spaces throughout the country until World War II. These riches have been made more accessible to the general public through the publication by Classical America of journalist and publisher Herbert Small's original *Handbook* of 1897. This edition—sensitively edited by Henry Hope Reed, with an introduction by Pierce Rice, new photographs by Anne Day, and an illustrated glossary—provides new insights into this watershed of the Beaux-Arts tradition in America.

Some fifty artists were commissioned to execute its carefully orchestrated program of sculpture, painting, mosaics, murals, and decoration that carries the theme of mankind's progress through religion, history, literature, and the sciences as expressed through the word. Casey sought the advice of John Quincy Adams Ward, the first president of the National Sculpture Society, for guidance on the sculpture program. Ward selected Augustus Saint-Gaudens and Olin Warner to join him as a committee, and together they formulated what was the first major collaboration of the National Sculpture Society, consisting of nineteen sculptors.[43]

Richard Guy Wilson has with good reason called the trek up the entrance stairs, through the vestibule, into the great public hall, and then into the grand rotunda reading room (surrounded with statues by America's leading sculptors beneath Edwin Blashfield's murals in the dome depicting *The Evolution of Civilization* and *Human Understanding*) "one of the great architectural journeys of the American Renaissance."[44]

The main entrance to the library in the center of the west façade is set within a colossal pavilion 140 feet wide with an elevated landing, and consists of three triumphal arches creating a vast screen of paired columns supporting a grand entablature, the whole crowned with a dome, lantern, and cupola. This classical ensemble is fittingly enriched with portraiture, personifications, and allegorical figures in relief and freestanding sculpture that celebrate the universal glories of learning in styles reminiscent of the classical, Renaissance, and Baroque art and architecture of Europe.[45]

Freestanding busts of eminent people in literature by William Boyd

overlook the scene from the second story, and in the spandrels over the triumphal arches, personifications in low relief by sculptor Bela Lyon Pratt celebrate Literature, Science, and Art. Beneath the arches, each entrance has a set of bronze doors 14 feet high and 7½ feet wide with a lunette above. They carry reliefs that symbolize the sequence in which humankind preserved its religion, history, literature, and science by means of the word: *Tradition*, to the left, by Olin Warner; *Writing*, to the right, by Olin Warner and Herbert Adams; and *Printing*, in the center, by Frederick MacMonnies.[46]

The focus on humankind as the central theme of the Library of Congress is underscored by an innovative union of art and science in the keystones over the windows of the first floor pavilion. They represent thirty-three races of mankind and are the first such union of art and science on a grand scale for a civic building in the United States. Sculptors William Boyd and Henry Jackson Ellicott carved the granite keystones from plaster busts of different races of people, whose skeletal remains were in the collection of the National Museum of Natural History in Washington, D.C.

The gem of the Library of Congress is the domed Rotunda Reading Room.[47] Its comprehensive design uniting architectural clarity with sculpture, variegated marbles, murals, mosaics, and stucco remains unmatched anywhere in the United States.

The statuary in the rotunda personifies principal characteristics of civilized society and portrays major figures throughout the history of the world in whom those characteristics are best exemplified. Moreover, these personifications stand above the great piers that define the octagonal space and support the dome. Their position, therefore, as Small makes clear, becomes symbolic. As the piers define the space and support the structure, so the personified characteristics define and support civilized society. Those figures are in plaster painted ivory to match the stucco decoration in the room and stand 10½ feet tall. They represent *Religion*, by Theodore Baur; *Commerce*, by John Flanagan; *History*, by Daniel Chester French; *Art*, designed by Augustus Saint-Gaudens and executed by François M. L. Tonetti; *Philosophy*, by Bella Lyon Pratt; *Poetry*, by J.Q.A. Ward; *Law*, by Paul Wayland Bartlett; and *Science*, by John Donoghue. Above each are sculpture groups by Philip Martiny consisting of pairs of winged figures with palm branches, a lamp and open book, and an oak wreath, all symbolizing the power and goodness of wisdom. Inscriptions above each were selected by the great American educator Charles William Eliot, president of Harvard University at the time, who also selected inscriptions for the Columbian Exposition in 1893.

Along the balustrade of the gallery stand eight pairs of bronze portraits of historical figures whose lives were incarnations of what the personifications embody. *Moses* by Charles Niehaus and *St. Paul* by John Donoghue flank *Religion*, for example, while *Michelangelo* by Paul Bartlett and *Beethoven* by Theodore Baur flank *Art*.

Appropriately, setting this entire pageant within the context of historical and mythic time, John Flanagan's enormous clock of colorful marble and bronze figures surveys the scene from above the main entrance to the reading

room and reminds the visitor that time is fleeting and art alone endures, an early prophetic image for Herbert Small, who died of typhoid in Boston's city hospital at the age of thirty-four.

CHICAGO'S LEGACY

The spirit of the White City did not die with the closing of the fair. It lived on in the improvement plans in some of the nation's major cities, and most dramatically in three great world's fairs: the Pan American Exposition in Buffalo, 1901; the Louisiana Purchase Exposition in Saint Louis, 1904; and the Panama-Pacific International Exposition in San Francisco, 1915. They were tributes to America's material progress, and the development and supervision of the sculpture programs for all three were entrusted to Karl Bitter.[48]

In the Pan American Exposition, which ushered in the twentieth century, the exhibits dealt with the country's natural resources, its government, and its arts, sciences, and industries. So, according to James Dennis, Bitter developed a program to celebrate the nation's natural and human resources transformed by technology into its artistic, scientific, and industrial output. Sculpture included two colossal fountains, *Man* by Charles Grafly and *Nature* by Bitter, and smaller fountains by Bitter dedicated to man's social evolution, abundance, and the arts. Harnessing the energy of the Great Lakes was monumentalized in the Electric Tower, resembling Stanford White's tower for Madison Square Garden, and George Grey Barnard executed two groups for the base—*Great Waters in the Time of the Indian* and *Great Waters in the Time of the White Man.*[49]

The Louisiana Purchase Exposition commemorated the centennial of the purchase of the Louisiana Territory, which was seen by the founders and designers of the fair as expressing the doctrine of Manifest Destiny, which became the theme of the exposition. Bitter approached the theme in a straightforward manner as history and de-emphasized technology, industrial development, and the like. To capture the sense of history, Dennis explains, he used the naturalistic style to represent historical narrative and employed allegory to express the ideals of Manifest Destiny. In his own relief celebrating the signing of the Louisiana Purchase Treaty, for example, Monroe, Livingston, and Marbois were shown at the moment of the signing in lifelike poses and convincing likenesses. The symbol of St. Louis, the host city, became the city's patron saint, Louis IX, portrayed by Charles Niehaus in a colossal equestrian monument. The Atlantic and Pacific oceans, on the other hand, symbolizing the boundaries of the continent, were idealized figures in the classical tradition set within a fountain group of *Apollo and the Muses.*[50]

In 1912, Karl Bitter was appointed director of sculpture for the Panama-Pacific International Exposition in San Francisco, 1915, to celebrate the opening of the Panama Canal. When he was killed in an automobile accident in April, A. Stirling Calder, his acting chief of the Department of Sculpture, succeeded him.

The fair's colossal sculpture in the Beaux-Arts tradition would never be surpassed in virtuosity or in the "moral earnestness" that American sculpture

had embodied since the beginning of the American Renaissance.[51] Sculptors would continue to create in this vein until the end of World War II, but in conception, composition, modeling, and craftsmanship, the sculptor's technical skill in rendering the human figure had reached its apogee here in 1915, at the Panama-Pacific Exposition. For some scholars, several key examples illustrate this high-water mark of the classical figure in America.

A. Stirling Calder's monumental group, *The Nations of the East*, soared over the Court of the Universe atop McKim, Mead & White's triumphal *Arch of the Rising Sun*. The colossal group was composed of an amalgam of some dozen exotic figures, including Arabian horsemen, Asian warriors, desert tribesmen, camels, and a great elephant supporting an imperial howdah, much in the spirit of Bernini's elephant supporting an obelisk of 1667 in the Piazza S. Maria Sopra Minerva in Rome. In its pomp and pageantry, this monumental conflation of sculpture and architecture in San Francisco in 1915 recalled the elaborate Baroque *tableaux vivants* of the seventeenth century that were played out atop the triumphal arches that cities erected for celebrating the achievements of visiting dignitaries. One of the most famous, that for Marie de Médicis's visit to Amsterdam, became the subject of a painting by Rembrandt. It is in that same spirit that Jules Guerin's elegant rendering of McKim, Mead & White's *Arch of the Rising Sun* with Calder's colossal *Nations of the East* aloft may be seen today.[52]

Calder's group overlooked the fountains of the *Rising Day* and the *Descending Night* by Adolph Weinman in the court basin and the *Column of Progress* with reliefs by Isidore Konti with the figure of an adventurous archer above by Hermon MacNeil. Another fountain, the *Fountain of Energy* by Calder, was a marvel of balance, modeling, and engineering. As Daniel Robbins has discussed, an equestrian personification of Energy sat upright on a nervous steed pawing the earth, Energy's arms extended outward from his sides with remarkable steadiness, as winged figures of Fame and Glory stood securely upon his shoulders and gracefully placed trumpets to their lips.

Robert I. Aitkens's *Fountain of Earth* in the Court of Abundance was a direct descendant of MacMonnies's *Barge of State* in the Columbian Exposition, scholars have observed, but it was pressed into dealing with modern themes of science and psychology. A giant globe emerged from the waters of chaos and was surrounded by panels of interlocked nude figures in high relief representing themes of natural selection, survival of the fittest, and sexual love. While these Darwinian and Freudian themes were appropriate to the classical tradition, they lacked the "moral earnestness" of the familiar ideals celebrated in Chicago, Buffalo, and St. Louis, and augured ill for the future of the Beaux-Arts tradition in America.[53]

THE MCMILLAN PLAN AND THE FEDERAL TRIANGLE

The influence of the White City is reflected in the U.S. Government's improvement plan for the nation's capital, as William Wilson has analyzed. To celebrate the centennial of the city's founding, when the Federal

Government was moved to Washington, D.C., a commission was formed by Senator James McMillan of Michigan in 1901, consisting of architects Daniel Burnham and Charles F. McKim, sculptor Augustus Saint-Gaudens, and landscape designer Frederick Law Olmsted, to develop a plan for the improvement and beautification of Washington.

The goals of the McMillan Commission were to correct such desecrations to L'Enfant's Plan of 1791 as the unsightly railroad terminal that had disfigured the Mall, the improper placement of monuments, and haphazard landscaping that obstructed circulation and destroyed the views so integral to L'Enfant's original plan of radial boulevards and formal parks.[54] The McMillan Plan, as it came to be known, sought to unite a park and boulevard system, combine civic design with sophisticated city planning, and effectively revive L'Enfant's imposing monumental atmosphere that opened up and enhanced views of the monuments and architecture of the city.

Although the McMillan Plan was never officially approved by Congress, historians have noted that it demonstrated the need for a plan, and it offered one that was worthy of a great city and a seat of federal government. It therefore received extensive favorable publicity and garnered widespread support throughout the country, so that its goals continue to guide Washington's growth today. It shaped the legislation of 1926, for example, to build a massive complex in the Neoclassical style for the area bounded by 15th Street, Pennsylvania Avenue, Constitution Avenue, and 6th Street N.W., now called the Federal Triangle and consisting of seven buildings.[55]

In 1908, the American Historical Association asked the President and Congress to erect a building for the country's archives, some of which dated back to 1775, which were dispersed throughout the city and inadequately housed. The association's request generated a study that revealed the need not only for a national archive but also for the expansion of a number of government agencies, which ultimately led to the Federal Triangle, the largest federal building campaign and collaboration of architects and artists the capital city had ever witnessed, including figural groups for fifteen pediments and more than fifty pieces of statuary, friezes, and assorted ornament.[56] Delayed by bureaucratic red tape and interrupted by World War I, the campaign was finally carried out between 1929 and 1938, in the middle of the Great Depression.[57]

The Triangle, as it was completed, left vacant an 11-acre parcel of land, which is now the site for a federal office building and International Cultural and Trade Center, designed by architect James Ingo Freed, begun in 1991 and due for completion in 1995. Because its 2 million square feet (second in size for a federal building only to the 4-million-square-foot Pentagon in Arlington, Virginia) covers an area of 800 by 500 feet, it is fortunate for the rest of the complex that the classical style is once again in vogue. So, while Freed's design for the building that completes the Triangle lacks the ornamental richness of the original buildings, its 1990s brand of classicism will neither overwhelm nor detract from them.

Although the earliest published account of the Federal Triangle sculpture is the 1937 *W.P.A. Guide to Washington, D.C.*, as Keeper of the Smithsonian

Building James Goode has noted, George Gurney's book, published in 1985, is the first comprehensive study of the subject. While Gurney's exhaustive study of the sculpture for each building records in depth every commission, from the selection of the sculptor and the assistants to the completion of each work, and provides an abundance of sketches, plans, and technical data, it is particularly compelling in illuminating the Beaux-Arts symbiosis of architecture and the human figure.

A brief summary of several of the programs Gurney treats at some length illustrates the richness of the Beaux-Arts tradition in its last great gasp before it was eclipsed by the International Style and twentieth-century modernism.

While all the buildings of the Triangle conformed to the classical style, each expressed the individuality of its architect. So, too, each sculptor's individuality was expressed in his or her figures, groups, and ornament, yet the sculpture programs were compatible. The programs of James Earle Fraser, Adolph Weinman, and Robert I. Aitkens, for example, for John Russell Pope's National Archives Building—where the Declaration of Independence is displayed—illustrate this compatibility of styles.

The National Archives Building

Fraser designed the pediment and statuary for the Constitution Avenue program and used assistants to execute the sculpture; Weinman designed and executed the pedimental sculpture for the Pennsylvania Avenue program; and Aitkens designed and executed the jamb reliefs and the statuary for the Pennsylvania Avenue program.

Two seated figures, male and female nude to the waist, flank the entrance on Constitution Avenue.[58] The male represents guardianship, the female heritage, and together they express the custodial function of the National Archives: to protect the nation's heritage. David Kresz Rubins, assistant to Fraser, executed the figure of *Heritage* with a baby boy nestled in her right arm with a sheaf of wheat behind, symbols of regeneration signifying the nation's future. *Guardianship*, executed by Sidney Biehler Waugh, holds a plumed helmet, while the lion skin of Hercules is draped behind, reassuring symbols of strength. Gurney's juxtapositions of sketch models with the completed statuary illustrate aspects of the workshop process fundamental to the Beaux-Arts tradition.

Laura Gardin Fraser and assistants executed her husband's pediment facing Constitution Avenue, which carries the mission of the National Archives to gather and preserve the records of the United States for the American people. The central bearded figure seated on a colossal throne with an open book on his lap is the *Recorder of the Archives*, and the two media on which the nation's documents are inscribed, parchment and paper, are symbolized by his throne. Groups of men and women extend to the left and to the right and represent the host of archivists gathering and preserving the nation's documents and records. Symbolic of the government's fidelity to its mission of guardianship of the nation's archives, Great Danes maintain surveillance of the scene from

the corners of the pediment. Behind them, Laura Fraser also included portraits of the Fraser family's dogs, which, Gurney notes, reflected her passion for animal sculpture and added a personal signature to the pediment.

The Pennsylvania Avenue program is a collaboration between A. A. Weinman, who devised and executed the pediment, and Robert I. Aitkens, who designed two relief panels and two figures in the round at the entrance.[59] Weinman's pediment emphasizes that preservation and study of our heritage will determine the nation's destiny, and his sculpture group, like Fraser's, features a great bearded figure of Destiny seated in the center flanked by allegories in varying degrees of relief.

Aitkens's two jamb reliefs that flank the entrance beneath Weinman's pediment complement the flatness of Weinman's figures. They are the *Guardians of the Portal*. Both are Roman soldiers holding swords, and behind each is a lamp symbolic of the illumination of the nation's heritage. They embody the strength of the classical tradition. In the left jamb, the date 1776 in Roman numerals commemorates the founding of the Republic, and in the relief at the right is the date of the opening of the National Archives, 1935.

Aitkens's two colossal seated figures flanking the north entrance portico, *The Past* and *The Future*, are classically draped figures, in posture mirror images of each other, in composition reminiscent of Michelangelo's Medici Tomb figures in Florence, which appear in numerous collaborations of the American Renaissance. As *The Past*, Aitkens portrays a bald, bearded ancient philosopher holding a rolled-up scroll in his right hand, his left hand gripping the closed book of history in his lap, as he gazes into the past. *The Future*, to the left, is a young and comely female gazing into the future with an open book on her lap yet to be inscribed with the nation's deeds. Her message is clear: "America, you have the opportunity to write a future of promise, if wisdom prevails in the study of the past." In content, Gurney shows, the figures extend the archival symbolism of Weinman's pediment, and in their massive three-dimensional composition relate to Fraser's *Guardianship* and *Heritage* on Constitution Avenue, thereby linking the two sculpture programs on Pennsylvania and Constitution avenues.

Gurney's use of clay models, crayon sketches, and details in explaining Aitkens's pieces is particularly effective in conveying the strength of the sculptor's composition and treatment of the figure and provides the layman with useful insights into the nature of the Beaux-Arts tradition.

THE FEDERAL TRADE COMMISSION BUILDING

At the apex of the eastern end of the Triangle, defined by 6th and 7th streets and Constitution and Pennsylvania avenues, is the Federal Trade Commission Building, called the Apex Building because of its location. Its sculpture program is particularly significant, Gurney stresses, because it was the last building to be completed (1937–38) in the existing complex, and because the recently organized Section of Painting and Sculpture of the Treasury Department, headed by Edward Bruce, former director of the government's Public

Works of Art Project, became involved in the selection of sculptors. Bruce tended to seek young artists who were not yet well known, rather than rely on the East Coast establishment.

In that democratic spirit, the Painting and Sculpture Section announced in July 1937 a competition open to all American sculptors for the two sculptures for the East Terrace of the Apex Building. The budget for the pair of sculptures was $45,600, which had to cover materials, shipping, production of models, carving of the finished work, and the like; difficult terms, not likely to appeal to established sculptors. But then, established sculptors did not enter competitions anyway, unless they were very lucrative. The exact number of contestants is uncertain, but George Gurney estimates that 234 sculptors entered the competition. Almost all of the nominees were sculptors in the Beaux-Arts tradition and were working in the New York City area, and all were members of the National Sculpture Society, which reflected the dominant position of the East Coast establishment in the art world of the day.

The winner was Michael Lantz, who could not have been a better role model for Edward Bruce to present to the artists of the country.[60] Lantz had just lost his teaching job with the Works Projects Administration and did not know how he could continue as a sculptor. Winning the competition, therefore, meant not only that he could go on working as a sculptor but also that his future would be assured by the prestigious government commission.

Lantz's winning design, *Man Controlling Trade*, was a pair of models, each depicting a muscular man restraining a powerful and spirited Percheron stallion. The horses symbolized the enormous power of trade, and the men

Michael Lantz (1908–1988)
Man Controlling Trade, 1942
Limestone, over lifesize
East terrace of Apex Building,
Pennsylvania Avenue side
Federal Trade Commission,
Washington, D.C.

symbolized the Federal Trade Commission's role in controlling trade. Gurney explains that the idea for using horses came from Leo Friedlander's colossal horses symbolizing the arts of war for the Arlington Memorial Bridge in Washington, for which Lantz had assisted in making the plaster casts.

Lantz's groups were completed in 1942, and they reflect the changing face of American public sculpture. While the subject matter, a group symbolic of the governmental agency, is traditional practice, Lantz's portrayal of anatomy is different from that of the earlier commissions in the Triangle. His simplified and linear rendition of the human and animal figures reflects the general influence of Cubism and more particularly the archaism of Paul Manship and the late work of Karl Bitter, which derived from Archaic Greek and Far Eastern sources.

PRAGMATIC OPTIMISM AND THE NEW LOOK

The "moral earnestness" that was embodied in the great sculpture programs of the White City, the world's fairs, and the Federal Triangle gave way gradually to a pragmatic optimism in the programs of the Nebraska State Capitol in the 1920s, Rockefeller Center in the 1930s, and the Equitable Center in the 1980s. The new architectural sculpture was conditioned stylistically by the Modern Movement, while retaining the figural vocabulary of the classical tradition. European influences and the American sculptors' discovery of direct carving produced more geometric, more architectonic forms.

The union of architecture and sculpture in the new mode at its best is

Michael Lantz (1908–1988)
Man Controlling Trade, 1942
Limestone, over lifesize
East terrace of Apex Building,
Constitution Avenue side
Federal Trade Commission,
Washington, D.C.

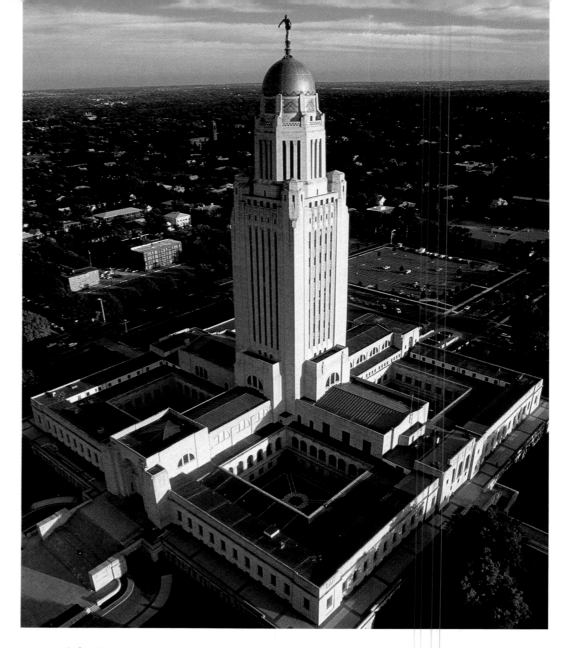

Bertram Grosvenor Goodhue
(1869–1924), architect
Nebraska State Capitol, Lincoln

OPPOSITE PAGE
Bertram Grosvenor Goodhue
(1869–1924), architect
Lee Lawrie (1877–1963), sculptor
The Sower
Nebraska State Capitol, Lincoln

exemplified in the collaborations of the architect Bertram Grosvenor Goodhue and the sculptor Lee Lawrie, according to Richard Oliver in his critical study of the architect. For Goodhue, it was the collaboration of the arts that produced a building.[61] From his earliest years, he was fond of symbolism, and he preferred it to be representational, which he believed best clarified "the purpose of the building by celebrating the history and lore which it embodies."[62] Moreover, sculpture played a major role in enriching architectural form. In Lee Lawrie, Goodhue found his ideal collaborator, and their crowning achievements were the Nebraska State Capitol Building at Lincoln and the Kleinsmid Library in Los Angeles.

Drawing on the contemporary skyscraper vernacular for the State Capitol Building, Goodhue created a central tower, monumental in its smooth articulation, rising 400 feet into the sky and capped with a tiled dome supporting the figure of a sower by Lee Lawrie, symbolic of the agricultural base of the state's economy. With its low-lying rectangular base hugging the level terrain that surrounds the site, Goodhue created a landmark on the Nebraska plain that was visible from afar and from all around.[63] Guidance for the themes and symbolism came from Hartley Burr Alexander, chairman

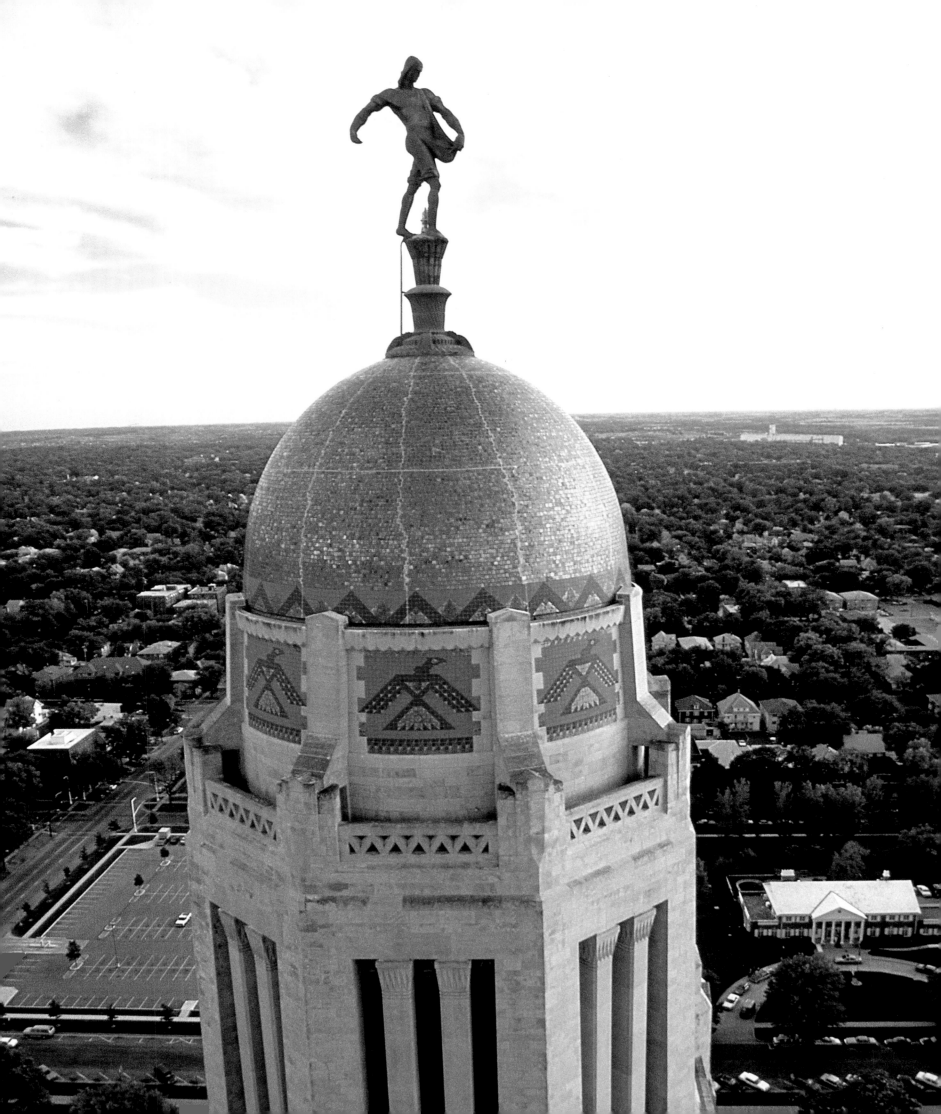

of the Philosophy Department, University of Nebraska at Lincoln, who had a vast knowledge of mythology, anthropology, and the study of symbols, and was widely published in those fields.[64]

The theme Alexander developed for the sculpture program for the exterior of the capitol was the history of the law from antiquity to the present. Alexander saw Goodhue's horizontal mass and monumental tower as symbols of heaven and earth. The "historic course of human experience" would be depicted around the peripheral square, where the narrative and symbol could be easily read, then to Goodhue's tower, a column to heaven, he relegated abstractions, growing out of the historical experience portrayed below.[65]

At the entrance, colossal figures symbolizing guardians of the law—Wisdom, Justice, Power, and Mercy—rise from the slanting base of the building as if emerging from the great pylons of an ancient Egyptian temple instead of being set within niches, as in Gothic churches. That device recalls Lee Lawrie's turret figures for the west façade of St. Vincent Ferrer Church in New York City and a pair of angels emerging from the stone parapet in the Chapel of the Intercession, also in New York City. But Lawrie's figures in the capitol building are flatter, more linear, and more architectonic, so the architecture and sculpture are a more unified whole.[66]

The names of Nebraska's ninety-three counties, the democratic foundations of the state, are inscribed like a frieze beneath the cornice of all four walls surrounding the horizontal base of the building. Above the cornice,

Bertram Grosvenor Goodhue
(1869–1924), architect
St. Vincent Ferrer Church, 1918
New York

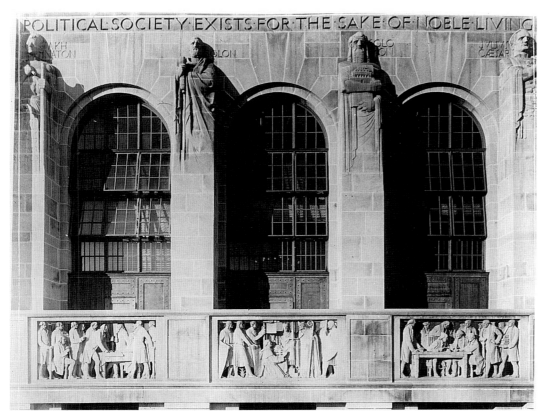

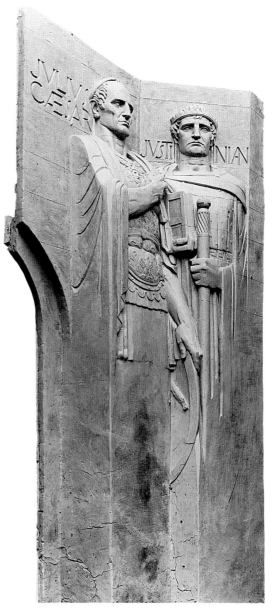

eighteen panels in low relief gird the building like a classical frieze and illustrate such key events in the history of the law in Western civilization as "Moses Bringing the Law from Mount Sinai," "Plato Writing His Dialogue on the Ideal Republic," "Signing the Pilgrim Compact on the Mayflower," and the "Admission of Nebraska as a State in the Union."[67]

Atop the dome is Lee Lawrie's 19-foot-high, seven-ton bronze figure, the *Sower*, which represents the early American pioneer and was inspired by the famous Barbizon French painter Jean-François Millet's well-known *Sower*.[68] The colossus stands on a 13-foot-high base of a stylized sheaf of wheat, representing man's reliance on agriculture for his physical life and symbolizing the fundamental role of farming to Nebraska's economy. The sower dispenses the seeds of Wisdom, Justice, Power, and Mercy to assure making a noble life of the spirit. The *Sower* thus echoes the foundations of the law announced at the entrance to the building and reminds the lawmakers within that "Political Society Exists for the Sake of Noble Living," the inscription above the Supreme Court and the Law Library at the south pavilion. Beneath the inscription three reliefs by Lee Lawrie portray the foundation documents of American political liberty: the "Signing of the Declaration of Independence," the "Magna Carta," and the "Writing of the U.S. Constitution," and above them, to underscore the continuity of those principles emerging from the pier buttresses of the building, are the colossal figures of the great lawgivers of the Western world—Solon, Solomon, Julius Caesar, and Justinian.

For the Rufus B. Von Kleinsmid Central Library in Los Angeles, 1921–26, Goodhue designed a three-story cube with a central tower, a reinforced concrete building clad in stucco, and again he collaborated with Hartley Burr

LEFT
Bertram Grosvenor Goodhue (1869–1924), architect
Lee Lawrie (1877–1963), sculptor
South Entrance Portal Figures
Nebraska State Capitol, Lincoln

RIGHT
Bertram Grosvenor Goodhue (1869–1924), architect
Lee Lawrie (1877–1963), sculptor
South Façade Pylon Figures:
Julius Caesar and Justinian
Nebraska State Capitol, Lincoln

Alexander to ensure the appropriate symbolism and ornament.[69] And Lee Lawrie executed the figures and ornament in a further refinement of the architectonic style of the Nebraska Capitol Building. Lewis Mumford praised the building's "modern symbolic architecture" and believed the success of the building lay in the unity of architecture and sculpture.[70]

Alexander developed a program around the theme "The Light of Learning." The central tower is capped with a tiled pyramid supporting the torch of learning, and the sculpture is concentrated in the south façade. Over the main entrance an open book is inscribed with *Lucerna pedibus meis* ("a lamp unto my feet") on the left and on the right *Lumen semitis meis* ("a light to my paths"). Beneath the book, inscriptions admonish the visitor that the way to wisdom is through reflection and that books put us in touch with the civilizations of all ages. Rays of light emanate from the open book, framing it in a half halo, and two colossal figures rise from the piers that flank the doorway—to the left the *Thinker* as a Greek philosopher, and to the right the *Writer* as an Egyptian scribe. The two figures symbolize reflection and expression most fully embodied in the lives and works of Herodotus, Virgil, and Socrates, portrayed over the *Thinker*, and Justinian, Leonardo da Vinci, and Copernicus, portrayed over the *Writer*. Their likenesses emerge from the giant pier buttresses of the façade as colossal guardians of the heritage within.[71]

The Nebraska State Capitol and the Los Angeles library are proudly linked to the best traditions of the past, but as Lewis Mumford has noted, they went beyond archaeologically based traditionalism and created a new blend of monumentality and symbolism that reaches new heights in the next decade in Rockefeller Center in New York City.[72]

ROCKEFELLER CENTER

As the White City gave hope to Americans that living cities could be built accordingly, the planners of Rockefeller Center applied principles of the City Beautiful Movement to the workplace of the corporate world and created a monument of human skill, taste, and imagination to economic democracy in America. The poverty and homelessness in our land bears witness to the failure of the republic to achieve that economic freedom, but John D. Rockefeller's monument to the dream remains unsullied.[73]

In creating an efficient, comfortable, and humane (some would even say luxurious) working complex, not just for the bosses but for all the workers and the public alike, John D. Rockefeller created a new social ideal in the country's economic life, in which the welfare and happiness of all the workers was integral to the enterprise. That he did it because it was good business in no way diminishes his accomplishment and the resulting benefits to the public at all levels. To the contrary, Rockefeller's self-serving concern for the welfare of all the workers and the general public gave the center a certain legitimacy in the pragmatic world of the twentieth century that justified its luxury for the masses and thereby assured its longevity.[74]

OPPOSITE PAGE
Paul Manship (1885–1966)
Prometheus Bringing Fire, 1934
Gilded bronze, over lifesize
Rockefeller Center, New York

The site he developed was a rundown area of row houses, speakeasies, abortion mills, and shops. In the creation of Rockefeller Center, Rockefeller extended Fifth Avenue respectability westward to Sixth Avenue. And he purchased land beyond Sixth Avenue to the west to prove his confidence in the commercial future of the West Side. Many people thought him mad.

Rockefeller Center, which extended from Fifth to Sixth avenues and from 48th to 51st streets and was composed of twenty-one buildings, was originally to have been a cultural center. The Metropolitan Opera needed a new home, and John D. Rockefeller was to be a major supporter. For a number of reasons, not least of which was the country's depressed economy, the opera board gave up the plans in December 1921. Rockefeller, undaunted, converted the enterprise into a business venture, and in the midst of the nation's Great Depression created a commercial complex and real estate venture of unparalleled scale. Moreover, by drawing on some of the most visionary architects, astute planners, and outstanding artists of his day, he gave the country an urban development of plazas, underground streets lined with shops, theaters, valet parking, sub-levels to improve shipping and deliveries, roof gardens, and a host of modern conveniences that embodied advanced technology, sound planning, and the best of modern art and architecture, which has influenced city planners and architects throughout the world but remains unequaled.

Although geographical frontiers had a vital effect on the growth and shaping of American civilization in the eighteenth and nineteenth centuries, the developers of Rockefeller Center saw the new frontiers of the twentieth century as the cultivation of man's mind and spirit for a fuller comprehension of the meaning and mystery of life and the cosmic and eternal forces that support it.

The new frontiers, then, gave priority to man's inner life and included medical science, education, general science, communications, and human relations such as capital, labor, and international trade, as well as better understanding of the problems and necessities of other peoples around the globe. They were to be celebrated through art, whose mission was twofold: to communicate the various themes of those new frontiers so that they could be read and understood with comparative ease by the general public; and to articulate the planes, modeling, and organization of the architecture through the effective use of light and shade and the appropriate use of color.

In the modern skyscraper of Rockefeller Center, there were no pediments, niches, or friezes—the traditional repositories for sculpture in classical buildings. Employing a modern figurative style, based on classical models, the architects, sculptors, and planners, therefore, developed alternatives.

Moreover, the art was coordinated with the overall visual perception of the center from all angles so that Lee Lawrie's *Atlas*, for example, in front of the International Building, or Paul Manship's gilded *Prometheus*, in the sunken plaza, as seen from the air or from the upper floors of the center's buildings, became part of the architecture, the pavement design, and the landscaping and would be read as forms within forms that created an architectural arabesque. From the ground level, on the other hand, they read as three-dimensional sculptural

forms within their appropriate settings. On the Fifth Avenue façade of the French Building, as seen from an office across the street or while approaching it on foot along the avenue from a distance, the limestone reliefs by René Chambellan at the sixth floor, like a classical frieze, articulate the first setback of the building. So, even though the subject of the reliefs is obscured by distance, the play of light and shade across the reliefs serves as a visual transition from one architectural plane to another.

Because the buildings and spaces of the center were organized as a unified, comprehensive whole, the didactic role of the art followed a general plan while the individual works were coordinated with the functions and locality of the particular buildings and spaces they embellished. When the stroller, for example, stands on the sidewalk in front of the French Building, René Chambellan's reliefs can be clearly read, like the metopes in a Doric frieze. But, instead of lapiths and centaurs relating to Greek mythological history, the pageant of French history unfolds in four panels, from prehistoric times to the centralization of power, the Monarchy under Louis XIV, and the birth of the Republic.

The Promenade between the British Empire and French buildings is the open approach to the sunken plaza. The sunken plaza was derived from the Roman Forum, so the planners desired it to have the appropriate celebrity. A wide thoroughfare features six rectangular pools of gray granite and illuminated glass floors landscaped with seasonal flowers and plants. The Promenade slopes gently downward from Fifth Avenue, inviting strollers into the center, where the pools' ample parapets provide seating opposite the broad shop windows of the British Empire and French buildings. Because of the location of the Promenade, it has been nicknamed the Channel Gardens, or "the Channel," after the English Channel, as the philosopher Hartley Burr Alexander had suggested and the planners intended. Carved reliefs and bronze figures combine didactic and ornamental features to enhance the architecture and the space. Appropriately, over the Channel entrances to the British and French buildings signatory gilded reliefs by Lee Lawrie combine symbols with nautical motifs. Mercury, complete with caduceus and winged helmet, flying over the ocean, symbolizes maritime commerce, a foundation of the British Empire, and a female personification of France sows seeds of good citizenship, in the form of miniature fleur-de-lis, over international waters.

For the six granite pools that extend the length of the Channel, René Chambellan modeled fountainheads as small figures riding dolphins to symbolize mankind's heroic struggle in the pursuit of beauty. He signed each one on its bottom flipper. According to another interpretation, Chambellan's six figures represent Tritons and Nereids riding dolphins who represent Leadership, Will, Thought, Imagination, Energy, and Alertness, attributes that have enabled mankind to succeed in the course of civilization.

The GE Building

Beyond the Promenade lies the GE (formerly RCA) Building, the visual and symbolic center of the complex. Above the entrance, facing the gilded

WISDOM AND KNOWLEDGE
SHALL BE THE
STABILITY OF THY TIMES

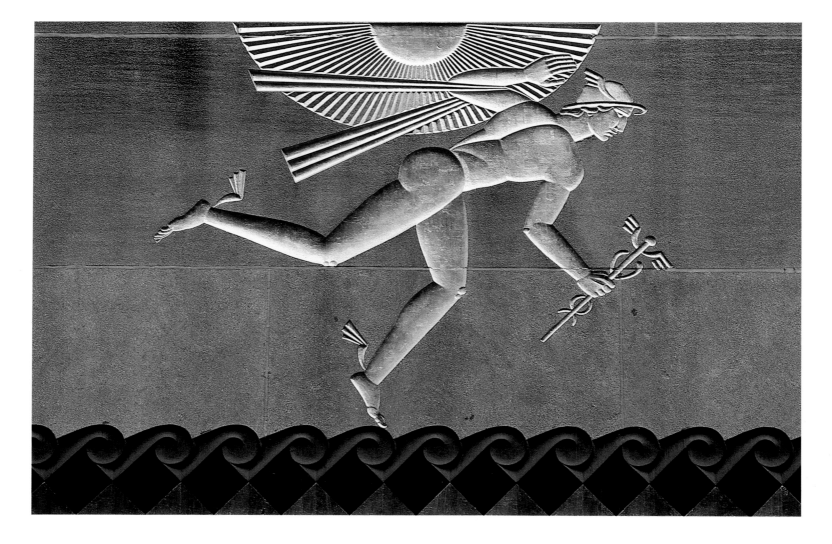

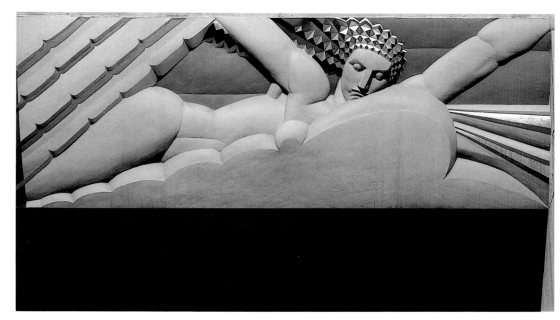

LEFT
Lee Lawrie (1877–1963)
Light, 1933
Rockefeller Center , New York

OPPOSITE FAR LEFT
Lee Lawrie (1877–1963)
Sound, 1933
GE Building, Rockefeller Center,
New York

OPPOSITE LEFT
Lee Lawrie (1877–1963)
Wisdom and Knowledge, 1933
GE Building, Rockefeller Center,
New York

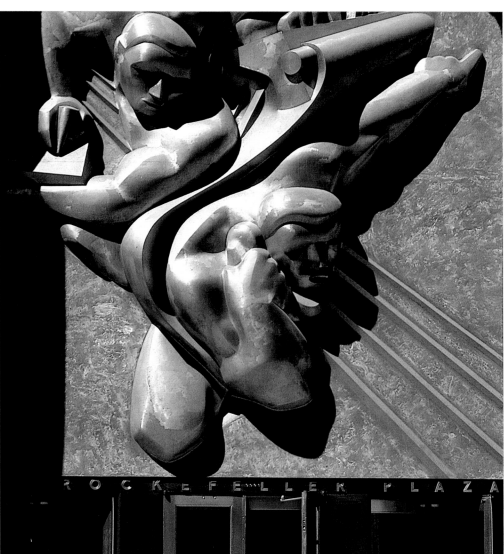

LEFT
Isamu Noguchi (1904–1988)
The Associated Press, 1940
Associated Press Building,
New York

OPPOSITE LEFT
Lee Lawrie (1877–1963)
Mercury, 1933
British Empire Building, Rockefeller
Center, New York

Prometheus in the sunken plaza across the street, is a giant relief of *Wisdom* in gold, blue, and red by Lee Lawrie that introduces the spectator to the art program of the GE Building. With compass in hand, tracing the cosmic forces illustrated below in illuminated glass, Wisdom interprets nature's laws for mankind. *Wisdom* is flanked by personifications of *Light* (right) and *Sound* (left) in limestone, carved in low relief, gilded and brightly colored, the means by which he communicates his message. Above the 49th and 50th street entrances, colossal limestone panels in low relief by Leo Friedlander are carved in a broad, simplified style and portray Mother Earth and her children, representing the transmission of music and dance through radio and television to all humanity. Lawrie's *Wisdom* relief consists of 240 blocks of Pyrex glass, 55 feet wide, 15 feet high, and weighing 13 tons, a tour de force of engineering skill when it was installed in 1933 and an innovative union of industrial material and classical forms and symbols. Beneath the ensemble is inscribed "Wisdom and Knowledge shall be the Stability of Thy Times" (*Isaiah* 33:6).

The International Building

A survey of man's journey along the road of civilization is the subject of Lee Lawrie's great limestone screen at the 25 West 50th Street entrance to the International Building. Fifteen-and-a-half feet wide and 21½ feet high and consisting of sixteen panels in gilding and brilliant color, it develops the international theme of man's journey through space and time. In the lowest register, the center panel consists of personifications of the red, white, yellow, and black races and is flanked by the lion on the right, symbol of monarchy, and the eagle on the left, symbol of the republic. In the center panel, directly above, a ship, the symbol of transportation, moves away from the medieval tower in the right panel toward the factory of the twentieth century in the left, symbolizing the world's shift away from feudalism toward capitalism. The next register portrays art, science, and industry flanked by an Aztec temple and a mosque, representing the religions of East and West. Directly above, Mercury, the god of commerce and messenger of heaven, transmits light and life to international affairs. By his gesture, he unites northern lands, represented by sea gull and whale, with southern lands, represented by palm trees, producing harmony with the universe, which is represented by the northern and southern constellations that flank the sun above him. The sun forms the crowning motif of the giant panel, and, as the face of a functioning clock, thematically unites the notions of space and time.

At the entrance on West 50th Street, man's progress through history is surveyed, while peace is admonished in the Old Testament and realized in the New Testament in reliefs by Lee Lawrie. Above the entrance at 19 West 50th Street is a plow, carved and painted gold, with the inscription "Sword and Plowshares IS II IV," recalling the critical moment in Israel's history in the eighth century B.C. when the prophet Isaiah appeared to his people and reminded them of their destiny. He preached a mission of peace, saying that

weapons would be made into tools for planting and harvesting and that war would be no more (*Isaiah* 2:4).

St. Francis of Assisi is portrayed above the entrance at 9 West 50th Street, surrounded by a halo of birds. Lawrie's hieroglyph of peace refers to an event in the life of the thirteenth-century ascetic. When Francis saved a flock of turtledoves from death, he not only freed them but also tamed them. To live in today's world, man must make adjustments in broadening and deepening his relations with his fellow man.

The world community prospers through immigration and international trade, the theme Lee Lawrie portrays in a pair of reliefs at the southeast entrance to the International Building. They are carved on the pier at the juncture of the two walkways there. The reliefs wrap around the pier from west to south, and the carving re-shapes the square pier to suggest free-standing statuary. The relief on the west face depicts a fisherman wading into the sea to set sail for the New World in his small fishing boat. As the carving wraps around the pier on the south face, the scene segues into a classically draped personification representing all immigrants disembarking from a fully rigged ocean-going vessel to be greeted by Columbia. Columbia, also classically clad, wears the Phrygian or *pileus* cap, the cap given to freed slaves in the ancient world, which in the 1760s Paul Revere appropriated as America's liberty cap, and which has been central to American Independence imagery since colonial times, when it surmounted the nation's liberty poles and flagstaffs, as Yvonne Korshak has explained in her study of the liberty cap as a revolutionary symbol. The cap is a poignant reminder that the nation has not achieved economic freedom, to which Rockefeller Center is a monument. It is worth noting that the symbol is very much alive today. A gilded liberty cap surmounts the recently restored Liberty Flagstaff in Union Square Park in New York City, and facing it across the street in the pediment of the old Tammany Hall meeting place, 100 East 17th Street, is another liberty cap overlooking the park and that city's monument to freedom.

Lawrie's figures are carved almost lifesize and set against naturalistic landscapes, which gives them a striking immediacy and attracts passersby to stop for a closer look and often to touch. Similarly, two pairs of reliefs accent the beginning and the end of the private street that bisects the center, and they pay tribute to the role of man's labor in building the center and the nation. Flanking the west entrance to 1 Rockefeller Plaza, two lifesize males in relief and nude to the waist by Carl Paul Jennewein personify *Agriculture* and *Industry*. The one on the left, a factory worker, holds a sledgehammer at rest, and the farmer on the right holds a scythe.

At the north end of the street, 45 Rockefeller Plaza, two panels by Gaston Lachaise above the paired entrances portray wreckers with crowbar and acetylene torch, over the north entrance, and steelworkers riding girders, over the south entrance. These panels portray the construction of Rockefeller Center and the steelworkers' role in the enterprise.

Directly across the street from Lachaise's reliefs, at the entrance to the Associated Press Building, 50 Rockefeller Plaza, Isamu Noguchi used a

simplified naturalism to depict a photographer, telephone operator, teletypist, reporter, and wirephoto operator in a ten-ton relief of stainless steel, the first to be manufactured in that medium. In Noguchi's tribute to the Associated Press news people, he has created a fitting alternative to the classical pediment in monumental stainless steel.

Foundations of Progress

The sculpture programs for the façades of the French, British Empire, and Italian buildings facing Fifth Avenue convey the prestige enjoyed in the 1930s by those three great nations. The façade sculpture for the International Building provides the ideological foundation for their nationalistic themes.

Above the main entrance of the International Building North, 636 Fifth Avenue, the relief designed by Italian-American sculptor Attilio Piccirilli portrays the new Apollo, god of light, music, and poetry, and symbolizes the spiritual basis of material progress, which is personified in the nude male and female figures of Industry and Commerce carved in a relief above. The panel, 16 feet high, 10 feet wide, and weighing three tons, is composed of Pyrex glass blocks manufactured by Corning Glass, an innovative use of industrial glass but appropriate in adapting classical figures to modern architecture. Piccirilli's figures are painted in dark tones so they are visible both day and night. At night, however, they are lighted from behind, and the irregular imperfections in the glass create the appearance of a textured surface, which enhances the three-dimensionality of the figures, and the illumination lends unique brilliance to the overall effect.

The figures in the panels at the sixth floor represent the four continents: Asia (Buddha), Europe (Neptune), Africa (an African), and America (a Mayan), which suggests the universality of the imagery below.

Piccirilli also designed the original bronze relief for the Palazzo d'Italia at 626 Fifth Avenue, depicting art and labor. The relief was replaced in 1965 by two bronze panels by Giacomo Manzú, gifts of the Fiat Automobile Company. The panel over the entrance, approximately 11 by 16 feet, bears the inscription "Italia," with cuttings of grapevine and wheat stalk below celebrating the earth's fruitfulness. A smaller relief, approximately 3 by 7 feet, shows a mother and child with traveling pack; it stands for the Italians who immigrated to America. Four panels at the sixth floor by Leo Lentelli represent periods of Italian history: Antiquity, Renaissance, Independence, and Fascism. The last designation was influenced by several of Benito Mussolini's associates, who leased the building in the 1930s.

In the cast-bronze, partially gilded panel by the French sculptor Alfred Janniot, 11 feet wide and 18 feet high, at the entrance of La Maison Française, 610 Fifth Avenue, personifications of New York and Paris are portrayed above figures of Poetry, Beauty, and Elegance. The watchwords of the French Revolution—*Liberté, Egalité, Fraternité*—are inscribed beneath the figure of Liberty in the cartouche above, proclaiming liberty to the world, and René Chambellan's panels depicting the stages of French history are at the sixth floor.

Over the main entrance to the British Empire Building, 620 Fifth Avenue, the cast-bronze, partially gilded panel by Carl Paul Jennewein portrays major industries of the British Commonwealth, such as fishing, mining, cotton, and grain; the sun that never sets on the British Empire is represented beneath the panel. The Royal coat of arms is carved above the doorway, and at the sixth floor, four panels by René Chambellan carry heraldic motifs from Wales, England, Scotland, and Ireland.

Few people shared Rockefeller's vision when the center was begun in 1931 that tawdry Sixth Avenue, obscured by the "El" (until 1939), its building covered with grime from soot-belching locomotives, could one day be a thriving revenue-producing thoroughfare. Yet the designers of Rockefeller Center did succeed in extending Fifth Avenue respectability to Sixth Avenue with their elegant limestone façades and monumental sculpture program, and by 1973 the wall of high-rises on the west side of Sixth Avenue confirmed Rockefeller's confidence in the commercial potential of the West Side. Then, in the 1980s, the Equitable Financial Companies converted the entire block from 51st to 52nd streets and from Sixth Avenue to Seventh Avenue into a cultural complex it christened Equitable Center, thereby extending the commercial and cultural life of Rockefeller Center another block westward.

EQUITABLE CENTER: PARADIGM OF "INVESTMENT REAL ESTATE"[75]

As Rockefeller Center had to change the character of Sixth Avenue in the 1930s to attract and hold tenants who would pay the rents that the center needed in order to prosper, so Equitable Center set out to change the character of Seventh Avenue in the 1980s to achieve the same ends. Its architects have employed some of the same devices employed at Rockefeller Center to accomplish that.

Moreover, as the GE Building tower (formerly the RCA Building), the centerpiece of Rockefeller Center, was extended west to provide Sixth Avenue with an elegant façade, called RCA Building West, so Equitable raised its new tower on Seventh Avenue west of its 1961 building on Sixth Avenue to push the commercial frontier another block west.[76] Recalling Rockefeller Center's shop-lined corridors and concourses, but on a grander scale, Equitable Center's architects designed an 800-foot-long covered street lined with shops and galleries set off with lattices and mahogany paneling that links the lobbies of the new tower on Seventh Avenue and the Paine-Webber Building on Sixth Avenue. The covered street intersects a through-block galleria between 51st and 52nd streets, where an escalator leads to the lower concourse that connects the two buildings with Rockefeller Center and the subway.

In the same way that Rockefeller Center was the product of a battery of leading architects, designers, and artists of the 1930s, Equitable Center was shaped by a cadre of leading design talents of the 1980s. Skidmore, Owings & Merrill renovated and modernized its 1961 building for PaineWebber, Edward Larrabee Barnes designed the new tower and art complex on Seventh

Avenue, and Kohn Pedersen Fox Conway designed the executive floors above the 34th story.[77]

Equitable's Tradition of Enlightened Patronage

In addition to reviving the principles of innovative planning established by the designers of Rockefeller Center, Equitable continues its practice of supporting progressive architectural design and figurative sculpture, a tradition that goes back to the nineteenth century. Equitable's first building at 120 Broadway (1868–70), by distinguished architect George B. Post, was also America's first skyscraper.[78] Twice as tall as the average commercial building at the time, it rose 130 feet. As Winston Weisman has noted, by realizing the possibilities of the passenger elevator, the Equitable Assurance Society Building became the first structure to break the height barrier to commercial architecture, and the skyscraper was born.

The company that built the first skyscraper was equally innovative in commissioning public art. Henry B. Hyde, founder of Equitable, understood the importance of art to create the desired company image. He commissioned John Quincy Adams Ward, founding president of the National Sculpture Society and one of America's leading sculptors, to translate Equitable's logo, *The Protector*, into a piece of monumental sculpture to be placed above the main entrance to his new building on Broadway.[79] *The Protector* had been designed for Equitable by the American Bank Note Company in 1860, Lewis Sharp relates, a year after Hyde formed the company.

Hyde's logo (which also became the title of the company's newsletter) expressed the lofty sentiments that appealed to the public at that time. The personification of Life Insurance holds the spear of Providence with her right hand, and with her left she extends the shield of Assurance protectively over a widow and her child. Ward's sculpture group, which he had carved of white marble in Carrara, Italy, was 11 feet high, weighed ten tons, and was placed above the entrance of the building on Broadway, where it was unveiled in 1871. Noted architectural critic Montgomery Schuyler wrote that Ward's sculpture was "the most dignified and successful if not the only dignified and successful sculptural monument" on Broadway. Schuyler went on to assure his readers that there was nothing to be ashamed of that this outstanding piece of art had a "business basis."[80]

By 1896, *The Protector* was almost destroyed by weathering, but two heads (now lost) were preserved on pedestals designed by James Goodwin Batterson, one of America's leading builders and authorities on stone (who has been surprisingly neglected by historians). Batterson provided the stone for New York City's first Waldorf-Astoria Hotel on the site of today's Empire State Building; the nation's capitol and Library of Congress buildings in Washington, D.C.; City Hall in Providence, Rhode Island; Vanderbilt mansions in New York City and Newport, Rhode Island; and the state capitols of New York and Connecticut.[81] Batterson designed the Worth Memorial of 1857 in New York City, as well as other historical monuments. It is ironic that

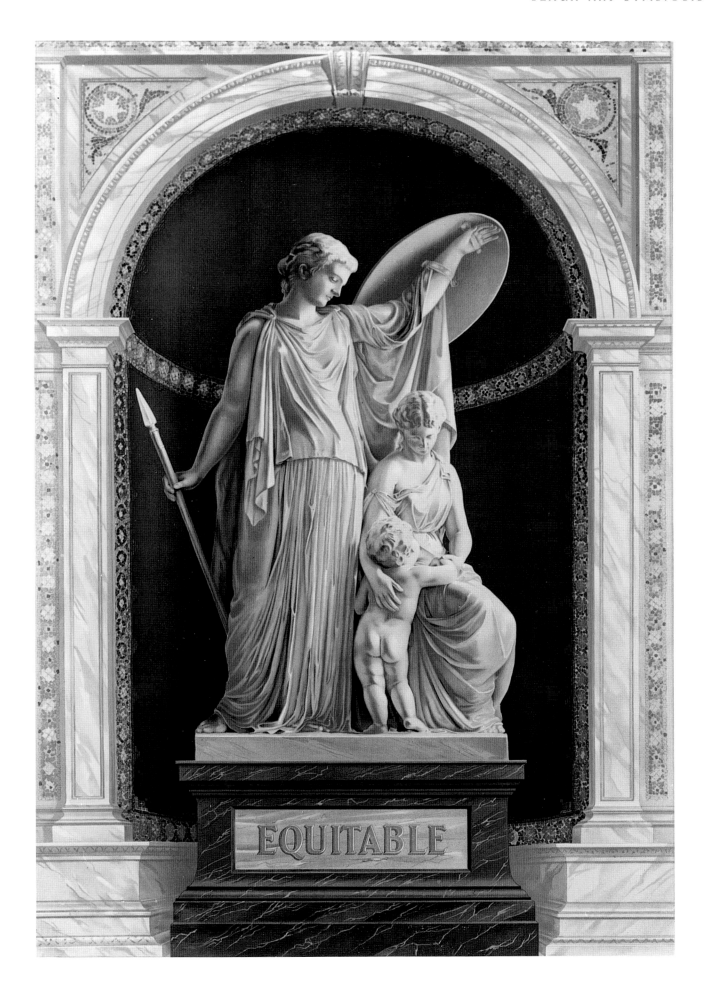

Batterson was commissioned to preserve the heads of Hyde's *Protector*, because he was also an insurance man. He had founded the Travelers Insurance Company in 1864.

In time, *The Protector* lost all connections to its origins, tradition, and meaning, and it also lost the company's respect. Alas, in recent years the personification of Life Insurance in the logo became known as "The Pizza Lady" by Equitable employees, and The Protector (the newsletter, also) was retired in 1985. A painful reminder of Hyde's logo remains in a stained glass version on the 50th floor of Equitable's new tower, down the hall from a statue of the founder.

A standing portrait of Hyde by J.Q.A. Ward is in the lobby. It faithfully records the features of Equitable's founder.[82] Commissioned by his son James Hazen Hyde in 1899, soon after the elder Hyde's death, the statue originally stood in the lobby of the Equitable Building at 120 Broadway. It was unveiled there on May 2, 1901, the second anniversary of Hyde's death. The statue survived the fire of 1912, and it was reinstalled in the new building on the same site in 1915. When the headquarters moved to 393 Seventh Avenue in 1924, the statue was put in storage until 1934, when it was formally dedicated in the new building. From 1961 until Equitable moved to its new tower, the statue stood at 1285 Avenue of the Americas. According to Sharp's catalogue, it appears that at least eighty-one small versions of the statue over the years have been cast in bronze as gifts. The original plaster (the model from which casts are made) and fourteen of the statuettes have been located. One of those bronzes is in Equitable's collection.

Equitable Center's Art Program

Beautifying its new headquarters with art would enhance Equitable's prestige and attract tenants willing to pay premium rates, reasoned its management. Equitable calls the concept "investment real estate," in which the corporation and its tenants, the artists, and the public benefit.[83]

With the Whitney Museum of American Art as consultant, Equitable commissioned original works by leading artists for its atrium, the through-block galleria, PaineWebber's urban plazas, the Palio Restaurant, Equitable's health club, and the lobby of the First National Bank of Chicago. Additional paintings and sculpture were acquired for the galleria, the corridors, and for Equitable's fifteen dining rooms and corporate spaces. The art is both figurative and nonfigurative. Two public art galleries complete the art complex and both are open free to the public. The PaineWebber Art Gallery, sponsored and operated by the PaineWebber Group, extends along the enclosed street, and features exhibits of nonprofit and cultural groups.

The atrium lobby at the Seventh Avenue entrance to Equitable's tower is the principal focus of the center's art program. Roy Lichtenstein's *Mural with Blue Brushstroke* and Scott Burton's *Atrium Furnishment* set the tone of the atrium and provide a transition from monumental to human scale in the five-story-high skylit atrium.[84] The first thing the spectator sees on entering the tall

atrium is Lichtenstein's mural, 68 feet high and 32 feet wide, which holds its wall facing Seventh Avenue like the great sixteenth- and seventeenth-century frescoes and altarpieces command their spaces in Renaissance and Baroque churches in Europe, which was Lichtenstein's intention. The mural is an homage to Pop Art, and it celebrates Equitable Center's link with Rockefeller Center and its role in the city's commercial expansion westward.

Scott Burton's *Atrium Furnishment* is an enclosure in the center of the atrium, beneath Lichtenstein's mural. It breaks up the floor area and provides a place for repose. A 40-foot semicircular bench in polished green marble with onyx lights faces a circular pond also in polished green marble containing various water plants. Echoing forms relate the enclosure to its space and keep it from getting lost in the atrium. An arc of tropical conifers picks up the shape of the bench, an 11-foot-wide broken circle of polished bronze set into the floor encloses the bench and pond, and occasional square, red granite pavers surround the circular enclosure, reconciling it with the rectilinear lines of the atrium.

A grand stairway from the atrium leads to the underground 495-seat theater and auditorium, also accessible by elevators, for films, concerts, and drama.

Paul Manship's bronze sculpture *Day*, which until recently stood in the south corridor of the atrium, formed a symbolic link with Rockefeller Center. *Day* is one of the four *Moods of Time* (Morning, Evening, Day, Night) that Manship made for a colossal fountain for the 1939 World's Fair. The fountain was destroyed after the fair, but small versions of the sculpture in bronze still survive. *Day* portrays Helios, the sun god in Greek mythology, racing across the sky carrying the sun in front of him. Properly oriented in the south corridor, Helios faced west where the sun sets and toward Seventh and Eighth avenues, the direction in which commercial expansion is moving on the West Side. The east-west axis of the sculpture also related it to Rockefeller Center, where Manship's *Prometheus Bringing Fire* is the signature piece of sculpture in the sunken plaza in front of the GE Building, the pivotal link between Fifth and Sixth avenues. A strong visual link between Manship's two pieces was forged by the similarity of the images of the sun and the fire that Helios and Prometheus carry.

The Galleria

Freestanding sculptures by British sculptor Barry Flanagan give the 90-foot-high galleria of glass, limestone, and polished granite that connects 51st and 52nd streets habitable scale.[85] *Young Elephant* (near 52nd Street) and *Hare on a Bell* (near 51st Street) flank a bronze- and glass-enclosed kiosk housing the escalator down to the lower concourse that connects Equitable Center with Rockefeller Center and the subway. These three elements define an axis that divides the otherwise overwhelming space into two north–south thoroughfares creating a comfortable space for strolling or for sitting. Moreover, Flanagan's sculptures are figures of contrast playfully commenting on the

Barry Flanagan (b. 1941)
Hare on Bell, 1986
Bronze, over lifesize
The Equitable Life Assurance
Society, New York

enormous size of the galleria, which could be intimidating if it were not for his sculptures. Employing fantasy and sleight of hand, Flanagan creates his own fairy tales. In *Hare on a Bell*, the colossal-sized hare says, "I'm as big as a bell," and in *Young Elephant*, the hare, properly scaled, dances on top of the elephant, which stands absolutely still while the hare asserts its agility and thereby its superiority over the enormous but lethargic creature. The sculptures are in cast bronze that retains the marks of the sculptor's modeling tools, giving the surfaces texture that invites close inspection and touching, which is possible from the granite benches around the bases of the sculptures.

Benefactor of the Arts

With its new headquarters and art center, Equitable has continued its tradition of progressive and enlightened design, extended the city's commercial expansion westward that was begun at Rockefeller Center, and established a new model of the corporation as patron, curator, and benefactor of the arts.[86]

To help support artists, through favorable rents and corporate assistance, Equitable encouraged the formation of the Arts Resources Consortium at Equitable Center. It consists of Volunteer Lawyers for the Arts, the Center for Arts Information, and the American Council for the Arts. Free legal assistance and information on grants, insurance, loft space, and arts resources are available to artists at the consortium. The New York branch of the Archives of American Art, whose mission it is to collect and preserve materials relating to the visual arts in America, also has its office at Equitable Center.

Equitable's art program has come a long way since Henry B. Hyde commissioned J.Q.A. Ward to transform the company's logo into monumental sculpture. And the public's attitude toward the collaboration of art and business has changed since Montgomery Schuyler smoothed feathers ruffled by Equitable's art with a "business basis." In fact, Hyde's recognition of the importance of art to his new company in the nineteenth century was remarkably prophetic of Equitable's philosophy of "investment real estate" that is taking the company into the twenty-first century.

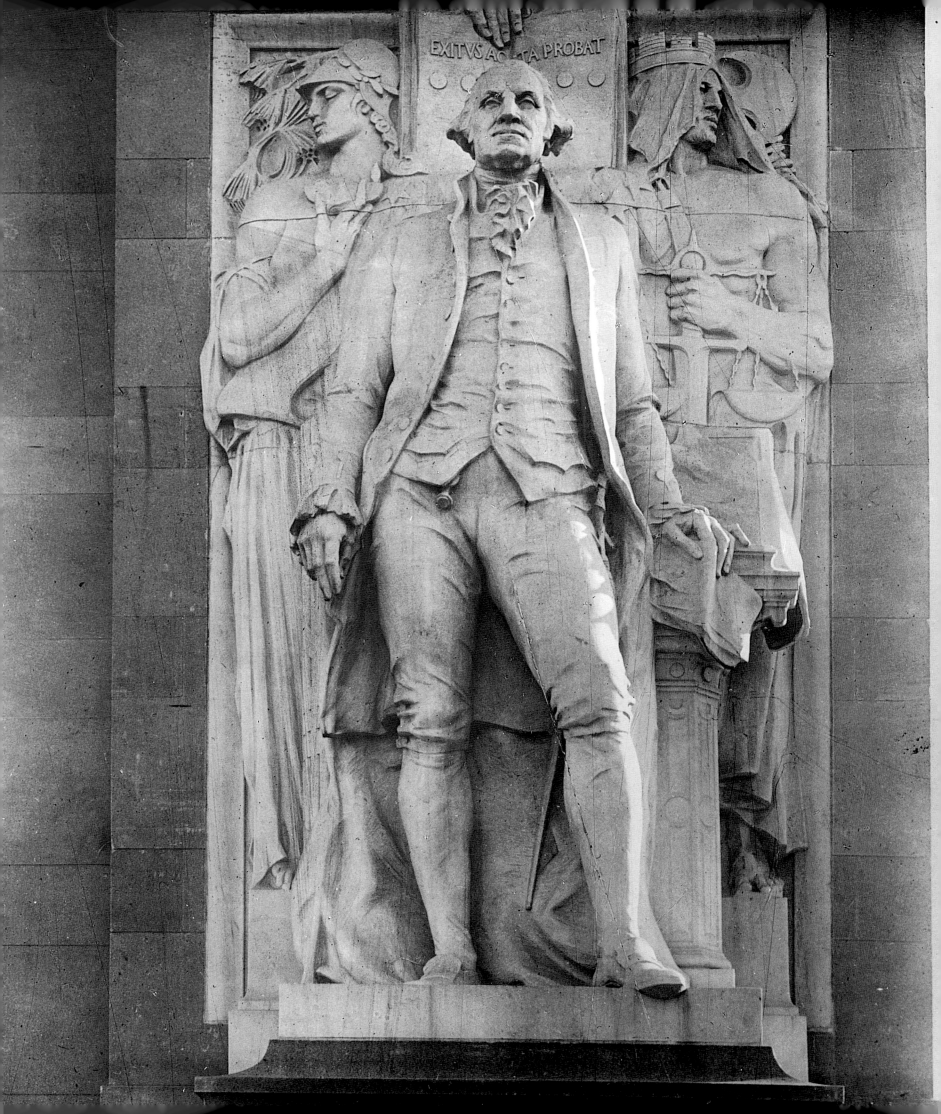

CHAPTER TWO
A NEW PERSPECTIVE ON THE NATURE OF PUBLIC MONUMENTS

The most important contribution the Beaux-Arts tradition made to American culture is the form it gave to America's public monuments. That is because our monuments are the physical embodiments of the fundamental principles of our cultural heritage and are one of the primary means by which we communicate our traditions, beliefs, and values from generation to generation.[1]

Because our monuments are essentially symbols of human values, the human figure was central to their composition and design in America's great age of public monuments, from the Civil War to World War II. That was the age dominated by the sculptors and architects who had been trained at the Ecole des Beaux-Arts or by their students and followers.

Beaux-Arts sculpture is virtually an encyclopedia of the almost limitless possibilities of the composition and rendering of the human figure. Its models and principles were drawn from ancient, Renaissance, and Baroque art, and it is rooted in man's earliest artistic expression of the human figure, whose origins are found at the dawn of humanity.

CARING: THE HUMANISTIC ORIGIN OF PUBLIC MONUMENTS

As *Homo sapiens* emerged from millions of years of evolution through natural selection to become the supreme biological specimen we know as modern man, he also developed intellectual and spiritual faculties that gave him the capacity to establish highly complex social structures, invent languages, make art, and explore his own mind.[2] He thereby created great civilizations and widely diverse cultures that continue today to populate every corner of the earth. He even put people on the moon and expects to go beyond the stars.

OPPOSITE PAGE
Alexander Stirling Calder
(1870–1945)
Washington As President, 1918
Marble, over lifesize
Washington Square Arch,
New York

Yet, as scientist René Dubos has noted, the characteristic that may assure modern man's survival into the twenty-first century and beyond may be the same characteristic that assured early man's survival 100,000 years ago, which is the most human thing about him—the capacity to care for his fellow human being. It is that trait that also produced the first monuments.

Psychiatrist Willard Gaylin has suggested that this capacity to care for one another may be so essential for the survival of humanity that it is built into the genetic nature of the species.[3] Perhaps the most convincing illustration of human caring in prehistoric times was found by anthropologists in the cave at Shanidar in Iraq.[4] In their excavations, they discovered the remains of a Neanderthal man who had been blind and crippled from childhood. Obviously, as scholars have pointed out, he could not have survived a long life of semi-nomadic existence without the constant care of his family group to sustain and nourish him.

It was also Neanderthals who first buried their dead, an act of caring that also suggests to anthropologists the belief in a life after death, or, as anthropologist Ian Tattersall has most recently noted in his discussion of the origins of humanity, "at least the presence of an ego that is reluctant to acknowledge its own ephemerality."[5] The deceased was placed in a flexed position to save space (digging was an arduous task), sprinkled with red ochre, and a flower was placed atop the corpse. Neanderthal burial with its accompanying ritual was man's first memorial and therefore the first monument to honor the life of another human being or to placate the gods, or both, thus another form of caring. Neanderthal ritual burial also demonstrates man's uniquely human need, and ability, to symbolize his experiences, a primordial trait that is expressed in the erection of public monuments.

Neanderthal man's early graves were simple burials. In time, Neanderthals probably learned to place a large stone on the grave to protect the remains from being dug up and devoured by wild beasts, another expression of caring as well as respect for the supernatural. Those stones, scientists observe, may have been the predecessors of the monumental megaliths found in southern Spain and in Portugal from 3000 B.C. and later ones in the British Isles from 2000 B.C. The best known are at Stonehenge, c. 1650 B.C., in Wiltshire, England. Those ancient monuments had religious purposes, which were related to burials and to the seasons of the year. Some were involved with cults of the dead, while others marked the paths of the sun and moon and were therefore set up to record the changing seasons of the year.

MAJOR MONUMENT FORMS

The creative spirit in man that produced the first Neanderthal memorials developed very gradually, and by thirty-four to eleven thousand years ago produced the first artists, who created images and symbols that were man's first representational art—the cave paintings of Altamira, Niaux, and Lascaux, the cave reliefs at Cap Blanc, and the carved fetishes found from the Atlantic coast to the Ukraine that scholars call "venuses," because of their obvious

reference to fertility.[6] The Willendorf Venus found near Krems in Austria is the most famous of those fetishes, with its exaggerated breasts, thighs, and abdomen. This compendium of material stands collectively as the first monument to the artist's mature creative genius.

With the development of agriculture some 10,000 years ago in the alluvial valleys of the Nile in Egypt and the Tigris and the Euphrates in Mesopotamia came permanent settlements and larger populations. In developing successful irrigation techniques and economic systems over the next several thousand years, Mesopotamia and Egypt created great civilizations with sophisticated government, law, and formal religion, and they developed writing, methods of measurement and calculation, as well as arts and crafts. There, in the service of religion, man's creative spirit produced the first monumental architecture—the great ziggurats at Ur, Warka, Nippur, Larsa, and Eridu in Mesopotamia, and in Egypt, Zoser's step pyramid at Saqqara and the Great Pyramids of Menkure, Khafre, and Kufu at Gizeh.[7]

Then, in the worlds of ancient Greece and Rome emerged the triumphal arch, the dome, the column, the obelisk, the tumulus, and allegorical and representational sculpture on a grand scale to celebrate and commemorate divinity and human achievement.[8] Through the course of history, those structures from Mesopotamia, Egypt, Greece, and Rome became the major forms used in public monuments until well into the twentieth century. In fact, it is only in recent years that those traditional forms are being challenged by contemporary images. Now, for example, a monument might be a wall, a horticultural arrangement, or simply a defined space.

THE VALUE OF PUBLIC MONUMENTS

Although monuments are often perceived simply as another form of public sculpture, they are first and foremost reminders—the word comes from the Latin *monere*, which means to remind—and symbols of our traditions and values.[9] We build monuments to people and events because those people and events are important to us for the values they possess or represent. In addition to communicating our traditions, beliefs, and values from generation to generation, monuments also help us to come to terms with the unknown, the unexplained, and the mysteries of life—as well as with our deepest emotions at the social and at the personal level, such as the pain we feel at the death of a loved one.[10]

The famous photographer Walker Evans, back in 1936, took a picture of the grave of an unknown child in Hale County, Alabama, an image that E. J. Johnson revived in the first Annual Symposium on Public Monuments in 1991. The grave was marked with two pieces of scrap lumber and the child's cereal bowl.[11] The arrangement of the lumber and the relic of the dead child was that family's memorial and their way to come to grips with the separation and isolation connected with the death of their child. Because of the impermanence of the materials, however, that monument soon withered and disappeared. We do not even know the child's name.

Walker Evans (1903–1975)
Grave of Unknown Child,
Hale County, Alabama, 1936
Photograph
Library of Congress,
Washington, D.C.

Amiable Child Monument, 1797
Riverside Drive at 122nd Street,
New York

The eighteenth-century monument to four-year-old St. Claire Pollock, however, which stands near Grant's Tomb at 122nd Street and Riverside Drive in New York City, is another matter altogether.[12] Consisting of a classical urn carved in stone, it is set picturesquely on a high bluff overlooking the Hudson River. On that site in the eighteenth century, wild strawberries grew so abundantly that the place was known as Strawberry Hill, and it was St. Claire Pollock's favorite place. While playing there one day, he lost his footing and fell to his death in the Hudson River, two hundred feet below.

Because Strawberry Hill was St. Claire's favorite place, and because the site was so serene and so beautiful, his family buried him there and marked his grave with a marble monument consisting of a base supporting a funerary urn. They inscribed it:

> TO THE MEMORY OF AN
> AMIABLE CHILD
> ST. CLAIRE POLLOCK
> DIED 15 JULY 1797
> IN THE FIFTH YEAR OF HIS AGE

That monument to an Amiable Child endeared itself to the hearts of New Yorkers, so that a century later, when the city tried to remove the little monument and the child's grave to make way for Grant's Tomb, the citizens of New York rose up and said *No!* "A monument to an Amiable Child, 'Who led no cause/Who only lived and died,' is as important to us as a monument to a national hero."

And so Grant's Tomb was erected where it is today, and the monument to an Amiable Child remains intact. A newspaper reporter who witnessed that ground swell of civic indignation expressed its essential meaning when he noted that the presence of that monument "is so fine a tribute to the gentleness that underlies the apparent brutality of a great city that the little stone monument [on Strawberry Hill] has come to be almost a national institution."

The material difference between the monument to the Amiable Child near Grant's Tomb and the monument to the unknown child in Hale County, Alabama, is that one has lasted longer. Even St. Claire Pollock's monument, however, is not going to last forever. But we want it to because of what it stands for—all that we cherish and respect in the innocence of childhood with its beauties, hopes, and dreams. So we make our monuments as permanent and as beautiful as we possibly can, because they symbolize the values we honor, cherish, and wish to preserve, which, René Dubos insists, are the vitality of our cultural heritage.

SURVIVAL THROUGH CELEBRATION

"The past is not dead history," Dubos has written. "It is the living material out of which man makes himself and builds the future," insisted the eminent scientist and author of the Pulitzer Prize–winning *So Human an Animal*.[13] From our past come the timeless, universal, and elemental truths that governed our earliest evolution, determined our gradual development as human beings over eons of time, and by which we slowly achieved our intellectual and spiritual potential that has enabled us to produce symphonies, conquer disease, and explore the mysteries of the universe.

When we lose touch with the past, we lose touch with the inner self, Dubos believes. We are cut off from what he calls "the deepest layers" of our nature, a kind of genetic and cultural memory bank, that repository of experiences and images that enables us to understand and deal with that mysterious and wonderful world of the past, which keeps us in tune with our origins and with the rest of the cosmos.[14]

With the Industrial Revolution, work formerly done by human and animal power was accomplished by machines, and many people moved away from the farm and the land to work in large industrial complexes in densely populated cities. The rise of technology brought an advanced standard of living, high productivity, better health standards, greater mobility, and more leisure time filled with endless diversions. In the process, however, a significant sector of modern society lost touch with the past and the traditions by which people understand their relationships with one another and with the rest of the world—those things that give meaning to life. Moreover, it lost touch with the inner self, a relationship that was nurtured by community and life on the land before the machine invaded the garden, to use Leo Marx's image. Little wonder, then, that the loss of that sense of continuity with the past and with the rest of creation resulted in the state of isolation and alienation that is the prevailing psychological peril of modern society today.

That sense of continuity with the past and with the rest of creation, which is served by our public monuments, not only enhances life, Dubos maintains, but "is also essential to sanity," because it keeps us mentally and emotionally intact.[15]

In prehistoric times, primitive people were aware that all of nature was interwoven into a single pattern and that they were a part of that pattern, which gave rise to complex rituals and taboos, the forerunners of our public monuments today. People who violated taboo or disparaged ritual did so at their own peril.[16] That primitive imperative resounds with meaning today for modern society, which neglects or destroys its public monuments at its own peril.

"In assuring continuity with the past through our public monuments, we assist our own survival," by means of what art historian Wayne Dynes calls the "triad of survival—observation, contemplation, and preservation."[17] The social anthropologist Francis Huxley would say that monuments objectify those truths, which constitute our cultural heritage, and so provide us with permanent and tangible means to study and analyze them.[18]

"The wise man preserves that which he values and celebrates that which he preserves."[19] I think the key word in this adage is "celebrates." It is not enough to gather at the base of a monument once a year and engage in religious, commemorative, or other ceremonies, in which we honor the person or the event. Those celebrations are important, to be sure, and they contribute to our awareness as well as to our own edification and enjoyment, as we join with others to honor the values we cherish and wish to preserve.

Celebration in the fullest sense, however, is not restricted to the formal ceremony once a year or on anniversaries. The word comes from the Latin and means "much frequented," suggesting continuity of involvement. To celebrate a monument properly, then, is to incorporate it into the everyday life of our society at all levels. Monuments should inspire us to study and analyze the people and events they commemorate and to contemplate the values they perpetuate. The monuments in our neighborhoods, for example, should be part of our grade school curriculum, and they should be the objects of continuing study at the college and university level. Monuments should be mini-laboratories of human values and the objects of interdisciplinary study and research.

It is through celebration, then, that the monument becomes a living force within our society for greater understanding and respect for human values.

PARADIGMS OF CELEBRATION

One memorial that exemplifies this notion of celebration as the full integration of society with its monuments is the monument to Raphell Lakowitz by the well-known sculptor Bruno Lucchesi. It was erected in 1983 at Creedmoor Psychiatric Center in Queens, New York City.

Back in 1968, when Raphell Lakowitz was studying psychology at Queens College, she felt the need for practical experience in dealing with the

Bruno Lucchesi (b. 1926)
The Raphell Lakowitz Monument,
1983
Bronze, lifesize
Queens, New York

mentally ill and the emotionally disturbed, so she went to Creedmoor and asked to do volunteer work with the patients there.[20] As Raphell became involved with the patients and the therapists at Creedmoor, she developed a group therapy program that not only has more than 300 student volunteers today but also became a model for other state mental hospitals.

On graduation from Queens College, Raphell went on to get her Master's degree in psychology and completed her course work for a Ph.D.[21] In the course of her studies, her classmates, associates, and instructors grew to admire her rare gifts for reaching deeply disturbed children and for breaking through their most obdurate defenses. Then, soon after opening a private practice in psychotherapy, at the age of twenty-nine, Raphell died suddenly of an aneurism, six weeks before she was to be married.

Her parents, Irving and Lenore, sought some meaning in Raphell's tragic death and a way to continue her life's work with the mentally and emotionally afflicted. So when the Creedmoor administration offered, as a tribute to Raphell, to restore and beautify a large pool in front of the institution's community center and to rename the center after Raphell, the parents suggested incorporating a fountain and a statue of Raphell with the pool as a fitting monument to her work. Raphell is portrayed standing near a rock formation like the side of a mountain, with her arms outstretched. Water flows from the rocks over her hands and into the pool. The rocks represent the strength of nature and the source of the water. The water symbolizes love, energy, and rebirth.[22]

The monument embodies Raphell's spirit of giving in her work with the mentally ill. It was inspired by two lines from a poem she had written to her fiancé shortly before she died, which are inscribed into the rim of the reflecting pool:

As we give love, so shall we receive love
As we give strength, so shall we receive strength.[23]

Lenore and Irving Lakowitz hoped, first, that their monument would "bring light and joy into the lives of the patients at Creedmoor" and, second, that it would inspire more public interest in mental health. Happily, many of the patients have grown attached to the monument, and it holds a different meaning for each one of them. One patient said she was "in awe of the statue at first," because she "didn't know what to make of it." "Was it a spirit?" or "Was it real?" Now she goes to the statue "to relax." "It soothes me," she says. Others come to pray. A young man who visits the monument regularly says he prays there for Raphell's soul. Still another, at the unveiling ceremony, said of Raphell's statue, "She gives the place class." When the monument was first installed, one of the patients criticized the patina because the bronze was all one color. "Raphell should be a different color than the rocks," he said. "She's a person." The polychrome patina today differentiates not only Raphell but also her clothing.[24]

The day the monument was installed, it inspired members of the 105th Precinct of the New York City Police Department to commemorate Raphell's work with children by establishing a girls' basketball tournament in her name. The first in the city, it is now in its tenth year.[25] The monument was the subject of Dr. Murray Schane's paper in the first Annual Symposium on Public Monuments in 1991, sponsored by the Municipal Art Society and funded by the Samuel Dorsky Foundation. The monument now promises to be the basis of ongoing scholarly research. A foundation has been established in Raphell's name to support work for mental health, and the monument is the foundation's symbol, which appears on foundation documents, publications, and correspondence. Moreover, the monument is the focus of foundation activities, awards, and ceremonies.

Dr. Schane, a psychiatrist who teaches at Creedmoor and supervises psychiatric residents there, has noted that the monument to Raphell has significant implications in the field of mental health that go beyond the

personal memorial to her. "It was a time of great excitement and optimism in the field of psychotherapy," he explained, "when Raphell was a volunteer at Creedmoor in the late 1960s. New hope for the cure and rehabilitation of the mentally ill seemed possible, and even imminent, with the discovery of Thorazine and related drugs."[26]

That treatment of madness as a biological disease at first produced a shift away from the psychoanalytic view, Schane remembers. Over time, however, experience showed that while medication can be an indispensable aid to successful treatment, it is the self-development and self-realization achieved, in what Dr. Schane calls "a kind of sanctuary formed between patient and therapist," that enables the emotionally disturbed and the mentally ill to reach their potential and to take their place in society.

It is to that end that Raphell Lakowitz dedicated her life. Her kindness and compassion are even commemorated in her name, which comes from *rachim*, the Hebrew word for mercy, and which is inscribed in her own hand at the base of the monument. So, while Raphell's monument is a tribute to her work with the mentally ill, Murray Schane sees it also as a monument to the psychotherapeutic process, which leads the patient to health through the understanding of the self, and as a monument to the sacred bond between patient and therapist.

As memorials, monuments may be either votive or utilitarian.[27] Votive monuments, such as the monument to Raphell, have as their function to evoke a range of associations with the one or the event commemorated for consideration and contemplation. If the votive memorial is successful, as in the case of Raphell, the expression is direct and the language simple. Utilitarian memorials, such as parks, buildings, museums, and the like, subordinate commemorative ideas to utilitarian function and often address issues other than those associated with the person or the event commemorated. Some monuments combine votive and utilitarian roles. Those, too, must be celebrated, if they are to be a living force within society.

Perhaps the most illustrious example in the nation is the Liberty Memorial in Kansas City, Missouri, overlooking the 172-acre Penn Valley Park.[28] It is this country's only major monument that combines the functions of museum and memorial dedicated to the study and contemplation of World War I, according to the monument's history by Lillie Kelsay.

The limestone monument, set on a high hill in the midst of the city, consists of a memorial tower with observation deck, a great frieze, a memorial court and mall, a museum, and a memorial hall. It was designed by architect Harold Van Buren Magonigle and features sculpture by Edmond Amateis. The site was dedicated on November 1, 1921.

The tower rises 300 feet from the great frieze that extends almost 150 feet along the wall, which defines the memorial court on the north. The frieze depicts the curse of war and celebrates peace. Atop the tower is the altar of sacrifice, whose eternal flame is visible for miles around and superintended by four guardian figures, each forty feet high, carved in relief directly beneath the altar supporting the eternal flame. A time capsule rests inside the base of

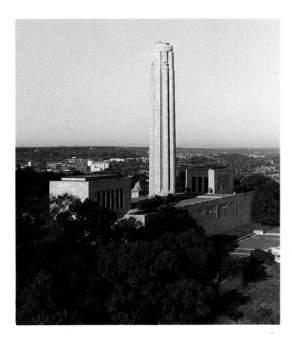

Edmond Amateis (1897–1981),
sculptor
H. Van Buren Magonigle
(1867–1935), architect
Liberty Memorial, 1921
Kansas City, Missouri

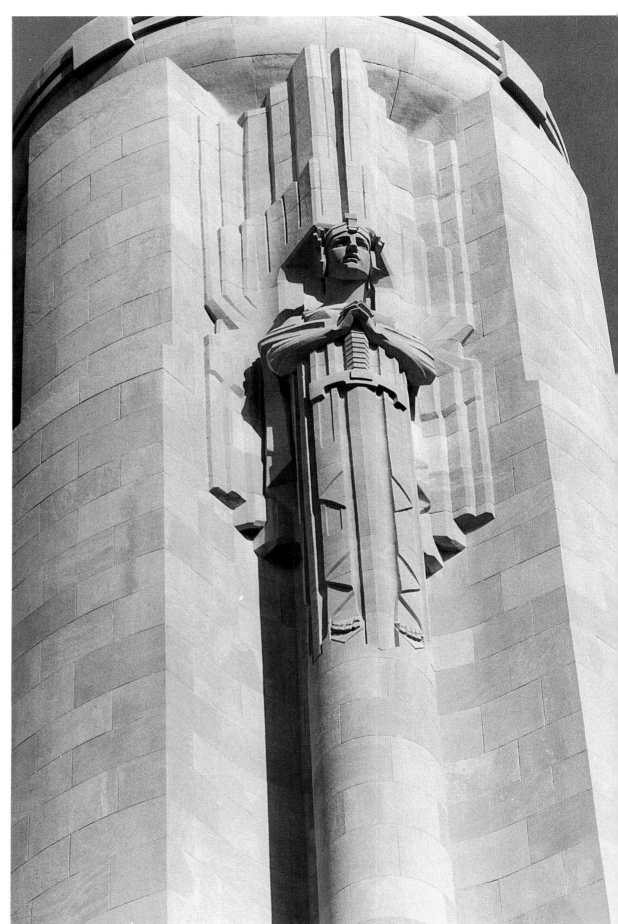

Edmond Amateis (1897–1981),
sculptor
H. Van Buren Magonigle
(1867–1935), architect
*Liberty Memorial, The Guardian
Spirits: Courage*, 1921
Stone, colossal scale
Kansas City, Missouri

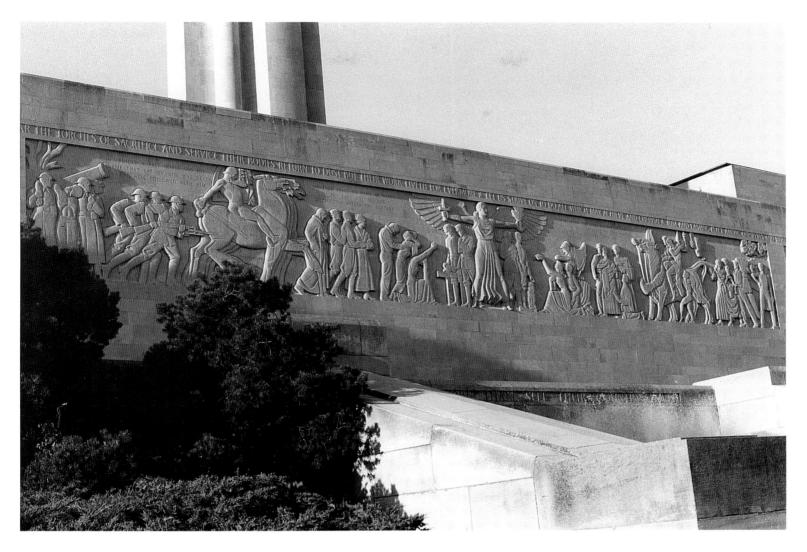

the shaft, Kelsay notes. It is to be opened in 2024, the 100th anniversary of the cornerstone laying in 1924. An Avenue of Trees extends 600 feet along the mall defining the memorial's east and west boundaries.

The museum features exhibitions of World War I artifacts and memorabilia ranging from uniforms and insignias to weapons and heavy artillery that trace the history of the war and illustrate America's role in it. The museum library's special collections and archives provide students and scholars with extensive sources for research.

Memorial Hall contains displays of paintings and military maps, and it hosts occasional art and military exhibitions. The hall serves also as a gathering place for veterans' functions.

The Liberty Memorial was the inspiration of a Kansas City lumber tycoon and civic leader, R. A. Long. Kelsay explains how a few days after the signing of the Armistice on November 11, 1918, Long invited twenty of Kansas City's leading professional and business men to a dinner to launch a campaign that would raise almost $2,500,000 for a "Soldier Memorial" to honor those who served in the Great War of 1914–1918. In a ten-day fund raising campaign in Kansas City that began on October 27, 1919, 83,000 citizens, almost one quarter of the city's population, contributed the nearly

Edmond Amateis (1897–1981), sculptor
H. Van Buren Magonigle (1837–1935), architect
Liberty Memorial, View of the Great Frieze, 1921
Stone, 18 × 148 ft.
Kansas City, Missouri

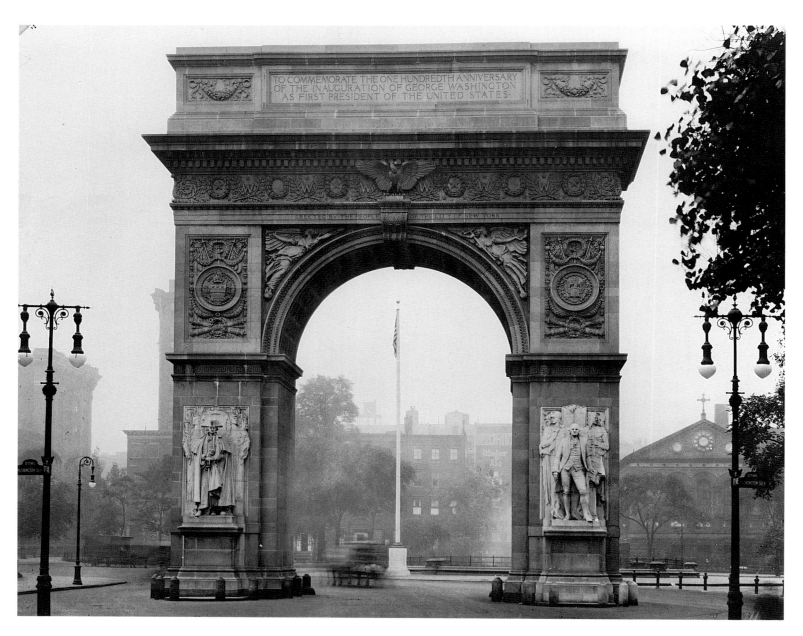

Stanford White (1853–1906),
architect
Washington Square Arch, 1895
New York

two-and-a-half million dollars to construct the monument, which was dedicated on November 11, 1926.

Then, from 1932 to 1938, according to Kelsay, 1,500 men were employed under the WPA on a tree planting project that produced the Avenue of Trees to honor Kansas City's fallen heroes. In 1942, 1944, 1945, and 1946, additional trees were planted to commemorate the war dead of World War II. The tree has long been a symbol of immortality, a testament to life after death.[29] With its roots reaching down for moisture and its leaves reaching upward for sunlight, the tree has become a popular symbol uniting heaven and earth, the sources of natural and supernatural life.

Through the maintenance and landscaping of the Avenue of Trees, the ongoing museum exhibitions, the activities conducted at the monument, and the new and continued research into the historical, cultural, sociological, and scientific aspects of World War I, the Liberty Memorial is a living force for the constant re-evaluation of the traditions and values that it perpetuates.

MONUMENT TO NEGLECT

If we do not integrate our monuments into our daily lives through preservation and appropriate celebration, we forget them, neglect them, and even destroy them with improper maintenance. Witness the tragedy of the Washington Arch in New York City, not only one of the nation's most important tributes to George Washington but also one of America's architectural and sculptural gems of the City Beautiful Movement, deserving of preservation and celebration for its monumental significance as well as for its artistic merit.[30] Yet, the monument is disintegrating, and the City of New York has erected a fence around it to protect the public from the statuary and ornamental marble falling from the monument.

The marble triumphal arch by famed architect Stanford White, standing in Washington Square Park in Greenwich Village, was built in 1892. It replaced the original temporary arch constructed of staff, a composition of plaster and fiber over a wooden armature, which was erected in 1889 as street ornament for the centennial celebration of Washington's inauguration. That arch straddled lower Fifth Avenue just north of the site of the present arch.

The two marble statues of George Washington, both 15½ feet tall and standing on the north face of the present arch, portray him as Commander-in-Chief, executed by Hermon A. MacNeil in 1916, and as President, executed by A. Stirling Calder in 1918. Both sculptors were assisted by the gifted sculptor Salvatore Erseny Florio, who did most of the carving.

MacNeil and Calder were distinguished members of the National Sculpture Society (both men served terms as president). Their monuments, public sculpture, and especially works for the great world's fairs had won them fame

Alexander Stirling Calder
(1870–1945)
Washington As President
(detail), 1918
Marble, over lifesize
Washington Square Arch,
New York

and had earned them the respect and recognition of the nation's leading critics. French-born Philip Martiny, perhaps America's most lyrical Beaux-Arts sculptor, designed the famous eagle atop the keystone of the arch, and the Piccirillis, the country's leading ornamental carvers of the period, carved the decoration. So popular was Martiny's eagle that the fashionable jewelry houses Tiffany and Gorham made replicas of it for their exhibits at the Columbian Exposition of 1893.

As tastes changed, the classical tradition fell from favor, and the Washington Arch, in the classical mode, became passé. Then, because it was never integrated into the community as a monument through appropriate celebration, the arch was neglected and its sculpture allowed to deteriorate. From time to time, public outcries of indignation at the neglect and the appalling condition and appearance of the monument have been met with destructive cleaning methods such as sandblasting, which rallied the community in defense of the monument, but those ground swells of public sentiment have never produced long-lasting results.

Back in 1966, for example, a group of sculptors, architects, and preservation-minded laymen learned that the city's Parks Department was sandblasting the city's public monuments, which included the Washington Arch, so they organized themselves into the Committee to Protect Public Monuments from Sandblasting, and they protested to the commissioner of Parks and Recreation, Thomas Hoving.[31] In spite of the commissioner's initial defense of the practice of sandblasting, the group was finally successful in securing the city's assurance that the destructive practice would stop. Since the 1970s, it has become fashionable to paint over the graffiti that the arch has attracted. Now an eight-foot-high band of light-colored paint girds the bottom of the arch, which conservationists say contributes to the destruction of the marble. Yet the practice continues.

Unfortunately, the root cause of the monument's destruction, which is neglect, has yet to be addressed. That is because the Washington Arch is not properly regarded as a monument. It has lost its meaning because it is not integrated into the community through appropriate celebration.

In 1976, during the nation's bicentennial, the *New York Times*'s architecture critic, while praising the artistic merits of the Washington Arch, unwittingly articulated the city's ignorance or rejection of the arch's primary role as a public monument. While calling the arch the "triumph" of Washington Square Park in Greenwich Village and praising Stanford White's artistry of design and execution, he insists that otherwise the monument "has no particular use save for the visual and symbolic enrichment of the landscape."[32]

A PHILOSOPHY AND A POLICY

The monument to Raphell at Creedmoor Psychiatric Center in New York City and the Liberty Memorial in Kansas City show how monuments, when properly celebrated, can become living forces within society for the perpetuation of traditions and human values.

A philosophy of celebration that fully integrates society with its public monuments acknowledges that monuments, before they are public art, or components of urban planning, or civic design, are primarily symbols and embodiments of traditions and human values, and that monuments are tangible and permanent means by which we perpetuate those traditions and values.

If we are to reclaim our "monuments to neglect" and prevent their continued deterioration and outright destruction, we must adopt this philosophy of celebration and we must develop a policy of preservation and education to implement that philosophy.

Our preservation policy must assure that we maintain and preserve our public monuments in perpetuity. Such a policy requires that standards and guidelines be established and supervised by professionals in dialogue with the community. There must be full and open disclosure of all conservational methods and techniques employed.

Our policy of education should take the form of education programs at the elementary and high school levels designed to produce a generation of citizens who are familiar with our public monuments and instructed in the historical, cultural, and aesthetic principles they embody.

Our colleges should expand their liberal arts curricula to include the interdisciplinary study of public monuments. Classroom and laboratory work should be supplemented by internships.

Curriculum development in public monuments at the university level should encourage research and publication. Chairs should be endowed to assure continued research and development in the field of public monuments.

Through symposia, lectures, special programs, and publications, the general public should be informed of the various aspects of our public monuments and the timely issues pertaining to them.[33]

SELECTED MONUMENTS TO THE GREAT AND THE SMALL

No sampling of the more than 50,000 public monuments in the United States can reflect the broad spectrum of human values they commemorate. Nevertheless, the following selection of monuments to people of various walks of life provides some insight into how those values are celebrated.

THE TITANIC AND STRAUS MEMORIALS

Two monuments inspired by the tragic sinking of the British steamship *Titanic* on April 15, 1912, express different responses to that great catastrophe in the icy North Atlantic waters 350 miles southeast of Newfoundland, but both monuments invite reflection on the nature of human love. One celebrates the bond between a husband and wife, the other honors the supreme act of love: "to lay down one's life for one's friend" (*John* 15:13).

Self Sacrifice, Gertrude Vanderbilt Whitney's monument of 1931, in Washington, D.C., commemorates the men who died that the women and children might live.[1] In spite of their martyrdom, over a quarter of the children and half

Gertrude
Vanderbilt
Whitney
(1877–1942)
Titanic Memorial,
1931
Stone, over
lifesize
Potomac Park,
Washington,
D.C.

Gertrude
Vanderbilt
Whitney
(1877–1942)
Photograph
of artist

of the women died anyway. There were not enough lifeboats, and even all of them were not fully utilized in the panic that gripped many of the passengers during the sinking.

This monument stands next to the Washington Channel, across from East Potomac Park. It consists of an 18-foot-high partially draped male nude figure, with arms outstretched, standing on a 6-foot-high pedestal supported by a 30-foot-long exedra designed by architect Henry Bacon. One of Whitney's sketches of 1915 for the figure of the monument, a 2-foot-high bronze similar to the large figure but nude, is on the gravesite of one of the sculptor's relatives, Mrs. Eugene Bowie Roberts, in Holy Trinity Cemetery, Collington, Maryland.

The *Straus Memorial* in a small park at West 106th Street in New York City, erected near the Straus residence in 1914 by friends of the couple, honors the memory of Isidor and Ida Straus.[2] The monument consists of a draped female figure cast in bronze reclining along the exedra of a gray granite fountain. The figure by Augustus Lukeman personifies Memory and gazes meditatively into a low broad basin of the fountain, designed by Evarts Tracy.

Ida Straus gave up her place in one of the lifeboats provided for the women and children, refusing to be separated from her husband. "We have been living together for many years," she said to him.[3] Then, adamant against the urgings of Archibald Gracie, Hugh Woolner, and other friends, and reminiscent of Ruth's commitment to Naomi in the Old Testament, she added, "Where you go, I go" (*Ruth* 1:16), leaving unsaid Ruth's next words they both knew, "Wherever you die, I will die, and there be buried." In one last desperate effort to save them both, Woolner said to Isidor, "I'm sure nobody would object to an old gentleman like you getting in" (Straus was sixty-seven). But Isidor refused: "I will not go before the other men." They made sure their

Augustus Lukeman (1872–1935), sculptor
Evarts Tracy (1868–1922), architect
Straus Memorial, 1914
Bronze figure on granite exedra, over lifesize
New York

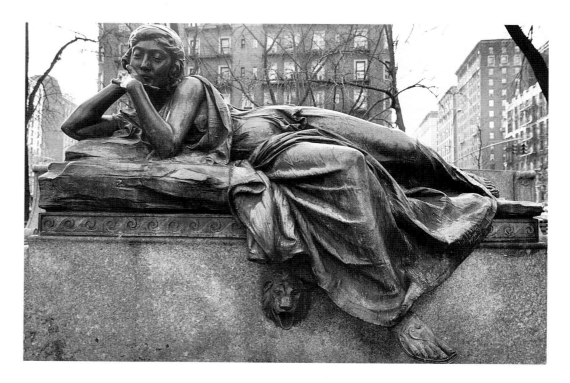

maid, Ellen Bird, got a seat, and she survived. Then they settled down in their deck chairs to wait.[4]

Inscribed on the wall of the monument, below Lukeman's figure of Memory, are the words, "Lovely and Pleasant were They in Their Lives, and in Their Death They were not Divided," from the scriptural elegy in the *Second Book of Samuel* (1:23) that David composed to celebrate the loving bond between Saul and his son Jonathan.

The Strauses had come a long way together, Walter Lord observed. They had built a small china business in Philadelphia, then Isidor and his brother Nathan had bought R. H. Macy and Company in 1896 and developed it into the world's largest department store. He had served for a short time in Congress (1894–95) and twice refused the Democratic nomination for mayor of New York City.

These two monuments are bound together not only by their subject and symbolism, but also by their form: the conflation of the human figure with an architectural base—a type of monument, though common now, that was developed in 1881 by Augustus Saint-Gaudens and Stanford White in the *Farragut Monument* in Madison Square Park in New York City.

THE FARRAGUT MONUMENT

The David Glasgow *Farragut Monument*, unveiled on Memorial Day, 1881, was not only the beginning of the careers of Saint-Gaudens and White, who would go on to collaborate on some of the nation's most outstanding monuments, but also, as scholars have noted, marked a break with the Neoclassical tradition in a new naturalism and the union of portrait statue and pedestal into a single entity.[5] The monument is no longer simply a statue standing on a pedestal in a landscaped setting. In the *Farragut Monument*, pedestal and statue are conceived as a single entity, the sculptor and the architect working in tandem. While it is true that it was only a matter of time before such a conflation would take place, because the Beaux-Arts tradition was based on the marriage of the sister arts, it was Saint-Gaudens and White who brought them together in this monument to Farragut in 1881 and created a new type of public monument.

In the *Farragut Monument*, the pedestal is an exedra, its bench welcoming visitors to walk up three steps and come into the monument. This aspect of public access would become a *sine qua non* for such sculptors as Karl Bitter. There, people can see the allegorical relief figures of Courage and Loyalty and read the inscriptions about the Civil War hero and the nation's first admiral. They can examine Saint-Gaudens's bronze standing portrait of Farragut holding his binoculars and looking out over the park as a breeze tosses the skirt of his coat. And looking down to the pebbled beachlike floor, they may read the names of sculptor and architect inscribed in the bronze crab nestled in the sand. Dolphins, terminating the walls of the exedra, and stylized waves flowing across its surfaces are carved in a new sinuous linearity that some scholars see as an early form of *art nouveau* in American sculpture. From the back of the

Augustus Saint-Gaudens
(1848–1907), sculptor
Stanford White
(1853–1906), architect
Farragut Monument, 1881
Bronze with granite exedra,
over lifesize
Madison Square, New York

monument, the curved surface of the exedra, with Farragut above, recalls the admiral's ship, the *Hartford,* as the admiral appears to be standing on its deck with Daniel Burnham's famous Flatiron Building on 23rd Street its backdrop, a view that Alfred Stieglitz made famous.

The combination of portrait and exedra, the new naturalism, and the sinuous handling of line had a widespread influence throughout the country well into the twentieth century. Augustus Lukeman's *Straus Memorial* is a direct descendant of the *Farragut Monument.* In Whitney's design for *Self Sacrifice* of 1931, however, the composition of figure and exedra moves in a different direction and reflects a tendency toward simplified forms that prevailed at the time. A monument that was influential in the transition from the naturalism of the Beaux-Arts tradition to that simplified form is Karl Bitter's *Carl Schurz Monument* on Morningside Drive in New York City.

THE CARL SCHURZ MONUMENT

Karl Bitter created a monument that combined the naturalistic portrait of the Beaux-Arts tradition with an exedra that expressed his new-found interest in contemporary Viennese architecture and Greek Archaic sculpture.[6] The subtle curves of the exedra reflect the influence of the Viennese architect Otto Wagner and his followers, and Bitter's flat, geometric reliefs echo the Archaic reliefs he saw in the National Museum in Athens, most notably the Stele of Aristion. A lesser talent would not have perceived the common denominators in the contemporary work of the Viennese group and the Archaic reliefs of the ancient Greek sculptors. Bitter, however, drew on the compatibility of the antihistorical rationalism of the Viennese architects and the abstraction of the two-dimensional geometric reliefs of the Archaic masters of ancient Greece and created a contemporary idiom for his reliefs to salute the life and career of Carl Schurz and to create a monument that was architecturally accommodating to the public as well as a sculptural tribute to Carl Schurz. Public accessibility, so much a part of Saint-Gaudens's and White's concept for the *Farragut Monument* and many of their succeeding monumental works, was a fundamental requirement in the portrait monuments Karl Bitter executed.[7]

Karl Bitter (1867–1915)
Karl Schurz Monument, 1909–13
Bronze, over lifesize
New York

In the relief directly beneath the statue of Carl Schurz, a classical altar is flanked on the left by a seminude male holding a sword as Defender, and on the right, by a fully draped female as Friend. The inscription above the altar reads, "Carl Schurz, A Defender of Liberty and a Friend of Human Rights." His role as a friend of human rights is celebrated in the relief to the right. A female personification of Liberty strides forward while the American Eagle flies overhead. She reaches out her left hand to a group of men and women and a child, symbolizing the country's diverse population, and beckons them to follow the torch of Freedom she holds in her right hand. The left panel celebrates Carl Schurz as an abolitionist, a Union officer in the Civil War, and as a laborer for the "civilization" of the Indians. An armored warrior breaks the chains of slavery and leads three slaves to freedom, while Liberty takes the hand of an American Indian and coaxes him forward to join the others.[8]

Statesman, Soldier, Journalist

Carl Schurz fled Germany during the revolution of 1848–49, and, after spending time in France and Switzerland, settled in the United States in 1852. He became a journalist, reformer, political leader, and public official dedicated to human rights. He was an abolitionist and supported Abraham Lincoln in 1858, and again in the national election of 1860. Lincoln appointed him ambassador to Spain, but Schurz relinquished the post to fight in the Civil War, and he distinguished himself in the battles of Second Bull Run, Chancellorsville, and Gettysburg. A strong voice for Negro suffrage, he served as senator from Missouri from 1869 to 1871 and helped to form the Liberal Republican Party. Schurz served as secretary of the interior under President Rutherford Hayes and followed what was in those days considered an enlightened policy toward the American Indians. That policy involved the establishment of industrial schools to "civilize" the Indians and make them contributing members in the workplace and society. Following the Civil War, Schurz held several journalist posts, including a short stint as a Washington correspondent for the *New York Tribune* in 1865, editor of the *Detroit Post*, 1866, and editor of the *St. Louis Westliche Post*, 1867.[9]

Schurz was an eloquent orator, and he spoke often on the issues he championed. He is, therefore, appropriately portrayed by Bitter as if delivering a speech. Bitter's three-dimensional naturalistic modeling of the organic forms of Schurz's bronze portrait in no way conflicts with the abstract treatment of the geometric forms of his reliefs below. The exedra and its reliefs form a coherent whole and act as a setting for the statue of Schurz much as a ring serves as a setting for its stone.[10]

The *Carl Schurz Monument* is sited picturesquely, 175 feet above Morningside Park, atop a sheer wall of Manhattan schist and at the terminus of the view eastward from Columbia University along West 116th Street. Flights of broad, open stairs wind their way downward from the open plaza that lies before the great humanitarian to the park below.[11]

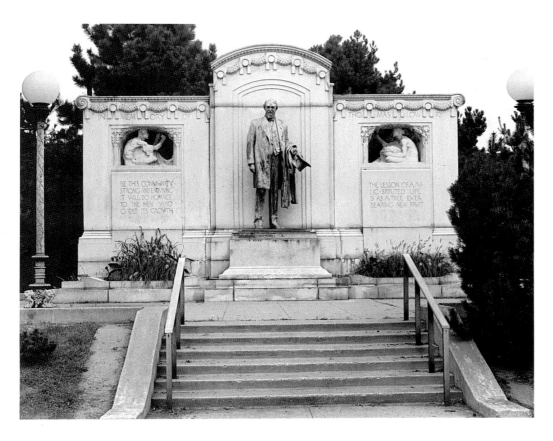

THE LOWRY MONUMENT

Bitter began working on his last monument of this type, the *Lowry Monument*, while he was completing the Schurz memorial, and it shows where his monumental style was going.[12]

Friends of Thomas Lowry in Minneapolis, Minnesota, raised funds and the city approved a small triangular park to commemorate Lowry's contribution to the twin cities of St. Paul and Minneapolis, a railroad connecting the two cities. According to James Dennis, Bitter's challenge was to create an appropriate memorial to the modest contribution of a local entrepreneur, not a tribute to a national figure or to some great cause. That was something Bitter had never done before, and he took it very seriously. For the likeness, he worked from photographs of Lowry, and he interviewed many people who had known him. Lowry was neither colorful nor charismatic, so the sculptor had to compensate for those limitations. Dennis explains how Bitter, to capture the simplicity of his subject, produced a standing portrait of the tall, lank businessman holding his stovepipe hat in his left hand with his coat over his arm. To animate the otherwise almost drab figure, Bitter allowed the surfaces of the clay to show his own spontaneous modeling, so that when cast the portrait had a sketchlike appearance. The down-to-earth portrayal of Lowry, as if he were talking with his neighbors, is enhanced by the movement of the lively surfaces of the bronze and is perfectly suited to the small park.

Lowry stands on a low pedestal bearing his name and against a broad granite wall divided into three panels with swags of moldings across the top.

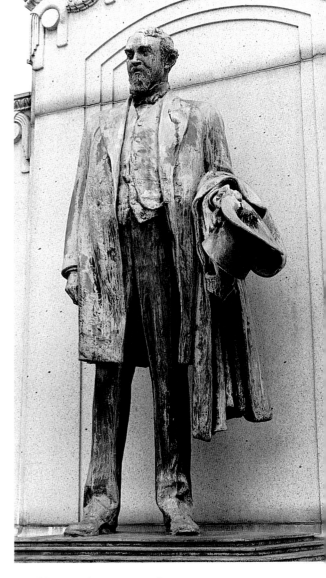

Karl Bitter (1867–1915)
Thomas Lowry Monument (overall view and detail), 1911–15
Bronze portrait against limestone panels with allegorical reliefs, over lifesize
Minneapolis

The central panel behind Lowry is plain and slightly arched, with relieved molding creating a nichelike effect for the statue. The flanking panels carry open reliefs of crouching seminude allegorical figures of Planting and Vintage, celebrating the productive life of Thomas Lowry. The male figure of Planting on the left ties up the young vines, and the female figure of Vintage on the right harvests the grapes. The inscription beneath Planting reads, "The Lesson of a Public Spirited Life is as a Tree Ever Bearing New Fruit," and beneath Vintage, "Be This Community Strong and Enduring It Will do Homage to the Men Who Guided Its Growth."

Above the two reliefs is inscribed, "In Memory of Thomas Lowry." The wall is thick, so that no matter which way one approaches the monument, from the front or from the back, the open relief figures appear to be sculptures in the round set within vaulted spaces. The sketchy carving of these open relief figures, surrounded by changing light, and the spontaneous modeling of Lowry's portrait statue are ingenious devices that enliven the principal components of the monument. Where this departure from traditional Beaux-Arts naturalism would have taken Bitter can never be known. He died before the dedication of the monument, which was held on August 19, 1915.

Bitter enlisted a friend from Austria, designer Hans Kestranek, to help plan the triangular park. Dennis notes that the two had successfully collaborated in 1902 on a monument to John Erastus Hubbard, a prominent businessman of Montpellier. The *Lowry Monument* stands at the base of the triangle, facing a deeply curved stone bench at the opposite end of the park. In between are paths and flower beds, picked out by ornamental lampposts. The scale of the bench, paths, and flower beds enhances the intimacy of the small park and creates an ideal setting to contemplate this memorial to a local figure, who contributed to the improvement of communication and transportation in his community. Bitter's monument says that this is no small contribution to that community or to humanity.

THE JOHN BALL MEMORIAL

A little-known sculptor, Pompeo L. Coppini, created a monument to a local philanthropist in Grand Rapids, Michigan, that also relies on a parklike setting.[13] Less innovative in its plan, its lifelike genre quality is reminiscent of Gutzon Borglum's work and anticipates the realist figures in urban settings of Bruno Lucchesi. These slice-of-life portraits are like John Rogers's groups enlarged to lifesize.

John Ball was a land speculator, lawyer, schoolteacher, and state legislator who bequeathed 40 acres of parkland to the city. To honor this benefactor's many contributions to the life of Grand Rapids, the city commissioned the Italian-born Coppini to create a monument to Ball, in which he is seated on a granite bench, not unlike Borglum's use of a bench rather than the traditional pedestal in his statue of Abraham Lincoln of 1911 in the Essex County Court House Plaza in Newark, New Jersey. Lincoln gathers two youngsters to him as he tells them stories. Georg Lober's 1956 bronze statue of Hans

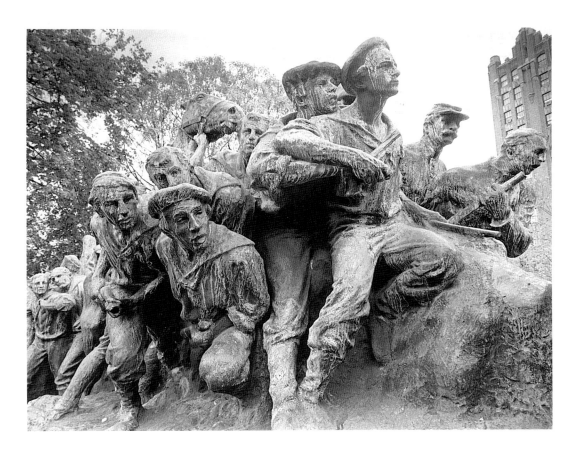

Gutzon Borglum (1867–1941)
Wars of America, 1926
Bronze group on natural rock,
colossal scale
Newark, New Jersey

Christian Andersen, who is shown seated on a granite park bench in Central Park in New York City with a book of his stories on his lap open to "The Ugly Duckling," continues this same tradition.[14]

SOME MONUMENTS BY GUTZON BORGLUM

It is not often that a sculptor has the opportunity to capture the spirit of a city's history through generous patronage, but Gutzon Borglum was so blessed with four major works in Newark, New Jersey: *The Indian and the Puritan* lampstand, 1916; the *Abraham Lincoln Monument* for Lincoln Post No. 11, GAR, 1911; the *Founders Fountain*, 1916; and the *Wars of America*, 1926. The *Founders Fountain* and *The Indian and the Puritan* lampstand were dedicated on the 250th anniversary of Newark, and the *Lincoln* and *Wars* monuments were executed under the bequest of the philanthropist Amos H. Van Horn.[15]

Borglum's *Lincoln* is sited in the large, open Essex County Court House Plaza, and the sculptor has seated Lincoln on a park bench instead of portraying him standing on the traditional pedestal or seated in an ornate armchair. Unlike Borglum's colossal 6-ton Lincoln head of 1908 commissioned by the Library of Congress, this Lincoln is lifesize and sits casually, his left hand and arm placed across his lap, while his right hand rests on the bench. Another Abraham, Abraham Pierson, was the spiritual leader of the Puritan founders of Newark in 1666. He came from Newark-on-Trent, England, for which this town was named. Pierson was effective in establishing good relations with the Indians in those first days. The *Indian and Puritan Memorial*, a

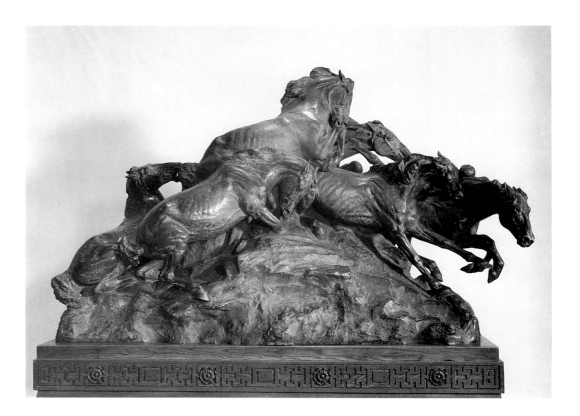

Gutzon Borglum (1867–1941)
Mares of Diomedes, 1904
Bronze, 62 in. (157.5 cm) high
The Metropolitan Museum
of Art, New York; Gift of
James Stillman, 1906

17-foot-high lamp standard, flanked by lifesize marble figures of a Puritan and an Indian, celebrates the Puritans' early peaceful relations with the Indians and the enterprising spirit of the colonists.

In the *First Landing Party of the Founders of Newark Monument*, Borglum honors the secular founders of Newark, under the leadership of Robert Treat. A 7-foot-high granite stele rises above a fountain and in its center bears a low relief of Treat and a companion. The names of the founding group are listed on the reverse side. At the top, Borglum has carved in low relief the scene near this site where the Puritans purchased from the Indians the land that now makes up most of Essex County.[16]

The *Wars of America Monument* in Newark's Military Park honors all those who served in the Revolution, Civil War, Spanish-American War, and World War I. Borglum has composed forty-two over-lifesize figures marching along together with two horses over a hillock. The colossal band of Americans he has compressed within those four time periods include a nurse, a conscientious objector, an aviator (the former mayor of New York City, John Purroy Mitchel), and a portrait of the donor Amos Van Horn, who was a veteran of the Civil War.

As Albert Ten Eyck Gardner has noted, the monumental and naturalistic execution of this immense group marked a dramatic departure from traditional war memorials in the United States and is a mature expression of the influence of Rodin and the *animalier* Barye, whose works Borglum studied in Paris early in his career. Those influences were first apparent in the *Indian Scouts* Borglum exhibited in the Columbian Exposition and in the *Mares of Diomedes*, called by one critic "a cowboy stampeding a herd of broncoes,"

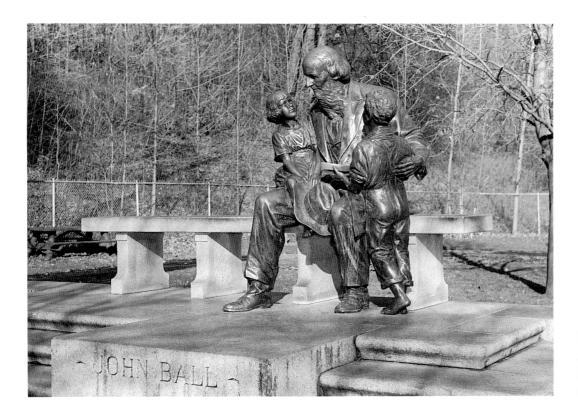

Pompeo L. Coppini (1870–1957)
John Ball Memorial, 1925
Bronze, lifesize
Grand Rapids, Michigan

which Borglum exhibited in 1904, at the Louisiana Purchase Exposition in St. Louis.[17] The "Mares" also presaged Borglum's future works on a gargantuan scale, for which he is best remembered.

From the late 1920s, Borglum's *Texas Cowboys* for San Antonio, Texas, was a 32-foot-high, 40-foot-long composition of two cowboys on horseback and part of a herd of longhorns, commemorating the famous cattle drives of the Chisholm Trail.[18]

To fit the imagination of Borglum, but eventually neither the patience nor the pocketbook of the patrons, he attempted to carve a salute to Robert E. Lee on a surface of Stone Mountain near Atlanta, 800 feet high and 2,000 feet wide. Composed of the famous Confederate leader and a host of supporting figures, the project took too long, and Borglum's contentious manner and the mounting budget, estimated at $2,000,000, alienated too many people. Following World War I, Borglum was removed, and Augustus Lukeman was commissioned to complete it. By then, however, interest had waned while costs soared, and the project died.[19]

Stone Mountain was prologue for Borglum's greatest feat, the presidential portraits for Mount Rushmore in South Dakota, the project with which every schoolchild in America associates the name of Gutzon Borglum. At the top of the 1,300-foot-high mountain wall the relief busts of Washington, Jefferson, Lincoln, and Theodore Roosevelt loom 450 feet high, carved out of the living rock with dynamite and jackhammers. Washington's portrait, the first to be completed, was unveiled on July 4, 1930, Jefferson's in 1936, Lincoln's in 1937, and Roosevelt's in 1938. Borglum continued to work on the project until he died in 1941.[20]

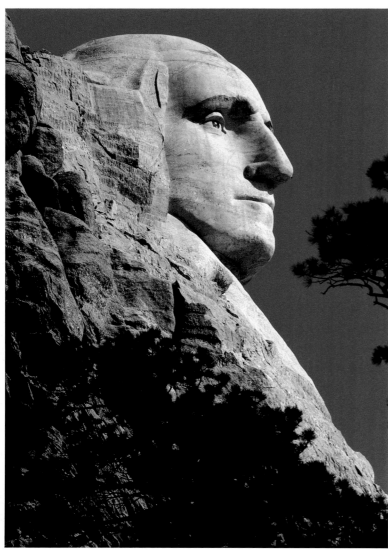

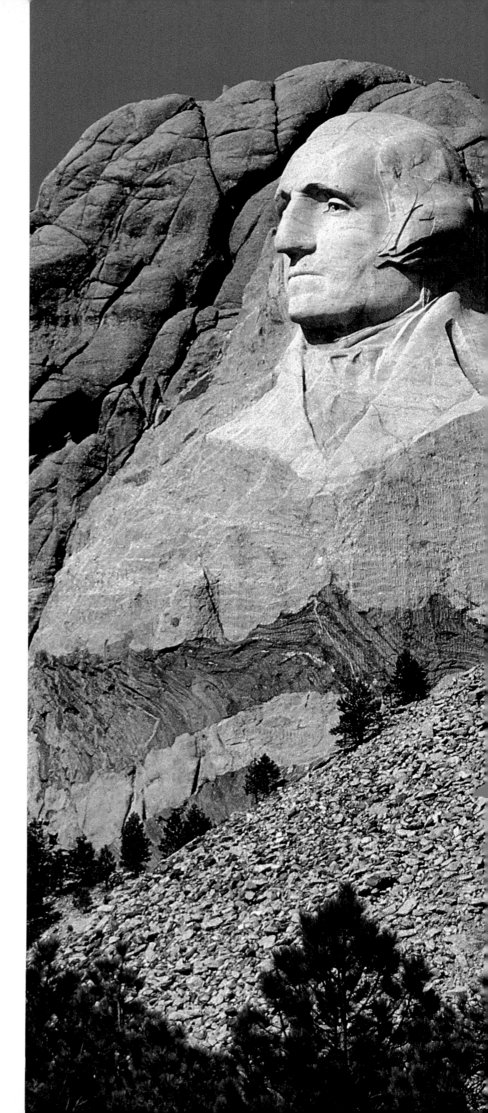

Gutzon Borglum (1867–1941)
Presidential Portraits: overall view
(RIGHT) and detail of George
Washington (LEFT), 1941
Natural rock, colossal scale
Mount Rushmore, South Dakota

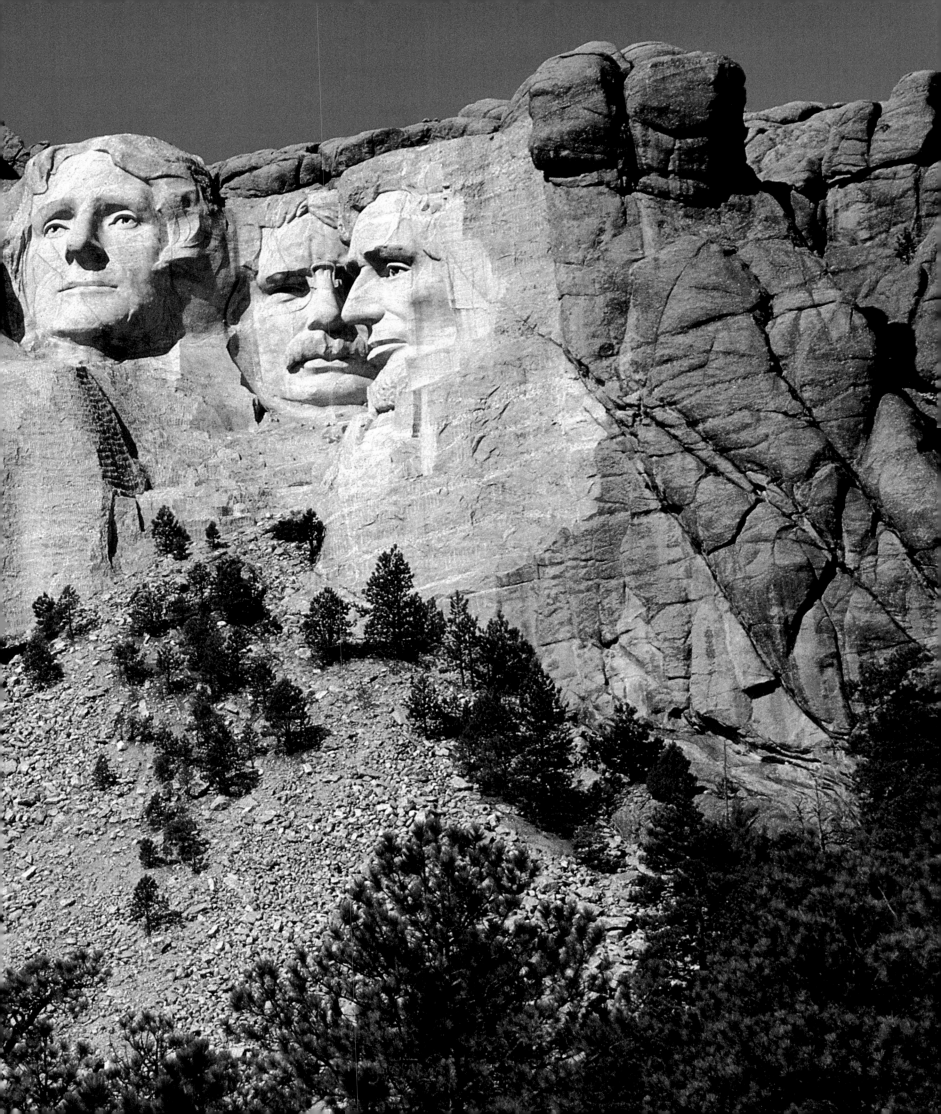

THE ROOSEVELT MEMORIAL

Two years before Borglum's portrait of Theodore Roosevelt was completed on Mount Rushmore, the twenty-sixth president's memorial in New York City was completed—long overdue and fraught with setbacks.

The Roosevelt Memorial at West 79th Street and Central Park West was designed by John Russell Pope with an equestrian monument by James Earl Fraser. It consists of a plaza, statuary, relief sculpture, and an educational building in classical style featuring a barrel-vaulted memorial hall 120 feet long, 67 feet wide, and 100 feet high, in marble and limestone with murals celebrating Roosevelt's African explorations as well as his roles in the Panama Canal and in settling the war between Russia and Japan.

Pope's granite façade consists of a triumphal arch defined by paired Ionic columns and supporting broken entablatures bearing free-standing statues of Meriweather Lewis and William Clark, whose expedition, 1803–06, explored the Louisiana Purchase and opened vast new territories to the United States; Daniel Boone, who in 1775 blazed the principal route of westward migration from Virginia to the Ohio River; and John James Audubon, American ornithologist, whose *Birds of America* (1827–38) and

John Russell Pope (1874–1937)
Roosevelt Memorial, 1936
Elevation
National Sculpture Society,
New York

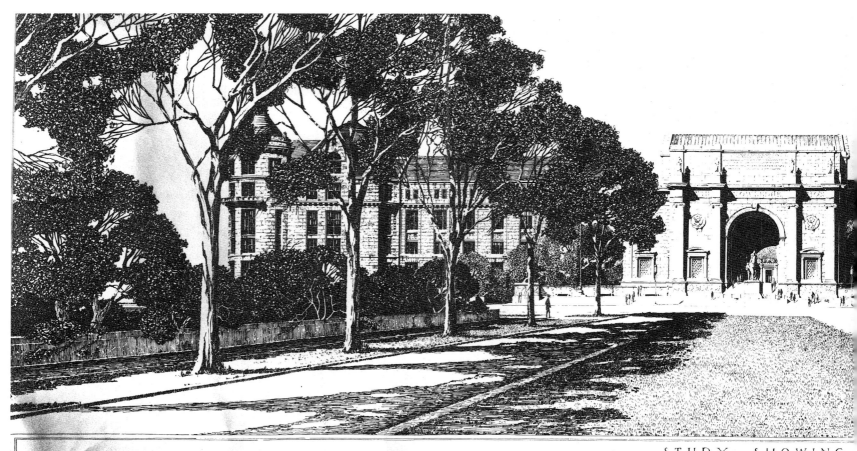

STUDY SHOWING
THE APPROACH FROM THE WEST DRI
TO THE EASTERN FACADE OF THE AMERICAN
AND NEW YORK STATE ROOSEV

five-volume *Ornithological Biography* (1831–39) in collaboration with William Macgillivray are landmarks in America's cultural history. The four statues are set before an attic parapet, overlooking Central Park across the street to the east. Plain wings pierced by colossal windows are set back from the triumphal arch, framing it and relating the façade to the American Museum of Natural History behind, which extends south to West 77th Street and north to 81st Street.

A 16-foot-high bronze equestrian statue of Theodore Roosevelt on a colossal pedestal stands at the base of the upper tier of stairs. By portraying Roosevelt as a hunter and explorer, flanked by an Indian, symbol of America, and a Black Man, symbol of Africa, with the statues of Lewis and Clark, Boone, and Audubon above, Fraser pays tribute not only to Roosevelt's role in the American Museum of Natural History but also his role as a conservationist and to what has been called Roosevelt's greatest achievement: the addition of millions of acres of forests and mineral lands to the country's natural preserves, thereby reversing the trends of disposing of public lands to private interests.[21]

Roosevelt's likeness is based on a portrait bust Fraser modeled in 1909–10. Fraser's composition of the statue is derived from the two most

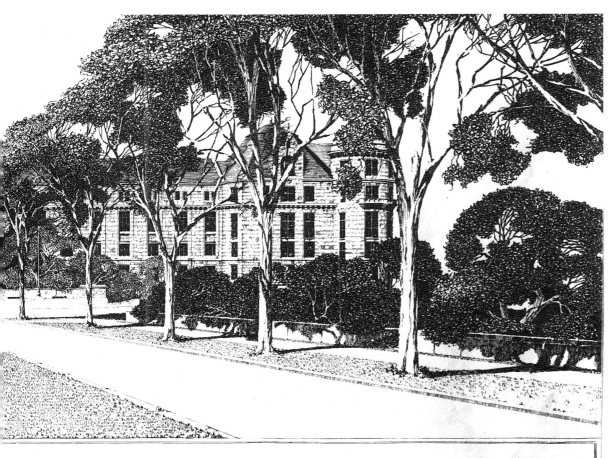

WAY OF CENTRAL PARK
SEUM OF NATURAL HISTORY
T MEMORIAL
PREPARED BY ORDER OF THE BOARD OF TRUSTEES
OF THE ROOSEVELT MEMORIAL, JUNE 3, 1930.

important equestrian monuments of the Renaissance: Donatello's portrait of Gattamelatta (1445–50) in Padua and Verrocchio's portrait of Colleoni (c. 1483–88) in Venice.[22] Roosevelt's posture, with his left shoulder thrust forward, is a direct quotation from Colleoni, and the enlarged scale of Roosevelt's steed and the generalized modeling of horse and rider are influenced by Gattamelatta. The monumental scale and forward motion of Fraser's composition was appropriate for the original design of the memorial and its site because the statue was meant to face a long corridor that the architect had designed to extend into Central Park, curving northward to the Metropolitan Museum of Art, thereby connecting two great cultural institutions of international renown. The Inter-Museum Promenade through Central Park, as it was called, was never executed, which leaves Fraser's monument and Pope's building greatly diminished, and the monument fails to command the space as it was intended to do. The result was good for Central Park but bad for New York State's monument to a deserving statesman and effective advocate of the preservation of our natural resources.

In 1920, Governor Al Smith had established the New York State Roosevelt Memorial Commission, headed by paleontologist Dr. Henry Fairfield Osborn, president of the American Museum of Natural History, to erect a monument to the memory of Theodore Roosevelt. At the outset, disagreement arose over whether the memorial should be in Albany or New York City. Osborn's preference for New York City, which was largely motivated by his desire to make the American Museum of Natural History more accessible and better known, prevailed.[23]

Legislators in Albany insisted that a state memorial should be in the capital of the state. Osborn pointed out, however, that Roosevelt was born in New York City and that his father had been a founder of the American Museum of Natural History and a trustee. Furthermore, Theodore Roosevelt himself had been a trustee of the museum and an ardent lover of nature and natural history. He studied and wrote on the subject and carried out explorations tied in with the museum's projects and excavations. In the field of public service, Osborn reminded the legislators, Roosevelt had represented a New York City district twice, run for the office of mayor of New York City, and was a member of the Police Board.[24]

It was Osborn's proposal of an Inter-Museum Promenade through Central Park along with political support at the state and local levels, however, that won the day, initially, for the memorial to Theodore Roosevelt at the American Museum of Natural History in New York City. Osborn, however, had underestimated the power of the Central Park Association. Fearful that the promenade would impair the plan of Frederick Law Olmsted, designer of the park, the association launched a vigorous campaign opposing the promenade and succeeded in blocking it, even though Pope's design received the support of the prestigious National Sculpture Society.[25]

While Osborn did not succeed in getting the Inter-Museum Promenade approved, he tried to salvage, at least, the monumental approach to the memorial from Central Park. John Russell Pope prepared drawings of

the modified approach, which extended the 450 feet from the west driveway of Central Park to the entrance and which consisted of a thoroughfare 150 feet wide lined with gingko trees and grass as in the original plan. The Parks Association rejected that design, too.

It is lamentable for the memorial that alternatives to Pope's plan that would respect the inviolability of Central Park have never been explored. If north-south traffic along Central Park West, for example, were accommodated by a tunnel underground or an overpass from 77th to 81st streets, the memorial's plaza could be extended to the edge of Central Park, and through sensitive landscaping at least a modicum of the integrity of Pope's original design could be realized.

Thomas Jefferson and Abraham Lincoln were more fortunate in the memorials that commemorate their service to the nation.

THE JEFFERSON MEMORIAL

The *Jefferson Memorial* in East Potomac Park, Washington, D.C., was completed in 1943 and enshrines a colossal bronze portrait statue of Thomas Jefferson and key quotations from his writings inscribed on four panels and at the base of the dome. John Russell Pope, Otto R. Eggers, and Daniel P. Higgins were the architects, and the portrait statue is by Rudulph Evans. It portrays Jefferson in his middle years standing on a 6-foot-high marble base.[26] The likeness is based on Houdon's famous bust, and his dress—knee breeches, waistcoat, and long fur-collared coat—is based on the American painter Rembrandt Peale's portrait. He carries the Declaration of Independence rolled up in his left hand.

The memorial was dedicated in April 1943, the 200th anniversary of Jefferson's birth. Evans's 19-foot-high statue stands beneath the dome of the

John Russell Pope (1874–1937)
Jefferson Memorial, 1935–37
Washington, D.C.

Rudulph Evans (1878–1960)
Thomas Jefferson, 1938–43
Bronze, over lifesize
Jefferson Memorial,
Washington, D.C.

circular building based on the Pantheon in Rome, the building that inspired Jefferson's design for the Rotunda at the University of Virginia in Charlottesville. Jefferson was the major force for bringing about the classical revival in America, so relying on the Pantheon as the model for his memorial was especially appropriate.

Quotations for the panels and the inscription at the base of the dome were taken from the Declaration of Independence and the Act of Religious Freedom, as well as from letters and notes on education, slavery, and the Constitution.[27] It has been noted that the architects modified some of Jefferson's words in order to fit them onto the panels, but this was not discovered until 1973, and no effort has yet been made to correct them.

Sculptor Adolph Alexander Weinman designed the marble relief in the 10-foot-high, 68-foot-wide pediment above the north entrance portico. Thomas Jefferson is shown in the center standing behind a table looking straight ahead. On either side of him are the other four members of the five-man committee to draft the Declaration of Independence. On the left are Benjamin Franklin and John Adams and on the right are Roger Sherman and Robert Livingston. The Declaration of Independence and the Constitution are preserved in the National Archives Building and are on view to the public.[28]

THE MINUTEMAN AND THE LINCOLN MEMORIAL

It is unlikely that there is a schoolchild in America who does not know the bronze statue of the *Minuteman* in Concord and the colossal seated marble statue of Abraham Lincoln in the *Lincoln Memorial* in Washington, D.C., the two best-known statues in the United States besides the *Statue of Liberty*. It is just as unlikely that those same children know that both of those statues are by the same sculptor, Daniel Chester French. French gave the country the two major icons of the most important episodes in its history of freedom: the American Revolution and the Civil War.

The *Minuteman* was French's first famous statue, and he executed it in 1874, when he was but twenty-four years old. It was part of the town's centennial celebration of the Battle of Concord. French took the stance from the Athenaeum's plaster cast of the famous Apollo Belvedere and relied on local townspeople for the portrait. It was an instant success and continues to be loved today.

French's seated *Lincoln* was unveiled in 1922, when the sculptor was seventy-two years old, and it was, according to French scholar Michael Richman, "the paramount achievement of his long and productive career."[29] French sought to convey "the mental and physical strength of the great President," and he felt he succeeded through the pose of the figure, the expression of the face, and especially the "actions of the hands."[30]

While the *Minuteman*'s power comes from its symbolic importance, embodying the respect we have for the early patriots, historians have noted that it has given us no new insights into the art of the human figure and

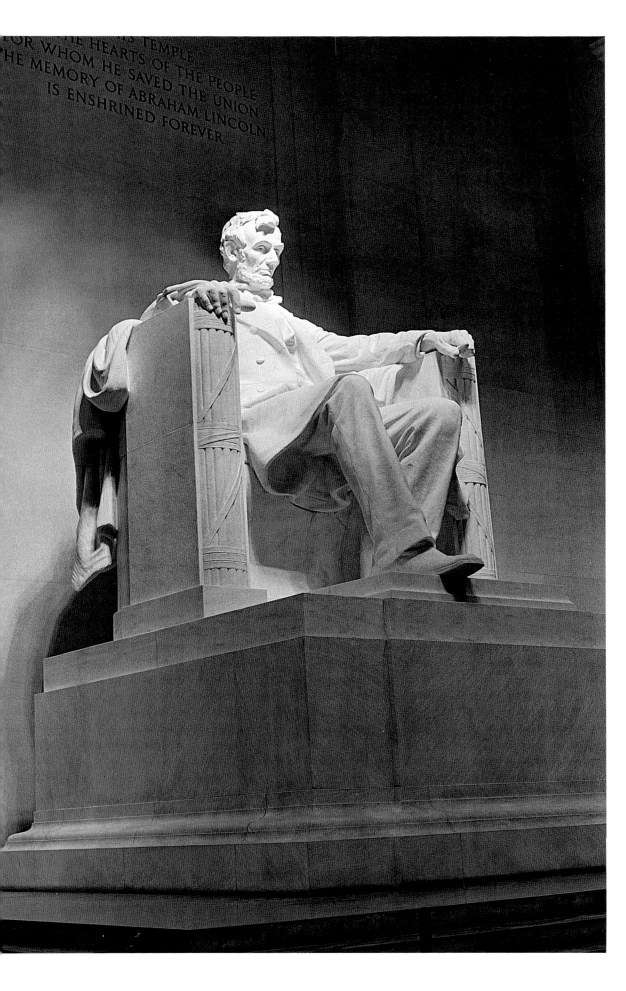

Daniel Chester French
(1850–1931)
Abraham Lincoln, 1911–22
Bronze, over lifesize
Lincoln Memorial,
Washington, D.C.

Henry Bacon (1866–1924),
architect
Lincoln Memorial, 1911–22
Washington, D.C.

is therefore not considered a great work of art. The *Lincoln Memorial,* on the other hand, not only succeeds as a major symbol but also succeeds in its relationship of architecture, sculpture, and site as no other monument in the nation.

A Lincoln memorial had been proposed, and its site at the west end of the Mall selected as early as 1901, as part of the McMillan Plan (see Chapter 1), as Richman recounts in his illuminating discussion of the key aspects of the commission. When the Lincoln Memorial Commission was established in 1911, it soon selected Henry Bacon as the architect to design the monument, and Bacon in turn chose Daniel Chester French, by 1914, as the sculptor to execute the Lincoln statue, notwithstanding a movement to have a version of Augustus Saint-Gaudens's standing Lincoln in Chicago enlarged for the memorial.[31] Bacon correctly felt that that would be inappropriate, and he knew the idea of enlarging his Chicago Lincoln would be offensive to Saint-Gaudens. Because the selection had to be approved by the Commission of Fine Arts and Daniel Chester French was its chairman, the sculptor resigned his office so he could accept the commission.[32]

Bacon designed a classical temple surrounded by a colonnade of thirty-eight Doric columns, elevated above a surrounding terrace. A reflecting pool enhances the majesty of the building, and the ensemble is circumscribed

by a scenic drive. A cella contains the statue of Lincoln, while two flanking halls with murals by Jules Guerin complement the two most important documents of Lincoln's career. The Gettysburg Address is engraved on a wall of the west hall, and Lincoln's Second Inaugural Address appears in the right hall.[33]

French's seated statue of Lincoln is 19 feet tall and is supported by an 11-foot-high pedestal. For anatomical accuracy, French based his portrait of Lincoln on copies of the life casts taken by Leonard Volk in 1860 and Mathew Brady's famous photograph of Lincoln.[34]

The statue was completed in 1920, but when its twenty-eight blocks of marble were assembled and the statue finally stood in its sanctuary, it was apparent that the principal light source—the large open doorway into the chamber—did not provide adequate illumination. However, by removing some panels in the ceiling and installing electric lights, then tinting the marble, the desired effect was achieved. Then, in 1926, French succeeded in having the monument lighted at night, much the way we see it today.[35]

While French's idealized portrait of Abraham Lincoln is unsurpassed, his rare gift for blending the real and the ideal is perhaps best realized in some of his other less well-known monuments.

THE HUNT MEMORIAL

At the sudden death of Richard Morris Hunt, on July 31, 1895, the Municipal Art Society called for a monument to be erected to the man whom they hailed as preeminent in raising the union of architecture and its sister arts of painting and sculpture to a high art. A committee consisting of Henry Janeway Hardenbergh, Will H. Low, and J.Q.A. Ward decided that the monument should take the form of a monumental exedra with a portrait bust of Hunt. They selected Daniel Chester French as the sculptor, who chose Bruce Price as the architect to assist him.[36]

The monument was to be placed at the edge of Central Park, facing Fifth Avenue on axis with 83rd Street, near the façade of the Metropolitan Museum of Art, which would have been Hunt's crowning achievement. It is uncertain when the decision was made to erect the monument facing the Lenox Library between 70th and 71st streets on Fifth Avenue.[37] Given the failure to complete Hunt's intended design for the Metropolitan Museum façade and the fact that the Lenox Library is generally conceded to be "Hunt's finest and most purely French inspired design," it turned out to be the best site.[38] Facing the library, the monument's exedra echoed the French plan of the library, with its wings flanking the forecourt directly across the street. The Henry Clay Frick residence replaced the library early in the twentieth century, so now the position of the monument at midblock between 70th and 71st streets seems awkward.

French executed Hunt's larger-than-lifesize portrait bust on a high pedestal for the center of the monument and two allegorical figures at either end of the exedra, one representing Painting and Sculpture, the other,

TOP LEFT, CENTER, AND RIGHT
Daniel Chester French
(1850–1931), sculptor
Bruce Price (1845–1903),
architect
Richard Morris Hunt Memorial:
overall view (CENTER), portrait
bust of Hunt (LEFT), and
personification of architecture
(RIGHT), 1896–1901
Bronze and granite against
exedra of stone, over lifesize
New York

Architecture. Painting and Sculpture, the south figure, holds the painter's palette and a miniature Dionysos from the east pediment of the Parthenon to represent sculpture. Architecture, to the north, holds the Administration Building from the Columbian Exposition of 1893, Hunt's masterpiece of the fair. Bruce Price included the names of the arts organizations of which Hunt was either a member or a founder, and the seal of the Municipal Art Society is set in the tiles of the floor.

HUNT'S ABORTED MONUMENT

Richard Morris Hunt's entrance wing of the Metropolitan Museum was called "the best classic building in this country" when it was opened to the public on December 22, 1902.[39] It was Hunt's last project, and it should have been his monument, as it has been called. Had he lived to complete it, it might well have been. His original intention was for an elaborate sculpture program of thirty-one pieces of statuary and ornament, and he specified that the

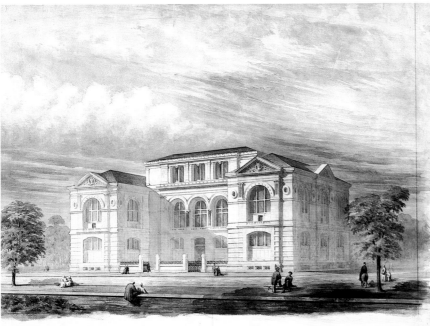

Richard Morris Hunt (1827–1895)
Lenox Library, perspective, 1871
Pencil and watercolor on paper
The American Architectural
Foundation, Washington, D.C.

façade be marble for its reflective qualities, to enhance the play of light across the ornamental carving.

Because of Hunt's death, the building was completed by his son, Richard Howland Hunt. Unfortunately, the elder Hunt's design was compromised. For budgetary reasons, limestone replaced marble for the façade, and the sculpture program was aborted. The massive stacks of limestone blocks that remain uncarved today were to have been monumental figure groups. They remain as painful reminders of Hunt's intentions. The relief panels between the paired columns also remain uncarved, and the niches designed for statuary are vacant. The façade, however, is not totally without the ornament Hunt envisioned. Karl Bitter carved the six rondels in the spandrels, profile portraits of Bramante, Michelangelo, Raphael, Dürer, Rembrandt, and Velázquez; the three colossal keystone busts; and the caryatids representing Painting, Architecture, Sculpture, and Music. Unfortunately, many of the architectural and ornamental features of the entrance are eclipsed today by the tasteless banners that the museum installs to advertise its exhibitions. Moreover, the fixtures that anchor the banners to the façade are destroying ornamental masonry. Without its full contingent of sculptural ornament, the façade "must depend instead," as Morrison H. Heckscher has noted, "upon the perfect scale and proportions of its parts." Even those have been compromised by the nondirectional stairways, in constant need of maintenance, and the ungainly fountains installed in the 1970s.

THE MILMORE AND MELVIN MEMORIALS

Soon after his return from Paris in 1888, where he had spent almost two years studying with the noted French Beaux-Arts sculptor Mercié, Daniel Chester French was at work on a memorial for Forest Hills Cemetery in Boston to the sculptor Martin Milmore, who had died in 1883, at the age of thirty-nine.[40] According to Richman's informative account of the monument, it is not clear whether the memorial was also to honor Milmore's brother Joseph.

French portrays the sculptor as he is carving a sphinx, perhaps the sphinx Milmore actually carved, with his brother Joseph, in Mount Auburn

Daniel Chester French
(1850–1931)
Milmore Monument: The Angel of Death Staying the Hand of the Sculptor, or *Death and the Sculptor,*
1889–93
Bronze and granite, over lifesize
Boston

Cemetery in Cambridge.[41] French shows the artist in his youth, as if to emphasize the uncertainty and tragedy of the interruption of an artistically productive life. Milmore holds his mallet in his right hand, while the Angel of Death stays the sculptor's left hand, which holds the chisel against the relief of the sphinx he is carving. The angel is a fully draped freestanding female framed in great sweeping wings, and French depicts her as beautiful and nurturing. For the wings of the angel, French studied the collection of an ornithologist friend, which also prepared him for the more ambitious wings of *Spirit of the Waters* for the *Trask Memorial*, 1913–15, in Saratoga Springs, New York.[42] The Milmore original was completed in 1893 in bronze, while the better-known version in the Metropolitan Museum was carved in marble between 1917 and 1926.

Another of French's replicas in the Metropolitan Museum is *Mourning Victory*, the Melvin memorial of 1915, from the original in 1909, for Sleepy Hollow Cemetery in Concord. It derives directly from French's figure of Death in the Milmore Memorial. Commissioned by James Melvin for his three brothers, who died in the Civil War, Asa, John, and Samuel, whom French had known in childhood, it is one of French's most successful allegories and one of the country's most compelling Civil War monuments.[43] French shows Victory coming forth from a great stele as if dissolving the stone and walking straight into the spectator's space. French no doubt knew Karl Bitter's *Villard Memorial* in Sleepy Hollow Cemetery in Tarrytown, New York, of 1902–04, in which the figure emerges from the marble but remains part of a pictorial scene.[44] While both sculptors owe a debt to Rodin for this device, French's unique treatment links the here-and-now with the world of the spirit. The voluptuous modeling of the seminude Victory caught in the middle of her stride forward stirs the recreative forces that deny the cessation of life and promise immortality.

It should be noted that while Karl Bitter's handling of the figure of Labor in the *Villard Memorial* is Rodinesque in its emergence from the rough-textured background, it is the sculptor's use of *art nouveau* devices that is most remarkable.[45] The monument consists of an arched panel with a seated figure of Labor holding the handle of a sledgehammer that rests on the ground in the relief, the panel framed by a pair of elongated trees.

The tendril-like roots of the trees flare out at the bottom and entwine around the base while the full flowering of the leaves and branches at the top surround the panel and echo the hemlocks that enclose the site on a hilltop overlooking the Hudson. Henry Villard, the German-American entrepreneur who had died four years earlier, had championed human rights and had been a good friend to labor.

THE TRASK MEMORIAL

The *Spirit of the Waters* for the *Spencer Trask Memorial Fountain*, 1913–15, in Saratoga Springs, New York, was one of Daniel Chester French's best pieces, by his own account in 1922, "the best thing of the kind I ever made."[46] A fully

Daniel Chester French
(1850–1931), sculptor
Henry Bacon (1866–1924),
architect
*Spencer Trask Memorial:
The Spirit of Life,* 1913–15
Bronze allegorical figure,
stone fountain and architectural
setting, over lifesize
Saratoga Springs, New York

draped figure, except for the arms that reach upward, it has all the idealized beauty of the female nude because of the way French's drapery clings to the long sweeps of the figure's feminine contours. Moreover, the hair is swept up and gathered casually in soft tresses that reveal the Spirit's long neck and smooth temples. Her slightly parted lips, suggesting she is about to speak, animate the elegant features of the figure's finely modeled head and face. Reminiscent of those of the famous *Victory of Samothrace,* though much lighter in weight, the pair of magnificently feathered wings extend in a great sweep behind the figure, enhancing the buoyancy of life, which Trask's widow, Katrina, desired.[47]

The *Spirit of Life,* as she is also called, holds a sprig of pine in her right hand and in her left a basin from which the water flows. Both objects are symbolic of Spencer Trask's (1844–1909) dedication to restoring Saratoga Springs to its former prominence as a leading health resort, and to that end

he had helped to found the Saratoga Springs Preservation Commission. His friend and business associate in New York, George Foster Peabody, continued Trask's work and along with Trask's widow negotiated the monument with Daniel Chester French that was to commemorate Trask's commitment to that project.

Henry Bacon, French's frequent collaborator, designed the fountain and the architectural setting for French's figure, Richman recounts in his history of the work. The fountain and figure are set in a classical niche from which a masonry wall extends to left and right. A pair of urns set at the extremities of the niche frame the ensemble against a landscaped backdrop.

Unlike the *Trask Memorial Fountain*, the stories of three other fountain memorials, one dedicated to a great poet, the two others to philanthropists, illustrate the complexities and compromises that are all too common in the creation of civic monuments.

THE HEINE FOUNTAIN

To celebrate the centennial of the birth of Heinrich Heine (1797–1856), the German Romantic poet, some of his countrymen were determined to erect a monument to him in Düsseldorf, Germany, his birthplace. The city officials, however, rejected the proposal to honor the Jewish poet, who had fled Germany for Paris where he was an active member of the Young Germany literary movement supporting the social ideals of the French Revolution.

A German-American group in New York City took up the project in 1893, and commissioned the Berlin sculptor Ernst Herter to produce a fountain to honor their hero, as Michelle Bogart explains in her study of New York City's civic sculpture.[48] Following the political upheavals of 1848 and 1849 in Germany, a substantial German population had emigrated to New York City and brought with them a rich cultural heritage that they perpetuated through such organizations as the Mannerchor, a choral group that often performed at Arion Hall, still standing at 13 Arion Place, Brooklyn, New York, the home of the Arion Club (its initials and choral symbols on the exterior of the building have miraculously survived).[49] The statue of Arion by German sculptor Alois Loehr has, alas, long vanished. The club was named for Arion of Methymna, the great poet and singer of the seventh century B.C., whose poems were the basis of lyrical writing.

It was only appropriate, Bogart notes, to celebrate Heine with his best-known poem, "Die Lorelei," based on the legend of the maritime siren who lured sailors to their untimely deaths. Lorelei stands atop a circular pedestal twisting and turning in her domination of the mermaids below. The recumbent mermaids alternate with scallop shell basins from which spill the waters that fill the pool of the fountain. Heine's portrait is carved in low relief directly below Lorelei.

Influential donors to the Heine fountain fund included Joseph Pulitzer of the *New York World*, Ostwald Ottendorfer of the *New York Staats-Zeitung*, William Steinway, the piano manufacturer, and George Ehret, a brewer.

Obviously, with such distinguished support and a prominent sculptor to create the monument, New York City would be delighted to have it. When the Heine Monument Committee proposed it, however, and requested that the monument be erected in the plaza at the southeast entrance to Central Park at 59th Street (where the Sherman Monument is now), the city rejected the idea, and sought a professional opinion from the National Sculpture Society to support the rejection.[50]

Sculptor Augustus Saint-Gaudens, architect Stanford White, and critic Russell Sturgis, among others, agreed that the monument, while it was not totally without artistic merit, was not the kind of thing the city of New York needed. Pressed by the German-Americans for more specific reasons for rejecting Herter's proposed design, the National Sculpture Society said the design lacked "dignity and majesty," and besides, as Bogart shows, the fountain had been designed to be executed in marble, which would not survive in New York City's severe climate.

The German-American community and the city finally worked out a compromise, and the monument was erected in 1900 at 161st Street and the Grand Concourse in the Bronx, in what was at that time a German-American community. The fountain was later moved to the northern end of the park, and through generations of vandalism and neglect, the sculpture has severely deteriorated.

The Swann Memorial Fountain

The *Swann Memorial Fountain* in Philadelphia, designed by the architect Wilson Eyre, Jr., with bronze sculpture by Alexander Stirling Calder, was completed

Alexander Stirling Calder
(1870–1945), sculptor
Wilson Eyre, Jr. (1858–1944),
architect
Swann Memorial Fountain, 1924
Bronze figures with granite base,
11 ft. (3.4 m) high
Philadelphia

in 1924 and stands in Logan Circle on the parkway that links City Hall and the Philadephia Museum of Art. It is a circular fountain composed of three bronze nudes reclining centrifugally around a centerpiece of three concentrically tiered basins spilling out into a large pool. Jets of water create a series of low arcs.

Named for Dr. Wilson Cary Swann (1806–76), it was dedicated to him by his wife in her will when she died in 1891.[51] The sculptor called the monument the *Fountain of the Rivers* for the three rivers that enclose Philadelphia— the Delaware, the Schuylkill, and the Wissahickon—whose personifications make up the centerpiece of the fountain. Calder's three reclining figures are indebted formally in their languourous extended torsions to Michelangelo's *Times of Day* in the Medici Chapel in Florence and for their pedimental configuration to the figure of Dionysos from the east pediment of the Parthenon.

The Delaware is represented by an Indian brave of the Delaware tribe, but, as Victoria Donohoe explains, Calder meant to localize the imagery by conveying a secondary association with the Cayuga chief Logan, named after James Logan, for whom the square was named. James Logan was William Penn's secretary and is best remembered for his effective dealings with the Indians.

Wissahickon is a female nude reclining on the back of a swan. Her sinuous and flowing lines bespeak the curving path of that river. Calder's figure for the Schuylkill is a mature woman reclining between the wings of a swan, whose powerful forms recall the aboriginal waters of the river the Indians called "the mother."

When Maria Elizabeth Swann bequeathed $50,000 on her death in 1891 for the erection of a fountain, according to Donohoe, it was to be a tribute to her husband's lifetime of dedication to benevolent causes, most notably his founding of the Philadelphia Fountain Society. He established the society to erect fountains for people as well as animals, especially horses, the main source of transportation when he founded the society.

Complications in Maria Elizabeth Swann's will delayed the execution of the fountain for thirty years.[52] Whether or not the *Swann Memorial Fountain* is what Maria Swann envisioned, it is a powerful tribute to a generous Philadelphian. Calder orchestrated his bronze allegories, the arcs of water, and the views of the surrounding park like round pedestals with the imagery constantly changing as the spectator approaches and walks around the fountain. Eyre designed the fountain with a low configuration so that the view along the parkway was unimpeded and enhanced by the fountain in Logan Circle.

CIVIC VIRTUE

In 1909, Frederick MacMonnies was commissioned by New York Mayor George B. McClellan to execute a drinking fountain to the memory of philanthropist Angelina Crane, with funds the widow had left to the city for that purpose.[53] MacMonnies seemed a logical choice to the mayor. Since the 1890s, he had been working on a number of major commissions for the city,

such as the pedimental sculpture for York and Sawyer's Bowery Savings Bank in Manhattan and the sculpture for the Washington Arch in Greenwich Village that featured two portraits of George Washington, as general and as president, with allegorical figures in low relief as backdrops to the portraits (a commission he finally lost because he refused to return to America to complete it). He completed the equestrian monument to General Slocum for Grand Army Plaza in Brooklyn in 1905, and his quadriga atop the Soldiers and Sailors Memorial Arch at the entrance to Prospect Park nearby, which featured personifications of the Republic and classically draped Victories, was in place by 1898, and the military groups on the piers were erected in 1901. That same year, his *Horse Tamers* adorned the Pan American Exposition in Buffalo, and were then moved to Prospect Park where Stanford White incorporated them into an entrance to the park and designed bases for them. MacMonnies completed the figures *Beauty* and *Truth* that flank the entrance to the New York Public Library in 1914.[54] And there were other commissions: a statue of Shakespeare for the Library of Congress; bronze doors featuring personifications of the Humanities and the Intellect, also for the Library of Congress; General McClellan's equestrian monument, 1907, for Washington D.C.; the frontier scout for the *Pioneer Monument* in Denver, Colorado; and the monument to the Battle of Princeton, in Princeton, New Jersey.[55]

MacMonnies may have seemed the logical candidate to the mayor, but with all of that work, it was little wonder that his model for the fountain in memory of Angelina Crane was not ready until 1914. Then it took five years to get the Art Commission's approval, Bogart shows. MacMonnies's design had become considerably more grand than the drinking fountain Mrs. Crane had envisioned. It became a monument to Civic Virtue, a 57-foot-high fountain to be sited at the southeast corner of City Hall Park, complete with basins and decorative jets with a personification of Civic Virtue victorious over the vices that corrupt city government, the group to be supported by American mountain lions, symbols of strength.[56]

MacMonnies defended the size of his fountain. It should hold its own with the two new skyscrapers that threatened to overshadow it, the 40-story Municipal Building northeast of the park, with its 27-foot-high gilded statue of Civic Fame atop, and the 58-story Woolworth Building, then the tallest building in the world, across the street from the park to the southwest, with the world's largest gilded roof acting like a beacon to the world. Nonetheless, the Art Commission insisted that MacMonnies scale down the fountain to its present size of approximately 15 feet high.

In spite of the Art Commission's approval in 1919, the fountain encountered substantial public opposition. MacMonnies's *macho* personification of Civic Virtue in classical contrapposto with a sword over his shoulder and standing over two females, who were personifications of Vice and swimming amidst sea monsters above the broad base, evoked the wrath of many women's groups. MacMonnies explained that the writhing figures were actually mermaids, but that distinction fell on deaf ears. Women resented not only that Vice was represented as female but that Virtue was represented as

OPPOSITE PAGE
A. A. Weinman (1870–1952),
sculptor
McKim, Mead & White,
architects
Civic Fame (1913–14)
Sheet copper on steel frame,
25 ft. (7.6 m) high
Municipal Building, New York

Frederick William MacMonnies
(1863–1937)
Diana, 1890 (original plaster 1889)
Bronze, 30¾ × 12¼ × 12¼ in.
(78.1 × 31.1 × 31.1 cm)
The Metropolitan Museum
of Art, New York

male.[57] After all, abstractions were traditionally represented as female. More-over, women had won the right to vote with the passage of the Nineteenth Amendment in 1918, so even though MacMonnies's fountain was installed in City Hall Park in 1922, their continued opposition to it was registered in City Hall and the political clubhouses around town.[58]

MacMonnies tried to explain that he chose a male figure to convey the strength of city government. Such symbolism, however, had lost its credibility. Even in 1909, Bogart points out, the year he signed the contract, the integrity of New York City's government was not taken seriously. That year, Leo Lentelli's statue of *Purity*, a temporary statue in staff, was erected in Longacre Square (later, Times Square) for a celebration in honor of the 300th anniversary of Hudson's discovery of the Hudson River in 1609 and the 100th anniversary of Robert Fulton's innovations in steam navigation. Lentelli's 20-foot-high female personification of municipal integrity was even then little more than a joke to New Yorkers.[59]

MacMonnies was not alarmed at the resistance to his statue, at first, because public outcry was not foreign to him. Following his *Diana*, for example, he modeled a bacchante with an infant faun (1893) after he had returned to Paris following the Columbian Exposition, when his *Barge of State* had enjoyed fame and recognition. His votary of Bacchus was in actuality a portrait of a favorite and well-known Parisian model, Eugenia, in the role of the carousing priestess of Bacchus of ancient mythology.[62]

most celebrated sculptors of his time. He had gotten his start working in Augustus Saint-Gaudens's studio doing odd jobs. He eventually became an assistant, and then went to Paris in 1884, where he studied with the famous sculptor Falguiére at the Ecole des Beaux-Arts, then became Falguiére's assistant. MacMonnies won prizes for his sculpture and earned international fame with his *Diana*, when exhibited at the Salon in 1889, which brought him such important commissions in the United States as the three angels for Stanford White's baldachino in St. Paul's Church in Manhattan, his standing statue of Nathan Hale for City Hall Park in 1890, a gift to the city from the Sons of the Revolution, and the standing portrait of James S. T. Stranahan for Prospect Park in Brooklyn. MacMonnies was part of the generation that had rejected the Neoclassicism of such American expatriates as Hiram Powers and William Wetmore Story of the mid- to late nineteenth century and that adopted the more spontaneous modeling, naturalistic treatment, and lyrical composition reflected in contemporary dance.[61]

MacMonnies was not alarmed at the resistance to his statue, at first, because public outcry was not foreign to him. Following his *Diana*, for example, he modeled a *Bacchante with an Infant Faun* (1893) after he had returned to Paris following the Columbian Exposition, when his *Barge of State* had enjoyed fame and recognition. His votary of Bacchus was in actuality a portrait of a favorite and well-known Parisian model, Eugenia, in the role of the carousing priestess of Bacchus of ancient mythology.[62]

Kindly substitute the following pages for the text that appears on page 108:

Frederick William MacMonnies
(1863–1937)
Diana, 1890 (original plaster 1889)
Bronze, 30¾ × 12¼ × 12¼ in.
(78.1 × 31.1 × 31.1 cm)
The Metropolitan Museum
of Art, New York

male.[57] After all, abstractions were traditionally represented as female. Moreover, women had won the right to vote with the passage of the Nineteenth Amendment in 1918, so even though MacMonnies's fountain was installed in City Hall Park in 1922, their continued opposition to it was registered in City Hall and the political clubhouses around town.[58]

MacMonnies tried to explain that he chose a male figure to convey the strength of city government. Such symbolism, however, had lost its credibility. Even in 1909, Bogart points out, the year he signed the contract, the integrity of New York City's government was not taken seriously. That year, Leo Lentelli's statue of *Purity,* a temporary statue in staff, was erected in Longacre Square (later, Times Square) for a celebration in honor of the 300th anniversary of Hudson's discovery of the Hudson River in 1609 and the 100th anniversary of Robert Fulton's innovations in steam navigation. Lentelli's 20-foot-high female personification of municipal integrity was even then little more than a joke to New Yorkers.[59]

MacMonnies's male figure of *Civic Virtue* also came under attack on stylistic grounds as the academic Beaux-Arts tradition was gradually replaced by the broader, geometric shapes of modern art.[60] In the 1930s, for example, New Yorkers watched the works of such sculptors as Lee Lawrie, Paul Jennewein, Carl Milles, and Paul Manship installed in Rockefeller Center, and they tired of the academicism of MacMonnies's generation.

MacMonnies had been one of the most successful, most respected, and most celebrated sculptors of his time. He had gotten his start working in Augustus Saint-Gaudens's studio doing odd jobs. He eventually became an assistant, and then went to Paris in 1884, where he studied with the famous sculptor Falguiére at the Ecole des Beaux-Arts, then became Falguiére's assistant. MacMonnies won prizes for his sculpture and earned international fame with his *Diana,* when exhibited at the Salon in 1889, which brought him such important commissions in the United States as the three angels for Stanford White's baldachino in St. Paul's Church in Manhattan, his standing statue of Nathan Hale for City Hall Park in 1890, a gift to the city from the Sons of the Revolution, and the standing portrait of James S. T. Stranahan for Prospect Park in Brooklyn. MacMonnies was part of the generation that had rejected the Neoclassicism of such American expatriates as Hiram Powers and William Wetmore Story of the mid- to late nineteenth century and that adopted the more spontaneous modeling, naturalistic treatment, and lyrical composition reflected in contemporary dance.[61]

(text for page 108 continued on the reverse side)

(text for page 108, continued from the reverse side)

MacMonnies was not alarmed at the resistance to his statue, at first, because public outcry was not foreign to him. Following his *Diana,* for example, he modeled a bacchante with an infant faun (1893) after he had returned to Paris following the Columbian Exposition, when his *Barge of State* had enjoyed fame and recognition. His votary of Bacchus was in actuality a portrait of a favorite and well-known Parisian model, Eugenia, in the role of the carousing priestess of Bacchus of ancient mythology.[62]

Also, substitute the following material for the text that appears on page 162:

162 MASTERS OF AMERICAN SCULPTURE

Felix De Weldon (b. 1907)
Marine Corps War Memorial
(Iwo Jima Memorial), 1954
Bronze figure group on rock base, heroic scale
Washington, D.C.

sculptor created a monument that became the nation's best-known symbol of American courage.

VIETNAM REMEMBERED

In 1982, Frederick Hart was commissioned to create the *Three Servicemen* for the Vietnam Veterans Memorial in Washington, D.C. They stand across from Maya Lin's wall. Says Hart, "I see the wall as a kind of ocean, a sea of

It had been common practice since ancient times for powerful and fashionable people to be portrayed as mythological figures, but it was not common practice to flaunt the likeness of a common model of questionable morals in the face of the public.

The distinguished architect Charles F. McKim placed MacMonnies's *Bacchante* in the Boston Public Library that he had designed on Copley Square. Elevating a drunken woman, mythological or not, to the level of fine art was too much for the sensibilities of the Bostonians, who demanded the removal of MacMonnies's *Bacchante*. The Metropolitan Museum of Art in New York City welcomed the statue, where it stands today in the sculpture garden, and the French Government, which decorated MacMonnies, commissioned a replica of *Bacchante* for the Luxembourg Museum in Paris, 1896.

But this was not the 1890s. And MacMonnies clearly was out of touch with the times in America. As the opponents of *Civic Virtue* increased in number, the attacks became mean and tasteless. "Fat Boy" must go, demanded the women's groups, the enemies of the Beaux-Arts tradition, and the politicians, who saw votes in a popular cause.[63]

In July, 1932, Nathan Straus, Jr., president of the Park Association in New York City, in a letter to Mayor Jimmy Walker called MacMonnies's statue "a travesty on good taste," and asked for its removal and the assurance it would be placed in no other city park. Sculptor and member of the association A. Stirling Calder, however, took issue with Straus's stand and said that MacMonnies's work was "designed with skill, imagination, and fine decorative power." He called it an "opulent composition, characterized by a freedom and richness of modeling that are rare in American art. The creator of *Civic Virtue* is an artist of good taste and delicacy, whom to accuse of bad taste is unfair and unjust." Calder went on to admonish the public that "its proposed

LEFT
Lorado Taft (1860–1946)
Fountain of Time, 1922
Washington Park, Chicago

RIGHT
Frederick William MacMonnies
(1863–1937)
Bacchante and Infant Faun, 1893
Bronze, 83 in. (211 cm) high
The Metropolitan Museum
of Art, New York; Gift of
Charles F. McKim, 1897

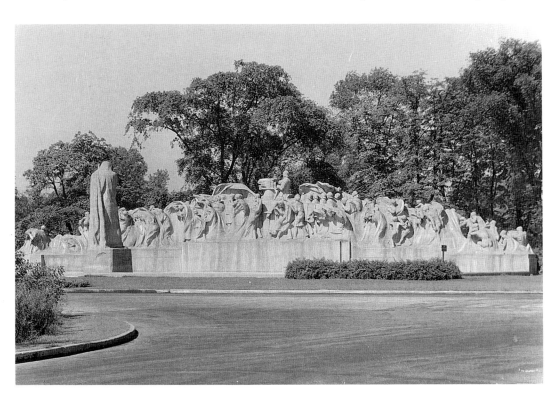

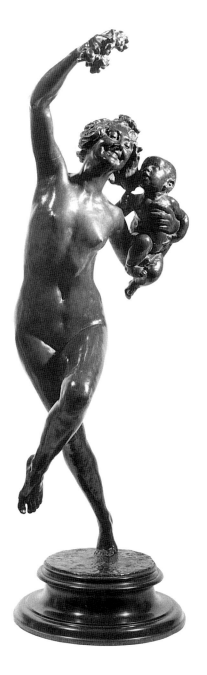

removal from its original site is too important a step to decide hastily. The matter should be referred to a committee of our most eminent sculptors, architects, and connoisseurs. Hasty action would create a precedent that might soon result in the removal, on one pretext or another, of many or all of the diversely interesting monuments of New York City."[64]

The venerable Lorado Taft, sculptor and author of the first survey of American sculpture and distinguished teacher at the Art Institute of Chicago, also came to MacMonnies's defense. If his original design on a monumental scale had been approved, Taft maintained, the monument would not have been opposed. Those testimonials to MacMonnies's abilities and accomplishments, however, garnered little support for MacMonnies, but he found contentment and satisfaction in his last colossal work, a monument to the Battle of the Marne in France, paid for with donations from the American people, and executed in the Beaux-Arts vocabulary he understood so well. One hundred thirty feet high, the monument features a colossal female nude personifying France and holding a dying soldier. The figure was carved by Edmondo Quattrocchi in 1936, the year before MacMonnies died, a fitting conclusion to an illustrious career.[65]

But even after MacMonnies was gone, the debate over the fountain dragged on, until Robert Moses, in his role as parks commissioner, decided to take action. "That ——— thing is going out at last. No hunk of junk like that is going to mess up my park, or any other park of mine. It's going into storage." It was destined probably for Randalls Island, and "From there on," Moses said, "as far as I'm concerned they could file it away at the bottom of the East River."[66] City Council President Newbold Morris seconded Moses's decision and the following year re-emphasized that it should be used for landfill—thereby assuring that it would never surface again.[67]

Sculptor Edmondo Quattrocchi of the Sculptor's Workshop, who had carved MacMonnies's *Marne Monument*, was alarmed at Moses's threats, and he appealed to the National Sculpture Society to take appropriate action. The society met on February 13, 1940, and secured the cooperation of Karl Gruppe, sculptor with the Parks Department, who was in charge of the city's monuments and outdoor sculpture. He agreed to move the fountain to Foley Square.[68] Even though the Art Commission approved the site nothing happened, so the following January the borough president of Queens, the Honorable George U. Harvey, asked to erect the sculpture across from the new Queens Borough Hall, by architects Gehron and Thomas, which had recently been completed in a classical style.[69] The National Sculpture Society praised Harvey for rescuing MacMonnies's sculpture "from the shabby treatment accorded him in his declining years, and the hounding of his memory beyond the grave."[70] "The same mind and hand which conceived and fashioned this fountain," the society wrote to Harvey, "also created such preeminent works in sculpture as the statue of Nathan Hale, considered one of the finest statues of its kind in America and standing but a stone's throw from the original location of the Civic Virtue Fountain in City Hall Park; the statue of Stranahan; the spirited quadriga atop the Brooklyn Memorial Arch; his two

superb horse groups . . . all in Prospect Park. . . . Countless other works by this master, of whom America has every reason to be proud, give eloquent testimony of his brilliantly creative genius. . . . In your effort . . . to have the fountain preserved in a dignified setting . . . you are rescuing the work by one of America's greatest sculptors from possibly being relegated to oblivion, after a torrent of undeserved abuse."[71]

The critic for the *Long Island Star-Journal* did not agree. "In defense of its creator, the sculpture society might better urge the storage of *Civic Virtue* in some dark corner or its disposal. At Kew Gardens, it will only invite more criticism."[72] Time has proved the critic wrong. Even in this day when most of our public monuments are filled with graffiti, *Civic Virtue* is surprisingly clean of "tags."

At 11:45 A.M. on March 14, 1941, a committee of three sculptors from the National Sculpture Society, A. A. Weinman, Karl Gruppe, and A. F. Brinckerhoff, met with the borough president in his office to settle the removal and siting of the fountain. The dedication took place on October 7, 1941.[73]

THE MAINE AND FIREMEN'S MEMORIALS

Monuments often have private meaning for the artist who creates them, which is unknown to the public. Such is the case with the *Maine* and *Firemen's* memorials in New York City. Both were designed by Attilio Piccirilli, sculptor, and H. Van Buren Magonigle, architect, in 1913 and both are linked by a Piccirilli portrait, which in turn links them to the Piccirilli family monument in Woodlawn Cemetery.

Like the *Shaw Memorial*, erected to commemorate the entire 54th Regiment of black volunteers in the Civil War, the *National Maine Monument* honors the 258 enlisted men who gave their lives when the *Maine* was sunk in Havana Harbor on February 15, 1898. The monument has come to take on broader meaning, however, symbolizing the emergence of the United States as a world power, and the allegorical sculpture carries that notion. *Columbia Triumphant*, the 15-foot-high bronze group of Columbia in her chariot drawn by plunging sea horses, is supported by a great pylon surrounded at its base by allegorical figures. They symbolize the reign of Peace supported by Courage and Fortitude, ushering in the New Era, and Justice, defended by Wars throughout History. Personifications of the Atlantic and Pacific oceans convey the universal nature of the symbolism.[74]

The *Firemen's Memorial*, as it arrests the view westward along West 100th Street and Riverside Drive, reads as a great sarcophagus, flanked by two sculpture groups, *Sacrifice* and *Duty*. From Riverside Drive the monument is faced with a bronze relief that was originally marble; severe weathering having eroded the relief, it was replicated in bronze during restoration of the monument in 1934. Restored again in 1991, the monument portrays a horse-drawn fire engine and firemen fighting a fire, and is flanked by the same two sculpture groups. On the north face is *Sacrifice*, a woman holding

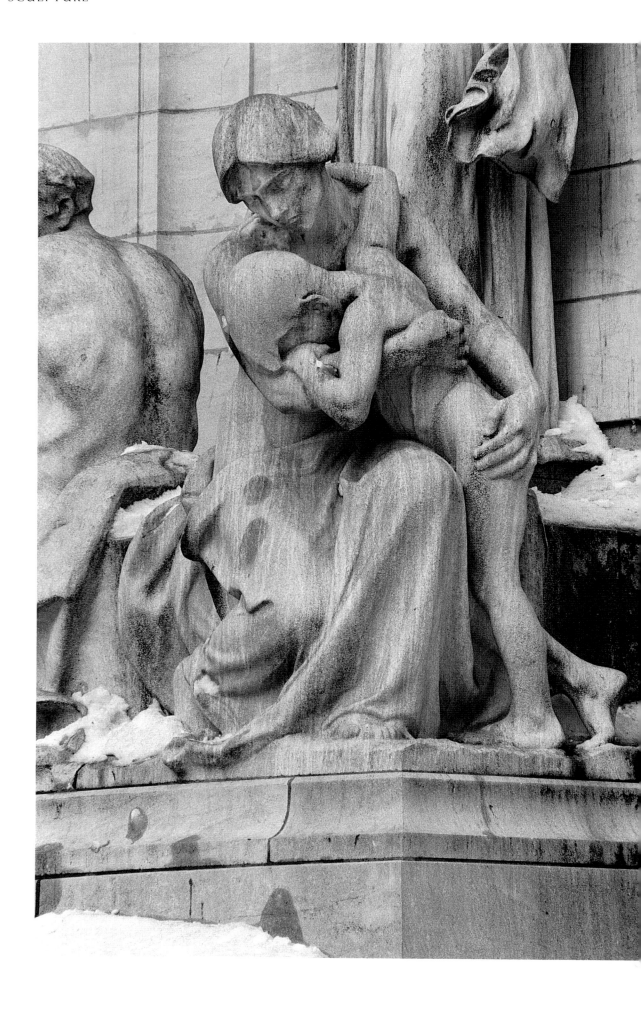

Attilio Piccirilli (1868–1945),
sculptor
H. Van Buren Magonigle
(1867–1935), architect
National Maine Monument
(detail), 1913
Bronze, over lifesize
New York

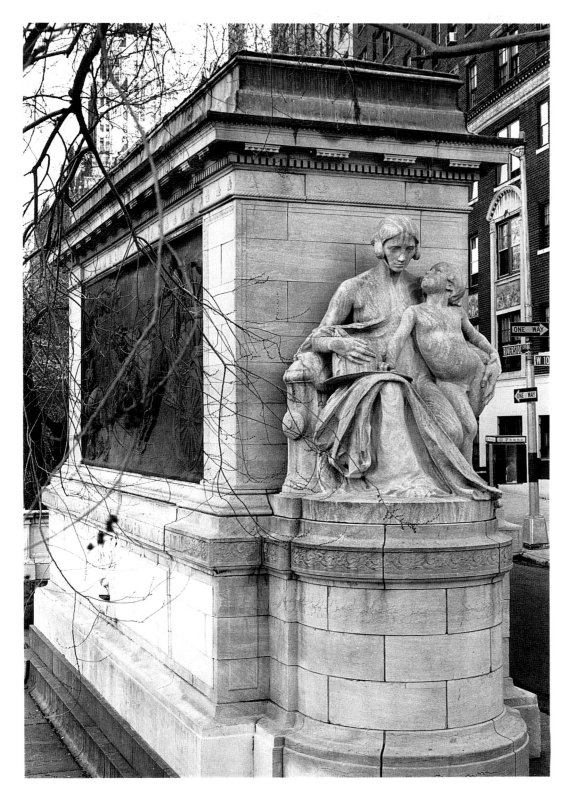

Attilio Piccirilli (1868–1945), sculptor
H. Van Buren Magonigle (1867–1935), architect
Firemen's Memorial (detail of Duty), 1912
Marble and bronze,
19 × 8 ft. (5.8 × 2.4 m)
New York

her dead fireman husband across her lap like a modern pietà. On the south face is *Duty*, the widow holding her dead husband's fire hat on her right knee and with her left arm around her child comforting him as he looks up into her face.

It is no coincidence that the woman and child representing *Duty* in the *Firemen's Memorial* bear a striking resemblance to the mother and child representing *Fortitude* on the *Maine Memorial*. The models were the same, believed

to be members of the sculptor's family. In 1910, as the monuments were underway, Piccirilli's mother died, and the sculptor cast the *Fortitude* group in bronze to become the Piccirilli family monument in Woodlawn Cemetery in New York City, where the monument still stands.[75]

THE BOY SCOUTS MEMORIAL

Many of the same values embodied in the *Maine* and *Firemen's* memorials are nurtured by such youth organizations as the Boy Scouts of America. The scouts are singularly honored in two little-known monuments.

The Boy Scouts of America memorial in Washington, D.C., was authorized by an act of Congress to celebrate the fiftieth anniversary of the organization's founding in 1910. Unveiled on November 7, 1964, it was dedicated to all those in the scouting movement, who serve America's youth. It was designed by sculptor Donald De Lue and architect William Henry Deacy and erected on the site of the first National Boy Scout Jamboree in 1937, at the Ellipse, 15th Street between Constitution Avenue and E Street N.W. Associate Supreme Court Justice Tom Clark accepted the monument for the United States and noted that it was his fiftieth anniversary as an Eagle Scout. He had joined the Scouts soon after the organization was founded in America.[76]

A pair of 12-foot-high allegorical figures, *Manhood* and *Womanhood*, flank an over-lifesize statue of a Boy Scout. *Manhood* is represented by a male figure nude to the waist, *Womanhood* by a draped female figure. The sculpture group stands on a 5½-foot-high granite pedestal that bears the Scout oath on its face. The contributions of Boy Scouts paid for the memorial, according to James Goode. Their names are inscribed on scrolls placed within the pedestal.

On February 8, 1950, the fortieth anniversary of its chartering in the

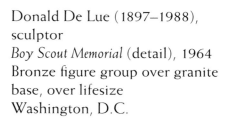

Donald De Lue (1897–1988), sculptor
Boy Scout Memorial (detail), 1964
Bronze figure group over granite base, over lifesize
Washington, D.C.

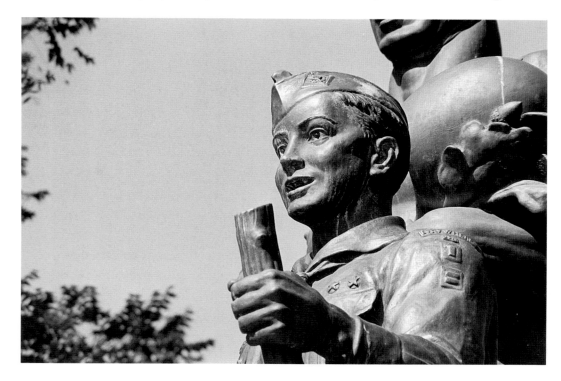

United States, the Boy Scouts of America, desiring "to strengthen the arm of liberty," distributed miniature copper replicas (8 feet 3 inches high) of Frédéric-Auguste Bartholdi's *Statue of Liberty* in New York Harbor to 260 communities throughout the country. In erecting the one in Kansas City, Missouri, on Meyer Boulevard at Prospect Avenue, the city also replicated the general configuration of Richard Morris Hunt's famous base for the statue, and a star-shaped planter repeats the landscaped garden surrounding the *Statue of Liberty* on Liberty Island in New York City.[77]

Another monument in Kansas City honors the Eagle Scouts throughout the nation, recounts Lillie Kelsay. The *Eagle Scout Memorial* on Gilham Road at 39th Street, designed by Kansas City architect Maurice McMullen, was unveiled October 6, 1968. Donated by Mr. and Mrs. John Starr, it consists of a colossal-scale replica of the Eagle Scout badge set within a wreath supported by female personifications of Night and Day on either side and flanked by a pair of American eagles. The sculpture group is set against a raking wall and stagelike platform overlooking a pool and approached by spiral stairs on either side. The whole is formally landscaped against a backdrop of tall trees. Below the fountain is an aluminum plaque describing the Eagle Scout Badge, designed by Adolph A. Weinman.

The sculpture group for the memorial was originally part of the Seventh Avenue entrance of the famous Pennsylvania Railroad Station in New York City, with its distinguished public space reminiscent of the Baths of Diocletian, erected in 1910 and designed by the foremost classical-revival architects in the United States, McKim, Mead & White. The sculpture was donated to Kansas City in the mid-1960s by the Pennsylvania Railroad when the station was razed (1963). In the original installation a clock occupied the center of the wreath, where the Eagle Scout Badge is now set.[78]

Although the destruction of Penn Station was reprehensible, and we can never again experience that peerless monument to transportation and American industry, the nation is blessed to have its relic here enshrined in a monument to the Eagle Scouts of America. Besides its eminence as a fitting tribute to scouting, the monument shines as a small beacon for the preservation of America's architectural and sculptural heritage that is so beautifully embodied in this good deed inspired by the Eagle Scouts of America.

The Boy Scouts of America was chartered on February 8, 1910, and the Girl Scouts was organized on March 17, 1910. The movement had been established in England in 1908 by Lt. Gen. R.S.S. Baden-Powell with the publication of his *Scouting for Boys.* The United States was the twelfth country to adopt scouting.[79] The first national commissioner was artist, author, and woodsman Daniel Carter Beard, whose Sons of Daniel Boone (for whom he was named), an organization he had founded in 1905, was merged with the Boy Scouts in 1910. In recognition of Beard's "leadership in promoting and establishing scouting in the United States," he was given the only golden Eagle Scout Badge ever awarded. He served for many years as associate editor of *Boy's Life,* the Boy Scout magazine. Mount Beard, adjoining Mount McKinley in Alaska, is named for him.[80]

Edward McCartan (1879–1947),
sculptor
Delano & Aldrich, architects
Eugene Field Memorial, 1922
Bronze figures on stone base,
over lifesize
Chicago

TRIBUTE TO CHILDHOOD

One of the most moving tributes to the spirit of childhood is the *Eugene Field Memorial* of 1922 in Chicago's Lincoln Park, by Edward McCartan. It commemorates the late-nineteenth-century Chicago poet and journalist, whose column, "Sharps and Flats," in the *Chicago Morning News* made him nationally known.[81] In his short life, 1850–95, he produced ten volumes of prose and

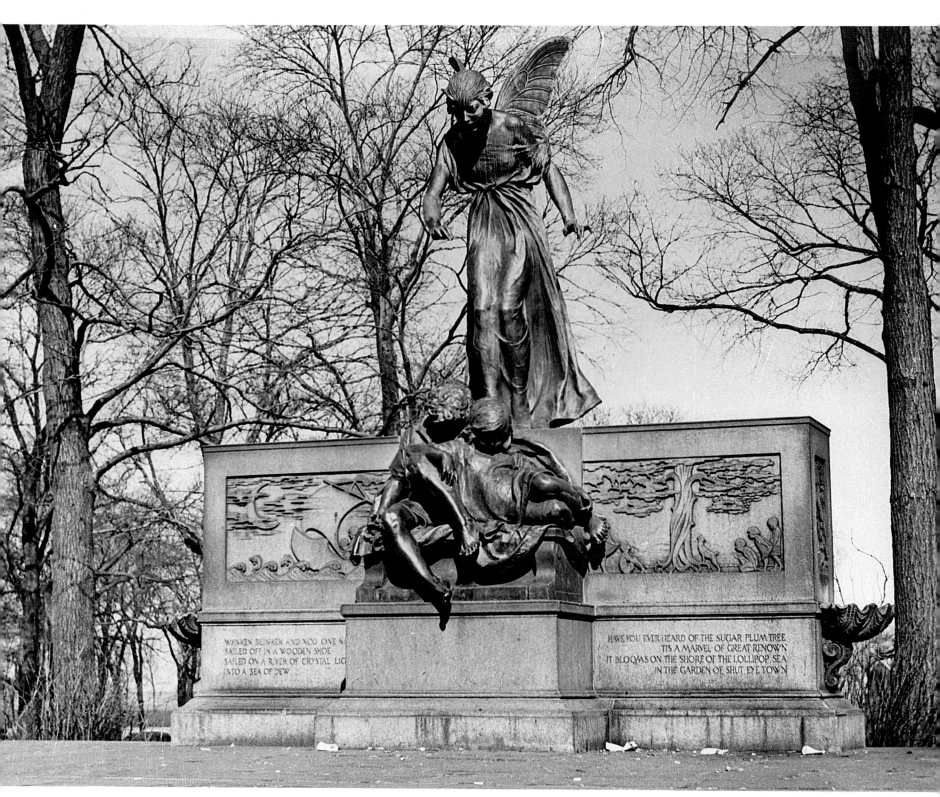

poetry that touched the hearts of every youth in America by the turn of the century. It was only fitting that Field's monument should celebrate his enduring spirit in the words he wrote and the images he created. Edward McCartan has given them sculptural form.

For the central figure, a bronze winged nymph, the "Rock-a-by Lady from Hushaby Street," stands on a broad granite base and looks down on two children sound asleep. In her hands she holds poppies with magical powers that bring children the best of dreams. The granite base, designed by Delano and Aldrich, carries more of Field's images carved by McCartan: *Wynkun, Blynkun, and Nod, The Sugar Plum Tree, Fly Away Home,* and fantasies from *Seein' Things.*[82]

Dedicated in 1922, the *Eugene Field Memorial* was awarded a medal of honor by the Architectural League a year later, but McCartan's sculpture for the New York Central Building in New York City, now the Helmsley Building, with its two monumental figures *Transportation* and *Industry* supporting a great clock overlooking Manhattan's fashionable Park Avenue, are better known images today.

FULFILLMENT IN MONUMENTS

Ever since Neil Estern found modeling the kneaded erasers in painting class more interesting than painting, he has been attracted to sculpture. That was when he was enrolled in Pratt Institute's Saturday morning classes for children. At fifteen he enrolled in the School of Industrial Arts in Manhattan, where he studied with working artists such as the sculptor Frank Eliscu of the National Sculpture Society. There, Estern decided to pursue a fine arts career rather than commercial art, so he went to the Tyler School of Art at Temple University in Philadelphia, where he earned his B.F.A. in 1947.[83]

While Estern has earned a reputation as a successful portraitist, he finds special fulfillment in creating public monuments, because, he says, "you interact at all levels with the history of the country and the people—it's not just aesthetic."[84] His portraits include a generous range of personalities, including entertainers and political notables such as Danny Kaye, Jack Nicholson, President Carter, and J. Edgar Hoover. It is noteworthy that his first public commission was a portrait for a monument: the bust of John F. Kennedy for the Kennedy Memorial in Grand Army Plaza in Brooklyn. It was unveiled in 1965, and other memorial commissions followed. The next year, Estern designed a commemorative plaque for Litchfield Villa in Prospect Park to celebrate the park's centennial. The plaque features the likenesses of the park's designers, Frederick Law Olmsted and Calvert Vaux. He also designed a medal, depicting the park, which was given to the donors for the centennial celebration.

His monument to Fiorello La Guardia began as a commission by the Port Authority of New York for the new terminal and control tower at La Guardia Airport in 1965. It was to be a statue of the "Little Flower," as New York City's mayor from 1934 to 1945 was called because of his first name, but

Neil Estern (b. 1926)
La Guardia Memorial, 1993
Clay to be cast in bronze, 81 in.
(205.7 cm) high
New York

budget cutbacks prevented completion of the monument. Meanwhile, in 1980, Friends of La Guardia, an organization of the mayor's followers, commissioned Estern to execute his design in a 9-inch figure to become their annual award to acknowledge important contributors to New York City.[85] Then, in 1983, Friends of La Guardia Place in Greenwich Village created a park to enhance the street and neighborhood, and they commissioned an over-lifesize version of Estern's portrait for the park, which was completed by the summer of 1992.[86]

"MONUMENTS TO NATURE"

Kent Ullberg was born in the fishing village of Gothenburg, Sweden, and studied art at the Konstfack School of Art in Stockholm. From field trips with his father, a landscape painter and seaman, Ullberg developed an appreciation of nature and an interest in conservation, which found its expression in animal sculpture. He traveled to Germany and France, where he learned taxidermy and prepared museum exhibitions, and then to Africa to see the animals of that vast continent in their natural habitat. He developed a sense for monumental expression and found that the most receptive market for his ideas was the United States, where he has been working since 1974.[87]

Ullberg's "monuments to nature," as they have been called, include *Conservation Fountain* of 1989, at the National Wildlife Federation Headquarters in Washington, D.C.; the Broward County Convention Center *Marine Fountain*, Fort Lauderdale, Florida; and an eagle monument he has proposed for placement in Alaska, to commemorate the tragic losses from the *Exxon Valdez* disaster at Prince William Sound.[88]

Conservation Fountain features a pair of whooping cranes in different stages of landing in the basin of the fountain beneath. A sailfish, 150 feet long by 36 feet high, is the centerpiece for the Fort Lauderdale fountain, and a great American eagle will soar above the Alaska shoreline, if Ullberg's dream is realized at Prince William Sound.[89]

CHAPTER FOUR

HIGHLIGHTS OF THE EQUESTRIAN MONUMENT IN AMERICA

The tradition of the equestrian monument in America has a venerable history, which Wayne Craven has traced back to the English sculptor Joseph Wilton's 1770 lead statue of George III in New York City, destroyed by patriots during the American Revolution to make lead shot for ammunition against the British.[1]

THE EMERGENCE OF A TRADITION

America produced four major equestrian monuments in the 1850s and 1860s that influenced the genre well into the twentieth century. These include Clark Mills's monument to Andrew Jackson in Washington, D.C., of 1848–52, and three monuments to George Washington: Henry Kirke Brown's of 1853–56, in New York City; Thomas Crawford's of 1843–57, in Richmond, Virginia; and Thomas Ball's of 1858–61, in Boston.

While Clark Mills borrowed from Gianlorenzo Bernini's rearing horse of Constantine in the Vatican of 1654, and from Etienne-Maurice Falconet's colossal statue of Peter the Great at Leningrad of 1766–82, Thomas Crawford's combination of contemporary dress for Washington and the uncertain rearing gesture of his horse seem to reject historical precedents in an effort to be true to nature, but with results that have consistently mystified critics. Thomas Ball and Henry Kirke Brown, however, perpetuated the classical tradition, whose roots are found in the ancient monument to Marcus Aurelius of A.D. 161–180 in Rome.

The influence of the *Marcus Aurelius* has been most widespread. Revived during the Renaissance by Donatello with his famous *Monument to Gattamelata* of 1445–50 in Padua, and the *Monument to Colleoni* of c. 1483–88 by Andrea del Verrocchio in Venice, it took on a Neoclassical calm with Franz Anton Zauner's *Monument to Emperor Joseph II,* 1795–1806, in Vienna, and a Romantic verve in the *Monument to Frederick the Great* in East Berlin, conceived by Johann Gottfried Schadow in 1836, but executed by his gifted follower Christian

OPPOSITE PAGE
Augustus Saint-Gaudens
(1848–1907), sculptor
McKim, Mead & White,
architects
*General William Tecumseh Sherman
Monument,* 1897–1903
Bronze, over lifesize
Grand Army Plaza, New York

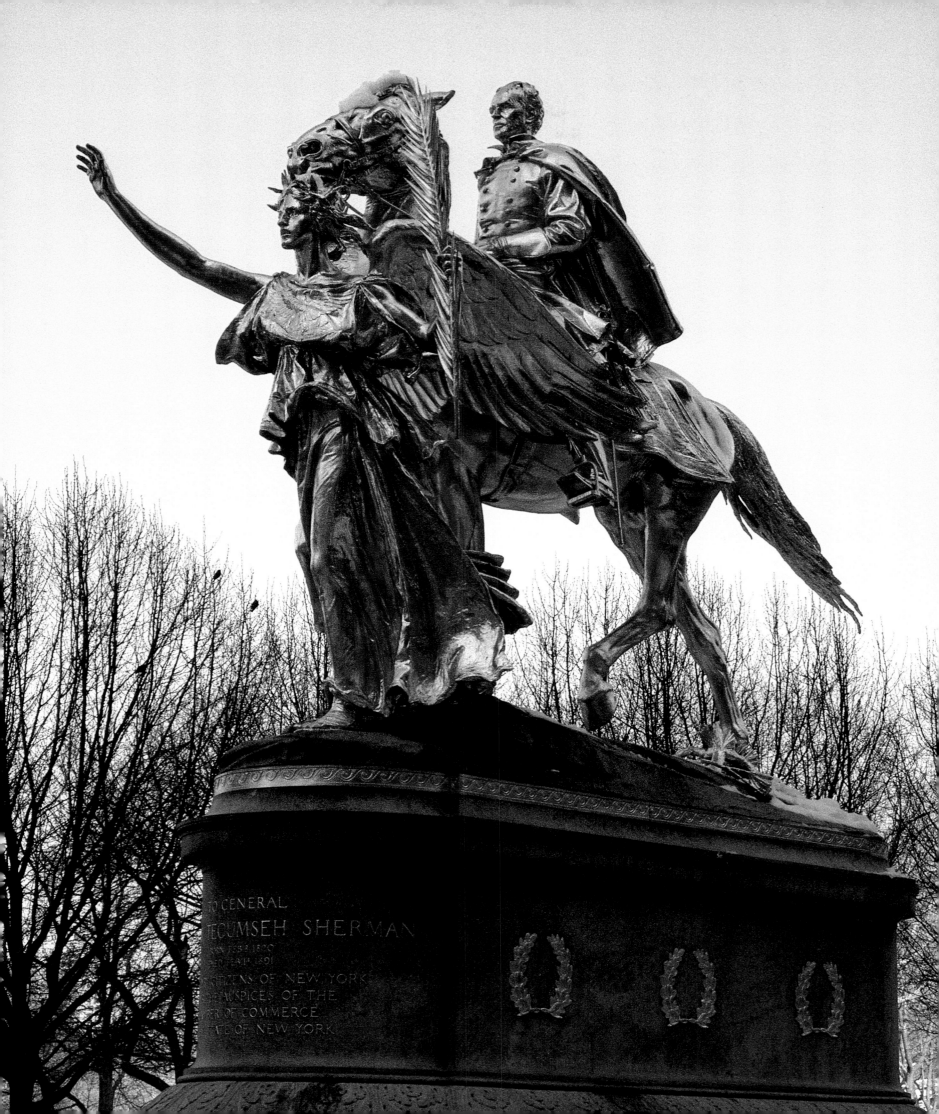

Rauch in 1851.[2] Schadow broke with the Neoclassical preference for ancient attire and chose to portray Frederick in modern dress, while retaining the regal composition of the horse that was epitomized in the power of Marcus Aurelius's ancient steed. This balance of the regal bearing of the animal and the immediacy of the contemporary portrait is what the nineteenth-century Americans sought and achieved with varying degrees of success in New York City and Boston. The Richmond monument remains in a class by itself with its questionable pedigree and awkward union of horse and rider.

VEHICLE FOR SENTIMENT AND CHARACTER

America's masters have recognized the capacity of the equestrian monument for expressing a wide range of human feelings. One of the most moving equestrian monuments to George Washington, for the mood it captures, is *Washington at Valley Forge* of 1906, at the foot of the Williamsburg Bridge in Brooklyn, New York. Washington's horse stands stark still, head and tail down. Washington's gaze is also downward, and he is swathed in a great cloak, its limp vertical folds emphasizing gravity's earthward pull. Here the sculptor, Henry Merwin Shrady, has organized the equestrian monument through sensitive modeling and composition of the vertical and horizontal components of horse and rider to convey the mood of hopelessness that gripped Washington's troops during that historic winter of 1777–78 in Chester County, Pennsylvania.[3]

The power of Shrady's monument moved the citizens of Kansas City, Missouri, to commission a replica, which stands in picturesque Washington Square Park in Kansas City. The contributions of 190,000 citizens paid for the replication and installation in 1925, when it was unveiled on November 11, Armistice Day, celebrating the end of World War I (called Veterans Day since 1954). On Armistice Day, 1932, the 200th anniversary year of George Washington's birth, the monument was re-dedicated.[4]

Little wonder that the country's three most important equestrian monuments to Ulysses S. Grant portray him not charging into battle or parading with saber aloft, but as contemplative and determined, the two traits that characterize the Civil War battlefield general as strategist and tactician and the compassionate victor when the war was over.

At his capture of Fort Donelson in western Tennessee, the northern boundary of Confederate control, Grant's famous ultimatum "No terms except an unconditional and immediate surrender . . ." presaged his dogged determination that turned the tide at Petersburg at the end of the war, when he vowed to "fight it out on this line if it takes all summer."[5] Yet, when the war was over, he urged compassion toward the South and retained close ties with some of those he defeated. In fact, Confederate generals Simon Buckner and Joseph Johnston were pallbearers at his funeral. Buckner, a classmate of Grant's at West Point, had been the officer who surrendered to Grant at Fort Donelson.[6]

In his monument to U. S. Grant of 1896, in Brooklyn, William Ordway Partridge captures the Union commander's informal, almost casual, manner,

which masked his celebrated traits of tenacity and determination. Partridge achieves his conflation of seeming opposites through the juxtaposition of contrasting moods captured by adroitly managing the vertical and horizontal components of horse and rider. Grant's bulky figure and rumpled clothing belie a deceptively dispassionate personality expressed in Partridge's soft and generalized modeling of the figure and clothing, which acts as a foil to the sharp, linear modeling of the general's horse, in which minute details of anatomy and accessories are clearly defined. In contrast to Grant, the horse is animated. Tail extended, he holds his head high with nostrils flared and ears cupped forward, responsive to every sound and smell.[7]

The monument is appropriately sited in Grant Square across from the former Union League Headquarters, whose façade bears a pair of terra-cotta relief portraits of Grant and Abraham Lincoln.

Henry Merwin Shrady's mount for his monument to General Grant in Washington, D.C., located at the east end of the Mall and completed in 1922, shares with Partridge's its animation. Shrady's portrait of Grant is intense, and he relied for its likeness on Grant's life mask in the Smithsonian Institution, as well as on the observations of his father, Dr. George Shrady, who treated Grant during his final illness, and on Grant's eldest son, General Frederick Dent Grant.[8]

In the contemplation it inspires, the monument is reminiscent of the sculptor's equestrian portrait of *Washington at Valley Forge* in Brooklyn. His memorial to Grant, however, includes two massive sculpture groups of military figures 252 feet wide and 71 feet deep, flanking the equestrian portrait, remarkably dramatic in its scale and expression. Congress appropriated $250,000 for the monument, which made it the nation's largest congressional commission for a figural monument up to that time, James Goode has noted. When Shrady, a little-known thirty-one-year-old sculptor, won the commission in 1902, many of the nation's well-known sculptors challenged the judgment of the jury in awarding such a historic commission to an unknown artist, even though the jury included such prestigious judges as Augustus Saint-Gaudens and Daniel Chester French. French's monument to Grant in Philadelphia is one of that sculptor's most revered equestrian monuments, and it is to his credit that he stood firm in his support of Shrady's design.

In 1892, the Fairmount Park Art Association selected Daniel Chester French and his former student Edward Clark Potter, who specialized in animals, to create Philadelphia's monument to Grant. Not only had French an international reputation but he was also one of the major sculptors for the famous Columbian Exposition in Chicago. Besides designing the monumental gilded figure of the *Republic*, the centerpiece for the Court of Honor there, he had also collaborated with Potter on four major equestrian and figure groups for the fair.[9]

While the Philadelphia Grant displays neither the conviction of Partridge's down-to-earth and rumpled Grant in Brooklyn, nor the drama of Shrady's Grant, flanked by engaged troops, it is a worthy tribute to a national hero and was the center of a great spectacle at its unveiling. French set out to

Daniel Chester French
(1850–1931) and E. C. Potter
(1857–1923)
Ulysses S. Grant Memorial, 1897
Bronze on stone pedestal,
over lifesize
East River Drive, Philadelphia

show Grant surveying his troops in battle and to capture "the latent force of the man" in his "character and stillness."[10] The monument's greatest strength lies in its portrait of Grant, which was apparently based upon a wide array of photographs of the general that French had at his disposal. French produced perhaps one of the most convincing portraits in all of American sculpture; certainly, the finest he had ever created in a long and productive career. The high collar and broad-brimmed hat permit us to see only the face, an ingenious device in itself that eliminates distracting information and focuses our attention only on the most expressive aspects of any portrait: the eyes and the mouth. Even today, as we view the disintegrating surfaces of the

bronze and lament its destruction through reprehensible neglect, we are still struck by the power of Grant's character, which French presents to us. French has captured Grant's straightforward gaze through subtle manipulation of the fleshy passages around the eyes and beneath the finely knit brows, which pull slightly downward in a barely perceptible squint. The rolled collar of Grant's great cape cushions his square-set jaw, and his lips are thin and silent beneath his closely cropped beard.

French's fastidious attention to every detail of Grant's clothing and to the horse's gear enhances the portrait's presence and immediacy. That sense of focus, so successful in Grant's portrait, however, deserts the sculptor in his obsession with Grant's cape. Its excessive bulk encumbers the general's figure and its overall mass overwhelms an already bedraggled horse. Moreover, the collar, which succeeds in framing the portrait, does not compose favorably in silhouette except from the back. From almost any other angle, it is just too close in its resemblance to the vampires' capes of Transylvania to be taken seriously. Notwithstanding this unfortunate flaw, the monument is a notable tribute to one of the nation's heroes in its most critical historical moment, and it is justifiably a favorite with Philadelphians and all Americans who know it.

Due to delays in the construction of the monument's base, the statue was not in place until May 1898.[11] Because the country was then at war with Spain, the unveiling was postponed until after the war, so the Pennsylvania troops could participate. The unveiling took place on what would have been Grant's seventy-seventh birthday, April 27, 1899, and the event was both a tribute to the general and a victory celebration for the country's triumph in the Spanish-American War.

LOGAN: HERO AND SPOKESMAN FOR HIS PEERS

One of America's grandest equestrian monuments that embodies the classical tradition is the monument to John A. Logan in Washington, D.C., of 1901 by Franklin Simmons, an American expatriate sculptor who worked in Rome for most of his career.[12] It was the last of Simmons's major commissions and one of his many Civil War monuments. The first one he produced, in 1865, is a monument in Acorn Cemetery, Rockland, Maine, to General Hiram G. Perry, killed in the battle of Chancellorsville. When the Logan monument was unveiled in his studio in Rome, the king and queen of Italy attended, and honored Simmons with knighthood.[13]

Born in Maine, Simmons received early training from the Maine sculptor John Adams Jackson, and he soon became proficient in portraiture. Simmons moved to Washington, D.C., Wayne Craven notes, to have access to government commissions and he did portraits of many of the nation's leaders, including William Henry Seward, General U. S. Grant, and Admiral David Glasgow Farragut. But it was his first statue of Rhode Island's famous colonial divine, Roger Williams, for the Capitol's Statuary Hall, which earned Simmons a national reputation when it was unveiled in 1866. He moved to Rome in 1867, where he remained for the rest of his life.

The *John A. Logan Monument* honors Logan both as a hero of the Civil War and a dedicated legislator in time of peace. In a larger sense, the monument celebrates the preservation of the Union through the Civil War and the promise of a "new birth of freedom" for the nation through its exercise of the democratic process.[14]

Logan distinguished himself as a volunteer and officer during the Civil War and as a political force for veterans' causes afterward. He organized the Grand Army of the Republic and the Society of the Army of the Tennessee, veterans groups of enormous prestige and influence, and he was one of the founders of Memorial Day, May 30, 1868, which at first honored Civil War veterans and now honors veterans of all wars.[15]

Simmons has divided his monument into two parts, the equestrian portrait statue and its rectangular pedestal bearing narrative and allegorical figures. The pedestal resembles a classical loggia with four massive fluted piers supporting an entablature. The loggia becomes a stage for the two narratives enacted on the east and west flanks of the pedestal, depicting scenes from Logan's life—one in war, the other in peace. On the west, General Logan presides over a council of war with his officers. The figures, each one a convincing portrait, fill the loggia as they examine a map probably of Vicksburg unfurled over the table. They stand in varying postures, some almost casual and coming forward as if to share the spectator's space, while others recede into the background. The figures in the east panel are equally naturalistic. Logan receives the senatorial oath of office in 1879 from Vice President Chester A. Arthur, in the old United States Senate Chamber. The anachronism (Arthur did not become Vice President until 1881) was due to Logan's widow, who chose to portray famous figures during her husband's lifetime with little regard for chronological accuracy.[16] True to life in their modeling, composition, and gestures, these scenes, which appear to be *tableaux vivants* enacted in the open loggia beneath the equestrian portrait above, create a remarkable immediacy, as if the spectator is actually present at these events when they happened.

Allegorical figures of War and Peace stand at the north and south of the pedestal, guardians of the drama taking place within the loggia, while American eagles, symbols of the Republic, perch vigilantly above the fluted piers at the four corners of the architrave.

Above this drama of war and peace, Logan proudly sits his elegant Thoroughbred. In uniform and pointing his drawn saber downward, he looks forward and slightly to the right, as if surveying his troops in the field. Simmons lets us catch this glimpse of the general by freezing the horse's downward step of his right front hoof in midstride and enlivens the composition by allowing a slight breeze to catch Logan's famous long mustaches and blow them against his collar.

Simmons's composition of horse and rider is most immediately indebted to Rauch's *Monument to Frederick the Great* and Zauner's *Monument to Emperor Joseph III*, both of which had their origins ultimately in the ancient monument to Marcus Aurelius.

THE "BRONZE JOKE," A MONUMENT COMPROMISED

In spite of the monument's limitations, or perhaps because of them, General William Tecumseh Sherman is well served in the monument to the hero of Atlanta by Carl Rohl-Smith in Washington, D.C., completed in 1903, three years after the sculptor's death. Covering 3,000 square feet, the 48-foot-high monument commands a gradually rolling rise overlooking the landscaped setting where 15th Street and Pennsylvania Avenue intersect. The southern façade of the Treasury Building, with its screen of classical columns, is a fitting backdrop to the elaborate and imposing Beaux-Arts monument honoring the life and perpetuating the memory of the Civil War hero who had died in 1891, five years before the monument was commissioned.

General Sherman sits astride his horse and gazes into the distance. A field glass in his right hand, he holds the reins in his left. The gallant stallion stands at rest, tossing his head to the right and flexing his tail. Except for these gestures, the 17½-foot-high equestrian portrait is calm. The paired portraits of Sherman and his horse stand 30 feet in the air on a rectangular stone pedestal rising from a broad stepped terrace. The slender pedestal is

Carl Rohl-Smith (1848–1900)
General William Tecumseh Sherman Monument, 1901
Bronze equestrian statue on granite base, over lifesize
Washington, D.C.

faced with sculpture groups and reliefs, which animate the monument and relate key events of Sherman's campaigns. "William Tecumseh Sherman" is identified in tall letters carved into the north face of the pedestal, and his battles are picked out in colorful tesserae, which surround the base of the monument in a 6-foot-wide mosaic.

At the four corners of the terrace stand lifesize bronze figures of Civil War soldiers representing the Infantry, Artillery, Cavalry, and Engineers. Each one stands on a plain pedestal echoing in miniature Sherman's elaborate and colossal pedestal in the center. The low walls that support the stairs approaching the terrace curve around the statues as if to enshrine them in niches, as icons of all the Union soldiers who fought in the Civil War. The four figures in Rohl-Smith's winning design consisted of an artilleryman, a cavalryman, a soldier with a flag, and a woman adorning Sherman's sword. Why the last two statues were replaced by the Infantry and the Engineers, although a logical change, is undocumented.[17]

Narrative and Symbol

Flanking the pedestal are bronze groups representing War (west) and Peace (east). Peace is portrayed by a woman holding an olive branch, surrounded by three children, the group representing the hope of the future in a world of peace. War is personified by a woman whose hands are bound, as vultures prey on the dead body of a soldier beneath her, symbols of how war shackles the body and the spirit.[18]

Four panels in low relief narrate pivotal events in Sherman's role in the Civil War—the *March through Georgia*, the *Battle of Atlanta*, *Sherman Planning While the Army Sleeps*, and the *Battle of Missionary Ridge*. The panels are remarkable for their genrelike style, the amount of information they convey, and for their clarity of detail. In the *Battle of Atlanta*, for example, Loggett Hill and its wooded terrain, where the Confederate lines were repulsed by Sherman's 16th Corps, are accurately and fully depicted, and the figures and equipment involved in the engagement are a tour de force of composition and modeling. Moreover, the power of grief is captured as General McPherson, one of the casualties of the battle, is shown being carried to the porch of the Howard House. Action is telescoped in the *Battle of Missionary Ridge*, with Sherman in the foreground directing the attack at dawn. He moves his troops toward the ridge in the background, where General Corse, with his troops, gains the crest of the ridge. Portrait medallions of Sherman's key officers flank the reliefs, and include John A. Logan of Illinois, Francis Preston Blair of Kentucky, Edward G. Ransom of Vermont, Grenville M. Dodge of Massachusetts, Andrew J. Smith of Pennsylvania, and James B. McPherson of Ohio.[19]

Rohl-Smith's Figure

Rohl-Smith's naturalism and genrelike treatment of his figures may have their origins in the works of his teacher, H. V. Bissen, notably *Soldiers Burying Their*

OPPOSITE PAGE
Carl Rohl-Smith (1848–1900)
General William Tecumseh Sherman Monument: Infantryman (TOP LEFT), Peace (TOP RIGHT), War (BOTTOM LEFT), and Sherman (BOTTOM RIGHT), 1901
Bronze equestrian statue on granite base, over lifesize
Washington, D.C.

Carl Rohl-Smith (1848–1900)
General William Tecumseh Sherman Monument (detail), 1901
Bronze equestrian statue on granite base, over lifesize
Washington, D.C.

Dead, in Fredericia, Denmark (1851 or 1864), and his well-known marble statue of the famous Danish Neoclassical sculptor Bertel Thorwaldsen, of 1819, in Copenhagen (a bronze replica stands in New York City's Central Park, which the Parks Department incorrectly calls a self-portrait). In their modeling, composition, and gesture, Rohl-Smith's figures may be compared, as the works of his teacher have been, to the genre groups of the American sculptor John Rogers, and affinities with the laborers of the nineteenth-century realist sculptors Vincenzo Vela, Constantin Meunier, and Jules Dalou are equally striking in their spontaneous modeling of naturalistic stance and gesture.[20]

Carl Rohl-Smith grew up in Denmark and attended Copenhagen Academy from 1865 to 1870, where he studied three years with the distinguished Danish sculptor Herman Vilhelm Bissen. Well grounded in the Beaux-Arts tradition, Rohl-Smith worked in Berlin from 1875 to 1877 and in Vienna from 1877 to 1881, then returned to Copenhagen Academy as professor of sculpture and taught at the academy for five years. He settled in the United States in 1886, and remained there until 1900, when he returned to Copenhagen, where he died at the age of fifty-two. In the United States, he worked primarily in New York, Chicago, and Washington, D.C., and distinguished himself for his portraits and memorials.[21]

Posthumous Completion

Because Rohl-Smith died before the Sherman monument was completed, his wife, Sara, oversaw its completion along with sculptor Lauritz Jensen, who finished the equestrian portrait of Sherman and the horse.[22] Jensen, like Rohl-Smith, studied in Copenhagen, and while he did genre figures, he was primarily an *animalier*, or animal sculptor, specializing in equestrian statuettes of Danish royalty.[23] In completing the soldiers at the four corners of the terrace, Sigvald Asbjornsen faithfully caught Rohl-Smith's straightforward naturalism, but gave the figures distinctly Scandinavian features, so they appear to be portraits. The bony and gnarled features of the Infantryman, in the way he stands resting his hands on his rifle, recalls Jean-François Millet's peasants toiling in the field.

The Norwegian sculptor Stephen Sinding executed War and Peace in a naturalistic style reflecting the tradition of the German masters of the nineteenth century. He was no doubt influenced by his teacher in Berlin, Karl Konrad Albert Wolff. Wolff had been a pupil of Christian Rauch, whose *Monument to Frederick the Great*, 1836–51, was universally known through countless reduced replicas and was even a model for the Washington Monument in Richmond, Virginia.[24]

The accomplished allegorical and equestrian sculptor Thea Alice Ruggles Kitson executed the reliefs. From Brookline, Massachusetts, she studied with Dagnan Bouveret in Paris and with the English sculptor Henry Hudson Kitson, whom she married. Thoroughly grounded in the Beaux-Arts tradition, she won awards at the Salon des Artistes Français (1899) and the St. Louis World's Fair (1904).[25]

The Original Design

The restrained classical style of the Sherman monument as it stands today bears little resemblance to Rohl-Smith's original Baroque conception, which is known from a published sketch by artist F. C. Clarke in 1896.[26] In Rohl-Smith's original design, Sherman sat a close saddle just as his horse reached the rise, where the general suddenly reined him in to survey the field. In fact, that site was chosen for the monument because Sherman was reported to have reviewed his troops from there in 1865.[27] Rohl-Smith caught horse and rider at the moment of halt—the horse's wide-spreading switch tail straight out, his neck arched with head down and pulled to the right, straining against Sherman's tight reins. A gust of wind catches the horse's mane. His right rear hoof is stopped in the middle of a stride, while the left paws the air. With rump retreating and withers high, the horse's distended flanks and strained thighs capture the tension of suddenly interrupted forward action. Precariously perched atop a rocky hillock, the mounted Sherman looks sharply to the left, raising his right arm with hat in hand in a broad wave as if signaling to his troops. Writhing figures of peace and war cling to the craggy surfaces below.

The animated equestrian group, jagged hillock, and tormented allegorical figures were to be cast in bronze and supported by a two-tiered granite pedestal resting upon a classically stepped base. That simple support, devoid of all ornament, would serve to lift the equestrian group high off the ground, like a colossal *tableau vivant*, perpetuated in bronze for all to see from near and far and all around. The only distraction was to be a pair of simple tablets on the flanks of the pedestal identifying the Society of the Army of the Tennessee as the patron of the monument.

Turnabout

At a time when the restrained classical style was preferred, Rohl-Smith's Baroque design, which subordinated architectural components and ornament to the dynamic and expressive sculpture group, was a bold step off the beaten path. On the other hand, it looked back to such early nineteenth-century monuments as Carlo Marochetti's *Monument to Emanuele Filiberto* of 1838, in Piazza San Carlo in Turin, and, on the other hand, it anticipated Augustus Saint-Gaudens's *Sherman Monument*, which was acclaimed in Paris in 1899 and unveiled in New York City in 1903, the same year Rohl-Smith's monument was completed in Washington, D.C. Why Rohl-Smith made such a courageous effort only to change his design so completely, conforming it to the more restrained vogue, may be explained by circumstances surrounding the way in which the sculptor was chosen for the commission.

THE COMMITTEE AND THE EXPERTS

Congress appropriated $50,000 for a monument to perpetuate the memory of William Tecumseh Sherman, and the Society of the Army of the

Tennessee, named for Sherman's army and founded to honor the Civil War hero, raised another $40,000.[28] At that time in American art, it was customary to award commissions on the basis of personal friendship rather than on artistic merit. One of the objectives of the National Sculpture Society was to change that practice. Because sculptors considered the Sherman monument the most important yet to be erected in the nation's capital, they were pleased when they learned the commission was to be awarded in an open competition.

A committee was authorized by Secretary of War Daniel S. Lamont and General Nelson A. Miles, U.S. Army, to invite plans and to select the one that "in their judgment was the best."[29] The monument committee was composed of six distinguished military figures headed by General G. M. Dodge. They approached the National Sculpture Society to assist them in setting up the competition and announcing it. In January, 1896, four of the most important sculptors in the nation and two of the country's leading architects donated their time to go to Washington and judge the entries. The sculptors were J.Q.A. Ward, the first president of the National Sculpture Society and one of its founders; Augustus Saint-Gaudens, one of the best sculptors the nation has ever produced; Daniel Chester French, not only an outstanding sculptor but also a guiding force in the art world of his time; and Olin Warner, an equally important spirit among American contemporary sculptors. The architects, Bruce Price and George B. Post, had not only the respect of sculptors but also of the nation's leaders in commerce, industry, and government as well. Such a blue ribbon panel would certainly assure the nation that it would get the best.

The panel selected the designs of Paul Bartlett, Charles Niehaus, William Ordway Partridge, and H. K. Bush-Brown. Because designs of the last two could not be executed within their budgets, the panel disqualified them, selecting, therefore, only two winners. The panel suggested that Bartlett and Niehaus be requested to make more developed models for a second competition, and they expected to be invited back to judge them.

The panel had considered Bartlett's design so superior to the others that upon their return to New York City, Ward and Warner wrote to Bartlett, who had his studio in Paris, and urged him to come to America to prepare a revised model and proposal. Bartlett came and spent three months in New York City working on his revised model. This episode raises a question about the impartiality of the judges, a point that was not raised publicly at the time, but this certainly could not have set well with Dodge and his committee. Dodge's committee, therefore, rejected the experts' selections and awarded the commission to Rohl-Smith, who was a friend of Dodge and whose portrait he had made.

Why Rohl-Smith revised his design in line with the more classical entries of Bartlett and Niehaus is unclear. The design change could not have assuaged the offended judges or the irate members of the National Sculpture Society. Perhaps Dodge's committee, through some twisted sense of logic, tried to demonstrate respect for the aesthetics of the panel of experts.

THE IMPLICATIONS OF THE DECEIT

The Dodge Committee, in their mandate, were not required to seek outside counsel in selecting a sculptor for the design. They acted in bad faith, however, when they "slighted the National Sculpture Society after soliciting its advice and assistance to select the most skillful artist for the work," the *New York Evening Sun* correctly observed.[30] Moreover, many artists entered the competition because of the trust they had in the art experts. Critics, therefore, noted that such a miscarriage of fairness in the Sherman competition would, no doubt, deter aspirants in future competitions to provide art for the nation's capital. The press found no fault with the panel of experts in its initial dealings with the Dodge Committee.

The *New York Times*, labeling Rohl-Smith's design a "jumble of things stuck together" and a "Bronze Joke," condemned the Dodge Committee's action and called for a permanent art commission to pass on all art for the nation's capital, which would prevent such abuses as the Dodge Committee had perpetrated.[31]

While the completed monument in its restrained classical form was not the work Rohl-Smith would have preferred to create, it is a worthy one, nonetheless, designed by an experienced and gifted sculptor particularly skilled in capturing the humanity of his subjects. The sculptors who completed Rohl-Smith's design had their own strengths and personal styles, which are compatible in their diversity and which contribute to the power and the commanding presence of the *Sherman Monument* as it stands in front of the Treasury Building in Washington, D.C.

SAINT-GAUDENS'S SHERMAN

The *Sherman Monument* in New York City by Augustus Saint-Gaudens suffers from none of the limitations of the Rohl-Smith *Sherman*. It is America's most successful equestrian monument from the standpoint of conception, design, and execution, and it is one of Saint-Gaudens's finest works.[32] Saint-Gaudens, America's leading sculptor at the time, was commissioned to make the monument in 1892, the year following Sherman's death. It was a long time in execution and was not unveiled until 1903, the same year Rohl-Smith's *Sherman* was completed. In the process, however, its plaster model earned unbridled praise at the Salon in Paris in 1899, and the monument attracted widespread recognition even before its completion.

As in Rohl-Smith's original design, which was never executed, in Saint-Gaudens's design the architecture was subordinated to the equestrian group. Saint-Gaudens, however, went beyond the *tableau vivant* raised up on a simple base and created a timeless image whose blend of symbolism and naturalism has meaning for all ages.

Saint-Gaudens portrays Sherman on his March through Georgia in 1864, led by a winged figure of Victory. By incorporating three principal figures in his composition Saint-Gaudens succeeded in achieving colossal scale

in the sculpture group while the figures of Sherman, Victory, and the horse, at their elevated level, had the appearance of human scale. The device goes back to ancient Roman times and had been revived by Rheinhold Begas for his *Monument to Emperor Wilhelm I*, 1892–97, H. W. Janson has noted.[33] To enhance its naturalism and consequently its immediacy to the spectator, Saint-Gaudens used the portrait bust of Sherman he had modeled in 1888, and the face and figure of Victory were conflations of several models he had used for his famous *Diana* for the top of Madison Square Garden and the equally well known *Amor Caritas.* Sherman's horse was also a portrait. While

RIGHT
Augustus Saint-Gaudens
(1848–1907), sculptor
McKim, Mead & White,
architects
*General William Tecumseh
Sherman Monument* (detail of
Victory), 1897–1903
Bronze, over lifesize
Grand Army Plaza, New York

OPPOSITE PAGE
Augustus Saint-Gaudens
(1848–1907), sculptor
McKim, Mead & White,
architects
*General William Tecumseh
Sherman Monument*, 1897–1903
Bronze, over lifesize
Grand Army Plaza, New York

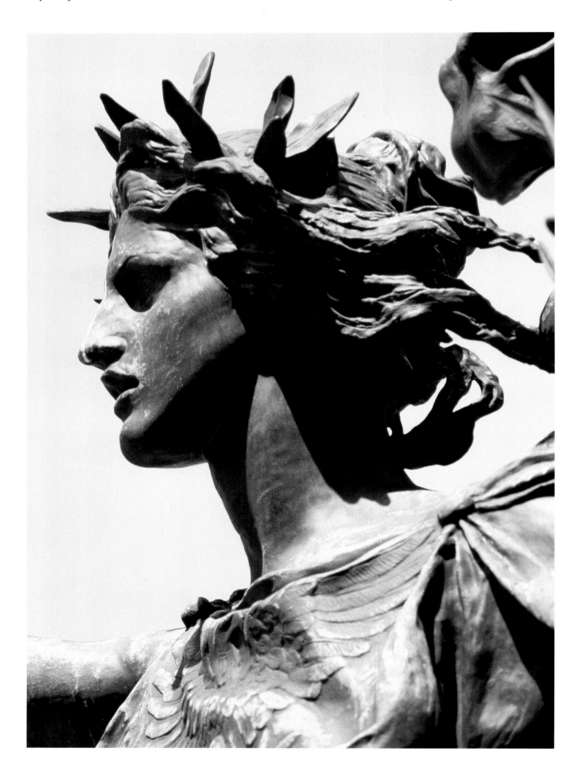

he used several different models to study gait and general movement, for the elegant proportions and magnificent musculature of Sherman's bronze mount, Saint-Gaudens relied on the famous Thoroughbred jumper Ontario. For the portrait of Ontario Saint-Gaudens was assisted by Alexander Phimister Proctor, the well-known animal sculptor.

Victory leads Sherman's steed along a slightly inclined rocky plane, strewn with fronds of palm, symbol of death, and she carries a palm extended in her left hand as an advanced guard would carry the colors. The pedestal in the shape of a great sarcophagus is carved of the same granite as the rocky incline above. The surface of the base is polished, however, distinguishing it from the rough finish of the rocky terrain it supports. Three bronze wreaths affixed to the east and west faces of the base celebrate the practice of laying wreaths at funerary sites, a custom that has prehistoric origins and that continues today.

The entire ensemble of equestrian group and sarcophagus rests on a broad stepped terrace set within a landscaped site facing the Pulitzer Fountain in front of the Plaza Hotel at Grand Army Plaza. The southeast entrance to Central Park is the backdrop for the *Sherman Monument*. Fountain and monument together were originally united by landscape and a surround of trees, which created an island retreat verdured from the passing parade. The statue was originally gilded. Its re-gilding in 1990 has correctly been criticized for its lack of modeling, which prevents the monument from being seen properly.

Saint-Gaudens's Feminine Ideal

The enigmatic and sensuous female that Saint-Gaudens created recurs throughout his works—*Diana*, which stood atop Madison Square Garden, Victory in the *Sherman Monument, Amor Caritas*, and the seated figure in the *Adams Memorial*.[34] She became the hallmark of Saint-Gaudens's ideal of female beauty: long neck, fullsome chin and lips, long nose, high cheekbones, and broad brow, combined often with an air of brooding introspection. This unique expression of the ideal he drew from various models at different times. They include Davida Clark, his mistress; Julia ("Duddie") Baird, a well-known model for many artists; Alice Butler, whom Saint-Gaudens discovered in Windsor, Vermont; and Elizabeth Cameron, a niece of General Sherman, whose beauty Rodin also found irresistible. The female type that Saint-Gaudens created recalls the Pre-Raphaelites' women, as John Dryfhout has observed, who were based primarily on Elizabeth ("Lizzie") Siddal, wife of the painter and poet Dante Gabriel Rossetti, and Jane Burden, wife of William Morris, artist and animating spirit of the Arts and Crafts Movement.

Even in Saint-Gaudens's less successful works, such as his little-known *Garfield Monument* in Philadelphia, the sculptor's distinctive female type captivates the spectator.[35] Immediately after Garfield's assassination in 1881, the Fairmount Park Association set about raising funds to erect a monument to the twentieth President of the United States to be placed in the park, and Saint-Gaudens was selected as the sculptor, although he did not get a contract

OPPOSITE LEFT
Augustus Saint-Gaudens
(1848–1907)
Amor Caritas, 1898; cast for the museum, 1918
Gilded bronze, 102½ × 48 in.
(260.4 x 121.9 cm)
The Metropolitan Museum
of Art, New York

OPPOSITE RIGHT
Augustus Saint-Gaudens
(1848–1907), sculptor
Stanford White (1853–1906),
architect
Adams Memorial, 1886–91
Bronze figure against
architectural setting, over lifesize
Rock Creek Cemetery,
Washington, D.C.

until 1889; then, he did not complete the monument until 1896. Habitual delay was characteristic of Saint-Gaudens, Dryfhout reminds us. The architect Stanford White collaborated with Saint-Gaudens on the *Garfield Memorial*, as he did on many of the sculptor's commissions.

Saint-Gaudens's and White's design for the monument has its origins in the classical herm, that is, a rectangular pillar terminating in a bust. By the

Augustus Saint-Gaudens
(1848–1907), sculptor
Stanford White (1853–1906),
architect
Garfield Memorial, 1896
Bronze bust and allegorical
figure, bust over lifesize
Philadelphia

nineteenth century, the herm had undergone profound transformations and was a popular mode for public monuments, Dryfhout notes. The rectangular base in Saint-Gaudens's herm is an elaborate confection of classical architectural components carved in stone with a female allegorical figure, *Republic*, cast in bronze. *Republic* stands in front of the pedestal, which is articulated by Ionic pilasters at its four corners and which supports a classical entablature. The bust of Garfield is its crowning element, even though the portrait of the President is less than inspired in its passivity.

Republic stands in awkward contrapposto, holding an enormous shield. The figure is based on the statue *St. George* by Donatello at Or San Michele in Florence. That Renaissance masterpiece had also influenced Saint-Gaudens's standing portrait of Admiral Farragut for the *Farragut Monument* of 1881 in New York City, but with much better results.[36] *Republic*'s shield is so large that it eclipses three-fifths of the figure. Originally, it was meant to accommodate a lengthy text, but when the text was abbreviated to eight words and a date, Saint-Gaudens failed to reduce the size of the shield at that time, for some mysterious reason. Then, years later, when the sculptor tried to persuade his patrons to permit him to reduce it to an appropriate size, they refused, so *Republic* continues to wrestle with her oversized shield.[37] The upper portion of the figure, however, is a powerful expression of allegory worthy to stand with Saint-Gaudens's other major figurative pieces.

Republic's head, shoulders, and bosom resting on the oversize shield appear to be a classical herm, as if replicating in miniature the overall composition of the monument. In its animation, rich modeling of drapery, and the sensuous and enigmatic face of the Saint-Gaudens woman, however, *Republic* overshadows the placid portrait of Garfield directly above and improperly becomes the primary focus of the monument.

For the attribute to identify *Republic*, Saint-Gaudens chose the Phrygian cap, the close-fitting, soft cap with floppy peak worn by the people of Phrygia in ancient Asia Minor. In the course of the American Revolution, the hat became the symbol of liberty in America. It represented to the revolutionaries the cap that slaves wore in ancient times when they were freed. Slaves had to shave their heads so that they were easily identified, thereby preventing their escape. When a slave was freed, he was "called to cap," that is, he was given a cap to wear as his hair grew out so he would not be apprehended.[38] The soft folds of the Phrygian cap are an appropriate frame and relief for *Republic*'s sensuous features, which are set between the precisely carved fluted pilasters of the geometric pedestal.

Saint-Gaudens's little statue of liberty in Fairmount Park, which stands in the city where our freedoms were hammered out 200 years ago, is a reminder even today, as we labor under the opprobrium of poverty and homelessness, that until we have economic freedom, we will not truly be free.

The most haunting and inscrutable figure Saint-Gaudens ever created was for the *Adams Memorial* in Rock Creek Cemetery, Washington, D.C. (1886–91).[39] A year after the philosopher and historian Henry Adams's wife, Marian Hooper, committed suicide, Adams commissioned Augustus

Saint-Gaudens to design a figure for his and his wife's gravesite that would embody the ideas of Buddhism, in which Adams was interested. Saint-Gaudens began with a number of ideas, such as a seated Buddha-like figure partially draped and holding what might be an oil lamp in his right hand, but discarded them all for a universal image of contemplation. Using both male and female models, he finally, over a period of five years, evolved an androgynous figure in bronze, inspired by Buddhist art and Michelangelo's Sibyls from the Sistine Ceiling in Rome, fully shrouded with only the face resting on the right forearm and a part of the neck visible.

The figure is seated on a roughly hewn block of fieldstone, and the whole is set against a rectangular block and base of polished red granite. Along the top of the block, a simple projecting cornice is supported by a register of egg and dart molding, and the base carries a continuous laurel relief symbolic of the soul's victory over death and framing the over-lifesize bronze figure. The sculpture occupies a hexagonal platform and faces a granite exedra, which occupies three sides of the hexagon, leaving two bays open for visitors' access. The sculpture is therefore at the focal point of the hexagon, and the entire ensemble is enclosed within a bower of shrubs and beneath a canopy of trees creating an enclave of meditation. The architectual components and the setting were designed by Stanford White. The sculptor never named the memorial, which adds to what Saint-Gaudens scholar John Dryfhout calls the "aura of mystery and isolation" that surrounds it.[40]

THE *SHAW MEMORIAL*—STUDY IN NOBILITY

While the well-known art historian H. W. Janson has correctly observed that Augustus Saint-Gaudens's *Shaw Memorial* on Boston Common is "the finest and most moving work of art among all Civil War memorials," it also produced, in addition to America's foremost equestrian relief, the most important study in sculpture of the black man that exists.[41] In the fourteen years it took the artist to complete the monument, Saint-Gaudens made almost forty heads from life, and those that survive constitute the finest group of portrait studies by a single artist in the history of American sculpture. The hallmark of this body of work is the uniqueness of each study. There is absolutely nothing stereotypical about the heads. Each one is the study of a unique human being, who happens to be black. Nothing like them exists—before or since. Saint-Gaudens's insights into the humanity of his sitters has captured the essence of the human spirit—its nobility and its life.

While these studies are an unparalleled body of work, they reflect Saint-Gaudens's profound fascination with the psychological complexities of the Civil War, expressed in all of his portraits related to that tragic chapter in the life of the nation. Among his best known are the bust of William Tecumseh Sherman of 1888, which served also as the portrait for the *Sherman Monument* in New York City, of 1903, and his standing statue of Abraham Lincoln of 1887, in Chicago. Scholars find it is noteworthy that Civil War monuments and works related to the war constitute the largest body of work in Saint-Gaudens's oeuvre.

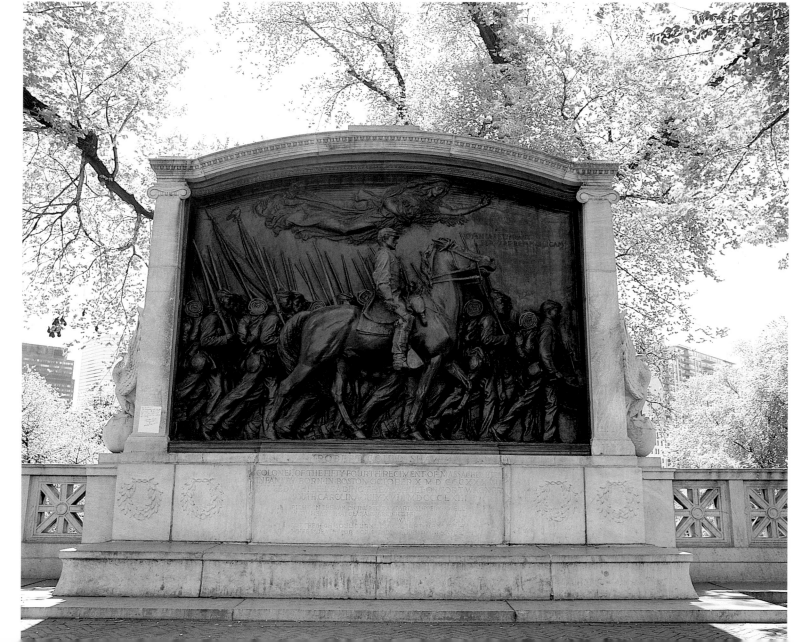

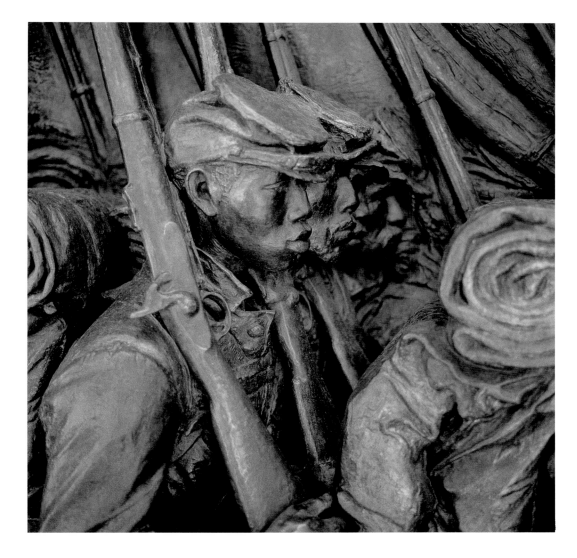

Augustus Saint-Gaudens (1848–1907), sculptor
Charles F. McKim (1847–1909), architect
Robert Gould Shaw Memorial: overall view, Shaw, and details of troops, 1884–96
Bronze, 11 × 14 ft. (3.4 × 4.3 m)
Boston

In May of 1862, Colonel Robert G. Shaw was assigned to lead Massachusetts's 54th Regiment of black volunteers.[42] Following their attack on Fort Wagner, in Charleston Harbor, South Carolina, in which almost the entire regiment was killed, including Shaw, his family decided to erect a monument to their son and all of his men. In his remarks at the unveiling of the monument on May 31, 1893, William James noted incorrectly that the *Shaw Memorial* was "the first soldiers' monument erected to honor a group rather than a single individual."[43] H. W. Janson has pointed out that war memorials honoring the soldiers who died in action in a particular war or engagement were a Prussian invention. The earliest was erected by the king of Prussia in 1793, to the Hessian troops who fell in the battle of Frankfurt.[44]

The form of Saint-Gaudens's monument evolved from this commission to commemorate them all. He portrays the members of the regiment marching with full pack and rifles over their shoulders, as Colonel Shaw rides alongside on horseback with drawn saber pointed downward while an allegorical figure floats above holding laurel, symbol of victory, a reference no doubt to the spiritual victory over death. Saint-Gaudens seems never to have come to terms, fully, with the floating figure. He executed four different versions of it.[45]

Cast in bronze, the marching soldiers, several abreast, range from a shallow *schiacciatto* to high relief, and the equestrian portrait of Shaw is freestanding. The dramatic contrast from the flattened figures in the background to the high-relief figures in the foreground and Shaw's full-bodied portrait creates a powerful sense of real space in which the regiment is passing before us. Although Saint-Gaudens's illusionistic tour de force is not unique in American sculpture, neither is it common. In his *Milmore Memorial* (1889–93) in Forest Hills Cemetery, Jamaica Plains, Massachusetts, and his *Lafayette Memorial* (1917) in Prospect Park, Brooklyn, New York, Daniel Chester French succeeds also in orchestrating these varieties of relief to create convincing spatial settings.

Saint-Gaudens's figures are lifesize and set within a classical frame carved in stone supported by a pedestal and flanked by a low parapet wall, isolating this vignette of that fateful day at Fort Wagner for us to contemplate lest we forget the sacrifice those men of color and their lone white commander made for the Union. American eagles stand on globes and face outward from the enclosing walls, and benches extend approximately eight feet, the depth of the rectangular plazalike setting for the monument. Two trees, apparently planted at the unveiling, full grown for many years, further enhance the realism of that march through South Carolina.

RICHARD SMITH'S WORTHY COLOSSUS

A remarkable combination of equestrian and pedestrian statuary adorns a flawed but worthy monument in Fairmount Park in Philadelphia.[46] Wealthy Pennsylvania electroplate- and typefounder Richard Smith bequeathed $500,000 to erect a monument to Pennsylvania's heroes of the Civil War. A gigantic triumphal gateway to West Fairmount Park, the monument is decorated with colossal portraits of Civil War heroes, the patron, his architect, the manager of his estate, and the wartime governor of Pennsylvania. Two colossal columns rise from monumental curved bases, each pierced by a triumphal arch defined by freestanding columns.

Before Smith died, he approved the architectural design and model of the monument by Philadelphia architect James H. Windrim. Smith stipulated in his will that the Fairmount Park Art Association would select and supervise the sculptors. His estate was in the hands of John B. Gest, president of the Fidelity Insurance Trust, whom he appointed custodian of the model and design drawings. The division of financial, design, and sculptural responsibilities may be the way a businessman retains control over the creation of a monument while he is living, but such a triumvirate is not self-governing, and when the patron is no longer present, confusion and delays can result. The *Smith Memorial* objectifies that flaw in its creation and execution.

Smith died in 1894, and, according to Lewis Sharp, the last statue was put in place on the monument in 1912. Over that eighteen-year period in which the great gateway was erected, two equestrian statues, three colossal figures, and eight busts were modeled and cast in bronze by twelve of the nation's leading sculptors.

J.Q.A. Ward and Paul Wayland Bartlett were commissioned for the two equestrian statues that would stand atop the extremities of the monolithic bases of the gateway. Ward was to do the statue of General Winfield Scott Hancock and Bartlett that of Major General George B. McClellan, but both commissions were reassigned. Ward resigned his commission because of too much work and advancing age (he was in his sixties), and the art association, unhappy with Bartlett's work, commissioned Edward C. Potter to finish the statue. Ward's friend Daniel Chester French took on Ward's commission and was assisted by Potter and Carle A. Heber.

Both equestrian statues are handsome examples of the genre of the period, but they are not a pair, even though they were conceived to be. Sharp attributes that flaw in design to lack of coordination between the sculptors, and as a result, he feels the statues never achieved their climactic role in the monument. A formal analysis of the two works in situ reveals their incompatibility and supports Sharp's conclusion. McClellan's horse stands at rest as the general looks forward. The horse's right rear and left front legs are back and the animal leans slightly forward as its tail arches at a slight angle, as if in stride, a posture that continues the sweep of the balustrade in a comfortable resolution. The general's cape, as it comes to rest behind his saddle, forms a diagonal that logically reinforces the slightly forward movement of the horse. Hancock's mount, on the other hand, is composed to resolve the vertical lines of its pedestal. Head and tail down, rider erect and looking off to the side instead of straight ahead, the statue of General Hancock echoes the vertical accents of the colossal columns of the monument. The Hancock, then, emphasizes the monument's vertical orientation, while the McClellan asserts its horizontal relationship to the landscape. Like mismatched bookends, these two equestrian statues awkwardly flank the entrance through the gargantuan gateway.

Would that these were the only problems the association either caused or encountered. John J. Boyle was offered the commission for the bust of John B. Gest, but declined when he discovered that his budget of $2,400 had been reduced to $1,800. Boyle, who grew up in Philadelphia, came from a long line of Irish stonecutters. He studied at the Pennsylvania Academy with the famous American painter and anatomist Thomas Eakins and then at the Beaux-Arts in Paris. He had already distinguished himself in his hometown in 1888, when *Stone Age America* was installed in Fairmount Park.[47] The nationally acclaimed sculpture portrayed an Indian woman defending herself and her children from an enormous American eagle in Boyle's original model. The sculptor reluctantly exchanged the eagle for a bear cub, robbing the group of much of its power, when Philadelphians criticized Boyle's demeaning of America's symbol of her greatness. He later regretted the change and was understandably unwilling to compromise once again for the Fairmount Art Association.

If Boyle was dissatisfied with the art association, he was not disillusioned with Philadelphia. His seated figure of Benjamin Franklin for the city has been called the finest statue of the colonial statesman executed by

Daniel Chester French
(1850–1931)
Major General George Gordon Meade
Bronze, over lifesize
Smith Memorial, Fairmount Park,
Philadelphia

Charles Grafly (1862–1929)
Major General John Fulton Reynolds
Bronze, over lifesize
Smith Memorial, Fairmount Park,
Philadelphia

LEFT
J.Q.A. Ward (1830–1910)
Major General Winfield Scott Hancock
Bronze, over lifesize
Smith Memorial, Fairmount Park, Philadelphia

BELOW
James H. Windrim, architect
Smith Memorial
Fairmount Park, Philadelphia

an American and was highly praised when it was exhibited in 1904 at the St. Louis World's Fair.[48]

The commission for Gest's bust was then given to Charles Grafly, who art critic Adeline Adams acknowledged was "the foremost American sculptor of male portrait busts." Grafly had already been assigned the bust of Admiral David Dixon Porter, and he would also inherit another commission.

Bartlett had also been commissioned to design two eagles for the base of the monument, another commission he resigned. The Scottish-bred sculptor J. Massey Rhind was an appropriate choice to do the eagles. The son and grandson of sculptors, and a student of the renowned Jules Dalou in the 1880s, Rhind also executed some major Civil War memorials. In the 1890s Rhind executed the colossal statue of John C. Calhoun atop the great column in Charleston, South Carolina, and he did Soldiers and Sailors monuments for Philadelphia and Syracuse. The Syracuse design, similar to that of the *Calhoun Monument*, consisted of a huge figure of Victory on a giant column with four military groups at the base. The *Soldiers and Sailors Monument* of 1914 in Philadelphia stands on the campus of Girard College and was a new design to replace the original monument to all the former students of the college known to have served in the Civil War. The original monument, which stood on that site since 1869, was executed by Philadelphia sculptor Joseph A. Bailly. It consisted of a single marble figure beneath a canopy. The sculpture deteriorated so badly that it could not be saved.[49]

William Ordway Partridge, whose equestrian monument to Ulysses S. Grant in Brooklyn had recently won national acclaim, was chosen to do the colossal standing portrait of Major General John Fulton Reynolds atop the right column. Daniel Chester French's statue of Major General George Gordon Meade occupies the column to the left. Partridge had studied in Rome, Florence, and Paris, and was an accomplished poet, actor, author, and critic as well as one of America's most gifted sculptors. Following the approval of his sketch model for the Reynolds figure, he prepared a full-scale model for the association's review, which they rejected. Partridge's spontaneous modeling, Sharp points out, they found lacking in "dignity," his summary treatment of detail a "defect," and his expressive treatment of Reynolds's figure "exaggerated." The sculptor prepared a revised model, which the association also rejected. At that point, totally insensitive to Partridge's vitally naturalistic style of modeling and composition and showing no respect for a sculptor of broad cultural background and recognized achievement, they appointed a committee to assist the sculptor in making a model they could accept. Predictably, Partridge declined their offer and withdrew from the commission, as the association wrangled among themselves, finally assigning Charles Grafly to complete the statue.

Meade, the hero of Gettysburg, who had led the Union Army in the battle that stopped the Confederate advance just 114 miles from Philadelphia and turned the tide of the war, is appropriately commemorated atop the column to the left of the gateway. He was most important, too, to Fairmount Park. Meade was one of the park's original commissioners and the one who

J. Massey Rhind (1860–1936)
Soldiers and Sailors Monument, 1914
Bronze sculpture group atop
simple stone base, over lifesize
Philadelphia

was most responsible for the planning of the paths and drives. He is also
commemorated in the park with an equestrian monument by Alexander
Milne Calder, unveiled October 18, 1887, and set in a broad landscaped
clearing north of Memorial Hall facing the Schuylkill River.[50]

Human Frailty Commemorated

Each of the statues on the Smith Monument, taken individually, has its
strengths, and some of the pieces are outstanding portraits, especially those
by Grafly; Herbert Adams's figure of the patron, Richard Smith, is uniquely
fetching in its somewhat obtuse placement, naively open and unprotected by
the customary niche. It is not the coordinated scheme, however, that Smith
and his architect had envisioned, Sharp makes clear. Because of the lack of
communication between the art association and the artists and the associa-
tion's lack of preparation for their task, the disparate character of the sculp-
ture program was the natural result. But, in spite of its limitations, it is the
result of, for the most part, an honest if limited effort, and it is a worthy trib-
ute to the Civil War heroes of Pennsylvania.

Anna Hyatt Huntington
(1876–1973)
El Cid Campeador, 1927–43
Bronze, over lifesize
New York

ART AND NATURE CELEBRATED

Perhaps the most versatile of the nation's animal sculptors, who also did equestrian monuments, was Anna Hyatt Huntington.[51] Her father was a leading paleontologist who taught at Harvard, and Anna Vaughan Hyatt grew up at Cambridge, where her sister Harriet, a sculptor, and her father's study of prehistoric life-forms through animal fossils helped shape her proclivities for animal sculpture. She studied first with the Boston sculptor Henry Kitson, then in New York with Hermon A. MacNeil and Gutzon Borglum at the Art Students League. Among her major works, two equestrian monuments deserve special consideration: *Joan of Arc* and *El Cid Campeador.*

For her *Joan of Arc,* unveiled in Riverside Park in New York City in 1915, Hyatt was decorated by the French Government with the Purple Rosette, and replicas of the monument were erected in Blois, France; Gloucester, Massachusetts; San Francisco, California; and Quebec, Canada, as Beatrice Proske has noted. Her model for the statue won honorable mention at the Paris Salon, 1910, and the statue won the Rodin Gold Medal at Philadelphia, and the Saltus Medal of the National Academy of Design. In 1922, she was made a citizen of Blois and Chevalier of the Legion of Honor. Influenced in her composition by the statues of Joan by Paul Dubois and Emmanuel Frémiet, Hyatt portrays the Maid of Orléans in full armor and standing upright in her stirrups holding her sword heavenward as she is about to lift the siege of Orléans in 1429.[52]

Hyatt's *El Cid Campeador* in the courtyard of the Hispanic Society in New York City is a replica of the original created in Seville in 1927. The eleventh-century Spanish knight holds his spear and banner aloft as he must have looked while leading his troops against the Moors. Four bronze warriors at

the corners of the pedestal represent Spain's Order of Chivalry. Other replicas stand in Buenos Aires, Argentina; San Diego, California; and San Francisco, California. In 1929, Huntington was awarded the Grand Cross of Alfonso XII by the Spanish Government.[53]

It is fitting that replicas of *Joan of Arc* and *El Cid* are also displayed at Brookgreen Gardens near Murrells Inlet along the coast of South Carolina. Founded in 1931 by Archer Milton Huntington, son of railroad and shipping magnate Collis P. Huntington, and his wife, Anna Hyatt Huntington, it is the nation's first public sculpture garden and continues to be the finest collection of American figurative sculpture in the world.[54]

The Huntingtons purchased a group of South Carolina plantations, totaling more than 9,000 acres, as a place to preserve South Carolina plants and animals and to exhibit sculpture. At first, they designed a series of informal connecting gardens and exhibited Anna Huntington's sculpture. Then they decided to develop a comprehensive survey of American figurative sculpture

ABOVE
Anna Hyatt Huntington
(1867–1973)
Photograph of artist with
Jaguars on Tree Stump

LEFT
Anna Hyatt Huntington
(1867–1973)
Jaguars on Tree Stump, 1964
Bronze, lifesize
Brookgreen Gardens,
Murrells Inlet, South Carolina

Marilyn Newmark (b. 1928)
Hacking Home, 1972
Bronze, 11 × 3½ × 9½ in.
(27.9 × 8.9 × 24.1 cm)
Collection of the artist

from the nineteenth century to the present. Today, 530 works by 235 sculptors make up the collection. Open year round, Brookgreen, where art and nature meet, accommodates more than 180,000 visitors a year.[55]

Some equestrian works are the expressions of the sculptors' involvement in racing, breeding, and the like. Marilyn Newmark, for example, combines the life of a horsewoman and the art of the *animalier.* Born and reared in the horse country of Long Island, Newmark grew up riding, and she still keeps her own stable there.[56]

As a child, she started sketching horses, and in her teens, when she began sculpting horses, she became the protégée of Paul Brown, author and well-known illustrator of horses. Brown's sketches often became the subjects of Newmark's pieces. Her works are in many private collections, and her numerous portraits of famous horses include *Man O'War, Majestic Light, Triple Crown,* and *Cormac.* The Professional Horsemen's Association selected her *Hacking Home* as their trophy at Madison Square Garden in 1972, and her honors include the Anna Hyatt Huntington award in 1971.[57]

Charlotte Dunwiddie, born in Alsace-Lorraine, France, also grew up with horses. Her stepfather owned racehorses and had his own racetrack. She learned to train her own horses and at age fifteen won her first championship in dressage. As Dunwiddie began to study sculpture with Wilhelm Otto at the Berlin Academy of Fine Art in Germany, she continued her work with horses. Over the years, she has created numerous medals and figures of famous thoroughbreds.[58]

Widowed twice, Dunwiddie traveled extensively and studied with Mariano Benillure y Gil in Madrid and with Alberto Lagos in Buenos Aires. Since coming to the United States in 1956, she has distinguished herself in

Charlotte Dunwiddie (b. 1907)
Pegasus, 1966
Bronze, 16 × 18 in.
(40.6 × 45.7 cm)
Collection of the artist

portraiture and ideal works as well as equestrian pieces, and she has received numerous awards from the National Sculpture Society, National Academy of Design, Pen and Brush, and other leading arts organizations. In 1966, for example, her bronze figure of *Pegasus* won the gold medal from the American Artists Professional League, and four years later her equestrian portrait of the famous World War II military leader General George S. Patton was awarded a gold medal by Pen and Brush. Dunwiddie became the first woman to be elected president of the National Sculpture Society, the oldest and largest association of professional sculptors in the United States.[59]

Allen G. Newman
The Hiker, 1916
Bronze figure
on stone base,
over lifesize
Staten Island,
New York

CHAPTER FIVE

SENTRIES, DOUGHBOYS, AND GI JOES

The lone figure on the battlefield standing over a buddy's grave, or ministering to a fallen comrade, or charging forward with fixed bayonet became a popular image with which to commemorate the soldiers who served and those who died in World War I. Those American doughboy monuments go back to the Civil War for their origins and to England for their name. To their British comrades, the gold-colored buttons on the American soldiers' uniforms looked like the little cakes or dumplings the British called "doughboys."[1] The solitary soldier on the battlefield as a memorial statue is descended from the Civil War sentry standing either at attention or at ease with his musket cradled in his arm or its butt resting on the ground.

THE CIVIL WAR SENTRY

While most of those sentries were produced by stonecutters and foundries to satisfy the needs of the many small communities that wanted to commemorate their local heroes, three well-known sculptors raised the genre to a fine art: Randolph Rogers, with his Civil War figures, *The Soldier of the Line* (or, the *Sentinel*), as well as his sentries for the *Soldiers' and Sailors' Monument* in Providence, Rhode Island, of c. 1870; the Irish-American sculptor Martin Milmore, with his sentry in Forest Hills Cemetery in Boston, and another in Claremont, New Hampshire, both of the late 1860s; and J.Q.A. Ward with his sentry of 1869, in New York City's Central Park, for the *Seventh Regiment National Guard Monument*.[2]

Those rudely crafted sentries that populated the northeast United States annoyed many artists and connoisseurs but not the well-known painter Cecilia Beaux. Her own impulse, when coming across one of those cast-iron or stone images, was not irritation at its ugliness but a sense of its emotional and historical significance. She was reminded of the sorrows and sacrifices of the "boys in blue" as they went out to battle shouting "Marching through Georgia" and "John Brown's Body." While she saw crude statues as "blunders of art and of bad taste," as she explained in addressing the tenth annual convention of the Arts Federation in New York City, in 1919, she recognized

Richard Morris Hunt
(1827–1895), architect
J.Q.A. Ward (1830–1910),
sculptor
Original Proposal for Seventh Regiment Monument with Circular Scheme for Central Park, 1868–74
Wash on paper
American Architectural
Foundation, Washington, D.C.

that "the youthful face and awkward cut of the uniform have the power of revival." Beaux believed the war memorial should communicate to all the people, to what she called the "average mind, and that is the only one worth considering in the matter."[3]

THE HIKER

The Spanish-American War of 1898–1902 and subsequent Philippine Insurrection not only established the United States as a world power and expanded its territories to include Puerto Rico, Guam, and the Philippine Islands, but it also produced a new icon of the American infantryman, the Hiker.[4] More naturalistic in his modeling and bearing, he was a product of the Beaux-Arts tradition, which had shaped American sculpture since the Columbian Exposition.

The American infantryman's participation in the international force to quell the Boxer Uprising, 1898–1900, in China assured the Hiker even greater fame. Dressed in tropical attire, the American trooper is portrayed hiking through the jungles of Cuba, the Philippines, and China. His broad-brimmed soft hat, bloused shirt open at the neck, and sleeves rolled up to the elbows were the most characteristic and striking features of his uniform that set him apart from the Civil War sentry, the World War I doughboy, and the World War II GI. The 8 foot 5 inch high bronze *Hiker* created by Theo Ruggles Kitson in 1906 for the University of Minnesota became a popular image, and more than fifty castings are found throughout the country. Two of the most picturesquely sited are the one on the state capitol lawn in Lansing, Michigan, dedicated on September 15, 1946, and the one in Penn Valley Park just south of the Liberty Memorial Mall and Memorial Drive in Kansas City, Missouri, dedicated on November 9, 1947.[5]

VICKSBURG'S MEMORIALS

Kitson also placed her stamp on the Civil War sentry at this time, in the Vicksburg National Military Park. Instead of standing still, Kitson's sentry strides forward in a classical stance with full pack and carrying his rifle over his shoulder. He stands on a pedestal composed of a 15-ton natural boulder, as the Massachusetts state memorial. So that he stands on his native terrain, Kitson had the boulder quarried in Massachusetts and shipped to its site.[6]

The park was established in 1899 to commemorate the Battle of Vicksburg. More than 1,200 memorials commemorate twenty-six of the twenty-eight states that took part in the Vicksburg campaign, which makes the park a unique and remarkable collection of Beaux-Arts figurative sculpture celebrating this chapter in the nation's fight for survival. Francis Edwin Elwell's Union soldier of 1908, for example, standing on a simple pedestal, honors Rhode Island's lone regiment of the 7th Infantry in the Vicksburg campaign. In its Beaux-Arts naturalism, like Kitson's *Hiker* and *Sentry*, Elwell's statue is

Francis Edwin Elwell (1874–1962)
Seventh Rhode Island Infantry Memorial, 1908
Bronze figure on stone base, over lifesize
Vicksburg, Mississippi

one of those solitary figures at the turn of the century that links the Civil War sentry with the World War I doughboy. Striding forward and holding his musket in his left hand, the figure in his stance is reminiscent of Daniel Chester French's *Minuteman* and the *Apollo Belevedere*, which inspired French's statue. In his right hand, he holds the regimental flag, its banner shredded and its staff shot away in the intense fire of battle.[7]

The site of the Battle of Vicksburg was strategic during the Civil War, as

well as picturesque, and efforts were made as soon as the war was over to commemorate those who took part in the conflict, historically and symbolically.

On July 4, 1864, the first anniversary of the surrender, the Union marked the site with its first monument, at the place where General John C. Pemberton and General Ulysses S. Grant parleyed. From a Vicksburg stonecutter's shop, Union soldiers appropriated an obelisk that the craftsman had carved as a monument to the Mexican War dead. Predictably, the shaft was vandalized, so it was removed for safekeeping until it was finally returned to its site in 1940.[8] Pemberton and Grant are also commemorated with their own monuments nearby. Sculptor Frederick C. Hill modeled Grant's bronze equestrian statue in 1918, and Edmond T. Quinn created a standing portrait of Pemberton in 1917.[9]

THE DOUGHBOY

By the time the country sought appropriate memorials to the men who fought in World War I, the idealized naturalism of the Beaux-Arts tradition had fully transformed the Civil War sentry into the all-American doughboy. Cecilia Beaux felt that the World War I doughboy on the battlefield with his "boyish, lean, American face" was the most poignant reminder for the average mind of the "seriousness, the real consciousness of the young life fallen in its prime, and never more to see the sun." In that image, Beaux insisted, was embodied "the consciousness of the sacrifice for our good, and what we owe it of eternal memory, from generation to generation."[10]

In their reliance on classical and Renaissance models, doughboys often resembled the *Dying Gaul* in blouse and puttees or an armed *Borghese Warrior* charging up a hill with fixed bayonet. Michelangelo's *Slaves* in the Louvre inspired what is perhaps the most forcefully charged doughboy in America. Called the *Abingdon Square Doughboy* because it stands in that square in Greenwich Village, in New York City, it was modeled by a Beaux-Arts master of bronze, Philip Martiny, and erected in 1921. A masterpiece of the genre, it blends physical power and sensuality through Martiny's modeling of flesh and figure.[11]

The lone doughboy stands on his 5-foot-high pedestal beneath a full canopy of trees as if on a hillock in the midst of battle. His right foot forward, he holds his drawn .45 automatic in his right hand and places the pole of the flag he carries in his left securely on the ground. As he looks sharply to the side, as if sensing danger, his helmet slips to one side showing his bandaged head. His flag furls around him, its fringe settling on his left shoulder near his blouse, which pulls open around the swell of his muscular neck. Martiny models the uniform as if it is an extension of the animated doughboy's agile physique. Although the figure is fully clothed and wearing cartridge belt, helmet, and puttees, it is clear that the pull of his arms around the taut torque of his body and the quick turn of his head are reworkings of Michelangelo's *Slaves* in the Louvre, representing man's active and contemplative natures.[12] Michelangelo's *Slaves* were fit choices for Martiny to convey the ambivalence

Philip Martiny (1885–1927)
Abingdon Square Memorial (detail of Doughboy), 1921
Bronze and granite, over lifesize
New York

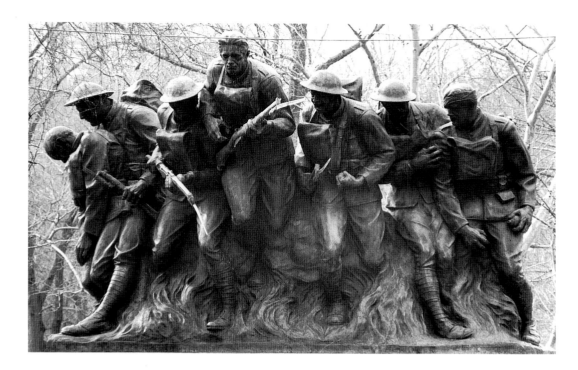

Karl Illava (1896–1954)
The 107th Infantry Memorial, 1927
Bronze figure group above
a tiered granite pedestal,
heroic scale
New York

of the wounded soldier on the battlefield, who would welcome rest yet holds his automatic at the ready, uncertain of what danger is near.

Sculptor Karl Illava's monument in New York City to the 107th Infantry stands at the terminus of 67th Street on Fifth Avenue with Central Park its backdrop. Composed of seven doughboys charging forward, the park creates for it a realistic setting, and Illava's reliance on the portraits of friends makes the group powerfully convincing. In the center is the sculptor's friend Paul Cornell (a well-known advertising executive at the time), and so no one would miss the likeness and his familiar shock of hair, the adman wears no helmet. All the doughboys' hands in Illava's monument, some bearing grenades, others grasping rifles or holding a fallen buddy, were modeled from the sculptor's own hands.[13]

Illava told his daughter that he wanted this monument to show the "hell of war."[14] To help him accomplish that he borrowed the composition of the figure of Christ from Michelangelo's *Pietà* in St. Peter's in Rome for the dying doughboy on the left supported by his comrade, and from the familiar posture of Christ in numerous Deposition scenes by Rubens, Van Dyck, and Rembrandt for the wounded doughboy on the far right.

THE VALUE OF IDEALS

Following World War I, scholars have noted, a sizable industry in producing war memorials emerged and promised to inundate the land with mass-produced doughboys. Such stock figures included a sentry standing at attention, rifle at his side, and flanked by a tree trunk with leaves scattered at its base and around the feet of the soldier. A space was left blank below this picturesque scene to place the name of the doughboy to be commemorated.

Manufacturers of bronze tablets estimated that the American people

would spend $8,000,000 on bronze plaques alone to commemorate their dead sons, brothers, and fathers, and they sought the services of professional sculptors to design panels that could be mass-produced then personalized by the purchasers. Members of the National Sculpture Society were repelled and horrified at such commercialism and along with other arts organizations encouraged the Fine Arts Federation, which represented the nation's arts organizations, to take a stand against such practices.

At its tenth annual convention held in New York City the second week of May, 1919, the federation pledged itself "to mitigate the plague of war memorials now sweeping over this land—a plague worse than the Egyptian plagues of old in that the memorials will be perpetual."[15]

R. Clipston Sturgis, past president of the American Institute of Architects, Boston, said that "If the war has taught us anything, it is the value of ideals."[16] Charles Moore, the federation's chairman, who was also chairman of the National Commission of Fine Arts, which oversaw government commissions, believed the artist should be the "expounder of our ideals, the one who makes visible our feelings of honor and patriotism, the leader who stirs us to still nobler deeds, the creator of the beauty that gives joy to life."[17] Moore's objective was clear: to ban "the stock soldier, the stock tablet, the stock anything," by "impressing on communities that each memorial should be a separate, distinct creation of an artist."[18]

The federation's involvement in the issue of war memorials went beyond the subject of memorials. The federation had 224 chapters throughout the United States, it had circulated traveling exhibitions to 106 cities across the country the previous year, it had twenty-five illustrated lectures on a constant circuit, and it published its monthly *American Magazine of Art* and *The Art Annual*, a comprehensive directory of art. The federation saw its principal role as tastemaker in the arts, and it worked to awaken the public conscience and to stir public opinion to that end. The popular demand for war memorials not only gave the federation a worthwhile project but also provided its members with a unique opportunity to shape the future of public art as they established guidelines for the creation of war memorials.[19]

The federation first identified appropriate types of memorials—portrait statues and symbolic groups, tablets, flagstaffs, gateways, bridges, memorial halls, stained glass windows, and village greens—and always insisted on using professional artists, architects, and designers in their execution. Major arts organizations such as the National Sculpture Society joined with the FAF in circulating the ideas expressed at the convention to artists and potential patrons.[20] Those same principles prevailed in World War II and beyond, which is well exemplified in the East Coast and West Coast war memorials.

AN ARC OF COMMEMORATION

The East Coast and West Coast war memorials complete a transcontinental arc from New York to California to commemorate the World War II martyrs of the Atlantic and Pacific oceans.

These two memorials were erected by and under the jurisdiction of the American Battle Monuments Commission, created by act of Congress on March 4, 1923, to erect and maintain memorials in the United States and foreign countries where United States Armed Forces have served since April 6, 1917, when the United States entered World War I. It also has the responsibility for permanent burial grounds in those areas.[21]

The *East Coast Memorial*, designed by architects Gehron and Seltzer, and dedicated by President John F. Kennedy on May 23, 1963, is located in Battery Park at the southern tip of Manhattan, in New York City, and commemorates the soldiers, sailors, Marines, coastguardsmen, and airmen who were martyred in the western waters of the Atlantic Ocean during World War II.

The monument consists of four pairs of gray granite monoliths, 18 feet high, bearing the name, rank, organization, and state of each of the 4,596 martyrs. The monoliths flank a plazalike court of honor whose centerpiece is a colossal bronze eagle 13 feet high on a 5-foot-high granite base. Monoliths and eagle are oriented westward to the Statue of Liberty across the upper bay of New York Harbor.[22]

The eagle, the ancient Roman sign of resurrection, alights with wings outspread, its talons clutching a funerary wreath, symbol of victory over death, which it lays on the curl of a great wave. Originally, the eagle by sculptor Albino Manca was to have been 18 feet high, but, with excavations for the Battery Tunnel directly beneath, the site would not support the weight. To maintain the necessary mass for the central icon of the memorial, the architects used a hollow base sheathed in black granite to retain the height for the eagle while reducing the weight of the bronze.

Gehron and Seltzer created an appropriate environment for this monument through sensitive attention to materials. The granite for the monoliths, for example, has vague wavelike striations running horizontally through it, suggestive of the ocean waters. The plaza surface is coarse concrete with large pebbles creating a beachlike effect relating it physically to New York's bay and symbolically to the martyrs' eternal resting place in the Atlantic. When the monument is approached from the promenade along the bay, the skyscrapers of lower Manhattan form a backdrop.[23] The architects, therefore, articulated the monoliths so that they echo the slabs of Manhattan's towers.

The *West Coast Memorial* is sited on a promontory overlooking the Golden Gate (the entrance to San Francisco Bay) in the Fort Scott area of the Presidio of San Francisco, California. The architects for the structure were Clark and Beuttler, and Lawrence Halprin was the landscape architect. Jean De Marco of New York City designed the sculpture, and the monument was completed in 1960.[24]

Echoing the broad, low landscape of the site, the monument is composed of a 9-foot-high monolith from which extends northward a 7-foot-high curved wall bearing the name, rank, organization, and state of the 413 men of the Armed Services who lost their lives in the eastern waters of the Pacific

Albino Manca (1898–1976)
Gehron and Seltzer, architects
East Coast Memorial (detail of monument), 1963
Bronze eagle, 18½ ft. (5.6 m) high; 8 granite slabs, each 19 ft. (5.8 m) high
Battery Park, New York

ABOVE
Jean De Marco
Clark and Beuttler, architects
West Coast Memorial, 1960
Gray granite; wall 16 ft. (4.9 m)
high with relief of Pegasus; figure
of Columbia, 8 ft. (2.4 m) high
Presidio, San Francisco

OPPOSITE PAGE
Walker Hancock (b. 1901)
*Pennsylvania Railroad War
Memorial*, 1950
Bronze allegorical figures on
granite base, heroic scale
Pennsylvania Station,
Philadelphia

Ocean during World War II. The stone is light gray granite, and at the north end of the wall, as a symbol of resurrection, De Marco has carved in low relief the image of Pegasus, rising from the sea heavenward.

In front of the monolith stands *Columbia Mourning the Dead*. The 8-foot-high light gray granite statue stands on a simple 3-foot-high base, and the terraced site of the monument provides the visitor with a panoramic view of the neighboring shore and through the Golden Gate to the Pacific Ocean.

PENNSYLVANIA MARTYRS

Monuments that carry on the guiding principles of the Fine Arts Federation dot cityscapes across the country—in post offices, office buildings, and even railroad stations and terminals, such as the *Pennsylvania Railroad War Memorial* of 1950 by Walker Hancock, at the 30th Street Station in Philadelphia. Of bronze and granite, the monument soars 39 feet. The archangel Michael, angel of the Resurrection, lifts the figure of a dead soldier upward, escaping

the flames of hell below. Angel and soldier are supported by a black granite base that bears the names of the 1,307 railroad employees who died in World War II. A discarded helmet and ammunition belt at the bottom of the granite base signal the dead heroes. On the front of the pedestal is carved: "That all Travelers Here May Remember Those of the Pennsylvania Railroad Who Did Not Return From the Second World War."[25]

Unfortunately, daylight through windows from all four sides of the cavernous station produced conflicting cross lights, preventing the monument from being properly seen. With the assistance of Geoffrey Lawford, the architect for the pedestal, the problem was solved by installing curtains in the windows behind the monument and directional lighting in the ceiling. If that lighting had been retained and the surfaces of the bronze maintained, the monument would enjoy its original power, but it has been sadly neglected.

THE IWO JIMA MEMORIAL

The most famous monument of World War II, the *U.S. Marine Corps War Memorial* of 1954, also carries on the Beaux-Arts tradition. Better known as the *Iwo Jima Memorial*, by the Austrian-born sculptor Felix De Weldon, the monument, like Karl Illava's World War I memorial, consists of a group of soldiers in battle. The principal difference is that De Weldon's monument represents a specific event and portrays actual combatants.

De Weldon transformed Associated Press photographer Joe Rosenthal's Pulitzer Prize–winning photograph of the flag-raising on Mount Suribachi on the island of Iwo Jima on February 23, 1945, into a three-story-high bronze colossus that stands west of Arlington National Cemetery. Long before de Weldon's sculpture group was dedicated on November 10, 1954, Rosenthal's image had become a national icon, historians note. This symbol of American courage commemorated the bloodiest battle the Marines fought in World War II, and when Rosenthal's photograph was published, it struck a responsive chord throughout the nation. Little wonder that the image was celebrated on a three-cent stamp in 1945, and in a movie (*Sands of Iwo Jima*) in 1949, and that it was used to promote bond sales in the waning months of the war. It was the logical image for a national memorial to commemorate all the Marines who sacrificed their lives in the defense of their country.

The Marines' surge forward has been likened to the ancient *Winged Victory of Samothrace*, while the pyramidal composition culminating with the American flag waving aloft recalls Delacroix's famous nineteenth-century revolutionary painting *Liberty Leading the People*.[26] Now, however, recent research attempts to discredit the monument on moral grounds, claiming Rosenthal's photograph was staged a short time after the actual event had taken place and is, consequently, fraudulent, thereby disgracing the monument, too. The claim has been denied by G. Greeley Wells, the adjutant who carried in the flag and was responsible for its raising.[27]

Notwithstanding the controversy over the time of Rosenthal's photograph, and the artistic merits of de Weldon's memorial, photographer and

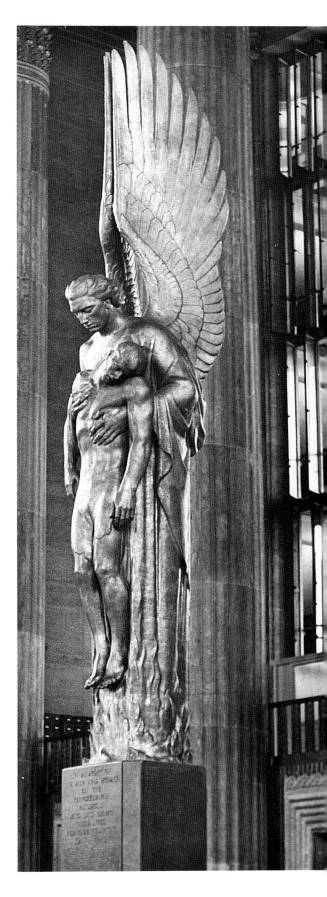

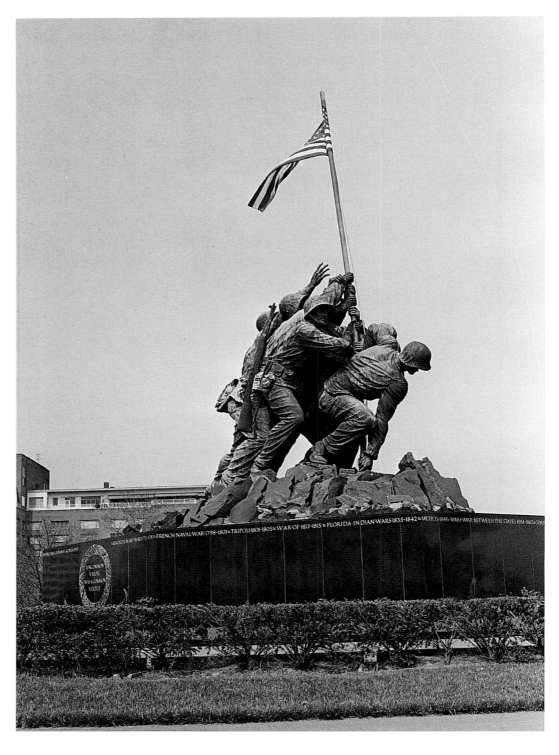

Felix De Weldon (b. 1907)
Marine Corps War Memorial
(Iwo Jima Memorial), 1954
Bronze figure group on rock
base, heroic scale
Washington, D.C.

staged a short time after the actual event had taken place and is, consequently, fraudulent, thereby disgracing the monument, too. The claim has been denied by G. Greeley Wells, the adjutant who carried in the flag and was responsible for its raising.[27]

Notwithstanding the controversy over the time of Rosenthal's photograph, and the artistic merits of de Weldon's memorial, photographer and sculptor created a monument that became the nation's best-known symbol of American courage.

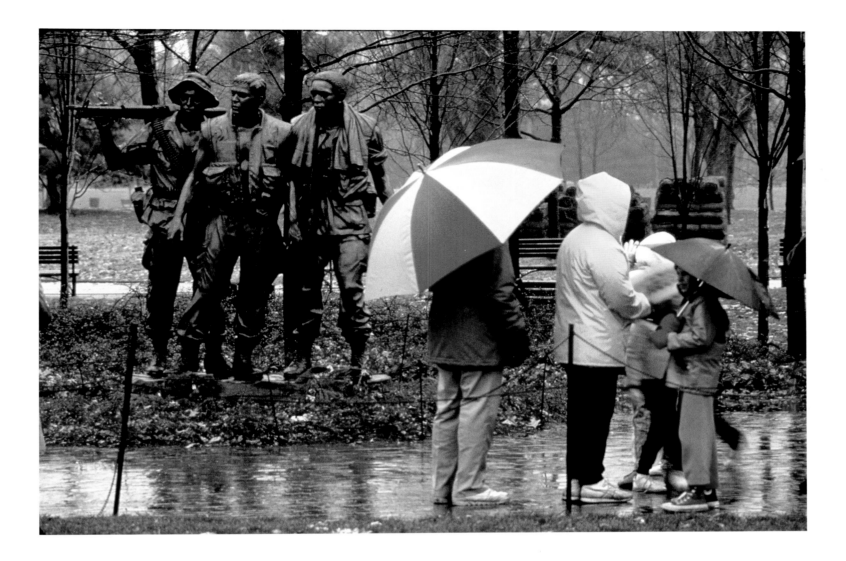

sacrifice that is overwhelming and nearly incomprehensible in its sweep of names. I place these figures upon the shore of that sea, gazing upon it, standing vigil before it, reflecting the human face of it, the human heart."[28] J. Carter Brown, former director of the National Gallery in Washington, D.C., sees "the three soldiers . . . as a kind of Greek chorus facing the wall, commenting on its meaning."[29] The National Geographic Society expressed the profound need that the nation feels for such memorials: ". . . the sons and daughters of men killed in Vietnam will look at the sculpture and say, 'This is my father: I never saw him alive. But he wore those clothes. He carried that weapon. He was young. I see now, and I know him better.' "[30]

Hart studied at the University of South Carolina, the Corcoran School of Art, and American University. He apprenticed to Felix de Weldon and ornamentalist Giorgio Gianetti and served as an assistant to sculptors Walker Hancock, Carle Mose, Don Turano, and Heinz Warnecke. The recipient of many awards, he is a trustee of Brookgreen Sculpture Gardens and a member of the Sacred Arts Commission for the Catholic Archdiocese of Washington, D.C.[31]

Frederick Hart (b. 1943)
Three Servicemen, 1982
Bronze, over lifesize
Vietnam Veterans Memorial,
Washington, D.C.

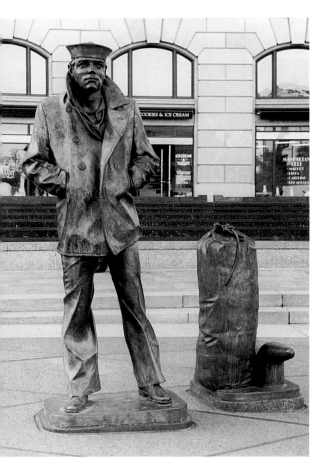

Stanley Bleifeld (b. 1924)
Lone Sailor (overall view and detail), 1987
Bronze, 7 ft. (2.1 m) high
Washington, D.C.

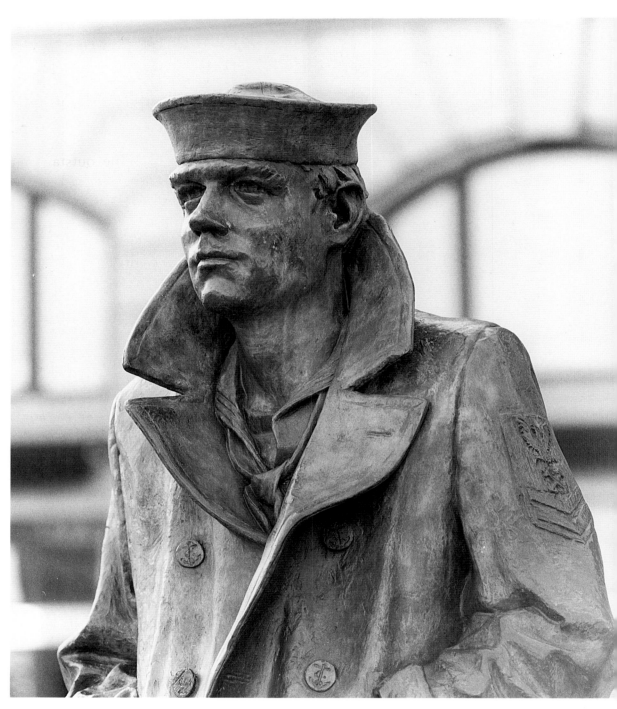

THE U.S. NAVY MEMORIAL

The tradition of the single commemorative figure for war memorials that was first popularized in the Civil War memorials of Rogers, Milmore, and Ward, and then in the doughboys of World War I, continues even today in the *United States Navy Memorial* on Pennsylvania Avenue in Washington, D.C., halfway between the Capitol and the White House.

The *Lone Sailor*, by sculptor Stanley Bleifeld, is the centerpiece of the memorial and was unveiled in 1987.[32] The 7-foot-high figure stands on the largest map of the world—a 100-foot-diameter granite gridwork—and

symbolizes all the men and women who have served, who are serving, and who will serve in the United States Navy throughout the world. With his hands in his pockets, peacoat collar turned up, and hat pulled down over his brow, he looks out over the oceans of the world. Extending the universal theme of water, the ensemble is completed by fountains, waterfalls, and pools surrounding Bleifeld's figure and the map of the world.

Lone Sailor won the Henry Hering Memorial Medal of the National Sculpture Society in 1990.[33] The medal is awarded for the outstanding collaboration of architects, owners, and sculptors, in distinguished use of sculpture. Sharing the honor with Stanley Bleifeld were Admiral William Thompson, U.S. Navy Memorial Foundation, and Tom Regan, of the Pennsylvania Avenue Development Commission.

It is fitting that Stanley Bleifeld, the current president of the National Sculpture Society, continues a tradition that was first popularized by the first president and founding member of the society, J.Q.A. Ward. Bleifeld was also commissioned to do a sculpture group for the Visitors Center, behind the memorial. Called *Homecoming*, it portrays the reunion of a Navy family and was unveiled in 1991.

Stanley Bleifeld studied at Temple University in Philadelphia, where he began his career as a painter.[34] In 1959, however, on a visit to Florence, he came face to face with the bronze masterpieces of such Renaissance giants as Ghiberti and Donatello, which enticed Bleifeld to try his hand at modeling. He was soon producing biblical themes in the tradition of the Old Masters, and then his work took a painterly turn, as he produced liquid landscapes in undulating reliefs and free-flowing portraits reminiscent of classical frag-

Stanley Bleifeld (b. 1924)
Oriental Landscape, VIII
(The Storm) 1976
Bronze relief, 13 × 16 in.
(33 × 40.6 cm)
Collection of the artist

ments. Bleifeld maintains studios both at his home in Weston, Connecticut, and in Italy.

AVENGER

How the lone warrior embodies ideas of patriotism for the many immigrant groups in the nation is forcefully expressed in the *Avenger* by the Polish-born sculptor Andrzej Pitynski. A World War II memorial to the martyrs of the Katyn Forest, it was erected in 1988, in the cemetery of Our Lady of Czestochowa, in Doylestown, Pennsylvania.[35]

The 22-foot-high bronze figure portrays a winged knight kneeling and resting on his sword at the gravesite of the many Polish soldiers who lie buried there. Our Lady of Czestochowa and the Polish eagle are emblazoned on the breastplate of the knight's armor, which bears the Polish motto, "For Our Freedom and Yours." It commemorates the 4,250 Polish cadets and army officers who were massacred by the Russians in the Katyn Forest in 1940.

OPPOSITE PAGE
Andrzej Pitynski (b. 1947)
Avenger, 1988
Bronze figure on granite base,
30 × 18 × 17 ft. (9.1 × 5.5 × 5.2 m)
Doylestown, Pennsylvania

GEORGE WASHINGTON

The General Assembly of the Commonwealth
of Virginia have caused this Statue to be erected
as a monument of affection and gratitude to
GEORGE WASHINGTON
who uniting to the endowments of the Hero
the virtues of the Patriot and exerting both
in establishing the Liberties of his Country

CHAPTER SIX
INSIGHTS INTO THE AMERICAN PORTRAIT

America's portrait tradition was shaped early in the republic to a large extent by the works of the French sculptor Jean-Antoine Houdon and the Roman sculptor Giuseppe Ceracchi. The strongest influence of English portraiture was felt in the works of Sir Francis Chantrey and Robert Ball Hughes, but the Enlightenment portraits of Houdon and the Roman portraits of Ceracchi were the predominant and formative European influences on early nineteenth-century American portraits.

Beginning with his likeness of *Diderot*, 1771, Houdon's portraiture established a new portrait style destined to shape the genre for the next century in both Europe and America.[1] H. W. Janson has called Houdon's portrait of Diderot "the earliest image of modern man."[2]

To achieve immediacy, Houdon employed various devices. He made casts of subjects' faces, hands, and sometimes accessories such as canes, spurs, and the like. Then, he studied the sitter's movements, gestures, and expressions as he engaged them in conversation to capture the spontaneity that makes his portraits live.[3] His subjects lean slightly forward and look to right or left, thus breaking away from the rigidity of traditional academic portraits.[4] Auguste Rodin, the master of the nineteenth-century portrait, also placed great emphasis on the angle of the head and called modeling and movement "the blood and breath of all great work."[5]

Fundamental to the vitality of Houdon's portraits was his unique understanding of the essence of facial expression, which for him lay in the flesh and the muscles surrounding the mouth and the eyes. In the mobility of those passages, the relaxed compositions of his subjects, and his genius for modeling lifelike textures, lay the unextinguishable vitality of Houdon's portraits.[6]

It was through Benjamin Franklin and Thomas Jefferson that Houdon was commissioned to execute the standing portrait of *George Washington* for the Virginia State House in Richmond. Some scholars consider it to be one of his two most successful portrait statues.[7] Washington stands in a relaxed contrapposto with his right hand resting on his walking stick and his left hand resting on a modern version of the Roman fasces composed of thirteen

OPPOSITE PAGE
Jean-Antoine Houdon
(1741–1828)
George Washington, 1785
Marble, lifesize
State House, Richmond, Virginia

Giuseppe Ceracchi (1751–1802)
Alexander Hamilton, c. 1793
Marble, lifesize
New-York Historical Society,
New York

rods, which stand for the original colonies of the Union. His sword, no longer needed, hangs to the side, and a plow stands behind him, symbols of peace. In the portrait, Houdon succeeded in capturing a convincing likeness while ennobling his subject, the formula for perpetual appeal in portraiture throughout the history of art, even when representational art has not been fashionable.

Jefferson's intention in having France's greatest sculptor of the late eighteenth century model the likeness of Washington for Virginia's State House was to create an icon for the American people that would serve as the model of the Father of Our Country for succeeding generations of artists. For that reason, he wanted an accurate record of Washington's physique and appearance.[8] The statue therefore conforms to Washington's measurements, and the portrait is based on a life mask that is today preserved in the Morgan Library in New York City. Jefferson's vision was prophetic. The Houdon likeness is the one that has been reproduced most widely and that is the best recognized today. A bronze replica[9] stands in New York's City Hall and must have been known by A. Stirling Calder, who was commissioned to do the standing figure of Washington as President for Stanford White's Washington Arch in Greenwich Village in New York City to celebrate the 100th anniversary of Washington's inauguration. Hermon A. MacNeil was commissioned to do the companion statue of Washington as general. While Calder's statue is not a slavish copy of Houdon's, it is clearly inspired by it, reflecting not only Thomas Jefferson's characteristically prophetic vision but also the timeless appeal of Houdon's statue.[10]

Whereas Houdon rendered personality through the changing aspects of his subjects, Giuseppe Ceracchi's portraits are solid, permanent, and unchanging. Faithful replications of nature, Ceracchi's subjects are portrayed with ancient Roman hair styles and clothed in Roman togas rather than contemporary dress. The busts are imposing and the likenesses convincing. Subjects look straight ahead and heads are set squarely on short thick necks supported by sturdy shoulders. Admirable for their imposing strength and courage and for their noble bearing, Ceracchi's likenesses portray our Revolutionary leaders as ancient Romans, half gods worthy of the country's adulation and celebration. They are portraits of power.[11]

Ceracchi came to America in 1790 to create a colossal monument to the American Revolution in the tradition of the great monuments in Europe, complete with a giant quadriga bearing the goddess of Liberty reigning over a collection of allegorical figures and portraits of the heroes of the American Revolution.[12] The monument was to be 100 feet high, but the cost was beyond the coffers of the young republic. As he was trying to sell his idea, Ceracchi proceeded to make portrait busts of Revolutionary leaders such as Alexander Hamilton, Benjamin Franklin, Thomas Jefferson, John Paul Jones, and, of course, George Washington.[13] Those portraits that Ceracchi carved, as well as the plaster casts of ancient busts and the works of other Neoclassical sculptors of the period, were the principal forces in establishing the Roman portrait tradition in America at that time.[14]

Ceracchi's influence on native carvers in particular is well illustrated by comparing his bust of John Jay of c. 1795 with John Frazee's bust of Jay of 1831, which is little more than a slavish copy of Ceracchi's bust by a New Jersey stone-carver turned portraitist. Frazee's broader understanding of Neoclassical principles, however, which he would have assimilated from many examples in New York City by then, is best reflected in his bust of John Wells of 1824. Considered to be the first portrait bust carved in marble by an American sculptor, it is a strong and well-proportioned likeness of the New York City lawyer and editor.[15] Draped in classical style, the portrait serves as the centerpiece of the distinguished jurist's memorial in St. Paul's Chapel in New York City.[16]

Houdon's and Ceracchi's portraits, as well as the statues and busts of other European sculptors, became well known throughout the country by means of a thriving industry in the unauthorized replication of busts of famous people. The busts were advertised and offered in marble, locally quarried stone, or in plaster painted to look like marble—a bust for every pocketbook. It was through those "pirated portraits" that the general public became acquainted with the works of the European masters and the portraits they made.[17]

In the nineteenth century, the allure of Rome and Florence, with their abundance of ancient statuary, marble quarries, and trained carvers—not to mention the contemporary works of the great Neoclassical masters Antonio Canova and Berthel Thorwaldsen—captivated a generation of expatriate American sculptors led by Horatio Greenough, Hiram Powers, and Thomas Crawford. Powers's portraits ushered in a new era of naturalism that combined Yankee ingenuity, keen analysis, and European models. Although Powers often portrayed his subjects in classical drapery, his portraits were very much of their time, and he was famous for capturing a faithful likeness. While Powers enjoyed a long and successful career—remaining in Florence for the rest of his life, producing marble busts and statues—the world of sculpture changed, and with it its geographical center, from Rome and Florence to Paris.

DAVID D'ANGERS

The greatest portrait sculptor of the generation after Houdon was Pierre-Jean David d'Angers (1788–1856). At the height of his career in 1834, he was commissioned to make a statue of Thomas Jefferson for the Capitol in Washington, D.C., which is a superb example of the historical portrait genre that he revolutionized and that James Holderbaum has carefully chronicled. As the portrait tradition in France was being transformed by the new freedom and spontaneity of David's modeling, American sculptors by mid-century were beginning to look away from Florence and Rome to Paris and the Ecole des Beaux-Arts for their models and their training. Moreover, the popular medium became bronze, with its almost boundless capacity for reproducing the subtle nuances of the new modeling style. Bronze was also more durable

Pierre-Jean David d'Angers
(1788–1856)
Thomas Jefferson, 1832
Bronze, over lifesize
United States Capitol,
Washington, D.C.

outdoors and therefore more suitable for public monuments, a burgeoning industry following the Civil War in the United States.

Portraiture in American sculpture during the century following the Columbian Exposition underwent profound and diverse change. While no attempt is made here to chronicle its breadth and depth, some select examples will serve to identify the variety of styles and the varying degrees of psychological insight that characterize portrait sculpture during that remarkable period.

If there was a preview of what the American historical portrait in bronze was to be in the years immediately following the Columbian Exposition of

1893, it is found in the remarkably vital full-length portrait of Thomas Jefferson by David.[18] Jefferson is portrayed slightly over-lifesize, wearing contemporary dress. He holds the Declaration of Independence, unfurled, in his left hand, and with quill pen in his right hand he gestures to the document. Books, traditional attributes of literary figures, rest near his feet on the pedestal.

David's genius as a modeler in capturing the likeness and the spirit of his subject was the hallmark of his style. When Auguste Rodin began to model in clay, he studied the portraits of David d'Angers to develop his own style. David's skill as a modeler was enhanced by new casting techniques developed at the time. A revival of the lost-wax process, dormant since the Renaissance, meant that the foundry in casting the bronze bust or statue was able to preserve the subtlest nuances of the sculptor's expressive manipulation of the clay's surfaces. Art and craft, then, were united in producing a new down-to-earth naturalism, animation, and crisp articulation of detail that were to be characteristic of the sculpture of John Quincy Adams Ward and Augustus Saint-Gaudens, as well as of the other American masters of the historical portrait at the turn of the century.

The Jefferson portrait by David d'Angers, Holderbaum explains, was commissioned by Lieutenant Uriah Phillips Levy of the United States Navy, a Jew, as a tribute to Thomas Jefferson's abolition of religious discrimination in the armed forces. The statue was installed in the Rotunda of the Capitol, but it was soon removed and placed in storage because in its dark patina it reminded some senators of a Negro. James K. Polk brought it out of storage during his presidency, 1845–49, when he was being criticized by Abolitionists for equivocating on the slavery issue. In an obstinate gesture, he placed it on the front lawn of the White House, where it remained until 1874. It was then moved to Statuary Hall, and in 1900 it was returned to the Rotunda, its original and present location. The plaster model from which the statue was cast (therefore called the original plaster) Levy gave to New York City in gratitude for his success in real estate in that city.[19] It stands in City Hall, where it is now all but forgotten.

J.Q.A. WARD

The naturalism and vitality that David d'Angers brought to the world of sculpture became the hallmarks of the American masters of the era following the Columbian Exposition. Called the "Dean of American Sculptors," John Quincy Adams Ward was certainly the father of the naturalism that prevailed during the second half of the nineteenth century.[20] Ward grew up in Ohio and came to New York City to study with Henry Kirke Brown. Even though Brown had studied in Florence and Rome, he admonished American artists to stay home and learn from nature and their own surroundings. That is exactly what Ward did. He stayed home and became the foremost realist of his day. However, as the younger generation of sculptors went off to study at the Ecole des Beaux-Arts and in the studios of France's leading academic

J.Q.A. Ward (1830–1910)
Horace Greeley (detail), 1890
Bronze, over lifesize
New York

sculptors, such as Falguiére, Julian, and Mercié, and brought back with them a new sophistication, Ward was quick to learn from their freer modeling and more animated surfaces, which enhanced his own naturalism in the 1880s and 1890s, as in his seated portrait of *Horace Greeley* of 1890 in City Hall Park in New York City.

For Greeley's likeness, Ward used a death mask and photographs, while relying on his own recollections of the famous editor.[21] Ward had met Greeley at the *Tribune*, and he remembered how welcome the publisher had made him feel as the sculptor walked into his office. In his portrait, Ward tried to capture that moment as Greeley stopped reading his newspaper and looked up at him. Meticulous attention to such details as the wrinkled newspaper, the fringe on the bottom of the chair, and Greeley's frock coat and baggy trousers, which cover his ample frame, all enhance the publisher's warm expression. It remains one of Ward's most successful portraits and represents his distinctive brand of realism at its peak.[22]

AUGUSTUS SAINT-GAUDENS

It was in the hands of Augustus Saint-Gaudens, however, that the Beaux-Arts portrait would blossom into its fullest promise in America, in conception, technical mastery, and psychological insight. His relief portrait of Robert Louis Stevenson represents Saint-Gaudens at his most lyrical in the composition of his subject and peerless in the control of his medium. The varying degrees of relief, the pool-like background surface supporting inscriptions reminiscent of early Renaissance works, and Saint-Gaudens's control of Stevenson's figure, the bed, and assorted accoutrements set within a pictorial space are deftly ordered. Saint-Gaudens did numerous versions of the Stevenson relief portrait, each unique in its own subtleties.

The Stevenson portrait resulted from Saint-Gaudens's fascination with Stevenson's *New Arabian Nights*. A meeting was arranged by Will Low, a mutual friend of the sculptor and the Scottish writer, and the two artists soon became fast friends. When Saint-Gaudens met Stevenson in 1887, the author

Augustus Saint-Gaudens
(1848–1907)
Robert Louis Stevenson, 1902
Bronze relief, 6½ × 13½ in.
(16.5 × 34.3 cm)
Museum of Fine Arts, Boston;
Bequest of Mrs. John Paramino

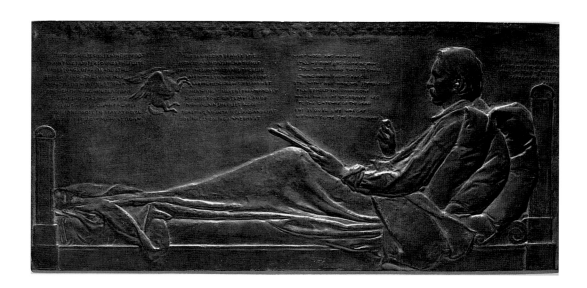

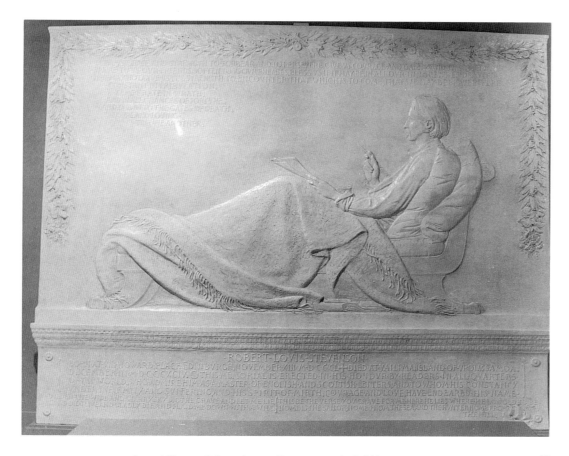

Augustus Saint-Gaudens
(1848–1907)
Robert Louis Stevenson
(third version), 1899–1903
Plaster for bronze relief; plinth
and plaque, 91 × 109 in.
(231.1 × 277 cm)
St. Giles Memorial,
Edinburgh, Scotland

was staying at the Albert Hotel in Greenwich Village in New York City.[23] Stevenson suffered from tuberculosis and therefore wrote propped up in bed. He also smoked, so Saint-Gaudens sketched him in the process of writing while holding a cigarette. Saint-Gaudens developed his composition for the portrait in a number of sessions during the year of 1888 and produced several variations in round and rectangular formats and in different sizes. After the portrait was completed, Stevenson traveled to California, and then on to his new home in Upolu, Samoa. The two men were never to see each other again, but they maintained an extensive correspondence until Stevenson died in 1894. Because of their close relationship over the years, Saint-Gaudens was commissioned to design Stevenson's funerary memorial for the Church of Saint Giles in Edinburgh in 1902. He modeled a variation of the relief of 1888, changing the cigarette to a pen and the bed to a couch. Saint-Gaudens's reliefs had a widespread influence on American sculpture, especially through his pupils.

Helen Farnsworth Mears, for example, one of Saint-Gaudens's favorite pupils, shows her debt to Saint-Gaudens's Stevenson reliefs in the bronze portrait relief she created of the American composer Edward Alexander MacDowell in 1909.[24] In that last portrait of the composer, he is shown in profile seated in a chair, the ensemble set against a simple ground with inscriptions from one of his poems and the third movement of the *Sonata Tragica.* The original is in the Metropolitan Museum of Art, and the Edward MacDowell Association and Columbia University, both in New York City, have the only two replicas.

Helen Farnsworth Mears
(1871–1916)
Edward Alexander MacDowell, 1906
Bronze, 33¼ × 39⅞ in.
(84.5 × 101.3 cm)
The Metropolitan Museum
of Art, New York; Gift of
Miss Alice G. Chapman, 1909

BELOW
William Ordway Partridge
(1861–1930)
Thomas Jefferson
Plaster, maquette for 1914 statue,
School of Journalism, Columbia
University, 28¾ in. (73 cm) high
New-York Historical Society,
New York

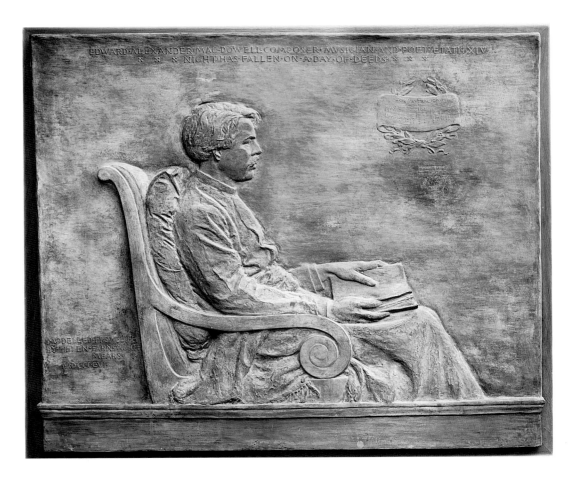

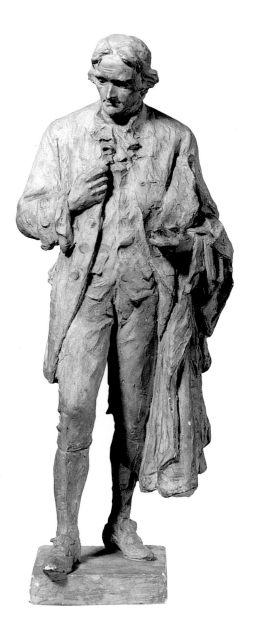

WILLIAM ORDWAY PARTRIDGE

The revolution that David d'Angers started in the early nineteenth century was long lived. Its impact on American sculpture can be detected well into the twentieth century. The bronze pedestrian statue of Thomas Jefferson of 1914, for example, by William Ordway Partridge, in front of the School of Journalism at Columbia University in New York City, owes a debt to that Romantic revolution. Yet, it is altogether distinct from David's Jefferson in composition, mood, and modeling. While it is true that Partridge's spontaneous style of modeling and his fresh naturalism are legacies of the eighteenth and nineteenth centuries, they were more immediately shaped by the works of the modern master Auguste Rodin. Moreover, the way Partridge conceived sculpture derives in large part from his unique blend of the visceral and the cerebral.[25] Those two components are easier to see in one of Partridge's small studies for the Jefferson statue in the New-York Historical Society, as his hand and mind are more evident in the sketch than in the 8½-foot-high bronze statue.

 The figure of Jefferson is immediately perceived as an organic whole, and the simplicity of the silhouette holds it together. The anatomical proportions are generally correct, but how the body parts and the clothing are shaped and arranged and how Partridge incorporates gesture—stance, turn of the head, position of hands—into this little figure that embodies the fullness of life is the magic by which Partridge achieves monumentality.

Jefferson stands in easy contrapposto, his shoulders, like a swimmer's, slouch slightly forward, and his right hand grasps the right lapel of his coat while cape and hat are neatly managed by the left arm and hand. He looks down and to the right, calmly. The general forms of torso, legs, and head are solidly built, while the surface detail is merely suggested. Partridge's loose modeling and rejection of superficial detail that Wayne Craven has noted produce the partially realized aspects of the study, which the mind's eye completes with ease.[26] This *engagement* is part of the power of Partridge's sculpture, which has as much to do with his dramatic gifts as with his abilities as a sculptor. In addition to being one of the country's leading sculptors, Partridge was also an accomplished poet, author, critic, actor, and lecturer. Born in Paris, he was educated in private schools in the United States, then studied art in Paris, Florence, and Rome.[27]

CHARLES GRAFLY

The most respected master of the traditional portrait bust at the turn of the century was Charles Grafly. Art critic Adeline Adams correctly called Grafly "the foremost American sculptor of male portrait busts," leaving intact the reputation of her husband (Herbert Adams) as the foremost sculptor of female portrait busts.[28] While it is true that by the early twentieth century Grafly was unchallenged in portraiture, he had started out in pursuit of the Ideal muse. He won a Gold Medal, for example, for the *Vulture of War* in the Paris Exposition of 1900, and it was praised in Buffalo's Pan American Exposition of 1901, for which he also created the *Fountain of Man*, an allegory of the five senses.[29]

In 1905, when he finished the personifications of France and England for Cass Gilbert's United States Custom House in New York City, Grafly began to make portraits exclusively. His search through traditional allegory to find out what life was all about had led him to a dead end. He found the more direct route for him was through the male portrait bust, and except for a brief time toward the end of his life, he remained completely committed to it.

In Grafly's quest to understand the nature and personality of each of his subjects, he transcended style so that nothing stands between the spectator and the presence of the subject, which is evidenced in his bust of Edward Redfield of 1909. Grafly's portraits, then, embody a kind of "real presence," and as such reflect a powerful strain running through the portraiture of the period. How successful the portrait was depended upon first the sculptor's vision, perception, and insight, and second upon his or her ability to capture all of that in clay. Grafly sketched and modeled from the figure or the head every day and loved to share the experience with fellow artists. He told his daughter how he and Robert Henri, the Ashcan School painter, on their ocean voyage to France would start their day by sketching each other.[30] Such an exercise remains forever fresh for the portraitist, because the artist can never fully comprehend the human figure or form nor capture it totally in

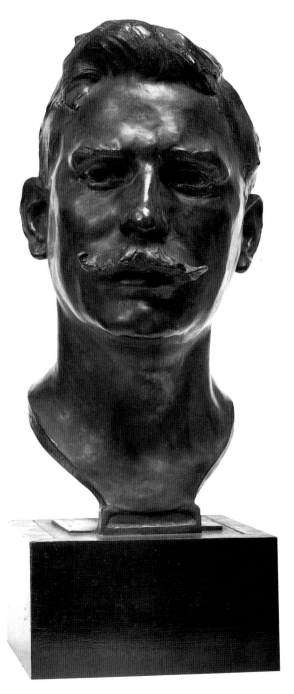

Charles Grafly (1862–1929)
Edward W. Redfield, 1909–12
Bronze, 16 × 17½ × 8⅓ in.
(40.6 × 44.5 × 21.2 cm)
The Corcoran Gallery of Art,
Washington, D.C.

any medium. Most important of all, however, for Grafly, he sought to find the true person within, which was even more elusive.

EXPRESSION IN COMPOSITION

The form of the portrait can determine the information that is communicated about the subject, as in the portrait d'apparat. Charles Niehaus's portrait of J.Q.A. Ward, for example, is a naturalistic and down-to-earth half-length view of the sculptor in his smock with a mallet in his right hand and a modeling tool in his left hand, showing that he was both a modeler and a carver, at home with clay as well as with stone, even though most of his work was modeled and then cast in bronze. The concept is characteristic of the nineteenth century, in showing the sculptor in working attire and in the half-length format. By the eighteenth and nineteenth centuries, portraying the artist as an intellectual and gentleman in fine clothing, unsullied by the craft of his art—an image that had prevailed since the Renaissance—gave way to portraying the artist working with his tools and his materials. The half-length composition derived from the portraiture of such Baroque masters as Coysevox, Coustou, and especially Bernini, as Janson has shown, and it allowed Niehaus to portray Ward with his tools as the attributes of the sculptor, a common device in both European and American sculpture well into the twentieth century. The English sculptor Alfred Gilbert, for example, had shortly before (1893) portrayed Dr. Hunter, a noted physician of St. George's Hospital, holding an *écorché*, a flayed figure illustrating the human anatomy, thus a symbol of his profession, and the French sculptor Constantin Meunier's *Puddler* of 1890 carries his mud paddle over his shoulder.[31] Malvina Hoffman used the half-length format similarly in some of her Hall of Man pieces of the 1930s, such as the *Portrait of a Warrior* with a head-knife over his shoulder and the *Woman Mud Carrier* of Hong Kong carrying a bamboo pole over her shoulder. In *Apache Brave*, the device enabled Hoffman to show the Indian's hair braids, which hung down across his chest, and she could show the plethora of breast ornament in her *Portrait of a Padaung Lady of Upper Burma*.[32] William Zorach used the device to incorporate the attributes of a child in his *Child with a Cat* of 1926 in the Metropolitan Museum of Art, and it allowed Hugo Robus to portray *A Woman Combing Her Hair*, 1927.

American sculptors, however, did not use the half-length format only for utilitarian ends, exclusively. It could be used to enhance a likeness or the artist's conception of the subject, as in Jacob Epstein's *Portrait of Dolores* of 1923,[33] with folded arms, or in Hoffman's *Pavlova* of 1924,[34] who has crossed her hands across her breast, expressive hands that were so much a part of the ballerina's choreography. Pavlowa's intimate sideward glance and crossed hands recall Joseph Chinard's delicate portrait of *Madame Récamier* of c. 1802, which Hoffman must have known, so close are they in composition and in what Fred Licht has called the piquance of Chinard's bust.[35] Another example is Edith Woodman Burroughs's bronze portrait of the American artist, author,

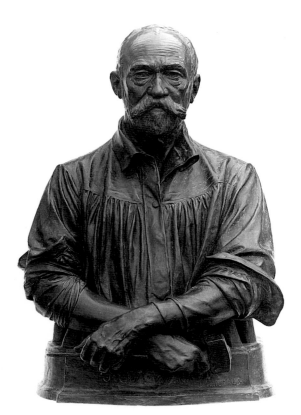

Charles Niehaus (1855–1935)
John Quincy Adams Ward, c. 1900
Plaster, half-figure
National Portrait Gallery,
Smithsonian Institution,
Washington, D.C.

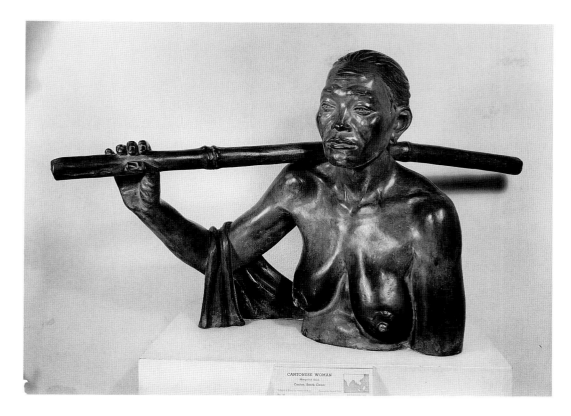

TOP
Malvina Hoffman (1885–1966)
Cantonese Woman, 1930s
Bronze, lifesize
Hall of Man, Field Museum,
Chicago

BOTTOM LEFT
Malvina Hoffman (1885–1966)
Samoan Man, 1930s
Bronze, lifesize
Hall of Man, Field Museum,
Chicago

BOTTOM RIGHT
Malvina Hoffman (1885–1966)
Photograph of artist at work

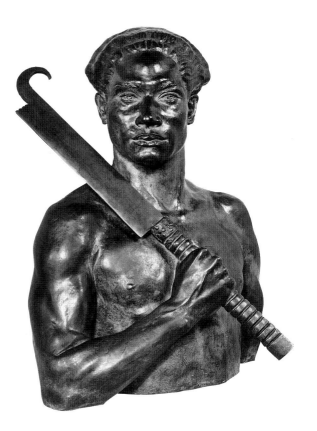

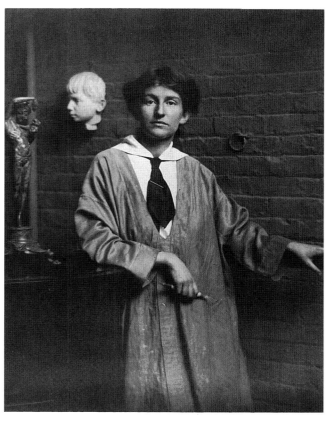

and teacher John La Farge of 1908 in the Metropolitan Museum of Art. The first two fingers of the left hand rest against his wrinkled face, providing support and enhancing the contemplative mood Burroughs catches in La Farge's aging face. One of Brancusi's most poignant representational figures is his half-

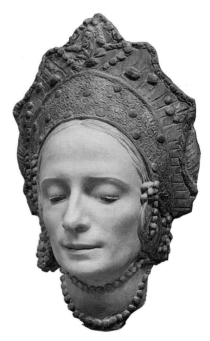

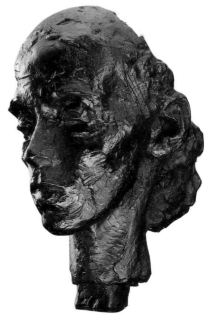

length portrait of a *Sleeping Child* of 1907, which must have been directly inspired by Aimé-Jules Dalou's engaging *Head of a Sleeping Baby* of 1878, in the Musée du Petit Palais, Paris.

When the portrait is disengaged from its pedestal or bust format, its traditional anchor, it can be a particularly powerful fragment of human expression. Its origins in modern sculpture are found in Rodin's *Man with the Broken Nose* of 1864, the portrait of a laborer named Bibi, whose "picturesque" features appealed to Rodin. Art historian Fred Licht considers it Rodin's "first completely characteristic work,"[36] and Rodin called it "the first good piece of modeling I ever did," one that he felt he never surpassed. He claimed that it "determined all my future work," and he made several versions of it, none as good, by his own admission.[37]

In departing from the traditional bust, the customary practice of incorporating part of the shoulders and chest, Rodin eliminated all distraction from his primary interest in the portrait: the face. While his *Man with the Broken Nose* was rejected and criticized at first, it eventually had profound and widespread influence on the portrait, and freed the genre from its traditional format for succeeding generations of sculptors.

The head as portrait has remained a popular mode of expression for sculptors ever since, in a wide range of styles. Malvina Hoffman, for example, who studied with Rodin in 1910 and 1911, was influenced by Bibi's portrait when she modeled the *Sakai Warrior* head for the Hall of Man series.[38] Its spontaneous modeling and dark patina emulate Rodin's irrepressible vitality. In her *Mask of Anna Pavlowa* of 1924, however, the treatment of the head is totally different.[39] In tinted wax, Pavlowa's features are smooth and finely finished with the immediacy of a life mask. It is as if the artist captures an eternal likeness just as the soul departs the body, a typically Victorian sensibility.

The most powerful collection of heads as portraits that capture the sitters' inner selves are Augustus Saint-Gaudens's studies of black soldiers for the *Shaw Memorial*. George Grey Barnard provides us with a compassionate frankness in his marble portrait of *Abraham Lincoln*, 1919, and George Winslow Blodgett's heads of American Indians are idealized likenesses of the people of the Southwest he admired and grew to love.

Isamu Noguchi's heads of the 1930s are timeless icons to humanity and have yet to be fully appreciated. His well-deserved fame from his abstract and carve-direct work has all but eclipsed his masterpieces of representational portraiture of the 1930s. Reuben Nakian's portraits of the 1930s have suffered similar oblivion. Through his natural propensities and his training in the 1920s in Paris with Constantin Brancusi, Europe's leading proponent of carve-direct sculpture, Noguchi's sights were set. Before he went to Paris, however, he had studied with Gutzon Borglum and then with Onorio Ruotolo at the Leonardo da Vinci School, and he had become proficient as a representational sculptor, even becoming a member of the National Sculpture Society. It was that side of his art that supported him through the early 1930s, upon his return to the United States from Paris. But by then, it was a representational style enriched by his Paris experience. His portraits in bronze and

terra-cotta from the early 1930s are very simply modeled heads. But they are peerless for their sensitivity to individual personality and for capturing the deeper meaning of the human spirit. Those qualities are especially evident in Noguchi's portraits of *Martha Graham, George Gershwin, José Orozco,* and *Buckminster Fuller.*[40]

The exhibition of his portraits in 1934 at the Marie Harriman Gallery drew favorable response from art critics and produced sales in the art world. It was that year that his portrait of the contemporary American dancer, poet, and artist Angna Enders was purchased by the Metropolitan Museum of Art.[41]

Two other major sculptors who are known primarily for their abstract works but who excelled in naturalistic portraiture in the 1920s and 1930s were Reuben Nakian and Gaston Lachaise. The expressionistic treatment of Lachaise's portrait of the artist John Marin of 1928, for example, with its spontaneously modeled surfaces, is among the best portraits of the period, yet it is so unlike the smooth and shiny surfaces of his well-known erotic nudes or even his stylized busts such as his alabaster portrait of Georgia O'Keeffe of 1923 in the Metropolitan Museum of Art.

Jo Davidson carried the portrait as self-revelation to new heights in the 1920s and 1930s, and his heads are among the most moving of all twentieth-century sculpture. While Noguchi and Nakian were making portraits in a traditional vein to support themselves, Davidson was making them because "portraiture became an obsession" with him. As he sought to accept his sitter not as a source of abstract design but "with sympathy," as he put it, to understand "the uniqueness of the face," his objective was to "express the living, talking, breathing man as I saw him," the artist declared.[42]

Eschewing artifice, Davidson found, like Charles Grafly, that man's true

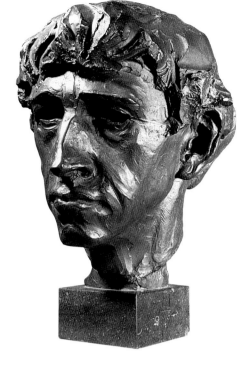

Gaston Lachaise (1882–1935)
John Marin, 1928
Bronze, 12 × 9 × 9 in.
(30.5 × 22.9 × 22.9 cm)
Museum of Modern Art,
New York

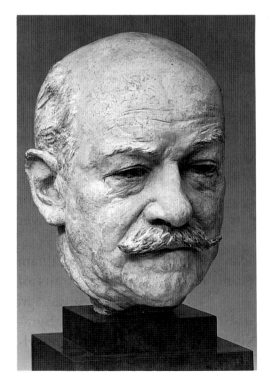

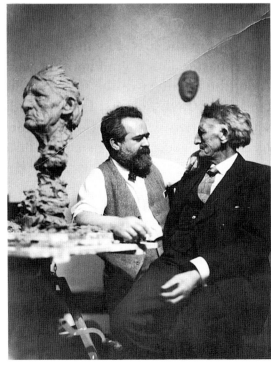

BOTTOM LEFT
Jo Davidson (1883–1952)
Jules Simon Bache, 1949
Terra-cotta, 17 × 7 ¼ × 9½ in.
(43.1 × 18.4 × 24.1 cm)
The Metropolitan Museum of Art,
New York; The Jules S. Bache
Collection, 1949

BOTTOM RIGHT
Jo Davidson (1883–1952)
Photograph of the artist at work

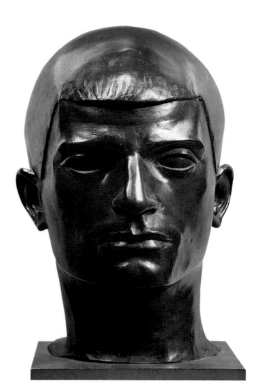

Maurice H. Sterne (1877–1957)
Bomb Thrower, 1919
Bronze, 17½ × 7 × 9½ in.
(44.5 × 17.8 × 24.1 cm)
The Metropolitan Museum of Art,
New York; Rogers Fund, 1922

Fritz Cleary (1914–1993)
Astronaut, 1950s
Stone, lifesize
Collection of the artist

spirit is revealed in the successful portrait. That spirit is uniquely captured in the contemplative terra-cotta head of the American financier Jules Bache of 1936, as the aging collector gazes downward, his lips slightly pursed beneath a full mustache. In Albert Einstein's bronze head of two years before, Davidson's spontaneous modeling calls forth a flickering surface of lights and darks that, along with the jaunty tilt of the famous scientists' head and his familiar shock of unruly hair, conjures not just the likeness of the genius but the warm spirit of the man.

Another rare glimpse into the human soul is preserved for us by Maurice Sterne in the *Bomb Thrower,* 1910. It is the bleak unembellished portrayal of a youthful anarchist, one of the many young people in the labor movement in Rome at the time Sterne was there. He made three variants.[43] Sterne combines political statement with contemporary European avant-garde simplicity and directness, which is the source of its power.

The bronze bust, iconic in its formality and frontality, consists of the head and neck of an unnamed subject set on a variegated marble block, which enhances its starkness. Tarbell sees the bust indebted to Brancusi and recalling Raymond Duchamp-Villon's portrait of Baudelaire.[44]

A sculptor of variety and rare insight into human personality, Fritz Cleary recalls Sterne's engimatic *Bomb Thrower* of 1910 in his *Astronaut* of the 1950s. The original was a portrait of Bob Wright, a student at Monmouth College who had studied writing with Cleary. The youth met an untimely death, while at Monmouth, and a group of his classmates commissioned Cleary to make the portrait as a memorial to the aspiring writer. In the 1960s, when the American astronauts Alan Shepard, John Glenn, Edward White, Neil Armstrong, Buzz Aldrin, and John Young came to world prominence, Bob Wright's likeness and crewcut evoked associations with America's pioneers in space, so Cleary exhibited a replica of Wright's portrait as the *Astronaut.*[45]

The product of an artistic household, Cleary seemed to be destined for a life in the arts. His mother was a violinist, his father an organist and choir master, and a grandmother was a painter and architect. William Van Alen, the architect of the Chrysler Building in Manhattan, was his mother's cousin. In high school, Cleary studied with Polynogtis Vargis, a Greek sculptor. Then, at the National Academy of Design he studied with Charles Keck, followed by a stint at the Beaux-Arts Institute of Design. He studied wood carving with Alexander Finta and modeled at the Clay Club in Greenwich. To support himself, he wrote and lectured on art and taught sculpture. By the time Cleary was thirty years old, he was exhibiting all over the country.

One of the nation's outstanding African-American sculptors, William Ellsworth Artis expressed the same clarity and restraint in his portraits of black subjects. Born in Washington, North Carolina, Artis later settled in New York City, where he studied at the Art Students League, then at Syracuse University, the State University of New York at Alfred, and Pennsylvania State University.[46]

While Artis sought in his portraits to show the beauty of African-Americans, critics called him "a poet of hope" because of the optimism and strength his busts embody, evident in his *Teenager* of 1973, in unglazed porcelain. He has works in the National Portrait Gallery of the Smithsonian Institution, in Washington, D.C.; the Walker Art Center in Minneapolis; Howard University Gallery of Art, Washington, D.C.; and the Afro-American Art Collection of Fisk University in Nashville, Tennessee, as well as other public and private collections.[47]

Paul Fiene's bronze bust of Grant Wood of c. 1942, the year the artist died, is a fitting memorial to the painter of *American Gothic* (1930). The blend of Wood's regionalism and his debt to Late Gothic and Northern Renaissance art in shaping *American Gothic*, his most famous painting, are embodied in Fiene's portrait, which is characterized by its smooth surfaces and linear articulation of detail. Composed of head and neck, the portrait is set on a tiered pair of light-colored stone blocks.

How angle and spontaneous modeling contribute to the animation of a portrait is paradoxically illustrated in Jacques Lipchitz's portrait head *Marsden Hartley Sleeping* of 1942, in the Whitney Museum of American Art. The pose Lipchitz caught was when the painter was clowning around imitating the pose of an old man Hartley had seen sleeping on a park bench.[48] The combination of Hartley's reclining head, closed eyes, and open mouth, with his left cheek resting against his hand, the flaccid features softly modeled, all makes for an animated portrait of the painter imitating a poignant slice of life, the sleep of an old man.

The composition is remarkably similar to Alexander Falguiére's head of a *Wounded Soldier* of c. 1872 in the Yale University Art Galleries, which Lipchitz may have had in mind and which illustrates the pervasiveness of Rodin's influence. Falguiére and Rodin were friends and made portrait busts of each other.[49]

GREAT AMERICANS COMMEMORATED

Two major collections that honor the United States' outstanding citizens with their portraits were established by leaders in American education. Justin Smith Morrill (1810–1898), who was the author of legislation in 1862 and 1890 that established land grant colleges and the principles of federal aid to education in the United States, proposed the establishment of a National Statuary Hall. When the House of Representatives moved to its new chamber in the South Wing of the Capitol, Morrill's proposal to maintain the old and historic Hall of Representatives as a hall for statues of distinguished Americans was passed into law on July 2, 1864.[50]

In spite of the presence of some missionaries such as California's Junipero Serra and Washington's Marcus Whitman, and physicians such as Colorado's Florence Rena Sabin, most of the statues in Statuary Hall honor public officials. Dr. Henry Mitchell MacCracken, chancellor of New York University, therefore, conceived the idea of a Hall of Fame to honor great

TOP
William E. Artis (1914–1977)
Teenager, 1973
Unglazed porcelain, 14 × 8 in.
(35.6 × 20.3 cm)
Location unknown
BOTTOM
Paul Fiene (1899–1949)
Bust of Grant Wood, c. 1942
Bronze on marble base,
16¾ × 7¾ × 8⅝ in.
(42.5 × 19.7 × 21.9 cm)
Whitney Museum of American Art; New York; Gift of Mr. and Mrs. George D. Stoddard

Americans from all walks of life.[51] A national body of electors from different fields would make the selections, and the competitions would be judged by leading university professors, jurists, and editors. In 1900, the year the Hall of Fame was founded, the officials included Theodore Roosevelt, governor of New York; Professor Woodrow Wilson, of Princeton; and M. Carey Thomas, president of Bryn Mawr. The Hall of Fame now honors eighty-seven men and ten women from sixteen different categories within the arts, sciences, humanities, government, business, and labor.

The Hall of Fame, designed by Stanford White and erected in 1901, is a semicircular covered colonnade in the Beaux-Arts tradition, 630 feet long and 10 feet wide, open on either side, which caps the high foundation walls of Stanford White's Gould Memorial Library, Hall of Philosophy, and the Hall of Languages. Raised up on this massive basement at the highest point in the Bronx, the Hall of Fame commanded a panoramic view of the Harlem River below and the Palisades to the west until Marcel Breuer's Julius Silver Residence Center and Cafeteria intervened in 1964.[52] Between the columns are the bronze busts of distinguished Americans, modeled by some of America's leading sculptors. Stanford White designed the space so that the busts are seen from below eye level, requiring the spectator to look up at them as a gesture of respect. Because the angle and the distance makes the busts appear to be smaller than they actually are, they are slightly over-lifesize so that they appear to be lifesize.

The people honored include famous Americans like John Quincy Adams, James Adams, Horace Mann, and Harriet Beecher Stowe, as well

ABOVE
Jacques Lipchitz (1891–1973)
Marsden Hartley Sleeping, 1942
Bronze, 15⅜ × 7¼ × 10¼ in.
(39.1 × 18.4 × 26 cm).
Whitney Museum of American
Art, New York; Gift of
Benjamin Sonnenberg

RIGHT
McKim, Mead & White,
architects
Hall of Fame for
Famous Americans
Bronx, New York

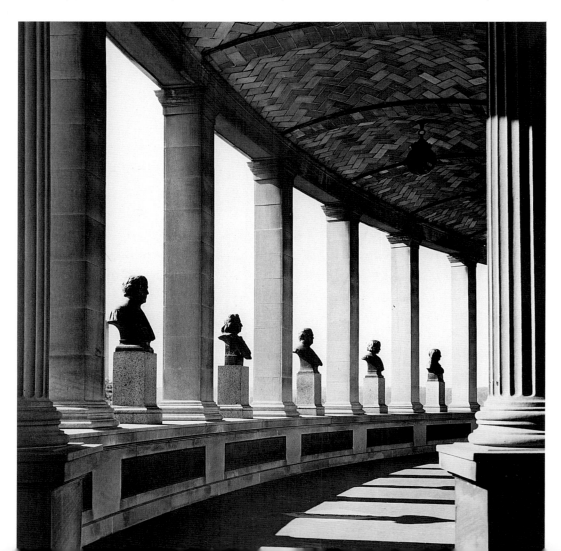

as those not as familiar to the general public like Maria Mitchell, professor of astronomy at Vassar College and the first woman elected to the American Academy of Arts and Sciences, and Matthew Fontaine Maury, who in 1855 was the author of what is considered to be the first work of modern oceanography.[53]

Sculptors who have modeled medallions for the hall include Donald DeLue (John Adams, Robert E. Lee), EvAngelos Frudakis (John Quincy Adams, Lillian Wald), Albert Wein (William Ellery Channing), Robert Weinman (James Buchanan Eads, James Madison, Daniel Webster, Emma Willard, Roger Williams), Granville Carter (Jane Addams, James Fenimore Cooper, Thomas Alva Edison, "Stonewall" Jackson, George Washington), Laci De Gerenday (David Glasgow Farragut), Laura Fraser and Karl Gruppe (Mary Lyon, Charles Gilbert Stuart), Walker Hancock (Stephen Collins Foster), Malvina Hoffman (Henry David Thoreau), Thomas Lo Medico (Patrick Henry, Alice Freeman Palmer), Albino Manca (Theodore Roosevelt), Eleanor Platt (James Kent, Maria Mitchell, Eli Whitney), and Elizabeth Weistrop (John Greenleaf Whittier).[54]

When the black sculptor Inge Hardison learned of the Hall of Fame in 1960, she was shocked that Booker T. Washington was the only black person honored.[55] What about such great black Americans as Harriet Tubman, Frederick Douglass, Phillis Wheatley, and Sojourner Truth? She, therefore, created her own hall of fame for black Americans, but made up of small busts so that they could fit on a mantel or windowsill. She calls her series "Negro Giants in History."[56]

Little known in the white art establishment, Hardison is revered among African-Americans. The syndicated columnist Tony Brown wrote in 1987: "This woman's life has been dedicated to preserving our legacy. . . . She will keep the eternal flame of our struggle alive with her genius."[57]

Inge Hardison was born in Portsmouth, Virginia, and grew up near Boston. She studied at the Art Students League in New York City and with William Zorach in the 1940s.

The founders of the Hall of Fame were meticulous in establishing a system by which worthy Americans could be immortalized. Unfortunately, they were not as mindful of the physical future of the hall, and no perpetual maintenance was provided. Consequently, the hall and the busts were neglected so that massive restoration efforts have been required to save this national treasure.[58] In 1980, for example, a five-year reconstruction of the hall was begun. At a cost of $3,000,000, the project was completed in 1985. The hall is once again sound, and in 1992, a conservation program for the bronze busts was established to restore them and to keep them properly maintained. It is hoped that a perpetual maintenance program will ensure that the monument will no longer be neglected.[59]

Inge Hardison (b. 1914)
Sojourner Truth, 1982
Bronze, 24 in. high
Collection of the artist

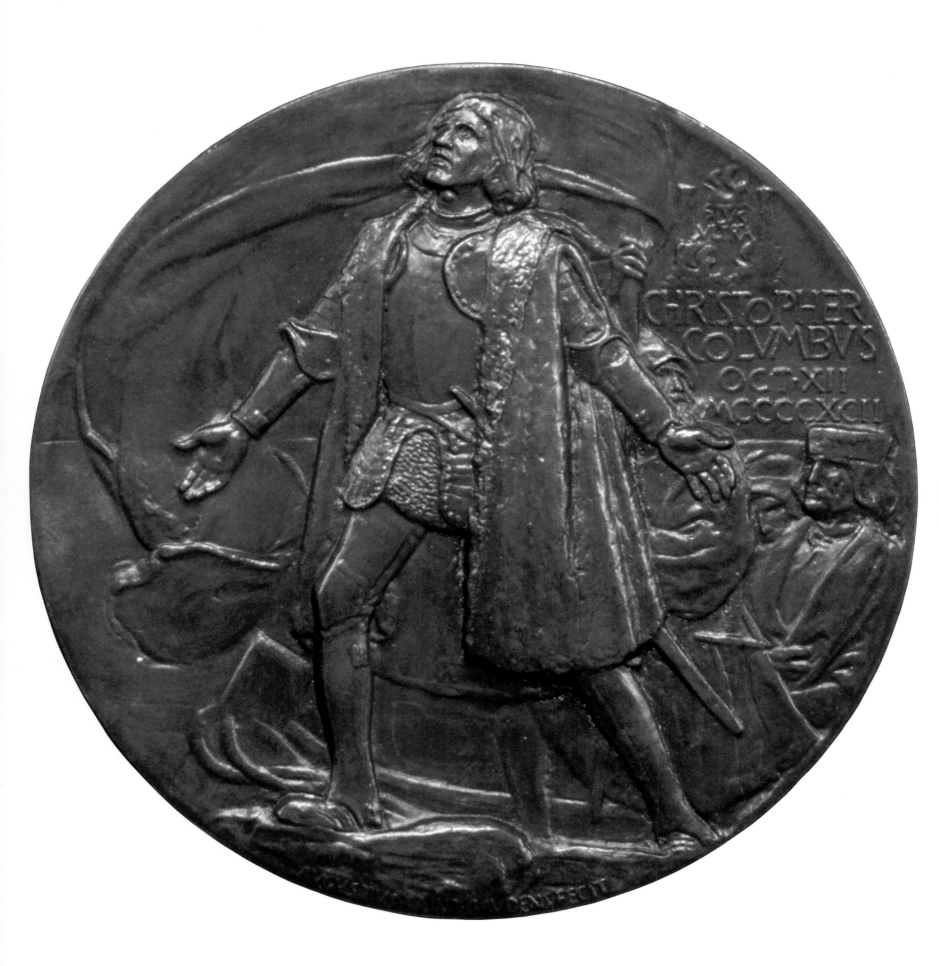

CHAPTER SEVEN
THE ART
OF THE MEDAL

The revolution in figurative sculpture that David d'Angers initiated in modeling the historic portrait, he extended to the art of the medal, thereby opening up to sculptors of the nineteenth century a medium that had been dominated by engravers since the seventeenth century.[1] Then, with the development of the reducing machine and refined methods of engraving, the sculptor's three-dimensional model could be translated into medallic art of rare sophistication, which was popularized throughout Europe by such French masters as Jules-Clement Chaplain and his pupil Louis Oscar Roty. Roty's painterly mode was influenced by Henri Chapu, who had developed new subtleties of low relief, which refined the medium further, attracting not only his contemporaries but also his students at the Academy Julian in Paris.

Some of those students were Americans, including John Flanagan, Hermon MacNeil, and Bela Lyon Pratt, who along with Olin Warner and Augustus Saint-Gaudens, the most innovative and accomplished American sculptor of the period, helped to shape the future of medallic art in the United States.[2] Warner and Saint-Gaudens studied with Jouffroy at the Ecole des Beaux-Arts, and Saint-Gaudens went on to study the Italian Renaissance masters. From the sensitive modeling of Pisanello and Donatello's unique *schiacciatto* (flattened-out relief), Saint-Gaudens developed a new style of energetic and irregular relief, distinguished for its pictorial, textured, and sculptural properties, which achieved a balance of illusionism and permanence unequaled then or since.[3]

The great expositions of the American Renaissance provided the perfect venue for America's medallic artists in the commemorative medals executed by the members of the National Sculpture Society.[4] Saint-Gaudens, for example, set the precedent with his award medal for the 1893 Columbian Exposition in Chicago, scholars have shown, and such sculptors as Hermon MacNeil carried on the practice with the Pan American Exposition Medal of 1901. Moreover, reproductions in limited editions of a wide range of medals by America's leading sculptors "furnished a model for the successful marketing of small-scale sculpture," Barbara Baxter correctly observed in her enlightening discussion of the Beaux-Arts medal in America.

The art of the medal reached new peaks from 1900 to World War I, and with the new interest in the medal came improved technology in its production. In addition to that of Tiffany and Gorham, accelerated medallic

OPPOSITE PAGE AND ABOVE
Obverse by Augustus
Saint-Gaudens (1848–1907)
Reverse by Charles E. Barber
(1840–1917)
*Award Medal for the World's
Columbian Exposition,*
Chicago, 1893
Struck bronze: gilt obverse,
silvered reverse, diameter: 3 in.
(7.6 cm)
American Numismatic Society,
New York

production of the twentieth century spawned such new companies as Joseph K. Davison's Sons in Philadelphia and the Medallic Art Company in New York City, creating a substantial industry in medallic art in the United States.

BETTER COINAGE FOR THE UNITED STATES

Beaux-Arts training in France had produced not only the dominant tradition in sculpture there but also what was generally acknowledged as the best-designed coinage anywhere in the world at the time, and it inspired the United States to do something about its circulating currency.[5]

Unhappy with the inferior status of United States coinage in the late nineteenth century, James Kimball, it has been noted, director of the United States Mint, called for its general redesign. Moreover, there were enough American sculptors trained at the Beaux-Arts by the 1890s that the United States should have been able to rely on its own sculptors for the task.

Strong lobbying produced Congressional action in 1891 to change any coin design in use for twenty-five years or more. At the insistence of the American Numismatic Society and the National Sculpture Society, supported by other leading arts groups in the country such as the Architectural League of New York, the Society of American Artists, the National Academy of Design, and the Pennsylvania Academy of Fine Arts, the United States Treasury launched a campaign to enlist America's best sculptors for the design of the nation's coinage, not only to enhance the culture of the nation but also to acquaint the general public with superior art and design and to generate a taste for small-scale sculpture.[6]

The American Numismatic Society and the National Sculpture Society found their most influential supporter in Theodore Roosevelt, who called on the nation's leading Beaux-Arts sculptor, Augustus Saint-Gaudens, to guide the project, which produced a body of superior medallic designs over the first two decades of the twentieth century that has yet to be surpassed. As the country now seeks once again to redesign its circulating currency, those designs can provide inspiration and perhaps even useful guidelines for future designers.[7]

In 1907, the ailing Saint-Gaudens led the way with his design of a twenty-dollar gold piece, modeled by Henry Hering, which is generally acknowledged by medalists to be "the finest numismatic issue in United States history."[8] It set new standards of excellence. His striding Victory on the obverse was inspired by the Victory for his *Sherman Monument*, which had been unveiled in 1903, and the eagle on the reverse came from an early American coin.

Naturalistically portrayed historical figures and indigenous themes were sought in the new coinage to replace the traditional engravers' stiff modeling and Neoclassical imagery. Bela Lyon Pratt, a former student of Saint-Gaudens, for example, designed a five-dollar gold piece in 1908, which

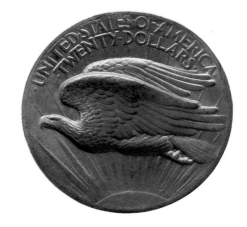

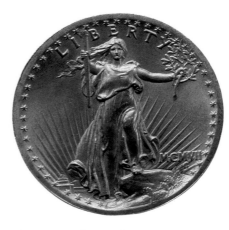

Augustus Saint-Gaudens
(1848–1907)
United States Twenty-Dollar Gold Piece (high relief version), 1907
Obverse and reverse
Struck gold
American Numismatic Society, New York

incorporated a naturalistic depiction of the head of an American Indian. It marked an innovative departure from the classical rendering of Indians in earlier designs. Lithuanian-born Victor Brenner designed the Lincoln head penny in 1909, commemorating the 100th anniversary of Lincoln's birth. It was the first penny to bear the words "In God We Trust." The motto was first used in 1864, on a two-cent piece, but that denomination was discontinued in 1873.[9]

Adolph A. Weinman designed the country's so-called "Mercury" dime in 1916. Actually the head on the obverse was not Mercury but Liberty, and the wings on Liberty's hat represented freedom of thought.[10] That same year, he modeled the Liberty half dollar, and the following year Hermon MacNeil designed a less well-known Liberty quarter. MacNeil's personification of Liberty was based on the figure for Painting from a medal Victor Brenner had designed for the Chicago Art Institute in 1909.[11] Weinman's Liberty for the half dollar, on the other hand, was inspired by Saint-Gaudens's *Sherman Monument* and a sower that Roty designed for the French two-franc piece. A standing eagle on the reverse is executed in the style of Saint-Gaudens.

James Earle Fraser, who had also studied in Paris and was probably Saint-Gaudens's favorite assistant, designed the "Indian head" or "buffalo" nickel in 1913, which bears an Indian head on the obverse and a buffalo (actually a bison) on the reverse. Fraser's nickel has been called the first uniquely American coin.[12] His lifelike image of the Indian was actually based on three different Indians he knew: Chief Iron Trail, John Big Tree, and Two Moons. He modeled his "buffalo" from an animal in the New York Zoological Park. Fraser's ambition to incorporate an "American character" into the nation's coinage came largely from his childhood experiences among the Indians in the Dakota Badlands, where his father was laying track westward for the railroad.[13] Fraser's tenure on the National Arts Commission (1920–25), and his subsequent role as the commission's consultant on coins and medals, in addition to his own designs, helped to produce "the Americanization of subject matter," which historian August Freundlich considers Fraser's greatest contribution to numismatics.[14]

THE SALTUS AWARD

Fraser was the first recipient of the Saltus Medal in 1919, which was to become the most prestigious award in medallic art. It is awarded for lifetime achievement in medallic art.[15] J. Sanford Saltus, one of the most generous and dedicated supporters of the American Numismatic Society, established a $5,000 fund for striking medals to be awarded "to sculptors for distinguished achievement in the field of the art of the medal, to authors who have merited signal honor for numismatic research and scholarship, to those who have materially aided in broadening the knowledge of the science of numismatics."[16] A. A. Weinman, who designed the medal, was its second recipient. He received it in 1920, for his contribution to the improvement of American coinage.

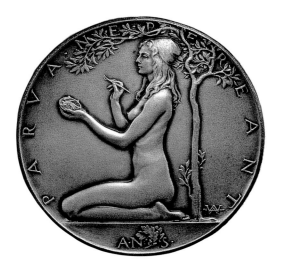

A. A. Weinman (1870–1952)
J. Sanford Saltus Award,
1919, obverse
Galvano, gilt copper,
17¾ in. (4.5 cm);
struck silver, 3⅛ in. (7.9 cm)
American Numismatic Society,
New York

THE AMERICAN NUMISMATIC SOCIETY

The United States government's actions in the 1890s for better coinage were coincident with the National Sculpture Society's leadership in promoting medallic art and with the more active role the American Numismatic Society was playing in furthering the art of the medal. Founded in 1858, the society was essentially a fellowship of collectors organized for "the collection and preservation of the coins and medals struck in this country, with an investigation into their history, and such connate matters as the society may deem worthy of its attention."[17]

As a learned body of specialists and antiquarians, whose primary interest had been collecting, study, and education, producing medals did not play a major role in the society's activities until the Columbian Exposition of 1893. The society had produced only five medals by 1890. From 1893 to 1926, however, it produced thirty-five medals commemorating events such as the dedication of Grant's Tomb, the 25th National Conference of Charities and Corrections, and the formation of Greater New York in 1898.[18]

As the production and exhibition of medals to commemorate significant events became part of the society's policy, its president in 1900, Andrew Zabriskie, called for the establishment of a school for medal design and die cutting that would combine the refinement of the French Beaux-Arts tradition with the strength and breadth of American sculpture.[19] The National Academy of Design cooperated with the society, but the school was unsuccessful in attracting serious professionals, and it failed after five years (1900–05).[20] In spite of the school's failure, however, the society attracted the country's leading medalists, and in the first two and a half decades of the twentieth century, the American Numismatic Society became a pervasive force in furthering medallic art in America. By the Great Depression, however, the society had shifted its focus by investing its energies in scholarly pursuits, so that it became primarily a research institution, producing only four medals from 1927 to 1971. As the society retired from the field, however, another group was organized that had its roots early in the century.[21]

In 1909, long-time American Numismatic Society member Robert Hewitt, Jr., and critic Charles de Kay, impressed by the successes of organizations in France, Belgium, and Austria in promoting medallic art, founded the Circle of Friends of the Medallion.[22]

Hewitt was a real estate man by profession and a numismatist by avocation. De Kay was a noted *New York Times* art critic and author on art, and an organizer of the National Sculpture Society. In the fifteen years of its existence, the circle sponsored twelve medals by some of America's leading sculptors, including John Flanagan, Victor Brenner, Paul Manship, and Isidore Konti. Some 500 medals were struck from the twelve issues, it has been noted, but with the outbreak of World War I membership declined and the circle died. But the idea did not.

THE SOCIETY OF MEDALISTS

George DuPont Pratt, the noted preservationist and benefactor of the arts, who had been a member of the circle, established the Society of Medalists in 1930, along the lines of the earlier organization but with major differences, Joseph Veach Noble notes.[23] It is a not-for-profit organization, its competitions are international in scope, and it produces two medals a year that go to the membership. It remains the largest organization of its kind today, with 2,000 members.

The first medal the society issued, a hunter with his dog, was designed by Laura Gardin Fraser, whose design for the Alabama Centennial half dollar, 1921, made her the first woman to design a government coin.[24] She also designed the Congressional medal for Charles A. Lindbergh in 1929, and she collaborated with her husband, James Earle Fraser, on the Oregon Trail half dollar in 1926, called America's "most beautiful" coin.[25]

The society has continued to choose distinguished sculptors throughout its more than sixty years. Its issues embrace all styles and treat a wide range of subjects. They commemorate historical events such as Charles A. Lindbergh's nonstop solo transatlantic flight (Frederick MacMonnies, 1931), the explosion of the atomic bomb (Berthold Nebel, 1945), World Peace (for example, Chester Beach, 1937; Edward McCartan, 1939; Cecil Howard, 1950), Indian lifeways (Hermon A. MacNeil, 1931; John Edward Svenson, 1972), the creation of the universe (Anthony de Francisci, 1935), philosophy (Stanley Bleifeld, 1974), human love (Bruno Lucchesi, 1975), the Pilgrims (Anthony Notaro, 1976), clowns (Dexter Jones, 1984), unicorns (Marcel Jovine, 1980), and dance (Carter Jones, 1983).

The medals range widely in conception, and some incorporate unorthodox shapes. Richard McDermott Miller, for example, pierced his medal of 1985 to incorporate both sides of the medal to catch the subtleties of the sexes in a dynamic interplay between man and woman. In his cat and mouse, 1987, Robert Weinman created a wedge of Swiss cheese incorporating the drama of the feline and the rodent, so the piece is both a medal and a diminutive freestanding sculpture, Noble has observed.[26]

A RENEWAL

In 1988, with its exhibition "The Beaux-Arts Medal in America" and its comprehensive catalog that accompanied the exhibition, the American Numismatic Society once again formally "turned its attention to medallic art," as Alan M. Stahl, curator of medals for the society, has noted.[27] This shift may have been presaged by the society's 125th anniversary medal of 1983, a design that is noteworthy for its hieroglyphic portrayal of the society's history. It was designed in a rectangular format by Marcel Jovine, a gifted and prolific medalist, who is also a past president of the National Sculpture Society. The obverse bears the image of an artisan striking a coin and surrounded by coins from the society's collection. On the reverse, Jovine has

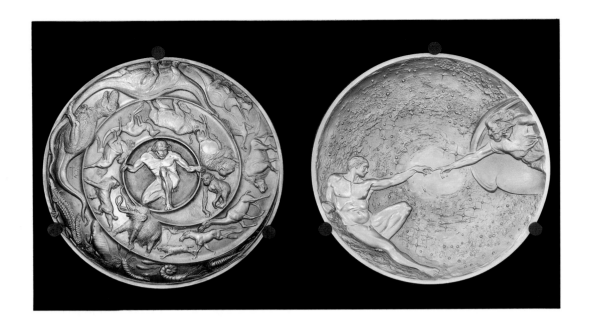

Marcel Jovine (b. 1921)
Medal of Creation, 1990
Copper, 4 in. (10.2 cm)
Society of Medalists, New York

portrayed the screw press and a pantograph for reducing designs in the preparation of dies.[28]

In 1984, Jovine won the J. Saltus Award, and in 1987, the *New York Times* called Jovine's design for the $5 gold piece that year to honor the Bicentennial of the Constitution "the most impressive work of coinage art to appear in this country in many years." Its issue of more than 850,000 examples has not only brought Jovine's art to a wider public but also has increased the public's appreciation of commemorative coins.

What Stahl has called the culmination of Jovine's career to date is the Creation medal, the society's 1990 issue.[29] For the obverse, Jovine borrowed Michelangelo's *Creation of Adam* from the ceiling of the Sistine Chapel in Rome as the dominant image. To express the broad sweep of the evolution of life and the universe, from its origins, Jovine portrays myriad animal, human, and cosmic forms emerging from the center and spiraling outward. The convex surface of the medal acts to propel the centrifugal composition with enormous force, enhancing the drama of Jovine's conception of the Creation.

Jovine is also a well-known *animalier* of Thoroughbred horses. *Spectacular Bid*, for example, won the National Sculpture Society's M. H. Lamston Prize for meritorious sculpture at the society's 1983 exhibition. Moreover, Jovine's bronze of the famous pacer Walt Hanover illustrates the sculptor's unique system of anatomical modeling, which produces not only recognizable portraits but also "living animals caught in a moment of action," as Stahl has noted.

The postwar generation knows Marcel Jovine through the Visible Man and the Blessed Event Doll, which he created and designed for the toy industry before turning his hand to sculpture as fine art.

One of the nation's most illustrious medalists, Elizabeth Jones served as chief sculptor and engraver of the United States Mint in Philadelphia from 1981 to 1990.[30] The eleventh person to hold that office, she is the first woman ever selected. Trained at the Italian State Mint in Rome and inspired

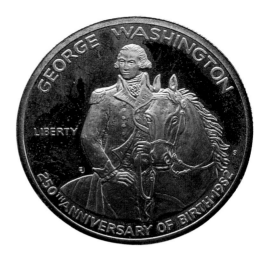

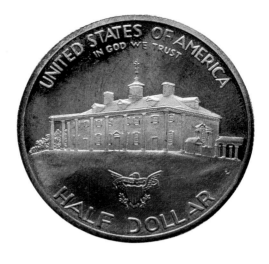

Elizabeth Jones (b. 1935)
George Washington 250th Anniversary Coin, 1982
Obverse and reverse
Silver
American Numismatic Society, New York

by the great Renaissance masters of the medal, Jones dedicated herself to improving the design of the nation's coinage.[31]

Some of Jones's own designs were struck. Her first coin design at the mint, for example, was a commemorative half dollar celebrating the 250th anniversary of George Washington's birth in 1982.[32] The obverse portrays Washington on horseback and was inspired by a painting of 1824 by the early American painter Rembrandt Peale. The reverse shows the eastern façade of Mount Vernon, Washington's home on the Potomac. Linking her design to that historical period, Jones placed beneath the image of Mount Vernon an American eagle in the style of the eagle that appeared on a United States dollar issued from 1798 to 1804.

Marcel Jovine (b. 1921)
Portrait of a Pacer, 1985
Polychrome bronze, 11 × 20 in.
(27.9 × 50.8 cm); base, 14 in.
(35.6 cm) high
William Perretti

THE FIRST AMERICANS REMEMBERED

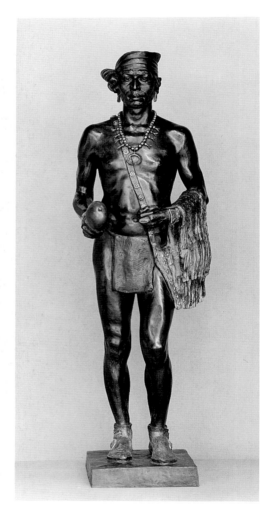

Malvina Hoffman (1885–1966)
Navajo Man, 1930
Bronze, 68 in. (172.2 cm) high
Field Museum of Natural
History, Chicago

OPPOSITE PAGE
J.Q.A. Ward (1830–1910)
Indian Hunter, 1864
Bronze, over lifesize
Central Park, New York

The broad sweep of human history, from the origins of mankind to the modern era, is uniquely embodied in the many cultures of the first Americans. While a study of those cultures, with their links to the past and to our origins, is beyond the scope of this book, a sampling of the sculptural record executed by the white man as well as by the descendants of the earliest settlers does provide us with some useful insights into the lifeways of the first Americans and, consequently, into our own humanity through the human figure in sculpture.

Wooden Indians marked the entrances to tobacco shops from America's Colonial period, and Neoclassical sculptors, European as well as American, carved Indians in the early nineteenth century. Luigi Persico's *The Discovery* and Horatio Greenough's *The Rescue*, for example, flanked the stairs to the United States Capitol in Washington, D.C. While the wooden effigies were popular symbols for the colonists as shop signs, the Neoclassical figures were high art and portrayed the aborigines as Greek gods. Thomas Crawford's *Indian Chief* of 1855, for the Senate pediment of the great east front of the United States Capitol, is such an example and was revered. A replica stands in the New-York Historical Society and remains a powerful record of the idealization of the North American Indian, whose physical proportions have little in common with the red man of the New World.

Among the earliest images of Indians made by our best sculptors that purported to be authentic portrayals was J.Q.A. Ward's over-lifesize *Indian Hunter* of 1864, in bronze, which stands in Central Park in New York City. Ward spent several months living among the Indians and making sketches of them as they went about their daily lives. The figure he fashioned is admirable for its naturalistic modeling of flesh and torso, and it established a major break with the previous generation's Neoclassical portrayals just described.[1] A comparison of *Indian Hunter* with Malvina Hoffman's lifesize statues of *Navajo* and *Blackfoot* Indians for the Hall of Man in the 1930s demonstrates that Ward was uncommonly successful in capturing the physique of an Indian. Nonetheless, Ward, too, was indebted to classical models. His composition for the *Indian Hunter* is based upon the ancient statue of the *Borghese Warrior* in Rome.[2]

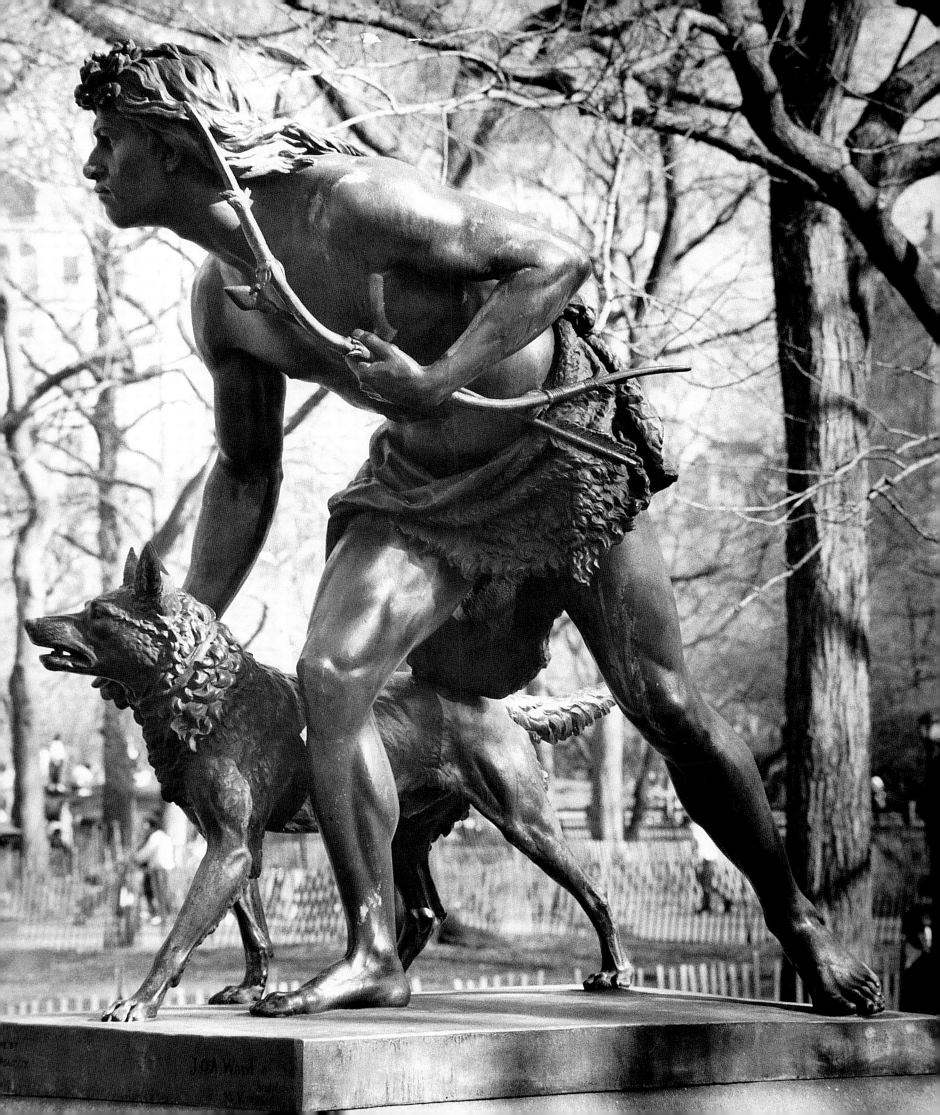

Although Ward eschewed European training, he was still influenced by it, for most of the leading American sculptors of the second half of the nineteenth century were trained at the Ecole des Beaux-Arts in Paris and worked in the studios of the Beaux-Arts masters. Those who were attracted to Indian subjects, therefore, saw them through classical lenses. At the same time, the country's increasing taste for greater naturalism could be satisfied through technological advances in bronze casting, which enabled sculptors to achieve more lifelike figures.

This curious ambivalence was further complicated by society's conception of who the Indians really were. They were perceived as either noble savages or savage brutes. Many white people did not believe Indians were actually human, and those who accepted their humanity believed, without a doubt, that Indians were not human in the same way they were.

While the perception of the American Indian remained confused, specific aspects of Indian life held great appeal for artists, whose images in paint, bronze, and stone perpetuated both myth and truth about the first Americans. Who, then, were those first Americans, and where did they come from?[3]

The First Americans

The prevailing theory among scientists is that the first Americans migrated from northeastern Asia across the great land bridge called Beringia, now under water and known as the Bering Strait, perhaps 18,000 years ago (some say 30,000 or more years ago). They were followed by subsequent migrations. As they followed the flora and fauna, their migration was a very gradual one, perhaps taking anywhere from 7,000 to 10,000 years. Then, the great glaciers in a warming trend began to melt, opening up what geologists call ice-free corridors, which allowed southward migration through the Yukon Valley and the Brooks Range foothills to the Mackenzie River Valley and the plains east of the Rocky Mountains.

Fossil remains in New Mexico document the presence of those first Americans deep in the New World by 11,500 years ago. As they dispersed, settled, and populated the enormously varied habitats throughout temperate North America over the next 10,000 years their various cultures underwent profound change. Plentiful game and wild flora supported hunter-gatherers, riverine areas produced fishermen. People learned to irrigate in the arid Southwest, and they farmed differently in the forested areas of the Eastern Woodlands. Foragers and small-game hunters populated the natural desert basin of Utah and Nevada, and the Plains Indians followed the buffalo.

Those first Americans developed different physical characteristics as they reproduced and adapted to their many varied environments. Those differences were further refined through intermarriage brought on by trade, war, and constant migrations, which produced an extraordinarily diverse population throughout North America. In other words, there was and is no such thing as "the North American Indian." Anthropologists identify twenty-one different

physical types in North America from the tall Indians of the Plains and the Eastern Woodlands to the short people of the Great Basin, with a passel of variations in between. By the time the Europeans arrived in the fifteenth century, the Indian population in North America was more than a million, the inhabitants spoke more than 1,000 different languages, and there were some 300 different nations or tribes with widely divergent lifeways.

While the general characteristics such as reddish-brown skin, high cheekbones, black straight hair, very little body hair, prominent noses, and dark eyes prevailed, there was enormous variety among the different Indian cultures.

WARNER'S LIKENESSES

Sculptor Olin Warner's sensitivity to those ethnological differences is rare, if not unique, for his time. He captured the wide range of facial types in the series of eight medallion portraits of Northwest Indians he modeled between 1889 and 1891. They are the first relief portraits of living American Indians, and they include chiefs as well as an Indian girl, Sabine, daughter of Kash-Kash, a Cayuse Indian. While all have high cheekbones, for example, Young Chief's and Poor Crane's, both Cayuse, are similar in shape and pronounced, while Lot's, a Spokane, are softened by vertical folds of flesh beneath them. Lot's earlobes are spare, but Chief Joseph's, a Nez Percé, are pendulous. Although all of their noses are long, Young Chief's is fine and chiseled, Lot's follows the contours of his forehead and is softer, Poor Crane's has a deep-set bridge, and Joseph's is aquiline and terminates sharply.[4]

A comparison with George Winslow Blodgett's bronze portrait head of a Tewa Indian of 1930, even though executed in the modern style, still demonstrates the physical differences in cultures. His sensitive response to his subject's individuality bespeaks his deep involvement with the Indians of the Southwest, whose different culture types he set out to record.[5] John

BOTTOM LEFT
Olin Levi Warner (1844–1896)
Joseph, Chief of the Nez Percé, 1889
Bronze; diameter: 17½ in.
(44.5 cm)
American Numismatic Society,
New York

BOTTOM RIGHT
Olin Levi Warner (1844–1896)
Poor Crane, Chief of the Cayuse Indians, 1891
Bronze; diameter: 10¾ in.
(27.3 cm)
The Metropolitan Museum
of Art, New York; Gift of Mr.
and Mrs. Frederick S. Wait, 1906

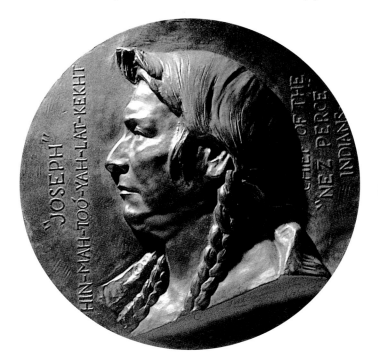

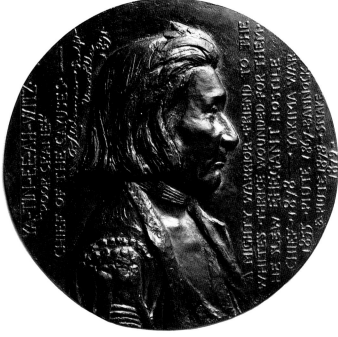

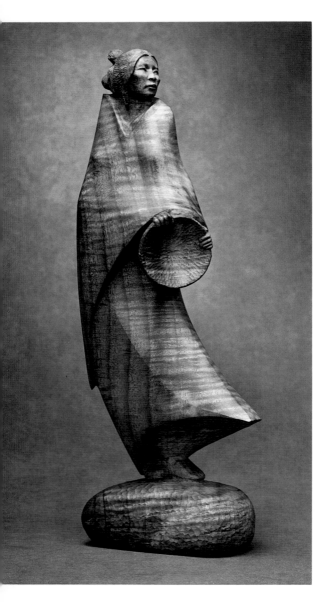

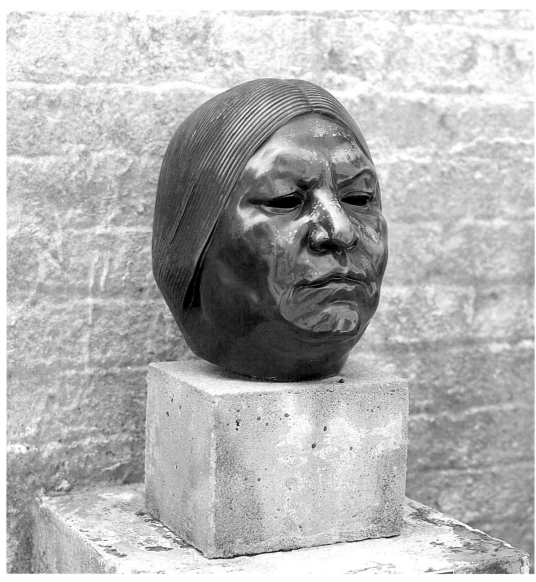

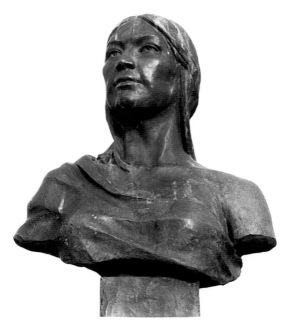

Boomer's *First Woman*, 1979, portrays a characteristic Navajo facial type with the epicanthic eye fold and full smooth cheeks, which comes from the Athapaskan culture from which the Navajo descended.

The angular features of the Northwest Indians contrast sharply with the softer, rounder features of the Navajo and Tewa Indians of the Southwest. And Kenneth Campbell's bronze bust of *Pocahontas* of 1965, in the Indian Hall of Fame, exemplifies the broad planes and the fine features of the Powhatans of the Eastern Woodlands.

While the collection of portrait busts of famous American Indians in the Indian Hall of Fame in Anadarko, Oklahoma, celebrates historically important Indians, it also illustrates the variety of Indian cultures.

The Hall of Fame for Famous American Indians

Thirty-five Indians from twenty-four different tribes are represented. The idea for an Indian Hall of Fame occurred to a young southerner, Logan

Billingsley, in the early 1900s, when he was in his twenties, working in the United States Indian Service in Anadarko, Oklahoma.[6] He had migrated there with his parents from Tennessee just before Oklahoma became the forty-sixth state in November 1907. The Five Civilized Tribes (Choctaw, Cherokee, Chickasaw, Creek, and Seminole) had also migrated there from the South, but they were driven on foot by the United States Army in the dead of winter, which claimed the lives of many of the Indians. Indian accounts of that Trail of Tears, as it is known, and the Indians Billingsley got to know in Oklahoma made a deep and lasting impression on him. Although he left Anadarko in 1919, and settled in Katonah, New York, where he built a real estate business, he never lost his desire to one day find an appropriate way to celebrate American Indians and their important part in the nation's history.

In 1952, at the age of sixty-nine, he founded the National Hall of Fame for Famous American Indians. And because Oklahoma has more than a third of the total Indian population in the United States, it was only fitting that his idea should be implemented there. In addition to such historical figures as Sacajawea, Sequoyah, Pontiac, and Osceola, modern heroes include Will Rogers, Jim Thorpe, and Alice Brown Davis. In its forty-one years, it has selected thirty-five Indians. A bust is made of each Indian selected and installed in the Hall of Fame, which consists of a reception center and an outdoor gallery for the busts, landscaped and maintained by the foundation Billingsley set up in Anadarko.

DIGNITY AND MAGNANIMITY RECORDED

In 1921, thirty-one years before the Hall of Fame was established, a statue of Massasoit by Cyrus Dallin was erected on a boulder in Plymouth, Massachusetts, a reference to Plymouth Rock, where the Pilgrims landed.[7] Massasoit was the great Wampanoag sachem who made peace with the Pilgrims. He befriended Roger Williams, the colonial clergyman and enlightened advocate of religious freedom, who founded Rhode Island. Together they forged one of the earliest working relationships between the Indians and the white man. Erecting Massasoit's statue in Plymouth commemorated the 300th anniversary of that peace of 1621.

In 1979, the people of Kansas City, Missouri, erected a replica of the Plymouth statue, which they also set on a boulder.[8] Instead of symbolizing Plymouth Rock, however, the boulder in Kansas City suggests a broader sweep of human history and at the same time gives it a local stamp. It identifies Massasoit with the origins of the first Americans following the Great Ice Age, and shows that Kansas City, as well as all communities in the United States, share in the heritage of those vast migrations. The quartzite boulder upon which Massasoit stands was reputedly part of the massive rock formations moved by glacial action more than 500,000 years ago from Minnesota to what became the farm of Ralph Dooley at Bosworth, Missouri.

Massasoit's dignity and magnanimity are recorded in his proud stance

OPPOSITE TOP LEFT
John Boomer (b. 1944)
First Woman, 1979
Walnut, 17½ × 4 × 3 in.
(44.5 × 10.2 × 7.6 cm)
Collection of the artist

OPPOSITE TOP RIGHT
George Winslow Blodgett
(1888–1958)
Albert Lujan, 1930
Bronze, 10¼ in. (26 cm) high
Brookgreen Gardens,
Murrells Inlet, South Carolina

OPPOSITE BOTTOM LEFT
Kenneth F. Campbell (b. 1913)
Pocahontas, 1965
Bronze, over lifesize
National Hall of Fame for
Famous American Indians,
Anadarko, Oklahoma

and benevolent gaze. His bearing is indicative of the simplicity and the nobility of the North American Indians, for Cyrus Dallin their two dominant characteristics that shaped his portrayal of them.

DALLIN'S INDIANS

Of all the American sculptors who produced Indian subjects, none equaled Dallin's empathy. Few sculptors seemed to share the emotions, thoughts, and feelings of the Indians with the conviction expressed in Dallin's bronzes, whether a chief with the regal bearing of Massasoit, a hunter drinking from a stream (Arlington, Massachusetts), a scout (San Francisco, California), or a brave on the warpath (Brookgreen Gardens). Dallin's insights derived from his childhood with the Indians.

Dallin (1861–1944) grew up in the days of the Wild West in a small community south of Salt Lake City, Utah.[9] He got to know the Utes, Paiutes, and Shoshoni who lived there in the Great Basin area, the "digger Indians" as they were called, because they subsisted on seeds, nuts, berries, and roots, and some rodents and small game.[10]

Understandably, Dallin could not be silent when it came to the subject of the Indians' plight, from their first contact with the white man to their subjugation under him. Dallin's profound compassion is most dramatically embodied in the four equestrian monuments to the American Indians he executed from 1890 to 1908.[11] His first, *The Signal of Peace*, 1890, was exhibited at the Columbian Exposition of 1893 and brought him to the attention of the American people. An Indian proudly sits his horse and holds his spear upward

LEFT
Cyrus Dallin (1861–1944)
The Signal of Peace, 1890
Bronze, over lifesize
Lincoln Park, Chicago

RIGHT
Cyrus Dallin (1861–1944)
Medicine Man, 1899
Bronze, over lifesize
East Fairmount Park,
Philadelphia

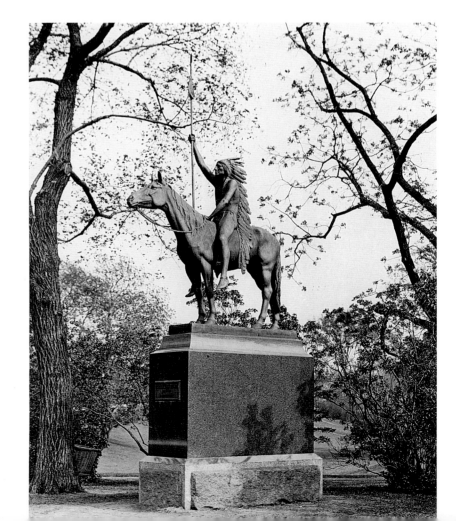

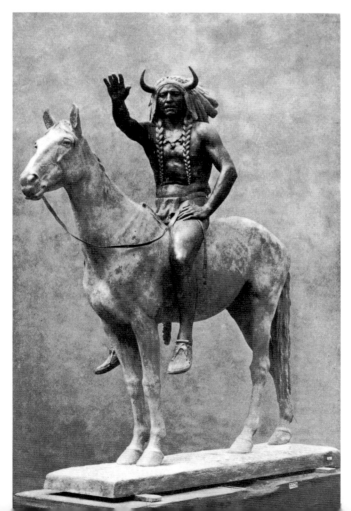

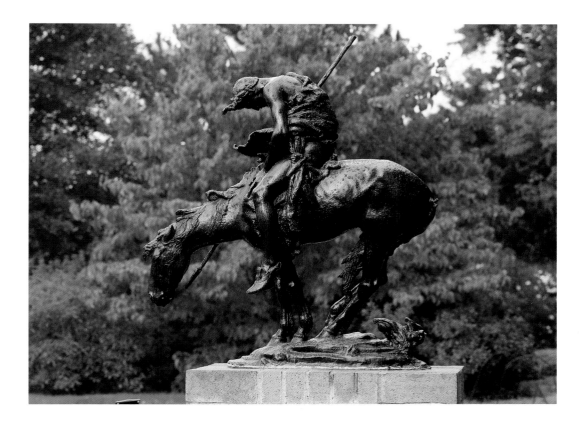

James Earle Fraser (1876–1953)
End of the Trail, 1915
Bronze, over lifesize
Brookgreen Gardens,
Murrells Inlet, South Carolina

in a sign of peace, which symbolizes the trust the Indians showed the white man at their first encounter. The statue was purchased for Chicago and today stands in Lincoln Park.

Unlike his first equestrian monument to the Indians, *The Medicine Man* of 1898 is canny and cautious. He holds up his right hand, palm facing out, a gesture meant to halt the aggressive settlement of the whites. The piece was acclaimed at the Salon of 1899 in Paris and earned a gold medal at the Paris Exposition of 1900. It stands today in Fairmount Park in Philadelphia.

Dallin's *The Protest*, for the St. Louis Exposition in 1904, was much too aggressive for the American public, and it was never cast in bronze. Mounted on a rearing charger, an Indian chief with hate in his eyes holds up his clenched fist in defiance and declares war on the white invaders.[12]

The last of Dallin's colossal equestrians, *The Appeal to the Great Spirit*, 1908, portrays the Indian defeated and stripped of all but his faith in the Great Spirit to whom he appeals, looking straight up with arms extended. The scene is reminiscent of the brave's first act of surrender in the "vision quest," when as an adolescent he goes out to a sacred place, fasts, and lacerates his flesh to induce a vision that establishes his first union with his guardian spirit, who will guide him through life. The beaten Indian in Dallin's *Appeal to the Great Spirit* offended no one. Indeed, it won a gold medal at the Paris Salon of 1909, and the City of Boston erected it in front of the Museum of Fine Arts, where it may be seen today.

James Earle Fraser infused the theme of the Indians' despair with dramatic power six years later at the great fair in San Francisco with his equestrian statue, *The End of the Trail*.[13] A lone Indian, scantily clad in an animal

skin, his spear pointing down, is slumped over and can barely sit his horse. Unsteadily perched on a rocky peak, the emaciated animal peers down as if looking into a bottomless crevasse. Its tail and mane and the fur of the Indian's wrap are blown by a wind from behind, making the stance of the horse even more precarious and the hopeless fate of the Indian crystal clear.

COLOSSUS OF THE BLACK HILLS

By far the largest equestrian monument to an Indian is *Crazy Horse* in South Dakota's Black Hills, just twenty-two miles from Gutzon Borglum's presidential portraits on Mount Rushmore, which it eclipses. The sculpture is literally a carved mountain, which the sculptor named Thunderbird Mountain. It was the dream of Boston-born sculptor Korczak Ziolkowski, who began the sculpture in 1948 as part of a cultural complex including an Indian museum and a college and medical school for Indians.[14]

The project was spawned at the 1939 World's Fair, historians have noted, when Korczak won first prize for his marble portrait of the famous musician, *Jan Paderewski: Study of an Immortal*, which brought him to the attention of some Sioux chiefs led by Henry Standing Bear. They asked Korczak to carve a monument to the Indian hero Crazy Horse in the Black Hills, their sacred precinct. Korczak sympathized with the Siouxs' cause. That summer, he worked for a short while for Gutzon Borglum carving the monumental portraits of the presidents at Mount Rushmore and got the feel for carving a mountain. He then determined to undertake the monument to Crazy Horse in similar fashion. World War II intervened, however, and it was not until three years after the war that he got started.

Korczak Ziolkowski (1908–1982)
Crazy Horse Monument, in progress
(begun 1948)
Natural rock, 641 × 563 ft.
(195.4 × 171.6 m)
Black Hills, South Dakota

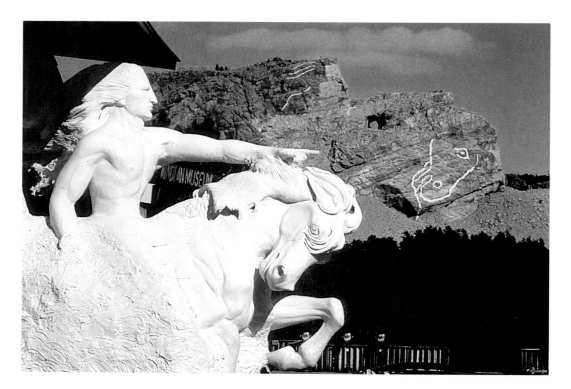

The Sioux chiefs chose to commemorate Crazy Horse because his fate best paralleled the tragic history of the red man since the white man took their lands. Crazy Horse wanted only to live on his lands with his people, which had been guaranteed under the Treaty of 1868, signed by President Andrew Johnson: "As long as the rivers run and the grasses grow and the trees bear leaves, Pahe Sapa, the Black Hills, will forever and ever be the sacred lands of the Indians." When the treaty failed, Crazy Horse took to the warpath. He was killed in 1877, under a flag of truce at Fort Robinson, Nebraska.

Korczak's sculpture portrays Crazy Horse at the moment he accepts the leadership of his people. Proudly sitting his horse, he points out across the lands of the Sioux nation that were being appropriated by the white man, and pronounces his famous declaration, "My lands are where my dead lie buried."

When completed, the monument will be 141 feet long and 563 feet high. Crazy Horse's outstretched arm will be 313 feet long by 136 feet wide, a surface large enough to accommodate four thousand people. Korczak died in 1982 at the age of seventy-four, but his wife and children are carrying on the project. As of September 1991, 8.3 million tons of rock have been removed, revealing the nine-story-high profile of Crazy Horse, which has been blocked out and is now visible in silhouette against the sky.

Private donations and tourism have financed the carving of the monument and the museum, which now has three wings. Once the monument is carved, the subsequent income will go toward developing the medical complex. Since 1978, the monument has provided $115,000 in scholarships for Indian students in the nine reservations in the area.

MacNeil's Monument

In his bronze group *The Coming of the White Man* of 1905, in Portland, Oregon, Hermon A. MacNeil created what amounts to a monument to the Indians' impending extinction. He portrays a Multnomah chief standing with arms folded across his chest looking out over the horizon contemplating the arrival of the white man, as a medicine man frantically waves a branch in a ceremonial gesture to ward off the dangers of white settlement. While the Multnomah and other Indian tribes of Oregon were affected little by the Spanish settlements that spread out from California (that is, the first Europeans to enter their lands), it was the expedition of Lewis and Clark in 1805–06 that presaged the inevitable conquest by the white man. It is the white man's conquest and all that came with it that is symbolized in MacNeil's sculpture.[15] With the discovery of gold in California in 1848, the native tribes were rapidly dispossessed and placed upon reservations. Most of the Multnomah went to the Warm Springs and Grande Ronde reservations in Oregon and the Yakima Reservation in Washington, confirming the medicine man's worst fears.

Hermon A. MacNeil (1866–1947)
Coming of the White Man, 1905
Bronze, over lifesize
Portland, Oregon

RELIGION AND CEREMONY

Medicine men and shamans were central figures, along with priests, in Indian tribal life. Tribes with complex ritual and ceremony such as the Natchez had priests whose function was to safeguard that ritual and see to it that it was performed properly and that it was perpetuated through training new priests. Priests were often members of the organizational hierarchy in such tribes. Medicine men and shamans, however, cured diseases, interpreted dreams, and interceded with the gods toward various ends—health, love, possessions. They were sorcerers, believed to possess supernatural powers and capable of influencing the many Indian spirits and deities. Their souls could leave their bodies and soar through space to commune with the spirits of one's ancestors, for example, if that kind of intercession was necessary. They served individuals as well as the tribe.

A sculptor today who keeps alive that tradition and its imagery while uniting it with his own belief in the spirit of man is Lincoln Fox. While his pieces include such traditional portrayals as *Shaman with Bearskull Headdress*, *Shaman with Owl*, *Bird Vision*, and *Hopi Snake Priest*, his most recent colossal bronze figure of a shaman celebrates the universal spirit of humankind. Called *The Dream of Flight*, the 14-foot-long seven-times-lifesize shaman soars 17 feet above the ground at the Albuquerque, New Mexico, International Airport. The piece is cantilevered 30 degrees from its base to create the illusion of actually floating in midair.[16]

Indian life and Indian religion, with its ritual, ceremony, and myth, were inseparable.[17] Survival and belief were interconnected in the mind of the Indian. Indians entreated, placated, and celebrated the immutable forces of nature that govern the growing cycles, and the animal spirits that provided them with food, clothing, and shelter. Among the many rituals they practiced, Indian dances are the most colorful and the most physically charged.

In *The Sioux's Buffalo Dance*, 1904, Solon Borglum has portrayed more than a reenactment of a dance. It more closely approximates a hieroglyph of the entire buffalo ritual. A crouching medicine man clothed in a buffalo hide holds a clutch of feathers in his extended right hand, a brave with feathered headdress stands upright looking in the opposite direction, and behind the two of them sits an old man beating a ritual drum. What is embodied in this piece is the preparation for the hunt, the hunt itself, and the ceremony of regeneration afterward.

In prehistoric times, before the horse had been reintroduced into North America by the Europeans, the Indians hunted by enticing herds of buffalo into a path they had fashioned, with parallel mounds of stones, leading to the edge of a cliff.[18] To get the buffalo into the path, medicine men attracted the nearsighted animals by clothing themselves with buffalo hides and imitating the buffalo's gait and movements. Once they got the animal's or herd's attention and lured them into the path, the hunting party then rushed out from behind the mounds of stones where they were hiding. With whoops and hollers, while brandishing their spears, they panicked

Lincoln Fox (b. 1937)
The Dream of Flight, 1980s
Bronze, seven times lifesize
Albuquerque, New Mexico

the buffalo into rushing headlong over the cliff. All that was left was to finish off the animals still alive and then butcher them. Butchering was an art that had been perfected over thousands of years to secure the meat and the hides and intestines for clothing, food, and shelter, and the bones for tools and utensils.[19]

Once the butchering was completed, ceremonies of regeneration were held to assure that the buffalo spirits would continue to provide the Indians with the necessary sustenance for the next season. Those ceremonies involved dancing and various rituals, and sometimes they included initiation rites and self-mutilation. A little finger might be cut off to the first joint or the flesh might be pierced with leather thongs to placate the spirits or to prove the worthiness of the supplicant.

This bronze by Solon Borglum was one of four he exhibited at the St. Louis Exposition in 1904 that drew public acclaim. The other subjects were an Indian and his son, a Plainsman in a blizzard, and a cowboy at rest.[20]

One of the most popular of these genre types at the turn of the century was Hermon MacNeil's *The Sun Vow* of 1898. A father and son are in the midst of a Sioux initiation rite that qualifies the young man as a warrior through successful handling of the bow and arrow. The youngster holds the spent bow outward in his left hand, his right hand having just released the arrow that sails toward the sun; his first two fingers are still flexed. Twelve replicas are known to have been made.[21] It was not only MacNeil's most popular piece, it also won numerous awards including a silver medal at the Paris Exposition of 1900, and a gold medal at the Pan American Exposition in Buffalo, 1901.[22]

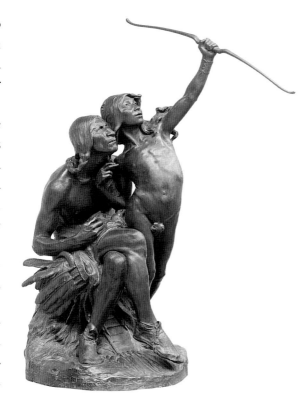

Hermon A. MacNeil (1866–1947)
The Sun Vow, cast in 1919
Bronze, lifesize
The Metropolitan Museum of Art,
New York; Rogers Fund, 1919

ALLAN HOUSER

It is a tribute to the undying spirit of the American Indian that such subjects continue to have appeal today. Indian sculptor Allan Houser's *Sacred Rain Arrow* of 1989, for example, portrays an Apache Indian down on one knee aiming an arrow straight up into the sky. The piece was inspired by an Apache legend that an elder of the Chiricahua Apaches told to Houser when the sculptor was a youngster. When there was drought, the old man explained, they would bless an arrow and select a strong young brave to go up onto a high place and shoot the arrow into the clouds to bring forth rain.[23]

Called the "patriarch of American Indian sculptors," Allan Houser is a Chiricahua Apache and was born in 1914, in Apache, Oklahoma. Originally a painter and muralist, then a carver in stone and wood, he now also works in steel and bronze and does fabrications involving various media. He is also accomplished on the Indian flute and continues to perform the ancient music of his ancestors.

Through his prodigious output and a generation of students and followers, Houser has been a formidable force in shaping contemporary Indian sculpture. In recognition of his contribution, a sculpture garden connected

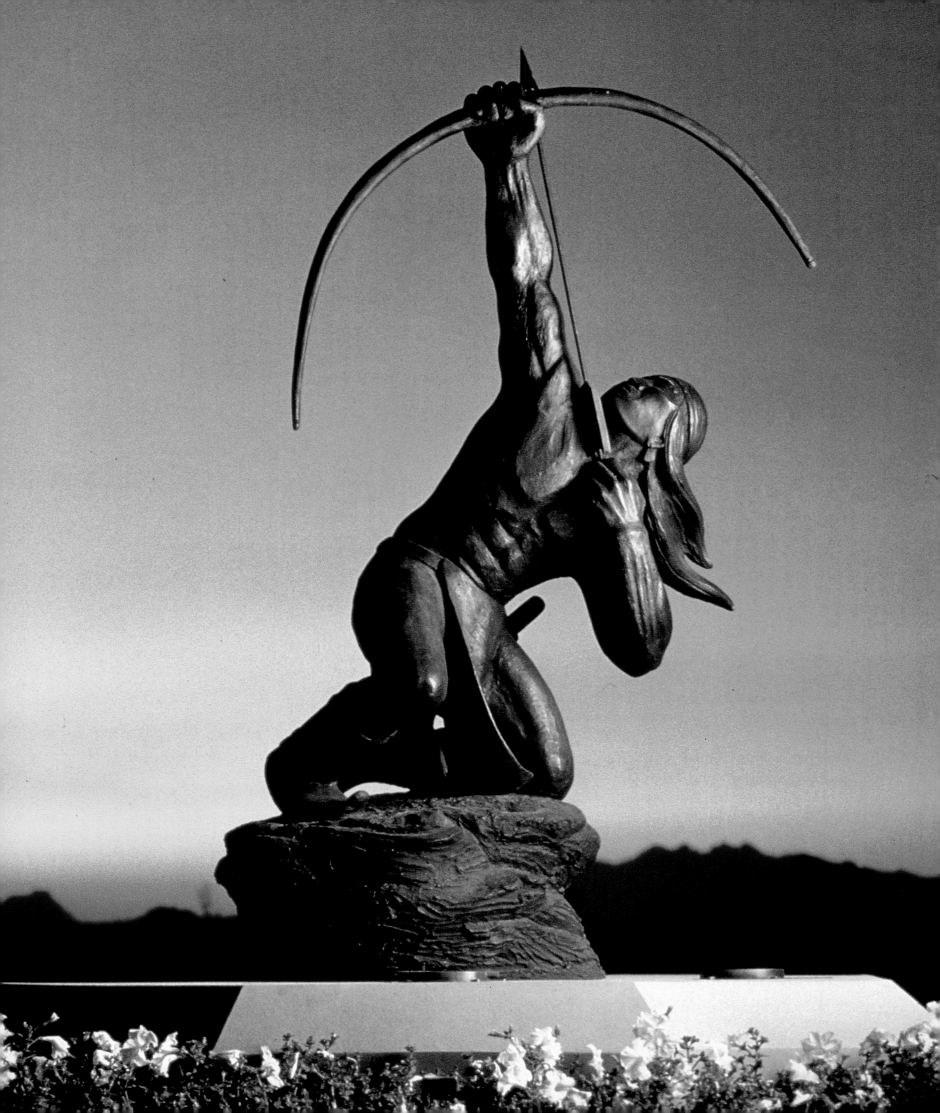

Doug Hyde (b. 1946)
Code Talker, 1980s
Bronze, 10 ft. (3 m) long
Phoenix

with the Institute of American Indian Arts in Santa Fe, New Mexico, was created in Houser's honor and opened on August 7, 1993. Houser donated a bronze cast of *Sacred Rain Arrow* to the National Museum of the American Indian, Smithsonian Institution, due to open at the turn of the century.

One of Houser's first students, Doug Hyde, from Oregon and of Nez Percé, Assiniboine, and Chippewa descent, draws his subjects, like Houser, from his Indian heritage. The stories, myths, and legends related to him by his grandfather, a Plains Indian, have been the main source of his material, which continues to shape his work today.[24]

As a Vietnam veteran and a sculptor, Hyde was a logical choice to bring his perspective on military monuments to honor the Navajo men of World War II who used their native language—largely in the South Pacific—as a military code that the Japanese could not break. Sworn to secrecy until the 1960s, the "code talkers," as they were called, were never recognized for their valor and contributions to the United States victory. Therefore, businessmen in Phoenix, Arizona, commissioned Hyde to design a monument honoring the Navajo "code talker." Because those young men were mostly sixteen- and seventeen-year-old sheepherders from the Navajo reservation, Paula Hall has noted, Hyde chose to portray the "code talker" in his civilian role, seated on the ground holding a flute to calm the sheep he is tending. The figure is fabricated in bronze and stands 10 feet high in downtown Phoenix.

NON-INDIANS CARRY THE MESSAGE

John Boomer, Glenna Goodacre, and George Carlson represent a sizable contingent of non-Indian sculptors who nonetheless perpetuate the timeless traditions of the first Americans.

OPPOSITE PAGE
Allan Houser (b. 1914)
Sacred Rain Arrow, 1989
Bronze, 98 × 39 × 31 in.
(248.9 × 99.1 × 78.7 cm)
Glenn Green Galleries, Santa Fe, New Mexico

First Woman, carved in black walnut in 1979 by John Boomer, who is married to a Navajo, represents the mother of mankind, according to Navajo mythology.[25] She holds the Navajo sacred basket, which is used in all major ceremonies such as marriages, healing rituals, and house blessings. Boomer's principal interest is the human face, for him the key emotional focal point, which he surrounds with sympathetic forms to evoke appropriate feelings. In *First Woman*, he tries to achieve this in the blanket and the characteristic Navajo hairstyle that frames the woman's face. "Face in form," he calls his way of working.

In *The Basket Dance*, Glenna Goodacre portrays three women participating in one of the most solemn and dignified of all Pueblo Indian ceremonies, and one of the most widespread—practiced from Hopi to San Ildefonso.[26] The dance celebrates woman's central role in the life of the Pueblo people. Each woman is bareheaded, wearing a blanket around her shoulders and carrying a basket in her left hand and fetish sticks in her right. The basket symbolizes the earth's bounty, and the sticks women's work in planting, harvesting, preparing food, and making utensils and clothing. In a highly

Glenna Goodacre (b. 1939)
The Basket Dance, 1980s
Bronze, 7 ft. (2.1 m) high
Collection of the artist

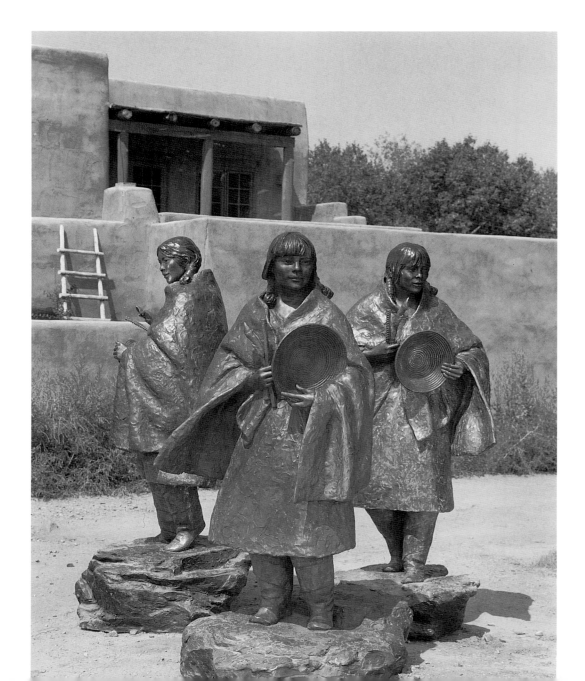

pictorial fashion, Goodacre has differentiated the flesh tones of each woman's face and hands from the textures of her blanket, hair, and moccasins by using different patinas.

George Carlson keeps alive the image of the noble savage and carries a message of cooperation between the Indian and the white man, which is well illustrated in *The Greeting* of 1972.[27] An elder of the Blackfoot nation, the great North Plains warriors, wears a buffalo robe and fringed buckskin leggings. His braided forelock signifies he is the owner of a medicine bundle, which bestows upon him great power. In his right hand he holds an eagle feather, his symbol of office, and his arms are opened wide in a gesture of universal greeting to all mankind. On his chest dangle the medals he received from a visit to Washington, D.C., indicating his willingness to try the white man's way. One of the medals, ironically, bears the likeness of President James K. Polk, who brought the tribes of the Southwest, California, and the Northwest under the jurisdiction of the United States.

A colossal-scale version of *The Greeting*, 11½ feet tall, was cast in bronze in 1988, commissioned to stand in front of the Eiteljorg Museum of American Indian and Western Art in Indianapolis, Indiana.

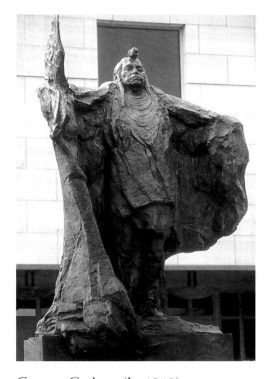

George Carlson (b. 1940)
The Greeting, 1972
Bronze, 12 ft. (3.7 m) high
Eiteljorg Museum of
American Indian and Western
Art, Indianapolis

EVERYDAY PEOPLE DOING EVERYDAY THINGS

Genre, which has been described as everyday people doing everyday things, has always been a part of American sculpture in varying degrees of importance. But genre has never been considered high art. Even in the gifted hands of one of the nation's foremost modernists, Reuban Nakian, genre was not taken seriously. His *Lap Dog,* 1927, in the Whitney Museum, a portrait of his friend William Zorach's daughter, Dahlov, playing with her pet, is an intimate piece, 6½ inches high, spontaneously modeled in terra-cotta, which captures the child's moment of fun through gesture and expression and the frolicsome pup's turn of head.[1] The piece is unusual for Nakian's work in the 1920s in its roughly modeled style, when his work had a more stylized look.

The power of genre lies in its naturalism and its immediacy. The character and balance of those two components determine the acceptance or rejection of genre in any given period. Whether or not Mahonri Young's small genre figures of laborers, introduced into American sculpture in 1904, were the first threat to Beaux-Arts academicism, as Daniel Robbins has suggested, they certainly helped to charge naturalism with a down-to-earth immediacy far removed from the small bronzes of Bessie Potter Vonnoh, whose intimate themes of mothers and children achieved both popularity with the public and recognition from her fellow sculptors.[2] For example, many replicas in plaster and bronze were made of *The Young Mother,* of 1896,

and it won a bronze medal in 1900 at the Paris Exposition and honorable mention at the Pan American Exposition in Buffalo, in 1901.

Mahonri Young's brand of realism would not gain broad appeal until the 1930s. Young's discovery of Jean-François Millet's French peasants was his first inspiration, but he was a sensitive observer of social conditions and won early recognition even if his works did not find a large market. Grandson of the Mormon leader Brigham Young, Mahonri grew up in Salt Lake City, studied in Paris, then settled in New York City. The National Academy of Design bestowed a gold medal on his *Bovet Arthur*, a statue of a laborer, in 1911, and the Metropolitan Museum of Art bought his *Stevedore*, of 1904, and *Man with a Pick*, of 1917. It is also noteworthy how reminiscent is *The Rigger*, of 1916, in the Newark Museum, of George Grey Barnard's *Two Natures of Man*.[3]

It was not until he turned to modeling athletes, especially boxers as in *Right to the Jaw*, 1926, in the Brooklyn Museum, and *Groggy*, 1926, in the

TOP LEFT
Mahonri M. Young (1877–1957)
Photograph of the artist at work

BOTTOM LEFT
Mahonri M. Young (1877–1957)
Groggy, 1926
Bronze, 14⅛ × 9⅜ × 8⅛ in.
(35.9 × 23.8 × 20.6 cm)
Whitney Museum of American Art, New York; Gift of Gertrude Vanderbilt Whitney

BOTTOM RIGHT
Harry Wickey (1892–1968)
The Old Wrestler, 1938
Bronze, 19¼ × 6 × 8⅜ in.
(48.9 × 15.2 × 21.3 cm)
Whitney Museum of American Art, New York; Gift of Gertrude Vanderbilt Whitney

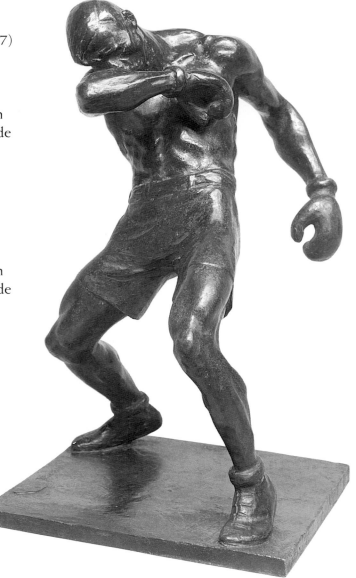
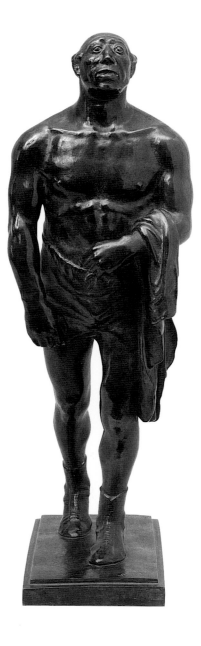

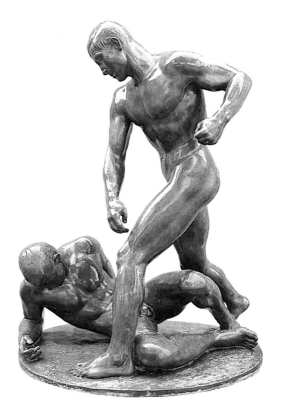

TOP LEFT
Cecil de Blaquière Howard
(1888–1956)
Knockout, 1935
Bronze, 24 in. (61 cm) high
Brookgreen Gardens,
Murrells Inlet, South Carolina

TOP RIGHT
Cecil de Blaquière Howard
(1888–1956)
Photograph of the artist at work

LEFT
Mary Frank (b. 1933)
Swimmer, 1978
Ceramic, 17 × 94 × 32 in.
(43.2 × 238.8 × 81.3 cm)
Whitney Museum of American
Art, New York; Purchase, with
funds from Mrs. Robert M.
Benjamin, Mrs. Oscar Kolin, and
Mrs. Nicholas Millhouse

Whitney Museum, that Young found a popular market for his works, and he was emulated by such kindred spirits as Harry Wickey in *The Old Wrestler*, 1938, and Cecil de Blaquière Howard in *Knockout*, 1935. Reverberations are felt even today, for example, in Joseph Sheppard's *Knockdown*, 1983, and *Basketball*, and Frank Gallo's *Swimmer*, of 1964, and Mary Frank's *Swimmer*, 1978.

It is in the idealized human form and the psychological nuances of personal combat that boxing has always held special appeal for both artist and spectator of all generations, as the exhibition "The Artist at Ringside,"

1992, vividly chronicled in a century-and-a-half-long view of the theme in painting and sculpture, from 1858 to the present.

Abastenia St. Leger Eberle remained faithful to her social commentaries and, consequently, never achieved popular acceptance. The piece she exhibited in the Armory Show of 1913, for example, which showed a young girl being sold into white slavery, scandalized the public. Eberle grew up in Ohio, traveled briefly to Italy and to Paris, and settled in New York City, where she studied at the Art Students League. In the spirit of life in New York City she found the principal stimulation for her work. She captured the life of the Lower East Side with rare insights, which she expressed in her small bronzes with freshness and immediacy, never lapsing into sentimentality. In *The Dance of the Ghetto Children*, c. 1914, and *Roller Skating*, before 1909, she found the sheer joy of youngsters at play with a spontaneity that is characteristic of her most successful pieces. Her work won recognition from the National Academy of Design and was purchased by museums, but she never found a public that appreciated her view of New York or her expression of the human spirit.[4]

Saul Baizerman was reared in Russia, where he studied art for a year in Odessa. He emigrated to America in 1910 and settled in New York City,

Abastenia St. Leger Eberle
(1878–1942)
Roller Skating, c. 1906
Bronze, 12¾ × 11¼ × 6½ in.
(32.4 × 28.6 × 16.5 cm)
Whitney Museum of American
Art, New York; Gift of Gertrude
Vanderbilt Whitney

LEFT
Saul Baizerman (1889–1957)
Road Builder, 1939
Hammered copper, 28½ in.
(72.4 cm) high
Wichita Art Museum, Kansas

RIGHT
John Rogers (1829–1904)
Wounded to the Rear, One More Shot, 1865
Plaster, 23½ in. (59.7 cm) high
New-York Historical Society,
New York

where he studied briefly at the National Academy of Design, then at the Beaux-Arts Institute of Design. He developed a highly personal style of hammering metal, and while he devoted himself to the figure, some heroic in scale, his small genre pieces are highly distinctive in their simplicity, with an occasional reference to Cubism.[5]

Had Young, Eberle, and Baizerman been born a half century earlier, they would have been contemporaries of John Rogers and might have enjoyed the fruits of an age that enjoyed and purchased genre pieces. Rogers was the first American sculptor to produce genre groups, called Rogers Groups, for a mass market. He started with Civil War groups, such as *Wounded to the Rear,* 1865, and expanded his repertoire to include literary subjects and historical subjects. Some of his groups sold several thousand copies. Rogers advertised and produced catalogs of his works, and his patrons were the general public. If John Rogers's groups were the sculptural equivalent of Currier and Ives prints, as scholars have suggested, then American genre sculptures of the early twentieth century may be said to be the sculptural equivalents of Ashcan School paintings.[6]

SOCIAL REALISM TODAY

By the time Young, Eberle, and Baizerman were working, high art had preempted genre, and sculptors had to wait for the jolt of the Great Depression before social genre was again acceptable. That brand of social realism,

LEFT
Max Kalish (1891–1945)
Photograph of the artist

MIDDLE
Max Kalish (1891–1945)
Laborer at Rest, c. 1924
Bronze, 14¼ in. (36.2 cm) high
The Newark Museum, Newark,
New Jersey; Purchase 1927,
J. Ackerman Coles Bequest Fund

RIGHT
Judith Weller (b. 1937)
The Garment Worker, 1984
Bronze, 41 in. (104.1 cm) high
New York

however, was anticipated by such works as Max Kalish's *Laborer at Rest*, of c. 1924, and it continues to have its adherents even today. Judith Weller's *Garment Worker* is a fitting example of how the genre piece can even become a symbol and a monument.

Weller, who came to America from Israel in 1957 as an exchange student, modeled the figure while watching her father, Yitzhak Rosenberg, sitting at work at his sewing machine. A Hungarian Jew who settled in Palestine in the 1930s, Rosenberg was a tailor in Tel Aviv, and when the family emigrated to New York, he continued his craft as a member of Local 9 of the International Ladies Garment Workers Union in New York City.[7]

When Weller exhibited her 24-inch-high sculpture in the National Sculpture Society exhibition at Lever House in 1978, someone from the union saw it, and from discussions with the artist came the idea for a large-size version for the garment district. The eight-foot-high seated figure wears a yarmulke and bends over his hand-operated sewing machine. While the statue was inspired by the sculptor's father, it was conceived as a monument to all the garment workers in America and their contribution to the country and its culture. Unveiled on October 31, 1984, the $35,000 sculpture was financed by forty-three unions, firms, banks, trade associations, and individuals, most of whom had links with the fashion industry, and it stands in front of 1411 Broadway at West 40th Street, one of the garment district's

Bruno Lucchesi (b. 1926)
*J. Walter Thompson Company
Copywriters*, 1964
Bronze, under lifesize
Graybar Building, New York

most sought-after showroom buildings. Philanthropist Jack Weiler, owner of
the property, had a plaza created for the piece laid out with trees, flowers,
and benches so that people could come and enjoy the monument.[8]

Bruno Lucchesi fits no category. His countless genre pieces not only cap-
ture the spirit of everyday people doing everyday things but also embody the
high points of Western art since antiquity. Such themes as *The Judgment of Paris,
Jacob's Ladder, The Trojan Women,* and the *Annunciation,* sensitively captured in
Dena Merriam's prose and David Finn's photographs, reflect his solid ground-
ing in the ancient and Judeo-Christian traditions. His figure groups of nursing
mothers, relaxing nuns, advertising copywriters, men in public baths, the old
and the young, the beautiful and the plain, the content and the dispossessed
draw on the whole of Western sculpture for inspiration and execution.[9]

Critics, patrons, and the public alike are quick to note the captured
moment in time, the telling gesture, the timeless quality, and the earthiness of
Lucchesi's work that tie him to the sculpture of Romanesque and Gothic
portals, as well as to the field hands of Breughel, the peasants of Daumier, and
the bathers of Degas.

Lucchesi grew up in Fibbiano Montanino, Italy, a small town near Pisa,
where he worked as a shepherd before going off to the monastery in Lucca
to study. During World War II, he met a Yugoslavian sculptor, a refugee,
who fostered Lucchesi's talent and encouraged his family to send the boy

to the Art Institute of Lucca to study. Following his studies there, Lucchesi got a job in Florence making models for the tourist trade, and then he started teaching sculpture at the Art Academy of Florence. In the late 1950s, Lucchesi came to New York with his new wife and got employment making mannequins and ceramics.[10]

Lucchesi's small genre pieces soon caught the attention of artists and collectors in Greenwich Village. He also started to teach, and by the early 1960s he was exhibiting at the Whitney Museum and the Forum Gallery. Success followed, and his work has earned him an extensive following among collectors all over the world. Lucchesi still maintains a studio in Italy, which also keeps him close to his roots, the source of much of his inspiration.

In addition to his familiar groups, he does monuments like *Raphell* and outdoor sculpture such as *Park Bench,* 1985, at the Montana Building in New York City, a kind of modern version of the ancient theme of the ages of man. A young woman with her child is engaged in animated conversation with two elderly people as they sit on a park bench.

It is in Lucchesi's people that we find the magic of his appeal. His unique view of the world is expressed through them. They capture the fullness of life in the simplest details—a child's sandal, an old man's hand resting on his cane, the hiked-up coat of a man standing at a urinal, the nonchalance of the angel sitting on the edge of Mary's bed as he announces she is to be the mother of God.

FREDERIC REMINGTON

One subject that finds expression in both high art and in genre is the vanishing West. Frederic Remington's small bronzes caught its spirit in a way that captivated the imagination of the American people, recalling the little groups of John Rogers in their meticulous attention to accurate detail and in their animation.

Frederic Remington was first and foremost a narrator of the vanishing West as he saw and imagined it in the 1880s and 1890s—the cowboys and Indians, ranchers and mountain men, soldiers and outlaws, horses and cattle. An illustrator and painter turned storyteller in bronze, Remington was prolific, and his pieces were enormously popular.[11]

Remington grew up in Ogdensburg, New York, attended Yale University's School of Fine Arts for a year, and in 1880, as historians have noted, he went west to make his fortune, possibly in cattle or in the gold fields there. However, the nineteen-year-old lad from the East was captivated by the colorful people and life of the Old West, and he spent the next five years, much of it on horseback, traveling from the cattle roundup camps of northern Montana to the gold seekers' camps in the Southwest and into Old Mexico. Remington followed the cattle trails, got to know the Indians, and rode with the United States Cavalry. He collected Indian paraphernalia, cowboy gear, old guns, and odds and ends of the Old West, which served him well later, as he modeled his bronze groups with meticulous attention to detail.

Remington wrote and sketched for such magazines as *Harper's Weekly*, *Collier's Weekly*, and *The Century* magazine, and through his remarkably adventurous life and diverse experiences he developed a reportorial style in his writing and illustrating that was consummately factual. Harrold McCracken has shown that therein was the appeal of his writing and painting. When he turned to sculpture in 1895, he brought to it the same insistence on factual detail, which accounts for his drama without sentimentality. Remington's first piece, *Bronco Buster*, was a rearing horse with its rider losing a stirrup. According to Wayne Craven, it sold more than 200 copies. His second piece, *The Wounded Bunky*, 1896, portrays two troopers fleeing the Indians. One of them supports his wounded bunky (bunkmate) as they ride precariously, side by side. *The Wounded Bunky* and *Bucking Bronco* were exhibited at the 1901 Pan American Exposition in Buffalo, where they were an immediate success, reminiscent of the Rogers Groups a generation earlier.

In 1899, the monumentality of Remington's little bronzes caught the fancy of Alexander W. Drake, art director of *The Century* magazine, who wanted to see a Remington "in a public square in New York, and I hope in many other cities in America."[12] His wish was partially realized in Philadelphia in 1908, when the first monumental Remington was erected and dedicated on the East River Drive, now Kelly Drive, a site Remington had selected. As David Sellin has noted, it was also his last. Remington died soon after.[13]

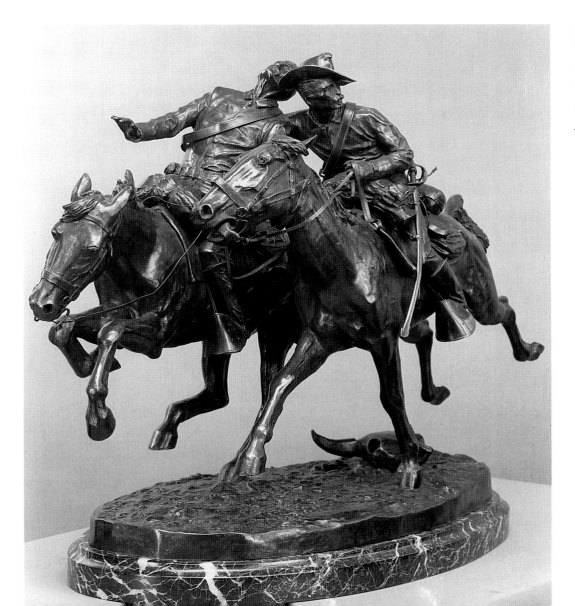

Frederic Remington (1861–1909)
The Wounded Bunky, 1896
Bronze, 21¾ in. (55.2 cm) high
The Metropolitan Museum
of Art, New York; Bequest of
Jacob Ruppert, 1939

Another monument to the vanishing West that shares the genrelike quality of Remington's bronzes is the *Pioneer Mother* in Kansas City, Missouri. Pioneers, both families and individuals, were popular themes in American sculpture since the early nineteenth century. Horatio Greenough and Thomas Crawford, for example, as we have seen, had executed such subjects for the United States Capitol in Washington, D.C., and they continued to appeal to sculptors on into the twentieth century. Lorado Taft in the 1920s and Frederick MacMonnies just before World War I did monuments to the pioneers, and Solon Borglum did an equestrian pioneer for the Court of Honor at the Panama-Pacific Exposition of 1915, the same year that Charles Grafly did a model for a pioneer mother.

Avard T. Fairbanks's *Pioneer Mother* at Vancouver, Washington, celebrates not only the universal image of pioneer motherhood but also the sculptor's own beginnings. Born of pioneer New England stock in Provo, Utah, in 1897, Fairbanks grew up studying sculpture. He went on to be a student of James Earle Fraser at the Art Students League in New York City, and of Injalbert at the Ecole des Beaux-Arts in Paris. His prodigious oeuvre includes the *Angel Moroni* atop the Washington Temple of the Church of Jesus Christ of Latter Day Saints in Kensington, Maryland, near Washington, D.C., and three statues (of Marcus Whitman, Esther Hobart Morris, and Justice John Burke) in the U.S. Capitol in Washington, D.C.

A. PHIMISTER PROCTOR

The most powerful monument to the pioneer mother, however, and one of the best-known monuments in the nation is the *Pioneer Mother* monument in Kansas City by A. Phimister Proctor, which may have inspired the monument by the nation's foremost Indian sculptor, Cyrus Dallin, to the *Pioneer*

A. Phimister Proctor (1862–1950)
Pioneer Mother, 1927
Bronze, over lifesize
Kansas City, Missouri

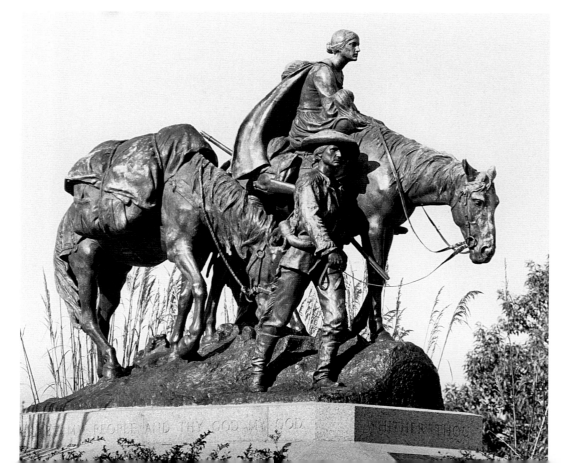

Women of Utah of 1931. Dallin's aged mother, herself a pioneer woman, was his model.[14]

If we can believe Proctor's autobiography, the *Pioneer Mother* monument in Kansas City was born of serendipity. He had wanted to do a monument to the pioneer mother for a number of years, but the idea for it remained vague until 1922, when it finally crystallized: a pioneer family made up of a trapper and hunter walking beside the pioneer mother while she rode sidesaddle, a packhorse behind carrying the family's supplies.[15]

The following year, Howard Vanderslice, a Kansas City businessman, bought a sculpture of a panther that Proctor was exhibiting in a show in Los Angeles. As they became acquainted, Vanderslice told Proctor that he had come from a pioneer family and wanted to erect a monument to the pioneer women in Kansas City. Saying nothing of his own desires, Proctor showed Vanderslice his model. Vanderslice liked it and commissioned the work. Proctor then took a studio at the American Academy in Rome, where he could get the artisans he wanted to complete the monument and cast it in bronze to his satisfaction. *Pioneer Mother* was unveiled on November 11, 1927, and remains today one of Kansas City's proudest monuments to the American spirit. Inscribed at the base of the monument are the words of Ruth to Naomi in the Old Testament, "Whither thou goest, I will go . . ." (*Ruth* 1:16).[16]

Another side of the frontier woman is celebrated by Lubbock sculptor Rosie Sandifer in *Plains Woman*, 1983, a lifesize polychrome bronze figure that stands on an outcropping in the Rock Garden of Saint Mary of the Plains Hospital in Lubbock, Texas.[17] The stately figure of the frontier woman with upswept hair and full skirt is a tribute to the thousands of single women of the nineteenth and twentieth centuries who went out west, staked claims, married cowboys and cattlemen, and reared a new generation of Americans.[18]

A twentieth-century breed of pioneer is celebrated in Alford's *Roughneck* of 1991, an 8-foot-tall oil field worker securing a 20-foot-high drilling pipe. Installed in front of Texas A&M University's new Joe C. Richardson, Jr., Engineering Building, the sculpture is a monument to human ingenuity in the petroleum industry.[19]

MONUMENTALITY IN SMALL BRONZES TODAY

Four sculptors of small bronzes share a monumental presence in their works. Michael Stelzer's small bronzes, such as *Doctor*, 1976, continue the venerable genre tradition of American sculpture, while *Avril* and *Spring's Bouquet*, of 1980, are among the most touching studies of a young girl in the dawn of her womanhood of any era. Simplicity of composition and total absence of any affectation render Stelzer's pieces timeless.[20]

Giancarlo Biagi's small bronzes, by turns, echo the great Renaissance and Mannerist masters and the Romantics to Rodin, while in no way compromising the sculptor's own distinctive style. In *Aurora* of 1986, for example, Michelangelo's *figura serpentinata* and the anguished figures of El Greco are recalled in the animated torque of Biagi's two figures rotating around a central

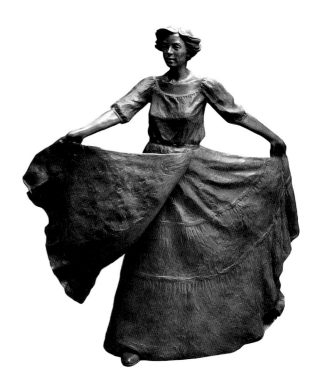

Rosie Sandifer (b. 1946)
Plains Woman, 1983
Polychrome bronze, 39 × 31 in.
(99.1 × 78.7 cm)
Lubbock, Texas

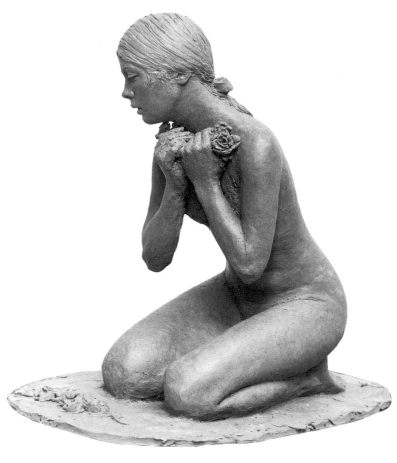

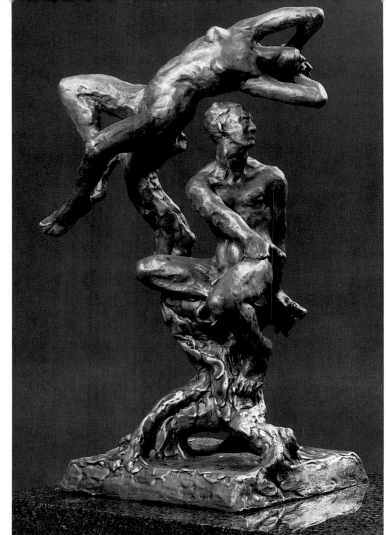

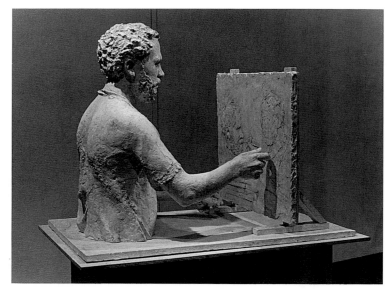

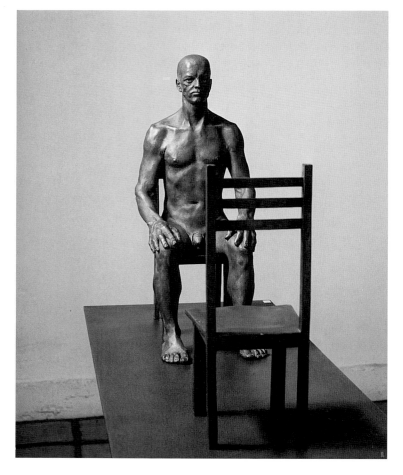

axis. *Winter*, of 1982, on the other hand, is indebted to the figures of Rodin in composition and modeling. The exuberance of Biagi's *Trumpet Player* and *Sax Player*, both of 1986, demonstrates the compatibility of academic models with contemporary subject matter when the two are united by the artistry of a master.[21]

Jonathan Shahn creates powerful and enigmatic portraits of multiple components that set up an internal dialogue within his pieces. In *Triple Self-Portrait*, 1975, for example, the sculptor is portrayed down to his waist modeling his left and right profiles in low relief. In *Portrait and Model*, 1974, model and unfinished bust stand side by side, while in *The Portrait*, 1976–80, the sculptor models a bust different from his sitter, as if capturing the inner self of his subject.[22]

Shahn's invitation to introspection takes a surreal turn in Don Gale's *Life Is Real Only Then, When "I Am,"* a seated bronze figure facing an empty chair, which reflects the influence of his teacher, the surrealist Lorsen Feitelson, and in his *Study for Brained Men* of 1979, which is indebted to Rodin's *Thinker*. In *Idol*, a standing female nude contemplates her double in miniature, the idol she holds in front of herself, while in another piece, *As Within, So Without*, she emerges into self-realization. Gale communicates the act of self-realization in two parts—the nude emerging from a wall and the fully freestanding nude.[23]

Gale's small reliefs are unique in their spontaneous treatment of the figure, which makes them resemble drawings transformed into three dimensions.

INVITATION TO CONTEMPLATION

The power of sculptural form to invite contemplation is singularly exemplified in the works of three sculptors. Leonda Finke perceives the figure as an expressive shape in space. Sculptural concern is expressed most dramatically in such over-lifesize works as *Woman in the Sun* for a park in Atlanta, Georgia. It also accounts for the power of her portraits, such as the head of Georgia O'Keeffe in the National Portrait Gallery in Washington, D.C., as well as her reliefs and medals. The simplified figures in *The Prodigal Son* medal she executed for the Society of Medallists in 1988, for example, are played off against an expanse of open space, which separates the Prodigal from his parents and captures the poignance of the moment.[24]

Lorrie Goulet's women emerge from their matrix of wood, marble, or stone and evoke contemplation of the origins of life. A student of José de Creeft in the 1940s, she learned to let the intrinsic qualities of her material determine the shapes of her sculpture. She enters into a relationship with each piece so that her hand is "both servant and bearer of my feelings." She delights in the process of direct carving and sees her work as "shaping spirit into form."[25]

A gifted teacher with an "uncanny ability to teach complex problems in the simplest ways," Goulet also writes verse about sculpture and has expressed her role as a sculptor:

OPPOSITE TOP LEFT
Michael Stelzer (b. 1938)
Avril, 1980
Bronze, 9 in. (22.9 cm) high
Collection of the artist

OPPOSITE TOP RIGHT
Giancarlo Biagi (b. 1952)
Aurora, 1986
Bronze, 16 in. (40.6 cm) high
Collection of the artist

OPPOSITE BOTTOM LEFT
Jonathan Shahn (b. 1938)
Triple Self-Portrait, 1975
Plaster and wood (for bronze),
33 × 38 × 24 in.
(83.8 × 96.5 × 61 cm)
National Sculpture Society,
New York

OPPOSITE BOTTOM RIGHT
Don Gale (b. 1939)
*Life is Real Only Then,
When "I Am,"* 1981
Bronze, 36 × 14 × 21 in.
(91.4 × 35.6 × 53.3 cm)
Collection of the artist

Leonda Finke (b. 1922)
The Prodigal Son, 1988
Bronze, 2¾ × 2⅞ in. (7 × 7.3 cm)
Society of Medalists, New York

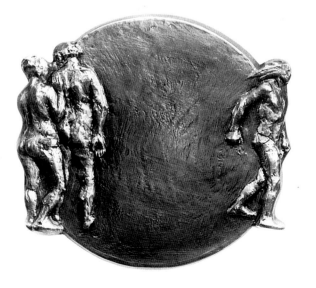

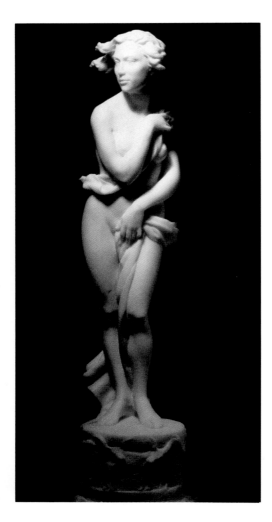

LEFT
Lorrie Goulet (b. 1925)
Water Fall, 1989
Lignum-vitae, 28 × 14 in.
(71.1 × 35.6 cm)
Collection of the artist

RIGHT
Jill Burkee (b. 1953)
La Tempesta, 1988
Marble, 29 × 7 in.
(73.7 × 17.8 cm)
Private collection

MAN SPOKE IN CLAY
A MILLION YEARS AGO
AND IN STONE
ALREADY OLD
TAKEN FROM THE ANCIENT EARTH
TO OPEN
A WINDOW TO THE SOUL.[26]

Jill Burkee's interest in classical subjects combined with slenderized proportions and elegant portraitlike identities gives her work immediacy and appeal. In spite of the small scale of her pieces, they have a deceptively monumental presence. A modeler of rare facility, Burkee executes most of her pieces in marble, yet she retains the flow and sinuosity of her modeled forms.[27]

CHARLES PARKS

Charles Parks's sculpture perpetuates the human values instilled in him from his earliest childhood. Born in a farmhouse on Chesapeake Bay, in Onancock, Virginia, Parks grew up in Wilmington, Delaware. His passion for art was awakened early, and in grade school he drew, painted, and carved

"anything that took my fancy," quotes Wayne Craven. Through a friend, he was introduced to his first teacher, whose name may have presaged Parks's classical bent, Marcus Aurelius Renzetti, who taught at the Graphic Sketch Club in Philadelphia.[28]

During the Depression, Parks worked in a machine shop founded by his grandfather, where he not only learned a trade but also gained valuable experience for his later years as a sculptor. Following World War II, he was again at work as a machinist, while he completed his studies at the Pennsylvania Academy of Fine Art.[29] By the 1960s, Parks was producing a wide range of work in wood and metal. A gifted carver and modeler, his wood torsos and modeled figures and groups express Parks's respect for the dignity of life and the nobility of the human figure.[30]

While that respect virtually transpires from all of Parks's works, it breathes poignance into certain pieces such as the black *Father and Son* of 1970 for Spencer Plaza in Wilmington. A renewal project in 1968, Spencer Plaza was underwritten by a local businessman and commemorates the site of the first black Methodist church in the United States. It is named for the Reverend Peter Spencer, an outstanding preacher of the Methodist congregation. In the portrayal of the barefooted father with his sleeping child cradled in his arms, Parks modeled a symbol of hope for those young men in the ghetto

Charles Parks (b. 1922)
Father and Son, 1970
Bronze, 7 ft. (2.1 m) high
Spencer Plaza,
Wilmington, Delaware

Charles Parks (b. 1922)
Tomorrow, 1976
Bronze, 9 ft. (2.7 m) high
Jacksonville, Florida

who will reach fatherhood, and he gave them an image that invites reflection on what that role means in today's society and for their future.[31]

Similarly, in the Percent for Art Program in Philadelphia, Parks created a symbol of family solidarity for Liberty Plaza, part of the city's East Poplar Urban Renewal Area.[32] Parks's original conception was a religious group— Elizabeth, Mary, and St. John the Baptist, a modern-day Visitation group— which Parks reworked into a black family, a father and mother with their young son. The National Urban League has extended the symbolism of the piece to all African-Americans by adopting it for its New York City headquarters. The league was founded in 1910 to assist African-Americans in achieving social and economic equality.[33]

Parks has become particularly known for his insightful children's sculptures, which may combine fantasy and reality, as in his *Sunflowers* of 1972, for

example, a particularly fetching piece featuring an adolescent girl playing her flute while sitting on the topmost bud of a group of sunflowers. The piece is 10 feet tall and is effectively sited in Brookgreen Gardens.

Parks has also distinguished himself with such works as the over-lifesize bronze of Homer Judson, a genre group portraying an itinerant woodsman the sculptor knew who could charm the deer of the forest. Embodying the romance of the early American pioneers, Judson stands bare to the waist with his right hand stroking his beard and his left hand extended over the doe by his side.[34]

Parks's monumental liturgical commissions are among his most powerful works. They include the 32-foot-high stainless steel *Madonna* for Our Lady of Peace Catholic Church in Santa Clara, California, of 1982, the 16-foot-high *Crucifixion* of 1961 for the Zion Lutheran Church in Wilmington, and a 21-foot-high figure of *Christ the King* for the Catholic Cemeteries of Chicago, of 1985.[35]

DOMENICO FACCI

Domenico Facci is also a modeler and a carver of rare gifts. The son of Italian immigrants, Facci grew up in the mining country of Pennsylvania. Largely self-taught, he works in various genres, including animal sculpture, portraits, and medallions, and he also creates monuments. Facci's amiable polar bear logo in bronze, 10 feet tall by 12 feet long, stands in front of Great Bear Spring Company's regional office in Teterboro, New Jersey, and a pair of nuzzling giraffes won the Audubon award for sculpture in 1961.[36]

His many portraits include some of the world's leading entertainers, among them Bob Hope, Lynn Redgrave, and Joan Fontaine. Facci has designed plaques and medallions celebrating civic and national causes: a plaque for the United Cerebral Palsy Foundation, the Nathan S. Kline Medal for mental health, and a conservation medal for Ohio's Big Woods Reserve. His memorials include the Peter D. Haughton Memorial for the Hall of Fame of the Trotter in Goshen, New York, 1981, and the bronze relief for the Tomb of the Unknown Soldiers of the American Revolution in Rome, New York, erected during the nation's Bicentennial in 1976.[37]

Domenico Facci (b. 1916)
Giraffes, 1961
Cherry, 38 in. (96.5 cm) high
Private collection

CHAPTER TEN

TWENTIETH-CENTURY TRANSFIGURATIONS

With the Chicago Exposition of 1893 came a breadth and depth of collaboration between sculptor and architect that could not have been imagined a generation before. That same year, the leading sculptors in the country organized themselves into a national organization, the National Sculpture Society, to create new markets for figurative sculpture. They enjoyed enormous success as long as the great architectural programs were in demand and as long as people erected monuments to the nation's heroes. In fact, the members of the society dominated public sculpture in America until World War II. From Ward, Saint-Gaudens, French, Warner, and MacMonnies to Manship, Lawrie, and de Creeft, the National Sculpture Society's members won all the choice commissions. The society never succeeded, however, in creating a mass market for household sculpture, which had been one of its professed aims: "to spread the knowledge of good sculpture, foster the taste for, and encourage the production of ideal sculpture for the household and the museum."[1]

The reason they failed was that they deceived themselves into thinking people would want the kinds of ideal pieces they were creating for public buildings. Very few people had the means or the space for such works, and even when reductions of the works of Saint-Gaudens, French, and other great Beaux-Arts masters were executed by Gorham and Tiffany at $90 and $100 apiece, that was hardly the way to get sculpture into every home in America.

In line with the National Sculpture Society's efforts to promote figurative sculpture and to encourage industry to explore new ways of providing opportunities for figure sculptors, Edward Holbrook, president of Gorham Company, instituted the practice of awarding bronze figures by American sculptors for trophies instead of the traditional winner's cup. *The Sprinter*, 1902, by Charles Albert Lopez, for example, was chosen as a trophy for track and field events by the United States Atlantic Fleet.[2] Evelyn Longman's *Victory* for the dome of the Festival Hall at the Louisiana Purchase Exposition in St. Louis, 1904, was probably the most famous one selected. *Victory* was a male figure that stood atop a globe and held a laurel wreath and oak branch in his left hand. Small replicas were adopted by the United States Navy for athletic competitions in the Atlantic Fleet.[3] Longman's *Victory* was also the

ABOVE
Charles Albert Lopez
(1869–1906)
The Sprinter, 1902
Bronze, 17 in. (43.2 cm) high
The Metropolitan Museum of Art,
New York; Rogers Fund, 1902

OPPOSITE PAGE
View of 1929 National Sculpture Society Exhibition, 1929
National Sculpture Society,
New York

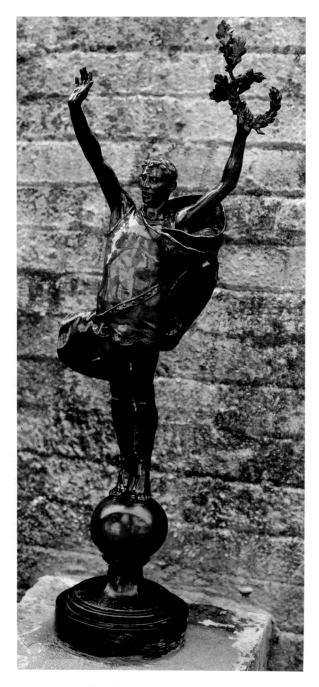

Evelyn Longman (1874–1954)
Victory, 1903
Bronze, 30¼ in. (76.8 cm) high
Brookgreen Gardens,
Murrells Inlet, South Carolina

model for the well-known symbol of AT&T that for many years stood atop its world headquarters at 195 Broadway in New York City. Known as the *Spirit of Communication*, the *Genius of Electricity*, and more popularly as *Golden Boy* because of its gilding, the 19-foot-high figure stood 434 feet above the street, his wings extended to a 12-foot span. Installed in 1916, the Apollo-like figure stood atop a globe, symbol of the world, above a simplified version of the famous tomb of Mausolus at Halicarnassus. In his left hand, he holds the thunderbolts he has just grasped to provide the power through the telephone lines he has coiled around his right arm.[4] In spite of *Victory's* fame, a popular market was never created for replicas. Longman was the only female assistant Daniel Chester French ever employed, and French was responsible for her getting the AT&T commission.

It was too bad for the society that it could not have taken its single most important triumph in this regard in the early years of the twentieth century, the design of government coinage (see Chapter 7), and have turned it to a universal and long-range advantage. If the United States Government was willing to commission the best sculptors in the country to make the nation's money, the government could certainly have been guided to commission our sculptors to work in many other areas, as did happen in the 1930s, but for different reasons. Properly marketing what had produced Saint-Gaudens's gold pieces, Fraser's buffalo nickel, Weinman's Mercury dime, and MacNeil's Liberty quarter could have revolutionized American figurative sculpture, without compromising its integrity. Opportunities that the average package-goods marketing director would see today were beyond the vision of the National Sculpture Society then. Daniel Robbins has shown that the Beaux-Arts sculptors so totally and intensely identified public sculpture with the nation's values that they simply could not see sculpture in any other role.[5]

GARDEN SCULPTURE

Another market emerged for figurative sculpture, even though it, too, was a limited one. That was for the fountains and gardens of America's grand estates, which flourished from the Columbian Exposition until the financial crash of 1929, as the wealthy fled the filth and congestion of the city, thoroughly documented in Michelle Bogart's exhibition of garden sculpture in 1985.[6] Beaux-Arts confections created by American masters replaced the abundance of cast-iron, lead, and zinc statuary purchased from pattern books and produced here or imported from Europe, which had proliferated since the Civil War.[7]

While leading sculptors executed many of those works, such as Frederick MacMonnies's lifesize figure of Pan for banker Edward Dean Adams's estate in Sea Bright, New Jersey, garden sculpture was never considered serious art. For Janet Scudder, perhaps the most successful of the garden sculptors, that made no difference, especially during the Great War. She was quite satisfied with celebrating life rather than death. "My work was going to make people feel cheerful and gay—nothing more."[8]

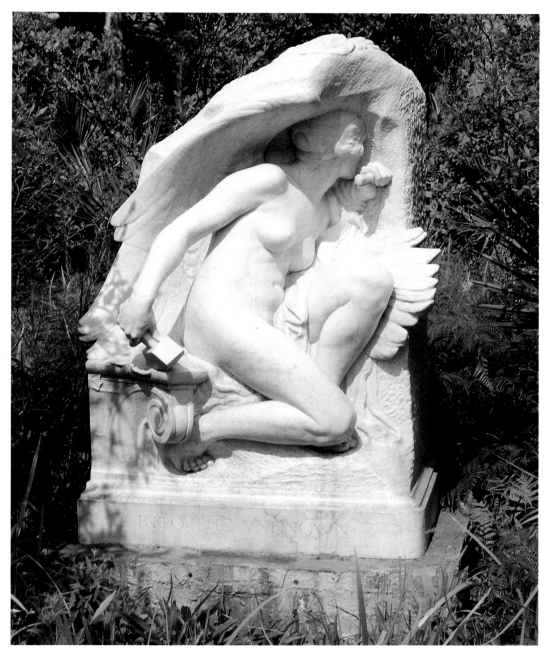

The sculpture society, nonetheless, relentlessly pursued the impossible. It mounted large and elaborate exhibitions of its monumental sculpture every year, often in collaboration with other arts organizations. Most of the exhibitions traveled to major cities in the country, and photographic exhibitions were created for works that could not travel.

THE GREAT EXHIBITIONS

The society's most ambitious efforts were the exhibitions of 1923 and 1929. They were heroic on a Wagnerian scale, and their mission was to save the Beaux-Arts tradition and make peace with the new modernism that was taking the field. Their fusion of art and theatrical effects achieved dramatic unity in exhibition but did not succeed in turning the tide, and the new sculpture

LEFT
Hermon A. MacNeil (1866–1947)
Into the Unknown, 1922
Marble, over lifesize
Brookgreen Gardens,
Murrells Inlet, South Carolina

RIGHT
National Sculpture Society Seal
National Sculpture Society,
New York

would not be appeased. As the financial crash of 1929 shook the confidence of the country, Beaux-Arts sculpture offered little comfort to a panicked populace, and even less direction to an age whose values were in disarray. Both of those exhibitions were made possible by the support of Archer Milton Huntington, who married the sculptor Anna Vaughan Hyatt in 1923 and became a dedicated supporter of the National Sculpture Society and American sculpture in general.

In the 1923 exhibition, more than 800 exhibits represented every important living American sculptor and ran from April 14 to August 1. A complete catalog of works was prepared, and for this event the critic Adeline Adams, wife of sculptor Herbert Adams, wrote a book, *The Spirit of American Sculpture*, which traced the development and trends in American sculpture.[9] Reviews praised her "Vasari-like familiarity with the subject," and even though a "blue stockings attitude" could be detected in her tone, critics found her designation "moral earnestness" appropriate in describing "the Spirit of American Sculpture."[10]

The exhibition was held at 156th Street and Broadway in the complex of buildings there that housed the Hispanic Museum, the American Numismatic Society, the American Academy of Arts and Letters, the American Geographical Society, and the Museum of the American Indian, Heye Foundation.

The success of the exhibition that Archer M. Huntington financed in 1923 inspired him to support and fund a larger and more comprehensive undertaking in 1929—a survey of contemporary American sculpture to be organized by the National Sculpture Society but not limited to its membership. Called the "greatest sculpture exposition America has ever produced," the exhibition was half again as large as that of 1923. It was to be held at the California Palace of the Legion of Honor, which was dedicated to the exhibition and study of the fine arts and to which Huntington had contributed.

The exhibition consisted of 1,300 exhibits by 300 sculptors, National Sculpture Society records show. Pieces were shipped in from American sculptors working in France, while sculptors from across the country transported their works by rail from a dozen states. Archer Huntington paid all transportation costs, estimated at $100,000. The pieces ranged from an inch-high bronze, *Bacchanalian Dance*, by Lithuanian-born Louis Rosenthal and numerous medals in low relief to Hermon A. MacNeil's two-ton marble *Into the Unknown*, the largest piece in the exposition, and the equestrian statue of *Joan of Arc* by Anna Hyatt Huntington, which was exhibited on the front lawn of the Palace.

The classical building and its surrounding grounds in Lincoln Park in San Francisco were superbly suited to the exhibition of American sculpture with its roots in the Beaux-Arts tradition. The original building had been erected by the French Government in impermanent material for the 1915 world's fair, the Panama-Pacific International Exposition, and it was a replica of the Palace of the Legion of Honor on the banks of the Seine, a building that had been inspired by the Parthenon on the Acropolis in Athens.[11] Following the fair,

California philanthropist Adolph B. Spreckels and his wife, Alma de Bretteville Spreckels, had the building erected in permanent materials as a museum of art to commemorate the California soldiers who died in the Great War. This shrine to "honor the dead while serving the living" was to be devoted exclusively to the exhibition and study of the fine arts. It was beautifully sited, as historians of the place have noted. "It stands in its majesty on a hill. On one side far, far below lie the blue waters of the Pacific. In the middle distance, one sees the Golden Gate. To the right San Francisco, shimmering in the sunlight, has the appearance of an Italian or a Spanish city."[12] George Adrian Applegarth, a California architect, built the palace in collaboration with Henri Guillaume of Paris, who designed the original for the 1915 fair.

While the exhibition surveyed the best traditional as well as avant-garde sculpture being produced at the time, critics tended to favor the avant-garde, as reflected in Junius Craven's review of the exhibition in *The Argonaut*. "If contemporary sculpture can be judged by the exhibition," he wrote, then "sculpture is the least progressive, the most under-developed, of the arts in this country."[13] He does not say why except that the pieces show no "originality" and "no tendency toward a true form of national artistic expression." Craven gives high marks, however, to direct-carve sculptors such as Ernest Dielman, Robert Laurent, German-born Heinz Warnecke, Ukrainian Alexander Archipenko, and Polish Enrico Glicenstein.

The jury tried to maintain a balance between traditional and avant-garde work. It rejected one of Jacob Epstein's abstract entries, *Madonna and Child*, for example, in favor of his *Weeping Woman*, a half-length figure of a woman wringing her hands in grief, a spontaneously modeled naturalistic piece.[14] The work was purchased by the museum after the exhibition for $1,500.[15] A total of thirty bronzes were sold from the exhibition of 1,300 pieces for a total of $22,939.[16] M. Earl Cummings's *Neptune's Daughter* at $5,000 was the highest-priced piece that was sold, and *Whirlwind* by E. A. Cavacos at $35 was the lowest-price sale.[17]

MASTERPIECES SUSTAIN TRADITION

By the beginning of the twentieth century, it was clear, especially from the great world's fairs, that the days of the American Renaissance and its linch-pin, the Beaux-Arts figure, were numbered. Notwithstanding such valiant attempts as Aitkens's *Fountain of the Earth*, with its magnificent figures enacting the modern, even progressive, theme of human evolution, and Calder's grandiloquent *Fountain of Energy*, both centerpieces in the San Francisco Fair of 1915, the great sculpture programs and the apprenticeship system that sustained them were doomed by the hypocrisy and the transparency of their imagery, but above all by a changing orientation to the human figure.

There were some notable exceptions, however, that remain examples of the fully realized potential of the academic figure, such as Daniel Chester French's *Memory* of 1909–19, and Hermon A. MacNeil's *Into the Unknown* of 1912—two masterpieces in marble.

ABOVE
Daniel Chester French
(1850–1931)
Memory, 1886; this version, 1919
Marble, 57½ × 25 × 42½ in.
(146 × 63.5 × 108 cm)
The Metropolitan Museum
of Art, New York; Gift of
Henry Walters, 1919

RIGHT
Vincent Glinsky (1895–1975)
Awakening, 1960s
Marble, lifesize
Brookgreen Gardens,
Murrells Inlet, South Carolina

French called *Memory* "the greatest effort of my life."[18] It is the most beautiful female figure that French ever created, and one of the most exquisite in the whole of American sculpture. The concept of the nude figure holding a mirror to look behind, suggesting the past, instead of into her own reflection was not a new idea. It is an idea that goes back to antiquity. French's innovation, then, is not in the subject but in his remarkable sensual and refined portrayal of the ideal female figure. From the soft flesh and open vulnerable pose to the luxuriance of drapery that folds, caresses, and frames the contemplative *Memory*, every contour and surface is to be contemplated. The sinuous line of *Memory*'s right thigh carries the eye over knee and ankle to its resolution in the right foot barely hidden by the left, as *Memory*'s toes are nestled in an opulent fold of drapery at the base of the piece. The entire sculpture quickens the heart and opens the mind from whichever point one approaches it. Not since Hiram Powers's miraculous blend of flesh and spirit in his memorable nudes of the mid-nineteenth century had an American sculptor succeeded in capturing the "matchless grace of infinite beauty of the human body and, shining through it, the human soul."[19] But French goes beyond Powers in his manipulation of line and approaches the conflation of sense and spirit in the ancient *déhanchements* of Praxiteles.

In Hermon A. MacNeil's *Into the Unknown* of 1912, the rich blending of varying degrees of relief, from *schiacciatto* to sculpture in the round, enhances the mystery of the subject. The winged muse of creativity with the sculptor's mallet and chisel in hand is portrayed in the act of freeing herself from the marble through the self-creating act of carving.[20] The image was the basis for the emblem of the National Sculpture Society, of which MacNeil was president from 1910 to 1912 and from 1922 to 1924.

Echoes of those creations may be heard down through the century, especially in such elegantly carved works as Vincent Glinsky's *Awakening*, a lifesize reclining female nude of the 1960s.

SIGNS OF CHANGE

Growing disillusionment with the social idealism of the American Renaissance climaxed with World War I. The utopian image of American society embodied in the allegorical confections of wisdom, justice, truth, and beauty that adorned our civic buildings was shattered by the cataclysm of international destruction and mass killing, and with it the Beaux-Arts figure. But it did not happen overnight. There had been signs of change right after the Columbian Exposition, even before the new century had dawned.

George Grey Barnard, scholars have noted, was the first sculptor in America to challenge the traditional idealism of the Beaux-Arts figure in favor of an unceremonious and totally unself-conscious frankness with his *The Struggle of the Two Natures of Man* of 1894.[21] Barnard's title was derived from Victor Hugo's line "Je sens deux hommes en moi *(I Feel Two Natures Within Me)*." The two over-lifesize primordial figures, one reclining, the other standing over him victorious, embody Barnard's own realization as a young man that "as soon as he realizes his larger part in the universe . . . he begins to cast off the earth and reach up toward the stars."[22]

Barnard became a celebrity in Paris when that work was exhibited at the Salon, and, in addition to Rodin's praise, critics proclaimed him a new-found genius.[23] Barnard was launched and enjoyed an international reputation from then on, but his works were too primordial to please the general public at home. In emulation of Michelangelo and Rodin, Barnard spent his life giving sculptural expression to humankind's basic drives, primitive urges, and psychological states.

In carving the figures of *Two Natures* himself from a single block, Barnard anticipated the school of *taille direct* (direct carve), sculptors who at the turn of the century would revolutionize sculpture and the role of the sculptor. Through his work, as well as his teaching at the Art Students League, Barnard spread his gospel of unorthodox idealism and direct carving that was both symptomatic of and contributed to the sculpture revolution of the early years of the twentieth century in America.

THE NEW WAVE

The worldwide movement of direct carving had its origins in France in the 1890s.[24] While George Grey Barnard was carving his figures, so were such modernists in France as Paul Gauguin, Aristide Maillol, and George Lacombe. Roberta Tarbell has shown that Robert Laurent brought new focus to direct carving in America in 1911, with his *Negress*.[25] Then, in the Armory Show of 1913, direct-carve works of the French sculptor Joseph Bernard, who has been credited with its invention, were exhibited. Others whose direct-carve works attracted attention at the time were Brancusi, Zadkine, Mestrovic, and Eric Gill.

Born of the modern movement's rejection of the academic tradition in general and of Rodin's dominance of the field in particular, as Robbins notes,

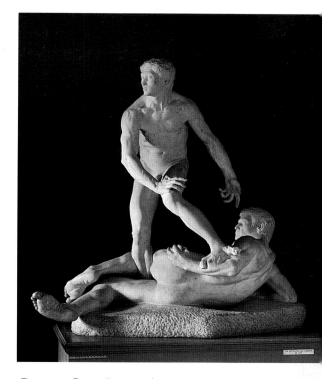

George Grey Barnard
(1863–1938)
The Struggle of the Two Natures of Man, 1894
Marble, 101 × 102 × 48 in.
(256.5 × 259 × 121.9 cm)
The Metropolitan Museum of Art, New York; Gift of Alfred Corning Clark, 1896

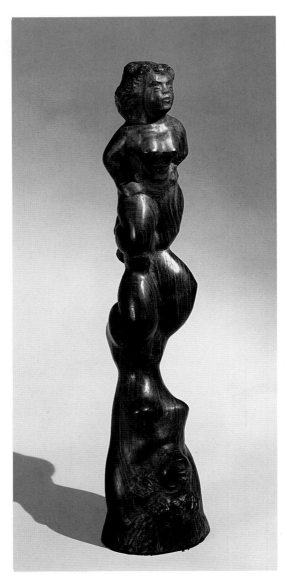

Chaim Gross (1904–1992)
Acrobats Balancing, 1951
Lignum-vitae, 30¾ × 7⅜ × 7⅛ in.
(78.1 × 18.8 × 18.0 cm)
Hirshhorn Museum and Sculpture
Garden, Smithsonian Institution,
Washington, D.C.; Gift of
Joseph H. Hirshhorn, 1966

sculptors in France turned to direct carving, which preempted the traditional process of making a model and casting it then in plaster to be cast in bronze or pointed in stone. In that process the sculptor had to rely on assistants, craftsmen, and artisans whose skills and loyalty had a great deal to do with the finished work. Moreover, most public sculpture was incorporated into elaborate architectural schemes, which meant the sculptor was dependent on the architect, and what he produced was toward utilitarian ends. In direct carving, sculptors could be free of those dependencies and select other options.[26] The direct carver worked alone in communion with his material. He made sculpture for himself, his patrons, the home, the museum, as well as for public spaces.

Although the Beaux-Arts tradition continued to have its adherents in the United States, direct carving grew to dominate the field of American sculpture by the 1930s and 1940s, as Wayne Andersen demonstrates, and it led to a style in which the greatest emphasis was placed upon the material a sculptor used. In that aesthetic of materials, the sculptor sought to respond to the properties inherent in the material and to respect its limitations as well as to explore its possibilities. Sculptors talked about the integrity of the medium and being true to it. It would be a violation of the integrity of stone, for example, which is permanent and monumental, to make it behave like drapery, water, and the like. Henry Moore was adamant on that point for many years.

As sculptors had begun early in the century to interact with their materials in direct carving, they made great strides in formal invention. For figurative sculptors, the human figure was consequently modified by the variations in tone, texture, and conformation of the sculptor's materials. The influence of Cubism, scholars have shown, the parent of modern abstraction, and its numerous descendants had already liberated artists from academic models, which made that evolution of the human figure possible.

Chaim Gross, one of America's foremost direct carvers, created masterpieces in his favorite medium, lignum vitae, a South American hardwood.[27] "He loved the tonality of the wood, its darker inner color coming through to the outer lighter color," which "takes a polish beautifully."[28] Gross was best known for his acrobats, jugglers, tumblers, dancers, and mothers playing with children. He preferred creating sculptures of two or three figures, which allowed him to work with interlocking forms.

When José de Creeft came to the United States in 1929 from his native Spain, he further energized the direct-carve school with his appreciation for massive volumes, expressed in *Maternity* of 1922 in the Metropolitan Museum of Art, and the magic he wrought through color in such pieces as *The Cloud* of 1939, carved in greenstone.[29] He earned almost immediate recognition during the early days of the Great Depression for the balance of abstraction and truth to nature that characterized his best work.

Although Seymour Lipton emerged in the late 1940s as the country's most powerful spokesman for "organicism" in sculpture and is remembered for his metal sculpture, his early figurative works were highly inventive

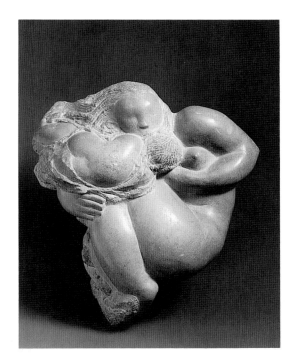

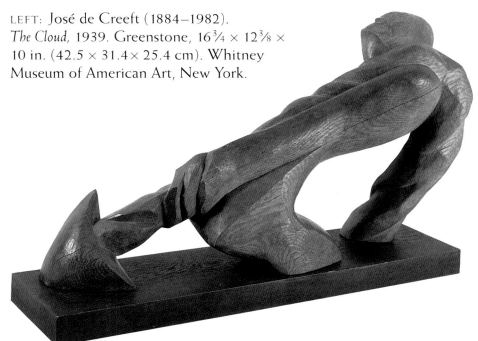

LEFT: José de Creeft (1884–1982). *The Cloud*, 1939. Greenstone, 16¾ × 12⅜ × 10 in. (42.5 × 31.4 × 25.4 cm). Whitney Museum of American Art, New York.

direct-carve wood sculptures, such as *Sailor* of 1936, carved in oak, now in the Whitney Museum.[30]

Direct carve has never died out. We may find part of the reason for that in the manifesto of one of its later practitioners, Elfriede Abbe. "In direct carving, idea and medium act upon one another, and a particular piece of material imposes on the finished product something of its own harmonies, persuading the creator to take advantage of its character in order to achieve an integrated whole."[31] Idea and medium are sensitively united in *The Illuminator*, of 1962, Abbe's memorial figure to Professor Homer E. Sterling of Carnegie-Mellon University in Pittsburgh.

ENDURANCE OF THE BEAUX-ARTS

The attitude toward materials expressed by Abbe, conditioned by abstraction, attracted sculptors to Pre-Columbian and African art. Fascination with the exotic, however, was not the sole domain of the avant-garde or the direct carver, but extended to the traditional Beaux-Arts sculptor as well, even if for other reasons. Malvina Hoffman, for example, began her travels around the world for the Field Museum to record the various races of mankind in lifesize statuary in 1930. Stanley Field, president of the Field Museum, wanted to fill the hall of anthropology in his museum, like the zoos filled their monkey houses. So he decided to tell the story of mankind with lifesize and lifelike statues of the races of man. To accomplish this, he commissioned Malvina Hoffman to take casts of people of all the races she visited throughout the world and make bronze statues of them for the museum.[32]

The Hall of Man remains a unique display of humanity captured in statuary through the union of science and art. Its power gives one pause to ponder the future possibilities for artistic excellence combined with human expression

ABOVE RIGHT
Seymour Lipton (1903–1986)
Sailor, 1936
Oak, 19 × 32¾ × 10¼ in. (48.3 × 83.2 × 26 cm)
Whitney Museum of American Art, New York; Gift of the artist

BELOW
Elfriede Abbe (b. 1919)
The Illuminator, 1962
Walnut, lifesize
Hunt Library, Carnegie-Mellon University, Pittsburgh

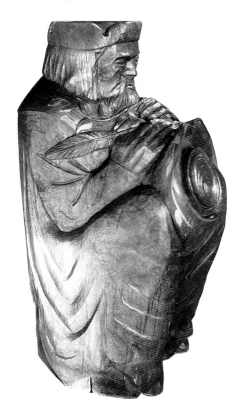

CLOCKWISE FROM TOP: The Hall of Man, Malvina Hoffman sculptures. Field Museum, Chicago. / John Storrs (1885–1956). *Composition Around Two Voids*, c. 1934. Stainless steel, 20 × 10 × 6 in. (50.8 × 25.4 × 15.2 cm). Whitney Museum of American Art, New York; Gift of Monique Storrs Booz. / Gaston Lachaise (1882–1935). *Woman Walking*, 1922. Bronze, 18½ × 10¾ × 7 in. (47 × 27.3 × 17.8 cm), including base. Museum of Modern Art, New York; Gift of Abby Aldrich Rockefeller. / Elie Nadelman (1882–1946). *Man in the Open Air*, c. 1915. Bronze, 54½ in. (138.4 cm) high; at base: 11¾ × 21½ in. (29.8 × 54.6 cm). Museum of Modern Art, New York; Gift of William S. Paley (by exchange).

that some of our Beaux-Arts sculptors continued to achieve, even as the American Renaissance was dying. Had more sculptors focused on the essence of the human figure, as Hoffman and some others had, rather than on its ornamental properties for the grand architectural schemes that had lost all meaning, the history of figurative sculpture might have recorded a different story.

Although twentieth-century modernism brought an end to the Beaux-Arts tradition, the human figure remained the most popular subject for

American sculptors until World War II. And, through the influence of such Paris-trained artists as Elie Nadelman and Gaston Lachaise, the new American sculpture became characterized by simplification and abstraction of form.

One of the first to experiment with abstract form, Robbins notes, Elie Nadelman in his work always dealt with simplified human and animal forms expressed in harmonious contours. Born and raised in Warsaw, he studied at the Warsaw Art Academy and then went to Paris to study at the Académie Colarossi in 1904. He exhibited in Paris, London, and Barcelona, and was represented in the Armory Show in 1913. The following year he came to New York and enjoyed immediate success. *Man in the Open Air* is characteristic of his work at that time. During the Depression his work in public sculpture reflected the influence of the American modernists such as Paul Manship, especially in his *Construction Workers* of 1930–32, carved in limestone for the façade of the Fuller Building in New York City.[33]

Gaston Lachaise grew up in Paris, studied at the Ecole des Beaux-Arts, and worked for the jeweler and glassmaker René Lalique. When he came to America in 1906, he worked for the Boston sculptor Henry Hudson Kitson, then for Paul Manship in New York City. Through Lachaise's diverse background, traditional and avant-garde principles were annealed by his passionate love for Isabel Dutaud Nagle into a distinctive figure style that accounts for some of the most remarkable celebrations of erotic love in the history of American sculpture. *Woman Walking* of 1922 fully embodies that conflation of principles.[34]

John Storrs lived and worked mostly in Paris, and while he worked in a Cubist style, his sculpture well into the 1920s, such as *Male Nude*, 1922, carved in composition stone, in the Des Moines Art Center, retained an identification with nature. By the 1930s, however, abstraction replaced any connection with representational anatomy, as demonstrated in his *Composition Around Two Voids* of 1932, in stainless steel.[35]

Hugo Robus simplified nature's forms into smooth planes and serpentine contours, but he also explored human themes such as *Despair*, 1927. He

RIGHT: Alexander Archipenko (1877–1964). *Woman Combing Her Hair*, 1915. Bronze, 13¾ × 3¼ × 3⅛ in. (34.9 × 8.3 × 7.9 cm), including base. Museum of Modern Art, New York; Acquired through the Lillie P. Bliss Bequest. BELOW: Robert Moir (b. 1917). *Mother and Child*, 1950. Limestone, 22¼ × 13½ × 10 in. (56.5 × 34.3 × 25.4 cm); base: 1¾ × 8 × 7¼ in. (4.5 × 20.3 × 18.4 cm). Whitney Museum of American Art, New York

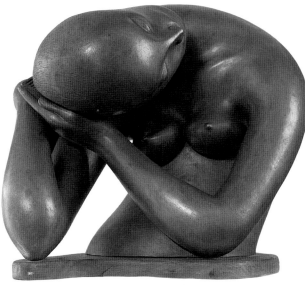

LEFT: Hugo Robus (1885–1964). *Despair*, 1927. Bronze, 13¾ × 13¾ × 9¾ in. (34.9 × 34.9 × 24.8 cm). Whitney Museum of American Art, New York. RIGHT: Hugo Robus (1885–1964). *Woman Combing Her Hair*, 1927. Bronze, 16½ × 18 × 17 in. (41.9 × 45.7 × 43.2 cm). The Corcoran Gallery of Art, Washington, D.C.; Gift of Mr. and Mrs. J. Henry Berne

Alexander Calder (1898–1976)
The Brass Family, 1927
Brass wire on painted wood base,
68 × 41 × 9 in. (172.7 × 104.1 ×
22.9 cm) overall
Whitney Museum of American
Art, New York; Gift of the artist

Paul Manship (1885–1966)
Dancer and Gazelles, 1916
Bronze, 32¼ × 35 × 11 in.
(81.9 × 88.9 × 27.9 cm)
The Metropolitan Museum
of Art, New York; Francis
Lathrop Fund, 1959

studied art at the Cleveland School of Art, the National Academy of Design, and with Antoine Bourdelle in Paris from 1912 to 1914. His *Woman Combing Her Hair* of the same years illustrates not only the broad spectrum of human feelings that interested Robus but also how he could express such a variety of human emotions through gesture. His smooth solids and sinuous forms, moreover, never lose touch with nature, so that simplified as his forms become they are always consummately human.[36]

Alexander Archipenko's sculpture of the same name, *Woman Combing Her Hair* of 1915, is an early work that embodies the sculptor's unique brand of Cubism, which was represented in the Armory Show of 1913. The style is characterized by alternations of solids and voids, concavities and convexities, oppositions he had abandoned by the time he came to the United States in 1923, but which may be reflected in Lipchitz's mature work in the 1940s and in the works of such little-known sculptors as Robert Moir, such as his *Mother and Child* of 1950 in the Whitney Museum.

In Archipenko's later work, the figure is reduced to elegant torsos, his most daring consisting of attenuated curves suspended in space, reminiscent of the elegant lines of Modigliani, whom he met when he first arrived in Paris from his native Kiev in 1908. A gifted and generous teacher and a prolific sculptor, Archipenko was a major force in shaping American sculpture up until the time he died in 1964. He taught at many universities and colleges throughout the country from east to west and had 118 one-man shows while he lived and a traveling retrospective when he died that toured major museums in the United States and Europe.[37]

Alexander Calder created a unique expression in the 1920s that had a lasting impact on the figure's relationship with space. Calder's sculptures, such as *The Brass Family* of 1929, have been called drawings in space, and scholars have pointed out that he began making them after an assignment in 1925 to make drawings of the Ringling Brothers and Barnum and Bailey Circuses for the *National Police Gazette* magazine. His mechanized circus was the outcome of that assignment.[38]

THE TENACITY OF THE FIGURE

It should be re-emphasized that in spite of the new European modernism, the academic figure did not disappear overnight. In the much-celebrated Armory Show of 1913, in which the modernists created such a stir for the general public, there were numerous conservative works by Karl Bitter, George Grey Barnard, Solon Borglum, James Earle Fraser, Bessie Potter Vonnoh, Jo Davidson, Mahonri Young, and Arthur Lee.[39]

While Robert Laurent, William Zorach, and John B. Flannagan led the way in direct carving, traditional sculptors like Karl Bitter and Paul Manship found common ground with the new modernism in Archaic Greek sculpture and began to forge new styles. The same year Bitter's *Schurz Monument*, which combined a Beaux-Arts portrait statue with Archaic Greek reliefs, was unveiled, Paul Manship exhibited his work to the acclaim of the Architectural

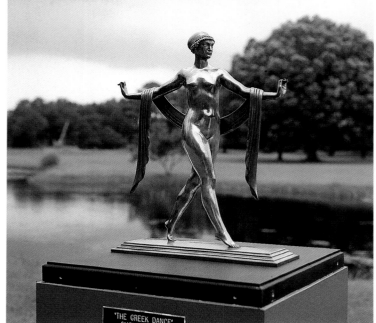

League of New York and the National Academy of Design, and the Metropolitan Museum of Art purchased Manship's *Centaur and Dryad*. Then, in 1916, he had a one-man show of 150 pieces at the Berling Photographic Gallery in New York City in which *Dancer and Gazelles* was the principal attraction, a piece that epitomized Manship's new style.[40] Two years later, the Metropolitan Museum of Art commissioned him to design the memorial relief to J. P. Morgan for its Great Hall. It was carved in 1920 by Gaston Lachaise, who was then one of Manship's studio assistants. Manship said of his success, "I was the right man at the right time."[41]

Manship was to become the leading sculptor of the 1920s, whose style would influence contemporary sculpture until the end of World War II. Distinguished by their simplified and polychromatic forms, clean sinuous lines, slender curves, and lyrical surfaces, Manship's groups although freestanding are usually relieflike in their frontality. His style derives primarily from Archaic Greek models, although Eastern influences have also been noted, and his smaller pieces in their elegant and colorful surfaces and frontal composition have a picturelike quality and lightness of spirit that is perfectly compatible with the international Modern and Art Deco styles of architecture that prevailed in the 1920s and 1930s. He relied on line as the essential element of design, he confided to his audience at the American Academy in Rome in 1912, just as he was completing a three-year fellowship there.[42]

In reworking ancient themes, Manship combined classical and archaic elements with simplified modeling to create a style for the period that had a wide and lasting influence, as reflected in any number of contemporary works, among them Edward McCartan's two *Dianas* of the 1920s, John Gregory's *Orpheus and Leopard* of 1918 and his *Orpheus* of 1941, and Josef Mario Korbel's *Adolescence* of 1923. Korbel's piece was developed from a garden sculpture he designed for George Gough Booth, owner of the *Detroit News* and founder of Cranbrook, the progressive art center in Bloomfield Hills, Michigan.

Carl Paul Jennewein's *Greek Dance* of 1926 also shares those same stylistic characteristics. The idea for his piece came from travels through Rome and Greece in preparation for the pedimental sculpture for the Philadelphia

TOP LEFT: John Gregory (1879–1958). *Orpheus*, 1941. Marble, 31½ in. (80 cm) high. Brookgreen Gardens, Murrells Inlet, South Carolina. TOP RIGHT: Carl Paul Jennewein (1890–1978). *The Greek Dance*, 1926. Silvered and polychrome bronze on wood base, 20½ × 16½ × 6¾ in. (52.1 × 41.9 × 17.1 cm). Brookgreen Gardens, Murrells Inlet, South Carolina. BELOW: Edward McCartan (1879–1947). *Diana*, 1920. Bronze, 32½ in. (82.6 cm) high. Brookgreen Gardens, Murrells Inlet, South Carolina.

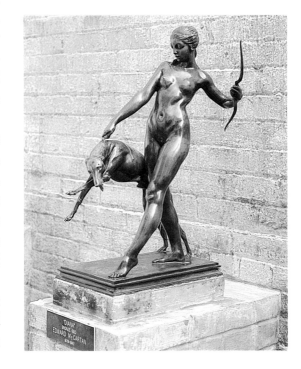

Museum of Art, which he was commissioned to do. The pedimental sculpture was to be executed in color, which explains why Jennewein also designed *Greek Dance* for color. He cast an edition of twenty-five bronzes with different patinas, such as the silvered and polychrome bronze in the San Diego Museum of Art. Years of preparation, it seems, had anticipated those unique conflations of craft, technology, and art.[43]

THE INFLUENCE OF CONSTRUCTIVISM

Constructivism, a Russian movement that grew out of collage and was founded by painter-turned-sculptor Vladimir Tatlin in 1913, had a profound effect on American sculpture following World War II. Its most influential proponents were Naum Gabo and Antonio Pevsner, who settled in Paris and declared in their "Realistic Manifesto" of 1920 that sculpture was not necessarily composed of static volumes. The movement dispersed throughout Europe, but its full impact on American sculpture was not felt until after World War II. Abstract Expressionism emerged then, and while it was primarily a painting movement, its gestural strokes and open forms influenced both the cast and the direct-metal work of sculptors like David Smith and Herbert Ferber and Ibram Lassaw, as William Homer makes clear in analyzing the return to figuration after World War II. Although their works were mostly abstract, surrealist influences have been noted in the distortion of the human figures they executed. Anatomy was always subordinated to expression.[44]

Wayne Andersen shows how David Smith went through a period of social protest against the horrors of war and other evils in the 1930s and 1940s, during which he produced his fifteen *Medals of Dishonor* (1937–40), "medallions for killing" and "for destroying," as he described them.[45] Cast in the venerable lost-wax process, they were executed in the style of ancient Mesopotamian cylinder seals, which Smith had seen in Greece, while the imagery was surrealistic. He also executed some remarkably strong freestanding war pieces, such as *Spectre of War* and *War Landscape*, both of 1944, and *The Rape* of 1945. In the 1950s, Smith's inventive genius found expression

David Smith (1906–1965)
Hudson River Landscape, 1951
Welded steel, 49½ × 75 × 16¾ in.
(125.7 × 190.5 × 42.6 cm)
Whitney Museum of
American Art, New York

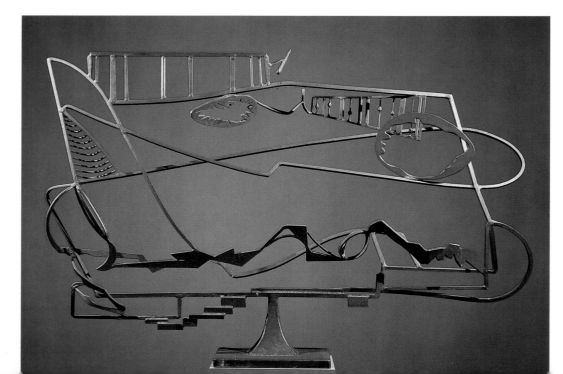

in broader themes such as *Hudson River Landscape* and *Australia*, both of 1951, and *Blackburn—Song of an Irish Blacksmith* of 1950.[46]

From carving realistic wood figures, Andersen chronicles Herbert Ferber's move to more open and attenuated forms under the influence of Abstract Expressionism and his fascination for Romanesque sculpture, especially the works he saw at Moissac and Souillac. Ferber was drawn to the work of Ossip Zadkine and Henry Moore, and by the 1940s his figures began to incorporate their surrounding space.

By opening up the mass of his pieces, Ferber created expressive contours that produced such works as *Reclining Woman I* and *Reclining Woman II* of 1945. Soon his figures became more linear as mass gave way to open space, and he relinquished the figure to pursue the formal properties of metal and various direct-metal techniques. He also did portraits, including that of his fellow sculptor David Hare, whose work influenced Ferber's interpenetrating forms.[47]

Ferber studied at the Beaux-Arts Institute of Design from 1927 to 1930, while studying dentistry at Columbia University. Like Seymour Lipton, he practiced dentistry while pursuing his sculpture.

How David Hare's explorations in interpenetrating forms relate to his surrealistic themes is ably represented in *Suicite*, a bronze of 1946. The piece embodies the complex associations connected with male and female eroticism and violence. Hare meant it to be what he considered a "masculine gesture, that of suicide, performed by a woman. The gesture is the driving into the ground . . . a sexual fantasy with the front element suggesting a horn, nose, sword, trumpet, clitoris."[48]

Whereas an artist like William King, who studied at Cooper Union and at the Academy of Fine Arts in Rome, eschewed surrealism to create a humorous style in his commentary on social stereotypes, such as *Italian Straw Hat* of 1950, Theodore Roszak adopted the machine aesthetic of the Bauhaus and became one of the pacesetters of the 1930s, uniting Constructivism and surrealism. One of Roszak's most powerful pieces, *Spectre of Kitty Hawk* of 1946, is a commentary on the destructive role of modern aircraft in World War II. The piece consists of a prehistoric lizard swooping down from the sky, its horned head and arched body of terrifying protrusions confected of welded and brazed steel.[49]

The Second World War produced one of Jacques Lipchitz's major works, *Sacrifice II*, 1948–52. The piece was inspired by the sculptor's rage over the loss of his personal possessions during the war and his being forced to leave friends, home, and studio. A man holds a cock in his left hand and plunges a knife into its heart with his right. The man is not a rabbi, but Lipchitz dressed him as one to show that he has been specially ordained to perform this ritual sacrifice. The lamb that sits between the man's knees has a twofold purpose—to suggest the continuity of the Judeo-Christian tradition and to stabilize the composition.[50]

In the 1940s, Peter Grippe portrayed what Wayne Andersen calls the "urban image of man in his environment . . . his loneliness and social

TOP
Herbert Ferber (b. 1906)
Reclining Woman II, 1944–45
Cast bronze, 16 × 36 × 16 in.
(40.6 × 91.4 × 40.6 cm)
Jane Vorhees Zimmerli Art
Museum, Rutgers University,
New Brunswick, New Jersey;
Gift of the artist

BOTTOM
William King (b. 1925)
The Italian Straw Hat, 1956
Bronze, 31½ × 7 × 3¾ in.
(80 × 17.8 × 9.5 cm)
Whitney Museum of American
Art, New York; Gift of the
Howard and Jean Lipman
Foundation, Inc.

TOP LEFT
Peter Grippe (b. 1912)
The City, 1942
Terra-cotta, 9½ × 11⅛ × 16 in.
(24.1 × 28.3 × 40.6 cm)
Museum of Modern Art, New York

TOP RIGHT
Richard Fleischner (b. 1944)
Walking Figure, 1970
Bronze, silver, and copper,
7¼ × 12½ × 1¾ in.
(18.4 × 31.8 × 4.4 cm)
Whitney Museum of
American Art, New York

BOTTOM LEFT
Jacques Lipchitz (1891–1973)
Sacrifice II, 1948–52
Bronze, 49¼ in. (125.1 cm) high
Whitney Museum of.
American Art, New York

BOTTOM RIGHT
Theodore J. Roszak (1907–1981)
Spectre of Kitty Hawk, 1946–47
Welded and hammered steel
brazed with bronze and brass,
40¼ × 18 × 15 in.
(102.2 × 45.7 × 38.1 cm)
Museum of Modern Art, New York

dependency," in a series he called *City 1*, *City 2*, and *City 3*.[51] Shaped by the multiple views of Cubism and the impact of New York City's great skyscrapers, Grippe appends anatomical fragments such as lips, hands, feet, noses, and eyes onto skyscraper walls to create a unified composition of independent elements.

The images of overwhelming loneliness of the 1940s influenced later artists. In his *Walking Figure* of 1970, for example, Richard Fleischner was influenced by Giacometti's *City Square* of 1948. Fleischner played with scale to create lifesize tableaux as well as miniature reliefs that appeared to be monumental, as Tarbell illustrates in her study of the figurative tradition.[52] *Walking Figure* is such a piece. Within a small format that would fit into one's hand, he portrays a brick wall supported by a natural rock foundation. A small window in the upper-left-hand corner of the wall, the small size of

the bricks that compose the wall, a small flight of stairs into the rock at the bottom right, and the diminutive figure all work together to produce the impression of a space that overwhelms the walking figure, hence insupportable loneliness. Fingerprints in the rock foundation that was modeled by the sculptor reveal the ambiguity of scale. Ironically, once the discovery is made, the message is in no way diminished. To the contrary, it invites reflection on the human condition.

THE FORTIES AND THE FIFTIES

The figurative tradition was largely in eclipse through the 1940s and 1950s. Even the exceptions, however, who continued the tradition of representational sculpture, reflected the influence of Abstract Expressionism in welded pieces, hammering, and texturing metals.[53] Saul Baizerman, for example, as Homer discusses, hammered bronze casts and beat copper sheets into molds to create his unique expressionistic rendering of the human figure. His most provocative piece of the 1940s is *Slumber*, 1948, fabricated of hammered copper. Born in Russia, he came to America early in the twentieth century and studied at the National Academy of Design and with Solon Borglum at the Beaux-Arts Institute of Design in New York City.

The character of welded sculpture lent itself to expressionistic and surrealistic themes. These spiky, aggressive forms were made to order for the monsters of Theodore Roszak, the mad dogs of Juan Nickford, and the primordial fantasies of surrealists, as Wayne Andersen has pointed out.[54] In Barbara Lekberg's welded-steel *Prophecy* of 1955, for example, the prophet with scroll unfurled and mouth gaping open like a menacing specter reads to mankind from the inspired Word. Lekberg was a member of the highly influential contingent of direct-metal sculptors who belonged to the Sculpture Center, and she showed in its historic inaugural exhibition in January 1951. Others included David Smith, Ruth Vodicka, Calvin Albert, and Theodore Roszak. The Center had descended from the Clay Club, founded in 1928 by Dorothy Denslow, and was the academic center for direct-metal sculpture.[55]

THE SIXTIES AND THE SEVENTIES

With the advent of Pop Art in the 1960s, following Abstract Expressionism's loss of momentum, the figure returned to prominence and respectability. Figurative sculpture then moved in various directions, such as the environments of Edward Kienholz and George Segal, the ultra-realism of Duane Hanson, John de Andrea, and John Jensen, and the anatomical classicism of Walter Erlebacher and Robert Graham.[56]

The ultrarealism of this genre seems to have been anticipated by the figures of William Sargeant Kendall, who studied with Thomas Eakins and at the Ecole des Beaux-Arts in Paris. It is best exemplified in his *Quest* of 1910, in polychromed cherry wood. It portrays a half figure of a woman, perhaps a Quaker, seated with one hand lying in her lap, the other resting on

TOP: Barbara Lekberg (b. 1925). *Prophecy*, 1955. Welded steel, 43 in. (109.2 cm) high. Private collection. BOTTOM: W. W. Swallow (1912–1965). *As the Earth Sings—Pennsylvania Dutch Family.* Terra-cotta, walnut base, 18 in. (45.7 cm) high. The Metropolitan Museum of Art, New York; Rogers Fund, 1942

RIGHT
Duane Hanson (b. 1925)
Woman with Dog, 1977
Cast polyvinyl, polychromed
in acrylic, with mixed
media, lifesize
Whitney Museum of
American Art, New York;
Purchase, with funds from
Frances and Sydney Lewis

BOTTOM
Samuel Nettles
Head of the Stevedore, 1989
Patinaed plaster, 17 in.
(43.2 cm) high
Collection of the artist

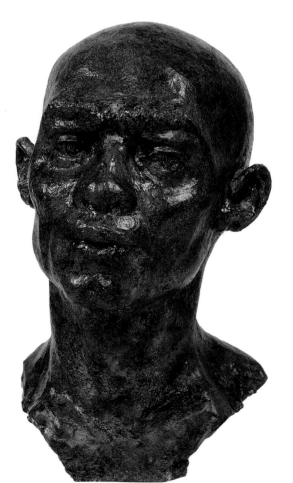

the armrest of her chair.[57] The piece is symbolic of those who came to America in search of religious freedom. William Swallow in the 1940s created a similar spirit with his *Pennsylvania Dutch Family*, a triple bust in terra-cotta but in a cubist style.

Duane Hanson casts and models figures from life to create commentaries on the man in the street. Clad in actual clothing with skin and hair that is deceptively real, as in *Woman and Dog*, of 1977, Hanson's figures are statements on a large segment of contemporary society. This heightened naturalism continues even today in such works as Samuel Nettles's portrait of a *Stevedore*. George Segal, on the other hand, also casts figures from life, but he is more interested in gesture and environment as barometers of the human condition, Martin Friedman might suggest. His figures are perceived as people involved in working out their destinies, as in *Cinema*, 1963. He is not interested in the human figure, the body, in itself as a work of art. Nor is Edward Kienholz, who employs the human figure in his environments. Kienholz says he "preaches." His works comment on society and the deeper psychological drama within each individual's life, whether they are about teenage love in *Back Seat Dodge '38*, of 1964, or the inhuman condition of state institutions in *State Hospital*, of 1964–66.[58]

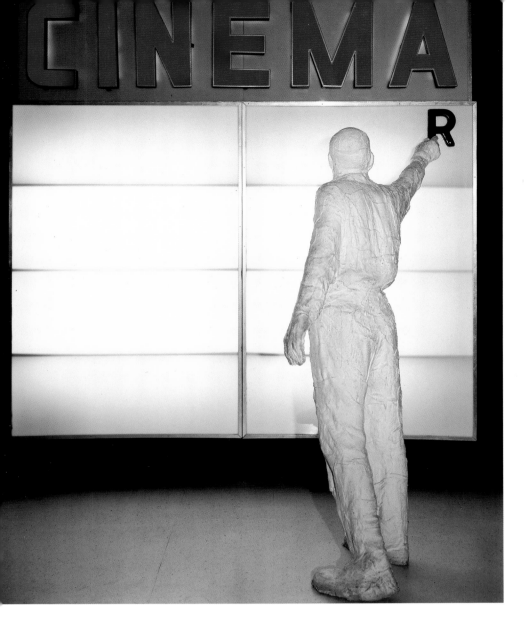

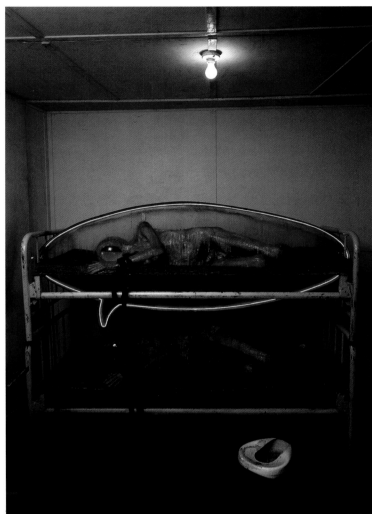

Marisol Escobar's conflations of found objects, photographs, and real clothing, and their juxtapositions with figures composed of wooden blocks and carvings carry collage and assemblage to dizzying new heights and produce as insightful a commentary as Hanson, Segal, and Kienholz, but totally different in character. Her group *The Kennedys* propelled her into the public's eye when it was exhibited in 1962. Consequently, Roberta Tarbell logically sees her *Women and Dog,* of 1964, the year following President John Kennedy's assassination, as a product of the "Kennedy-Camelot age."[59] Indeed, Marisol's pieces do hold up for our consideration the values of the American people and the wide range of stereotypes of contemporary society. For the most part, she does it with whimsy and wit through a wide range of familiar objects that involves us and thereby captures our attention.

Psychological themes in the 1960s are found in dramatic and often shocking imagery. For example, Nancy Grossman turned to sculpture from painting and collage in 1968 and makes wooden heads encased in leather.[60] These fantasies in sculpture are the continuity of a surrealistic sensibility with an emphasis on the masochistic/sadistic aspects of eroticism.

In *Child,* 1959, Bruce Conner portrays a child bound to a high chair with remnants of nylon hose, in a style dubbed "neo-surrealistic funk."[61] The child's

LEFT
George Segal (b. 1924)
Cinema, 1963
Plaster, illuminated Plexiglas, and metal, 118 × 96 × 30 in. (299.7 × 243.8 × 76.2 cm)
Albright-Knox Art Gallery, Buffalo; Gift of Seymour H. Knox, 1964

RIGHT
Edward Kienholz (b. 1927)
The State Hospital, 1964–66
Mixed media tableau, 8 × 12 ft. (2.4 × 3.7 m)
Statens Konstmuseer, Sweden

TOP
Marisol Escobar (b. 1930)
Women and Dog, 1964
Wood, plaster, synthetic polymer, and miscellaneous items, 77 × 91 in. (195.6 × 231.1 cm) overall
Whitney Museum of American Art, New York; Purchase, with funds from the Friends of the Whitney Museum of American Art

BOTTOM
Ernest Trova (b. 1927)
Study/Falling Man 1966, 1966
Silicon bronze, 21 × 78½ × 31 in. (53.3 × 199.4 × 78.7 cm)
Whitney Museum of American Art, New York; Purchase, with funds from Howard and Jean Lipman

OPPOSITE PAGE, LEFT
Nancy Grossman (b. 1940)
Head 1968, 1968
Leather, wood, and epoxy, 16¼ × 6½ × 8½ in. (41.3 × 16.5 × 21.6 cm)
Whitney Museum of American Art, New York; Purchase, with funds from the Howard and Jean Lipman Foundation, Inc.

OPPOSITE PAGE, MIDDLE
Bruce Conner (b. 1933)
Child, 1959–60
Assemblage: wax figure with nylon, cloth, metal, and twine in a high chair, 34⅝ × 17 × 16½ in. (87.9 × 43.2 × 41.9 cm)
Museum of Modern Art, New York; Gift of Philip Johnson

OPPOSITE PAGE, RIGHT
Leonard Baskin (b. 1922)
Hephaestus, 1963
Bronze, 63¼ × 23½ × 23¾ in. (160.7 × 59.7 × 60.3 cm)
Whitney Museum of American Art, New York; Purchase, with funds from the Friends of the Whitney Museum of American Art

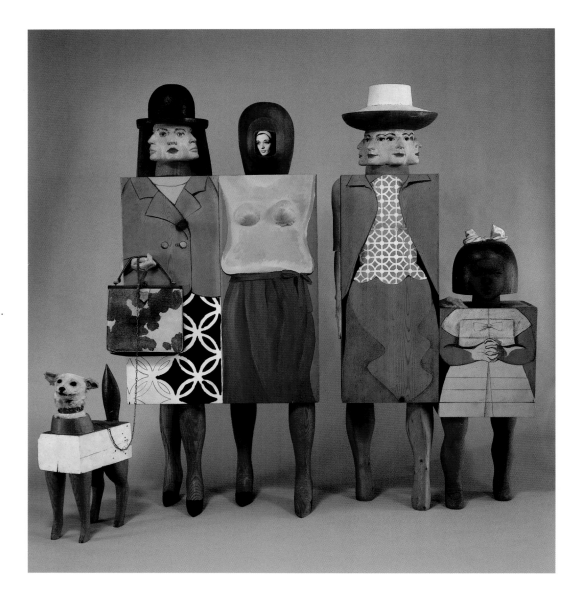

head, with mouth gaping open as if in a death gurgle, is pressed to the back of the high chair. The figure is made of old nylon stockings stuffed with discarded objects that have sentimental value alone, such as costume jewelry, letters, and photographs. Black wax is applied to form the face. The left leg is missing from the knee down and the right foot is gone. When the piece was exhibited at the DeYoung Museum in San Francisco it drew the public scorn and indignation that the artist sought in such pieces, which involve grotesque assemblages and mutilations of the human figure intended to shock the spectator.[62]

Conner was part of a group of California artists of the 1950s and 1960s, Andersen analyzes, who wished to set themselves apart from the New York scene and called their work "Funky," a New Orleans blues term, to reflect their nonart attitude.

Although less violent, Ernest Trova's transformation of the human figure into the chassis of a race car in *Study/Falling Man 1966*, 1966, is a symbol of the interdependence of modern man and his technology, and raises the issue of human mortality.[63]

Leonard Baskin's lifelong fascination with human mortality has produced compelling bronze figures that confront the mystery of life and death through sympathetic images. The lifesize bronze *Hephaestus*, of 1963, is obviously a self-portrait. Named for the son of Hera and Zeus and husband of Aphrodite, he was the divine smith and the god to craftsmen.[64] He stands, his massive frame tottering, a reference to Hephaestus's lameness. His left hand, palm open, crosses his waist, and his right arm hangs down to the side, right

Anthony Frudakis (b. 1953) *Female Nude,* 1982 Plaster, 64 in. (162.6 cm) high Plaster in Hillsdale College, Hillsdale, Michigan; bronze replica in private collection

EvAngelos Frudakis (b. 1921). *Icarus and Daedalus,* 1964. Sketch model, bonded bronze, 25 in. (63.5 cm) high, for 14 ft. (47. m) high fountain in Little Rock, Arkansas

palm also open. These open gestures, the closed eyes and stoic expression, have been seen by some students of Baskin's work as signifying the state between life and death. Whatever the interpretation, *Hephaestus*'s unceremonious and totally unself-conscious mien, reminiscent of George Grey Barnard's *Two Natures of Man,* strips away any affectations and invites the spectator to contemplate the meaning of Baskin's bronze effigy.

INTO THE EIGHTIES AND NINETIES

Although Pop Art prevailed, traditional figurative sculpture began to enjoy recognition once again in the 1960s, as in the nudes of Richard McDermott Miller, whose *Mary: Walking* was in the Whitney Museum of American Art's annual exhibition of 1964, where it won national recognition through a photograph of it that appeared in *Time* magazine.[65]

Miller believes with Gaston Lachaise that the artist's "obligation is to create a new Venus."[66] Because Miller sees the model as part of the process in the creation of his figure, he encourages her to come up with a pose that is natural. To help the model achieve that which is natural to her, he employs such devices as frames, vertical planks, lattices, and stools. Responding to the various props, the model is less likely to fall back on stock poses.[67]

Miller's experimentation in multiple figures includes *Falling from the Sky* and *Tower of Tranquility,* both of 1988, *Four Girls: Enclosed by Verticals,* of 1967, *Nanette Walking,* of 1963, *Diving, Plummeting, and Leveling Off,* 1977, and *Tripping, Bounding, Stretching,* 1977—the last two dealing with multiple figures soaring through space, a subject that also fascinates two of the Frudakises, brothers Zenos and EvAngelos.

Zenos Frudakis's *Reaching,* 1990, is composed of a pair of over-lifesize bronze figures, male and female, whirling through space. They are installed at the entrance to a 23-story high-rise at Capital Plaza in Indianapolis, Indiana. A second cast is in the Utsukushi-ga-hara Museum in Japan.

BOTTOM LEFT: Richard McDermott Miller (b. 1922). *The Tower of Tranquility,* 1989. Bronze, 15 ft. (4.6 m) high. First Union Center, Charlotte, North Carolina. BOTTOM RIGHT: Zenos Frudakis (b. 1951). *Reaching,* 1990. Bronze, 7 ft. (2.1 m) high on 6 ft. (1.8 m) poles. Indianapolis Capital Center Plaza

EvAngelos Frudakis employed the same technique in the ancient myth of Icarus and Daedalus, while his son Anthony Frudakis's *Female Nude* of 1982 is a straightforward interpretation of the standing nude that reflects some of the most enduring works of J.A.D. Ingres and Antoine Bourdelle.

Icarus and Daedalus was executed for a park in the center of downtown Little Rock, Arkansas, in 1964, as part of an urban renewal project.[68] Directly across the street from the town's library, Frudakis's piece soars above a fountain as it rotates one full revolution each hour to provide visitors to the park with ever-changing views of the sculpture.

THE INTEGRITY OF THE FRAGMENT

The anatomical fragment has a pedigree that reaches back to antiquity. In the nineteenth century, the fragment was especially popular with the American expatriate sculptors in Italy, as an alternative to the relics the Catholic Church venerated. The foot of the Venus de Medici, for example, of which many casts were reproduced, became "a monument in itself," noted the chroniclers of the period. The clasped hands of Robert and Elizabeth Barrett Browning, cast in bronze or tinted plaster, by the American sculptor Harriet Hosmer, were reproduced in numerous editions and became a symbol of that famous couple's union and an international icon to marital fidelity.[69]

The anatomical fragment in the twentieth century is not relegated to reliquary sculpture but is often just as charged with meaning, albeit subjective or ambiguous, and can reflect regional influences as well. Bruce Nauman's *From Hand to Mouth*, of 1967, for example, is a fragment of the sculptor's own body, incorporating his right hand, arm, and shoulder and his chin and mouth. A spin-off from San Francisco Funk Art, his work has been found by some critics, like Max Kozloff, to be a revival of Dada and "too frivolous," whereas others, such as Kenneth Stiles, find Nauman's ambiguity "infinitely suggestive."[70]

The torso is the most popular fragment to serve as a subject for modern sculpture, to which Jim Dines's triad of *Venus de Milos* in New York City attests. In spite of the recent revival of interpretations suggesting that the contemporary fascination with truncated Venuses derives from our infantile fantasies, those torsos have strong sculptural appeal. The critic Matthew Katangas recently recalled Peter Fuller's application of psychoanalyst Melanie Klein's theory of infantile breast envy to the ravaged Venuses to explain their appeal today.[71]

Sculptor Manuel Neri has identified an androgynous strain in the Venus fragments in elongating their solid mass into phallic forms. Judith Shea relates the Venus to contemporary fashion, and she has created Apollo partners to which she does violence by ripping off arms and shoulders but refuses to castrate the images.[72] Nancy Mee also makes a social statement through her images of Venus. She juxtaposes subtly etched Venuses on glass to rectilinear fused-glass images symbolizing women's corsets and other restrictive foundation garments of the nineteenth century that produced curvature of the spine.

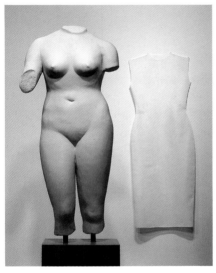

TOP
Bruce Nauman (b. 1941)
From Hand to Mouth, 1967
Wax over cloth, 30 × 10 in.
(76.2 × 25.4 cm)
Private collection

BOTTOM
Judith Shea (b. 1948)
Venus, 1989
Cast stone, cloth, 68 × 15 ×
15 in. (172.7 × 38.1 × 38.1 cm);
mounted figure, 45 × 14 × 1 in.
(114.3 × 35.6 × 2.5 cm) cloth
Collection of the artist

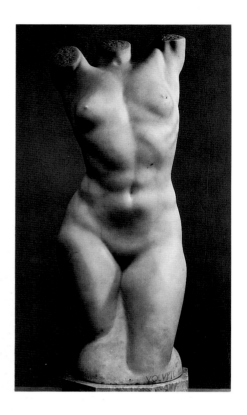 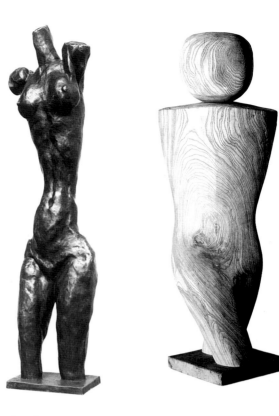 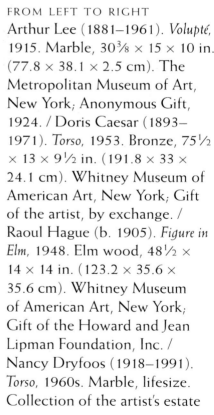

FROM LEFT TO RIGHT
Arthur Lee (1881–1961). *Volupté,* 1915. Marble, 30⅜ × 15 × 10 in. (77.8 × 38.1 × 2.5 cm). The Metropolitan Museum of Art, New York; Anonymous Gift, 1924. / Doris Caesar (1893–1971). *Torso,* 1953. Bronze, 75½ × 13 × 9½ in. (191.8 × 33 × 24.1 cm). Whitney Museum of American Art, New York; Gift of the artist, by exchange. / Raoul Hague (b. 1905). *Figure in Elm,* 1948. Elm wood, 48½ × 14 × 14 in. (123.2 × 35.6 × 35.6 cm). Whitney Museum of American Art, New York; Gift of the Howard and Jean Lipman Foundation, Inc. / Nancy Dryfoos (1918–1991). *Torso,* 1960s. Marble, lifesize. Collection of the artist's estate

Although those practices are passé, Mee's target is the influence of male standards on feminine beauty.[73]

Notwithstanding today's explorations, the freestanding torso has consistently attracted modern artists, even since the beginning of the century when the Beaux-Arts tradition was fading. While Arthur Lee, for example, maintained a traditional approach to the human figure, his soft modeling and idealized forms as reflected in *Volupté* of 1915 were compatible with the simplified style of his avant-garde contemporaries of the first decade of the twentieth century.[74]

Raoul Hague had two insatiable loves: the human figure and the materials he carved. They come together with remarkable clarity in his *Figure in Elm,* of 1948, a torso that demonstrates his mature style in the 1940s, when his figures became more abstract. He even includes the name of the wood in the title and actually composes the torso with the grain of the elm.[75] Its twisting and turning stride recalls the spiraling contrapposto of an ancient figure by Praxiteles.

Doris Caesar was totally committed to the nude female form, and she worked in an expressionist style to evoke powerful emotion.[76] Among her figures of the 1950s, *Torso,* 1953, is particularly successful in achieving such a response through the elimination of head, arms, and lower legs in celebrating the figure's fulsome nurturing breasts and the long undulating sweep from the rib cage to the slight swell of the lower abdomen in a modern version of a Hellenistic *déhanchement.*

Nancy Dryfoos's *Torso* of the 1960s, in Tennessee marble, is distinguished for its simplified yet abundant anatomical forms and sinuous silhouettes, hallmarks of her mature figures, which owed a debt to the classical idealism of Antoine Bourdelle and Aristide Maillol. Dryfoos's *Torso* is especially reminiscent of Maillol's *Chained Action* or *Torso of the Monument to Blanqui,* of c. 1905.[77]

A Spiritual Epilogue

It is impossible to do justice to the wealth of religious figurative sculpture in America in the scope of this book. Rather than try that, several selections that I find singularly moving will pay tribute to all those others that continue to celebrate eternal values that nourish the human spirit.

St. Helena

For the garden wall of the Church of St. Helena in West Hartford, Connecticut, sculptor Lloyd Glasson has portrayed St. Helena in a unique conception that the sculptor devised for its site. Glasson portrays the mother of Constantine with the True Cross, which she has discovered. Holding it upright so that its base rests on the ground, she envisions the body of Christ hanging on the cross. With her left hand, Helena reaches to touch the Savior's body, visible only to her. The sense of an interrupted moment is conveyed by the expressive modeling of the saint's hands, based on those of the artist's wife. The site of the relief, the garden wall, is a broad expanse of red brick that enhances the drama of the moment. Glasson based the likeness of St. Helena on ancient portraits.[78] An accomplished portraitist, Glasson won the National Academy of Design's Thomas R. Proctor Prize in 1985, for *Portrait of Nancy*.

Garden of Gethsemane

For the contemplative order of Cistercian monks at Gethsemani, Kentucky, in 1966, Walker Hancock created an ensemble portraying *Christ on the Mount of Olives*. It is composed of two separate pieces, Christ and two of his apostles. Hancock has chosen the moment when Christ has gone up the mountain to pray and the apostles have fallen asleep. The groups are set within the landscape of the monks' cloister, a setting that evokes a contemplative mood and the sense of sacred space that is required if the piece is to be fully appreciated. The group was replicated under the name Garden of Gethsemane for the Trinity Episcopal Church of Topsfield and Boxford, Massachusetts.[79]

Lloyd Glasson (b. 1931)
St. Helena, 1991
Bronze, 48 × 96 ft.
(121.9 × 243.8 cm)
Church of St. Helena,
West Hartford, Connecticut

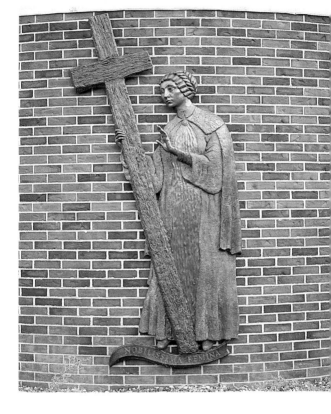

Walker Hancock (b. 1901)
Christ on the Mount of Olives, 1966
Bronze, lifesize
Gethsemani Monastery,
Trappist, Kentucky

Walker Hancock (b. 1901)
Robert Frost, 1950
Clay modeled from life, lifesize,
signed by Robert Frost and
Walker Hancock
American Academy of Arts
and Letters, New York

SCULPTOR OF ENDURING VALUES

Hancock has produced work in almost every category of sculpture, and without exception it all celebrates the nobility of the human spirit—monuments, genre, figures, portraits, and reliefs of all description. His portrait of Robert Frost, for example, shall always remain a favorite of New Englanders, because he was their most penetrating interpreter. Frost was never a pedagogue but an "awakener," and Hancock has caught that spirit of the portly bard, whose poetic realism was as "teasing-tender" as it was severe, the perceptive anthologist Louis Untermeyer has noted.[80] As Frost's poetry was personal and yet full of symbols, so Hancock's portraits capture the human spirit through timeless imagery. His monuments include *Stone Mountain Memorial* in Atlanta, Georgia; the *Field Service Memorial* in Blérancourt, France; and the *Founders Memorial,* Bell Telephone Company of Canada in Montreal; while his many memorial busts include Stephen Foster and Woodrow Wilson for the Hall of Fame.

It is fitting that Walker Hancock has been acknowledged not only through his work but also through his many awards. One of the National Sculpture Society's most distinguished members, he received the society's Medal of Honor in 1981, and in 1989 President Bush awarded him the country's National Medal of Arts "for his extraordinary contribution to the art of sculpture, and for demonstrating the enduring beauty of the classical tradition." Hancock wrote that "I am especially pleased with the second half of my citation."[81]

Judging from his body of work, his almost two generations of successful students, his many architectural collaborations, and the accounts of his many patrons from the public and private sectors over the decades, it is clear that in Walker Hancock, American sculpture has not so much a distinguished master—a description altogether too limiting—as it has a unique force, whose works and influence will forever nurture in us the ideals and values that have shaped our culture, that foster civilized life, and that can bring us to a full realization of our humanity.

TOWARD THE MILLENNIUM

As we approach the millennium, sculptor Frederick Hart, disturbed by what he sees as a century of abstraction and nihilism, believes that "If art is to flourish in the 21st century, it must renew its moral authority by . . . rededicating itself to life . . . and must pursue something higher than itself."[82] Toward that end, he created his first major work, the sculpture program adorning the three portals of the west façade of the National Cathedral in Washington, D.C., commissioned in 1974 and completed in 1990, for which he received the National Sculpture Society's Henry Hering Award. The theme of his sculpture is the Creation.[83] Each portal features a relief in the tympanum above the doorway and a statue standing beneath in front of the trumeau, the vertical support for the tympanum. In the central tympanum, 15 feet high by 21 feet wide, *Ex Nihilo* (out of nothing), the centerpiece

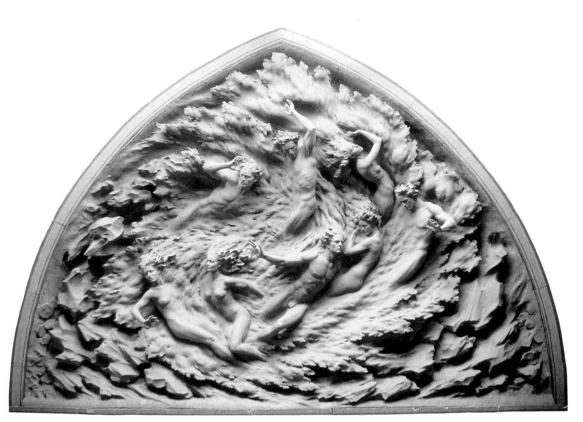

of the sculpture program, is composed of eight lifesize nudes, male and female, twisting and turning through the firmament, in the process of being formed from a primordial cloud. Adam stands in front of the trumeau directly beneath *Ex Nihilo* as "Everyman, pulled from the waters of baptism," and emerging into consciousness.

While the writhing figures swirling through irrational space in the *Ex Nihilo* relief may recall Rodin's *Gates of Hell* to many spectators, if H. W. Janson were still alive, he would probably see Hart's muscular and sensuously beautiful bodies as closer in spirit to the Neo-Baroque dynamism of Jean-Baptiste Carpeaux's figures in *The Dance* of 1867 on the Paris Opera House and François Rude's *Marseillaise* on the *Arc de Triomphe* of 1838, also in Paris, as well as to the sinuous contours and enfolding shapes of Auguste Préault's expressive reliefs such as *The Slaughter* of 1834 and *Ophelia*, twenty years later. I also see Hart's figures, in their conflation of sense and spirit, as linear descendants of Hiram Powers's "unveiled soul." Other influences on Hart's figures may be identified in the works of such English and American sculptors as Alfred Gilbert, Frederic Leighton, Daniel Chester French, and Augustus Saint-Gaudens, whom Hart has long admired.

In honor of the approaching year 2000, Hart designed *The Cross of the Millennium*, which was unveiled at the ecumenical Easter Sunrise Service at Arlington National Cemetery in Arlington, Virginia, on April 19, 1992.[84] The cross is 30 inches high, 24 inches wide, weighs eighty-five pounds, and is fashioned in Lucite, a clear acrylic, according to a process Hart has been developing over the past ten years. Within the amorphous mass of Lucite,

LEFT
Frederick Hart (b. 1943)
Central tympanum of *Ex Nihilo*
(Creation Portals), 1990
Washington National Cathedral,
Washington, D.C.

RIGHT
Frederick Hart (b. 1943)
Ex Nihilo (Creation Portals)
detail, 1990
Stone, over lifesize
Washington National Cathedral,
Washington, D.C.

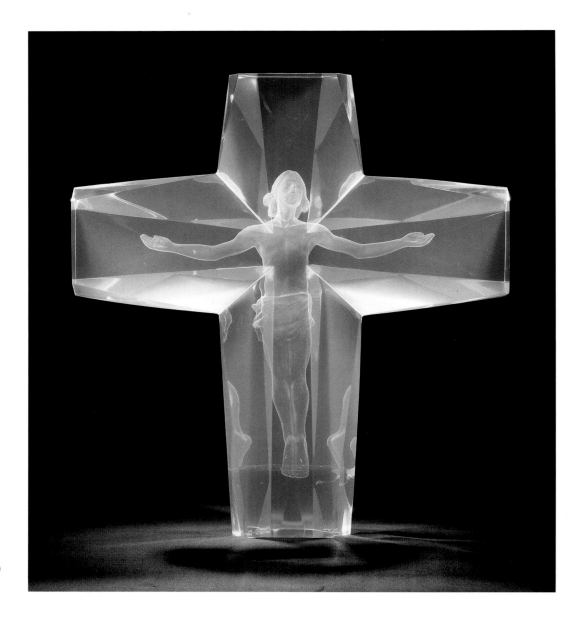

Frederick Hart (b. 1943)
The Cross of the Millennium, 1992
Lucite, 30 × 24 in. (76.2 × 61 cm)
Collection of the artist

arrangements of figures interrelate, like so many holograms, as changing light pours through the material. From the front, the viewer looks through the Star of Bethlehem to the figure of Christ, and as the viewer moves around the cross Christ's figure rises from it. Thus, in Hart's Lucite hieroglyph of the Redemption are captured Christ's birth, death, and resurrection.

Because over the centuries the Redemption has fostered human concerns and values that are universal to humankind and not limited to any single religious belief, Hart cast an edition of 175 crosses, one for each of the member nations of the United Nations at the time of issue. *The Cross of the Millennium* is therefore humankind's universal symbol of brotherhood, reminding all the people of the world that "No man is an island" and that we are indeed all "involved in mankind."[85]

NOTES TO THE TEXT

INTRODUCTION

1. Walker Hancock, "To Celebrate Our Heroes," quoted in *Sculpture Review*, Winter 1971–72, pp. 7, 28.

2. For explications of these ideas, J. J. Pollitt guides the general reader to useful summaries of the principal ancient authors and their relevant texts, in the series *The Art of Greece 1400–31 B.C. Sources and Documents in the History of Art* (New York: Prentice-Hall, 1965); see especially pages xi–xiv.

3. While there is an abundance of texts and manuals on human anatomy and physiology that illustrate the body's marvels, one of the most useful is Gerard J. Tortora's *Introduction to the Human Body* (New York: Harper & Row, 1988). Dr. Fritz Kahn's *The Human Body* (New York: Random House, 1965), however, remains peerless in clarifying the poetry and mysteries of the human body. Another physician, Dr. Jonathan Miller, opened up this world to the youthful reader in *The Human Body* (New York: Viking Penguin, 1983), which illustrates the workings of the body through three-dimensional scale models and movable illustrations.

4. In *Touching: The Human Significance of the Skin* (New York: Columbia University Press, 1971), Ashley Montagu was the first scholar to address the skin as the prime organ of relation with the outside world. His insights are particularly useful to any consideration of the human figure in art.

5. I have borrowed this term from *The Cloud of Unknowing*, a medieval primer for contemplation written by an unknown English monk toward the end of the fourteenth century, translated into modern English with an introduction by Clifton Wolters (London: Penguin Books, 1961).

6. Scholars trace the origins of the term to St. Paul's epistles to the Ephesians (1:22; 4:15; 5:23), the Colossians (1:18; 2:19), the Corinthians (12:27), and the Romans (12:4). Early saints and writers such as Clement and Augustine referred to the church as the "body of Christ." The term *mystical body* was in use in the early Middle Ages, and toward the end of the twelfth century it became the general term for the church. For sources of the term and its origins, see Ludwig Ott, *Fundamentals of Catholic Dogma* (Rockford, Ill.: Tan Books and Publishers, 1955), pp. 270–72.

7. John Donne, "Devotions, *Upon Emergent Occasions*, Vol. XVII," in Louis Untermeyer, *A Treasury of Great Poems.* (New York: Simon and Schuster, 1942), pp. 355–56. I am indebted to Charles Sarner for reminding me of the penultimate sentence in this passage.

8. John B. Flannagan, quoted in Albert Ten Eyck Gardner, *American Sculpture* (New York: Metropolitan Museum of Art, 1965), p. 168.

9. For a useful survey of cave paintings within this context, see Desmond Collins, *The Human Revolution: From Ape to Artist* (New York: E. P. Dutton, 1976), pp. 130–59.

10. René Dubos, *Beast or Angel?* (New York: Charles Scribner's Sons, 1974), pp. 49–50.

11. Donald Martin Reynolds, *Monuments and Masterpieces: Histories and Views of Public Sculpture in New York City* (New York: Macmillan Publishing Company, 1988), p. 26.

CHAPTER 1

1. *The American Renaissance, 1876–1917* (New York: Brooklyn Museum, 1979), p. 11. In "Periods and Organizations," Richard Guy Wilson notes that the first use of the term *American Renaissance* was in *The Californian* 1 (June 1880): 1–2. He further discusses its history and use in his essay, "Expressions of Identity." This catalogue for the exhibition by the same name remains an indispensable aid for a comprehensive grasp of the American Renaissance. Wilson, Professor of Architectural History at The University of Virginia, and Dianne H. Pilgrim, Curator of Decorative Arts at the Brooklyn Museum, conceived the idea for the exhibition and Richard N. Murray, later Director of the Birmingham Museum of Art, joined them to bring it to fruition.

2. Daniel Robbins, "Statues to Sculpture from the Nineties to the Thirties," in *Two Hundred Years of American Sculpture* (New York: Whitney Museum of American Art, 1976), pp. 113–14.

3. Adeline Adams, *The Spirit of American Sculpture* (New York: Gillis Press, 1923), p. 56.

4. Talbot Hamlin, *Benjamin Henry Latrobe* (New York, 1955), pp. 271–72; see also Hamlin, p. 267; I. T. Frary, *Thomas Jefferson, Architect and Builder*, pp. 49–50.

5. Hamlin, *Latrobe*, p. 267.

6. Frary, *Jefferson*, pp. 86, 108, 112–14, 125; Hamlin, *Latrobe*, pp. 269, 271–72, 441, 446; Glenn Brown, *History of the United States Capitol* (Washington, D.C.: U.S. Government Printing Office, pp. 75–76; G. K. Nagler, *Neues Allgemeines Kunstler-Lexikon* (Leipzig: Schwarzenberg and Schumann, 1924), pp. 524–25.

7. Hamlin, *Latrobe*, p. 446; Brown, *Capitol*, p. 75.

8. Frary, *Jefferson*, pp. 80, 86.

9. Hamlin, *Latrobe*, pp. 267–68; Charles E. Fairman, *Art and Artists of the Capitol of the United States of America* (Washington, D.C.: United States Government Printing Office, 1927), p. 21; Frary, *They Built the Capitol* (Richmond: Garrett and Massie, 1940), pp. 86, 107–8.

10. *Compilation of Works of Art and Other Objects in the United States Capitol* (Washington, D.C.: United States Government Printing Office, 1965), p. 365.

11. Ibid., pp. 364, 372, 374, 380, 390.

12. Fred Licht, *Sculpture: Nineteenth and Twentieth Centuries* (Greenwich, Conn.: New York Graphic Society, 1967), pp. 311, 326.

13. Henry W. Bellows, "Seven Sittings with Powers, the Sculptor," *Appleton's Journal of Literature, Science, and Art* 12, 14 (1869): 402, 595–97.

14. Donald Martin Reynolds, *The Ideal Sculpture of Hiram Powers* (New York: Garland Publishing Company, 1977), p. 250; see also Reynolds, *Monuments and Masterpieces: Histories and Views of Public Sculpture in New York City* (New York: Macmillan Publishing Company, 1988), pp. 47–57.

15. J. H. Calvert, "The Process," *Living Age* 15 (1847): 169–70.

16. Hiram Powers to Elizabeth Barrett Browning, Hiram Powers archives, Smithsonian Institution, first published in Donald Martin Reynolds, "The 'Unveiled Soul': Hiram Powers's Embodiment of the Ideal," *Art Bulletin* 59 (September 1977): 394.

17. My term "Yankee Classicism," which I first used in 1975, was

inspired by Horatio Greenough's "Yankee Doric," which he used to describe "the Yankee's inherent penchant and aptitude for simplicity of design and expression of fundamental structural and formal principles in architecture and manufactured things." "Yankee Classicism" is more generic and refers here to the sculpture of Greenough and Powers as it reflects their synthesis of natural and classical forms and the transformation of those forms by means of an ingenuity identified with Yankee craftsmanship of the eighteenth and nineteenth centuries. Greenough's *Washington* in the Smithsonian Institution was seminal in the development of this phenomenon; Powers's ideal statues represent a maturation and a perfection of it. Reynolds, *Hiram Powers*, p. 70.

18. Albert Boime, *The Academy and French Painting in the Nineteenth Century* (New York: Phaidon Publishers, 1971), pp. 31–33; Wilson, *American Renaissance*, p. 92. Henry Hope Reed has called it an adaptation of the apprentice system to the "exigencies of the classroom"; see Henry Hope Reed, *Beaux-Arts Architecture in New York City* (New York: Dover Publications, Inc., 1988), p. VII. For useful insights into the nature of the Beaux-Arts tradition, see *The Architecture of the Ecole des Beaux-Arts*, exhibition catalogue (New York: Museum of Modern Art, 1976), and Robin Middleton, Guest Editor, "The Beaux-Arts," *Architectural Design*, special issue (London: Architectural Design, 1976).

19. Ibid., p. 75.

20. Ibid., p. 76. See Paul R. Baker's *Richard Morris Hunt* (Cambridge, Mass.: MIT Press, 1980), for an authoritative biography and checklist of the dean of American architects. For a useful review of Hunt's works and ideas, see Susan R. Stein, editor, *The Architecture of Richard Morris Hunt* (New York: Metropolitan Museum of Art, 1986), particularly Lewis I. Sharp's essay, "Richard Morris Hunt and His Influence on American Beaux-Arts Sculpture," pp. 121–49.

21. Henry-Russell Hitchcock, *The Architecture of H. H. Richardson and His Times* (Cambridge, Mass.: MIT Press), pp. 136–46.

22. Dianne H. Pilgrim, "Decorative Art: The Domestic Environment," in *The American Renaissance*, p. 120.

23. James M. Dennis, *Karl Bitter, Architectural Sculptor, 1876–1915* (Madison: University of Wisconsin Press, 1967), pp. 23–24, 48–55.

24. Leland Roth, *A Monograph of the Works of McKim, Mead & White* (New York: Arno Press, 1977), p. 20 and plates 100–109; William H. Wilson, *The City Beautiful Movement* (Baltimore: Johns Hopkins University Press, 1989), p. 59.

25. Roth, *McKim, Mead & White*, p. 20; Roth, *A Concise History of American Architecture* (New York: Harper and Row, 1979), pp. 193–95.

26. Wilson, *City Beautiful*, p. 58; p. 316, n. 11.

27. Wilson, *American Renaissance*, pp. 21, 27–28.

28. Wilson, *City Beautiful*, p. 42.

29. Ibid., p. 43.

30. Ibid., pp. 45, 46–47; Wilson, *American Renaissance*, p. 90.

31. Daniel H. Burnham, "White City and Capitol City," *The Century* 63 (February 1902): 619, quoted in Wilson, *American Renaissance*, p. 88. See also William Wilson's discussion of Burnham as director of the exposition, *City Beautiful*, pp. 54–57.

32. So wrote Thomas Adams, *Outline of Town and City Planning: A Review of Past Efforts and Modern Aims* (New York: Russell Sage Foundation, 1935), p. 173.

33. Robert C. Post, ed., *1876: A Centennial Exhibition* (Washington, D.C.: Smithsonian Institution, 1976), p. 11. For the relationship of the Columbian Exposition and the City Beautiful Movement, see Wilson, *City Beautiful*, pp. 53–74. For a popular summary of the fair's history and a comprehensive visual record of its architecture and sculpture, see Stanley Appelbaum, *The Chicago World's Fair, 1893* (New York: Dover Publications, 1980). For a general discussion of fairs, see John Allwood, *The Great Exhibitions* (London, 1977). See also Reid Badger's *The Great American Fair: The World's Columbian Exposition and American Culture* (Chicago: Nelson-Hall Publishers, 1979).

34. Richard Guy Wilson, "Challenge and Response: Americans and the Architecture of the 1889 Exposition," in *Paris, 1889: American Artists at the Universal Exposition*, ed. Annette Blaugrund (New York: Harry N. Abrams), pp. 93, 99–100.

35. Ibid., p. 100.

36. Ibid., p. 104; John H. Dryfhout, *The Works of Augustus Saint-Gaudens* (Hanover, N.H.: University Press of New England, 1982), pp. 29–30; he lists all the sculptors.

37. Dennis, *Karl Bitter*, p. 47; Montgomery Schuyler, "Last Words About the World's Fair," *Architectural Record* 3 (January–March 1894): 283, quoted by R. Reid Badger, *The Great American Fair* (Chicago: Nelson Hall, 1979), pp. 127–28, Jeanne Madeline Weinmann, *The Fair Women* (Chicago: Academy Chicago, 1981), pp. 145–56; 190–91.

38. Wilson, *City Beautiful*, p. 63.

39. Dennis, *Karl Bitter*, pp. 41–47.

40. Appelbaum, pp. 15–52.

41. Herbert Small, *The Library of Congress, Its Architecture and Decoration, Classical America Series in Art and Architecture* (New York: W. W. Norton and Co., 1982). This book is based on Boston newspaperman Herbert Small's *Handbook of the New Library of Congress*, 1897.

42. Ibid., pp. 26–28; see also *Ten First Street, Southeast: Congress Builds a Library, 1886–1897* (Washington, D.C.: Library of Congress, 1980), catalogue for an exhibition in the Thomas Jefferson Building of the Library of Congress, revised and updated by the author for an article that appeared in the *Quarterly Journal of the Library of Congress*, October 1972, to mark the 75th anniversary of the 1897 building, pp. 13–31; see also "Library of Congress: Masterpiece in High Quality Sculptured Granite," *Building Stone News*, August 1971, pp. 4–5.

43. Ibid., pp. 33–35.

44. Wilson, *American Renaissance*, p. 106.

45. Small, *Library of Congress*, pp. 36–37.

46. Ibid., pp. 37–39, 40.

47. Ibid., pp. 87–98.

48. Dennis, *Karl Bitter*, pp. 104, 254–255.

49. Ibid., pp. 104–6.

50. Ibid., pp. 111–15.

51. Robbins, "Statues to Sculpture," p. 115.

52. Wilson, *American Renaissance*, p. 95, and figure 5, p. 14.

53. Robbins, "Statues to Sculpture," p. 115, 117–18.

54. Wilson, *City Beautiful*, pp. 65, 67–70.

55. The name was in popular usage in city guidebooks by 1937, according to George Gurney, *Sculpture and the Federal Triangle* (Washington, D.C.: Smithsonian Institution Press, 1985), p. 44, n. 2.

56. Ibid., p. 69.

57. James M. Goode, *The Outdoor Sculpture of Washington, D.C.* (Washington, D.C.: Smithsonian Institution Press, 1974), pp. 142–76.

58. Gurney, *Sculpture*, pp. 210–22.

59. Ibid., pp. 222–35.

60. Ibid., pp. 391–402. Federal Assistance for the Arts: In less than three years after the stock market crash of 1929, the nation's relief resources were depleted. To alleviate the financial crisis of the nearly 15 million Americans out of work, and to provide business capital, President Herbert Hoover signed legislation to lend money at low interest rates (Reconstruction Finance Corporation, January 22, 1932, and Emergency Relief Act, July 21, 1932). The following year the new president, Franklin Delano Roosevelt, introduced innovative measures in monetary, commercial, industrial, and agricultural policy called the New Deal. At the heart of his policy was work-relief to replace the dole, which was not only more economically sound but also preserved the dignity of the workers and enabled them to maintain their skills. Francis V. O'Connor, *Federal Support for the Visual Arts: The New Deal and Now* (Greenwich, Conn: New York Graphic Society, 1969), p. 16.

To help the 10,000 artists out of work, the government established the Public Works Art Project, an experimental program to put unemployed artists to work decorating nonfederal buildings and parks. It was the nation's first program to support art for its own sake (O'Connor, *Federal Support*, p. 17). Its success led to the formation of the Works Progress Administration on May 6, 1935, later named the Works Project Administration (WPA). Two months later, the Federal Art Project (FAP) was set up as a permanent program to provide work-relief for artists in music, drama, literature, and art. In its eight years of existence (1935–43), FAP reached into every corner of America. In providing employment for indigent artists, the FAP supported contemporary American art and worked "toward an integration of the arts with the daily life of the community, and an integration of the fine arts and the practical arts" (quoted in O'Connor, *Federal Support*, p. 28, from the FAP operating manual of October 1935).

The WPA assisted many of the nation's most influential artists including David Smith, Chaim Gross, Jackson Pollock, Willem de Kooning, and Mark Rothko. Former WPA artists who were polled in Francis O'Connor's research on the WPA were "overwhelmingly positive in their attitudes toward the WPA/FPA" and felt they had "complete artistic freedom" (O'Connor, *Federal Support*, p. 95). While some felt there was too great an emphasis on representational art, most of them believed the FAP had a substantial, positive, and long-lasting impact on American art. Most important of all, FAP made it possible for artists to continue working as artists (ibid.).

61. Christine Smith, *St. Bartholomew's Church in the City of New York* (New York: Oxford University Press, 1988), p. 138.

62. Richard Oliver, *Bertram Grosvenor Goodhue*, American Monograph Series (Cambridge, Mass.: MIT Press, 1983), p. 61.

63. Ibid., pp. 184–212.

64. Frederick C. Luebke, *The Nebraska State Capitol* (Lincoln: University of Nebraska Press, 1990), pp. 33–36.

65. Ibid., pp. 36–38.

66. Oliver, *Goodhue*, pp. 200–201. Lawrie's correspondence with his secretary, Meyer Stein, is illuminating for its insights into the sculptor's aesthetics (Abbie Cohen archives).

67. Luebke, *Nebraska State Capitol*, pp. 111–12.

68. Ibid., p. 57.

69. Oliver, *Goodhue*, pp. 226–34.

70. Ibid., p. 232.

71. Ibid., pp. 226–29.

72. Lewis Mumford, "American Architecture Today," *Architecture* 58 (October 1928): 189–90, quoted in Oliver, *Goodhue*, p. 232.

73. The art program was developed by Alexander with participation in the RCA (now GE) Building by professors George Vincent and M. I. Pupin, both of Columbia University. The account here is summarized from the art theme papers in the Rockefeller archives. For a discussion of the liberty cap, see Yvonne Korshak, "The Liberty Cap as a Revolutionary Symbol in America and France," *Smithsonian Studies in American Art* I, no. 2 (Fall 1987): 53–69.

74. For a description and discussion of the center and its history, see Reynolds, *The Architecture of New York City: Histories and Views of Important Structures, Sites, and Symbols* (New York: Macmillan, 1984), pp. 249–65. For a comprehensive discussion, see Carol Herselle Krinsky, *Rockefeller Center* (New York: Oxford University Press, 1978).

75. Benjamin D. Holloway's term to describe Equitable's art program. As chairman of Equitable's Real Estate Group, Holloway was one of the originators of the art program. See Martin Gottlieb, "Equitable Life Will Mix Art and Commerce," *New York Times*, September 20, 1984; Tom Walker, "Business, Art Mesh at Equitable," *Crane's New York Business*, May 20, 1985; Douglas McGill, "Art Complex Planned in New Tower," *New York Times*, May 14, 1985; clippings in Equitable archives.

76. Deborah Gimelson, "The Tower of Art," *Art and Auction* 8 (October 1985): 150–155; Paul Goldberger, "Equitable's New Tower: A Curious Ambivalence," *New York Times*, February 20, 1984, sec. B, pp. 1–5.

77. Michael Brenson, "Museum and Corporation—A Delicate Balance," *New York Times*, Feb-ruary 23, 1986; Janice Castro, "New Jewel for the West Side," *Real Estate*, Spring 1986; Calvin Tomkins, "The Art World, Medicis, Inc.," *New Yorker*, April 14, 1986; Suzanne Stephens, "An Equitable Relationship?" *Art in America*, May 1986, pp. 117–23; Roger Kimball, "Art and Architecture at the Equitable Center," *New Criterion*, November 1986, pp. 24–32; clippings in Equitable archives.

78. Winston Weisman, "A New View of Skyscraper History," in *The Rise and Fall of an American Architecture*, ed. Edgar Kaufmann, Jr. (New York: Praeger Publishers, 1970), pp. 115–25.

79. Lewis I. Sharp, *John Quincy Adams Ward, Dean of American Sculpture* (Newark: University of Delaware Press, 1985), pp. 49–52.

80. Ibid., pp. 183–84; See also R. Carlyle Buley, *The Equitable Life Assurance Society of the United States, 1859–1964.* 2 vols. (New York: Appleton-Century-Crofts, 1967), pp. 106, 109, 533.

81. Reynolds, *Monuments and Masterpieces*, pp. 16–23, 236–37.

82. Sharp, *Ward*, pp. 77–78, 183–84, 246, 259.

83. McGill, "Art Complex."

84. McGill, "Public Space, But Is It Art?" *New York Times*, February 17, 1986; "People," *Time*, February 10, 1986; Jana Jevnikar, "New Directions in Art," *American Artist*, May 1986; Janet Kutner, "Of Murals and Marble," *Dallas Morning News*, July 24, 1986; clippings in Equitable archives.

85. Castro, "New Jewel."

86. McGill, "New Arts Groups Move into Equitable Center," *New York Times*, December 11, 1987; clippings in Equitable archives.

CHAPTER 2

1. Donald Martin Reynolds, *Monuments and Masterpieces: Histories and Views of Public Sculpture in New York City* (New York: Macmillan Publishing Company, 1988), pp. xi–xii.

2. René Dubos, *So Human an Animal* (New York: Charles Scribner's Sons, 1968), pp. 67, 224.

3. Willard Gaylin, *Caring* (New York: Alfred A. Knopf, 1976), p. 33.

4. Ibid., p. 44. René Dubos, *A God Within* (New York: Charles Scribner's Sons, 1972), p. 257.

5. Ian Tattersall, "Human Origins and the Origins of Humanity," paper delivered at the first annual *Symposium on Public Monuments*, March 21, 1991 (New York: Gordon and Breach Publishers, in press). See also Tattersall's chapter, "The Human Spirit," in his recent book, *The Human Odyssey* (New York: Prentice Hall General Reference, 1993), pp. 153–171, published in conjunction with the opening of the acclaimed Hall of Human Biology and Evolution at the American Museum of Natural History.

I established the annual Symposium on Public Monuments in 1991, as a tribute to the eminent art historian Rudolf Wittkower, on the twentieth anniversary of his death. The papers from the first two symposia are being published by Gordon & Breach Publishers, and the royalties will go to the Rudolf Wittkower fund for graduate students at Columbia University, thereby perpetuating the tribute to Wittkower in supporting scholarship to which he devoted his life. Each year, the symposium is funded by the Samuel Dorsky Foundation. Margot Wittkower has been supportive of this effort from its inception, and her spirit has contributed to its success.

6. René Dubos, *Man Adapting* (New Haven: Yale University Press, 1980), p. 5.

7. Dubos, *So Human an Animal*, p. 39. Tattersall, "Human Origins." Helen Gardner, *Art Through the Ages*, 6th ed. (New York: Harcourt Brace Jovanovich, 1975), pp. 48–49.

8. Most recently noted by James Ackerman, "The Persistence of Classical Models," *Symposium on Public Monuments*. E. J. Johnson, "Do You Know a Monument to Modesty or Mirth?" *Symposium on Public Monuments*.

9. Johnson, "Do You Know . . ." Reynolds, *Monuments and Masterpieces*, pp. xi–xii.

10. Donald Martin Reynolds, "Monuments to Neglect," *Symposium on Public Monuments*, reprinted in *Sculpture Review* 40, no. 1 (1991): 20–25, and *American Arts Quarterly*, Fall 1991, pp. 4–7.

11. Johnson, "Do You Know . . ."

12. Reynolds, *Monuments and Masterpieces*, pp. 13–14. Gerard Devlin, "Ceremony Honors an Amiable Child," *News World*, July 16, 1981. St. Claire Pollock archives, Museum of the City of New York.

13. Dubos, *So Human an Animal*, p. 242.

14. Ibid., p. 76.

15. Ibid., p. 201.

16. Ibid., p. 235.

17. Wayne Dynes, "Monument, the Term," *Symposium on Public Monuments*.

18. Francis Huxley, *The Way of the Sacred* (London: Bloomsbury Books, 1989), p. 60.

19. Reynolds, *Monuments and Masterpieces*, p. xii; "Monuments to Neglect," *Sculpture Review*, p. 23; *American Arts Quarterly*, p. 6.

20. Murray Schane, "The Psychology of Public Monuments," *Symposium on Public Monuments*. Raphell Sims Lakowitz Memorial Foundation archives. It was through Dr. Murray David Schane's presentation at the first symposium that I learned of the monument to Raphell. Subsequent conversations in 1991–1993 with Lenore Lakowitz, the Raphell Sims Lakowitz Memorial Foundation archives, and Dr. Schane's paper are the sources cited here.

21. Ibid.

22. Ibid.

23. Ibid.

24. Ibid.

25. Ibid.

26. Ibid.

27. Reynolds, *Monuments and Masterpieces*, pp. 192–93.

28. Lillie F. Kelsay, *Historic and Dedicatory Monuments of Kansas City* (Kansas City, Mo.: Board of Parks and Recreation Commissioners, 1987), pp. 29–33.

29. Reynolds, *Monuments and Masterpieces*, p. 180.

30. Reynolds, *Monuments and Masterpieces*, pp. 356–66. "Monuments to Neglect?" *New York Newsday*, April 18, 1989, p. 60. "Monuments to Neglect," *Symposium*, *Sculpture Review*, *American Arts Quarterly*.

31. Richard A. Miller and Elias S. Wilentz to Thomas P. Hoving, Commissioner of Parks, undated. Thomas P. Hoving to the Committee to Protect Public Monuments from Sandblasting, August 9, 1966. Walter Beretta, Monuments Officer, to Commissioner Thomas P. Hoving, undated, defends sandblasting. Walter Beretta to Richard A. Miller, December 5, 1966, assures Miller that sandblasting of the city's monuments will cease.

32. Paul Goldberger, "The Washington Arch," *New York Times*, November 19, 1976.

33. To achieve those objectives, the Monuments Conservancy, a not-for-profit corporation, was established by the author in 1992. Its first project was the Third Annual Symposium on Public Monuments, "Humanity and the Human Figure in Public Monuments," March 19, 1993. It will sponsor the Fourth Annual Symposium, "Human Dignity and Public Monuments," on March 18, 1994.

CHAPTER 3

1. James M. Goode, *The Outdoor Sculpture of Washington, D.C.* (Washington, D.C.: Smithsonian Institution Press, 1974), p. 391.

2. Donald Martin Reynolds, "Monuments to Neglect," *American Arts Quarterly*, Fall 1991, p. 6; *Sculpture Review* 40, no. 1 (1991): 22; "In Death Not Divided," *The Leaflet*, April 17, 1987, Department of Parks and Recreation, New York City. The Straus Monument was officially accepted for the City of New York in 1915 by Mayor John Purroy Mitchel, who served and died in World War I and is commemorated by a public monument in New York City at the entrance to Central Park at 90th Street and Fifth Avenue; see also Reynolds, *Monuments and Masterpieces*, p. 213.

3. Walter Lord, *A Night to Remember* (New York: Bantam Books, 1956), pp. 46–47; Reynolds, *Monuments and Masterpieces*, p. 213.

4. Ibid.

5. Originally the monument was sited at the northwest corner of the park facing Fifth Avenue so parades down the avenue would

pass in review before Farragut. At that site, the park served as a picturesque background for the monument. Unfortunately, the Parks Department moved the monument to its present location in the 1930s. A replica of the base was made (the original base disintegrated from neglect) and the original was placed in the Saint-Gaudens museum in Cornish, New Hampshire (Reynolds, pp. 69–72). Another slight to the monument occurred in 1988, when the Parks Department built a playground directly to the east of the monument, depriving it of its surrounding landscape.

The Farragut Monument, as one of the nation's world-class monuments, should be preserved at all costs. In 1986, efforts on the part of the Parks Department and the Metropolitan Museum of Art to replicate the bronze statue were opposed by civic groups (see correspondence in the Department of Parks and Recreation archives between the author, New York City's curator of parks at that time, and Lewis I. Sharp, Curator of American Sculpture, the Metropolitan Museum of Art, and minutes of meetings, April 1, 1986). The plan was to house and exhibit the original statue of Farragut in the Metropolitan Museum and place the replica in the park to protect the original from the environment that is destroying it. Once the statue of William Shakespeare by J.Q.A. Ward in Central Park was replicated in 1987, resistance to replicating the Farragut was overcome and replication of it got underway. But, unfortunately, the replica is to be kept in storage, in case something happens to the original.

6. Reynolds, *Monuments and Masterpieces*, pp. 92–95; James Dennis, *Karl Bitter, Architectural Sculptor, 1867–1915* (Madison: University of Wisconsin Press, 1967), pp. 191–92; Dennis was the first to note the influence and points out that Karl Bitter had visited the Vienna Secession in 1909. Bitter wrote to his wife from Athens on May 16, 1910, that he had seen some reliefs in the National Museum that had special meaning for him in designing his reliefs for the Schurz Monument. The architect Henry Bacon, who was partial to Greek forms, may have had something to do with the design of the exedra (Dennis, *Karl Bitter*, p. 200).

7. Ibid., p. 204.

8. Ibid., pp. 195–99.

9. "Carl Schurz," *Webster's Guide to American History* (Springfield, Mass.: G. & C. Merriam Company, 1965), pp. 1219–20.

10. Dennis, *Karl Bitter*, p. 195.

11. Ibid.

12. Ibid., pp. 92–93, 204–20.

13. Fay L. Hendry, *Outdoor Sculpture in Grand Rapids* (Okemos, Mich.: Iota Press, 1908), pp. 96–97, 130.

14. Reynolds, *Monuments and Masterpieces*, p. 443.

15. Fearn C. Thurlow, "Newark's Sculpture," *Newark Museum Quarterly* 20 (Winter 1975): 6–9.

16. Ibid.; Craven, p. 491.

17. Albert Ten Eyck Gardner, *American Sculpture* (New York: Metropolitan Museum of Art, 1965), p. 101.

18. Wayne Craven, *Sculpture in America* (New York: Thomas Y. Crowell Company, 1968), p. 489.

19. Ibid., pp. 490–94.

20. Ibid.

21. Reynolds, pp. 117–18.

22. Ibid.

23. Chapter 265, *New York State Laws*, 1930, Albany; Report of September 2, 1930, supplemented by Report of April 9, 1931, issued by the New York State Roosevelt Memorial, May 19, 1931; this document and the cited correspondence are the basis for my reconstruction here of the events that led up to the construction of the monument.

24. Report, 6; Diana Rice, "Roosevelt Memorial Trustees Urge Their Central Park Plan," *New York Times*, undated clipping (c. October 11, 1931), National Sculpture Society archives.

25. Mrs. Van Rennselaer to Richard Welling, October 12, 1931; Richard Welling to Charles Keck, October 15, 1931, NSS archives; "Dr. Osborn Gives Seven Reasons for Urging Revision of Park Project," letter to the editor, *New York Times*, February 16, 1931; Harriet Frishmuth, secretary, National Sculpture Society, to Henry Fairfield Osborn, June 23, 1931, NSS archives.

26. Goode, *Outdoor Sculpture*, p. 394.

27. Ibid., pp. 393–94.

28. Ibid., pp. 395–96; see Michael Richman's thoroughly researched and insightful catalogue.

29. Michael Richman, *Daniel Chester French: An American Sculptor* (New York: Metropolitan Museum of Art, 1976), p. 184.

30. Ibid.

31. French had chosen Bacon as his collaborating architect for the Lincoln Memorial for the State House grounds in Lincoln, Nebraska, 1909–12 (Richman, p. 121). No doubt, if Bacon had wanted a standing Lincoln, he would have turned to French.

32. Richman, *Daniel Chester French*, pp. 171–75.

33. Goode, *Outdoor Sculpture*, pp. 401–2; in the Nebraska Lincoln, a high, broad stone panel acts as the backdrop for French's Lincoln, and Bacon has inscribed on its face the Gettysburg Address.

34. Richman, *Daniel Chester French*, p. 179.

35. Ibid., p. 183; H. W. Janson, *Nineteenth-Century Sculpture* (New York: Harry N. Abrams, 1985), pp. 261–62.

36. The memorial was dedicated October 31, 1898; for the history of the monument, see Richman, pp. 83–89.

37. Richman, *Daniel Chester French*, p. 86.

38. Sarah Bradford Landau, "Richard Morris Hunt: Architectural Innovator and Father of a 'Distinctive' American School," in *The Architecture of Richard Morris Hunt*, edited by Susan Stein (Chicago: University of Chicago Press, 1986), p. 68.

39. Ibid., Morrison Heckscher, "Hunt and the Metropolitan Museum of Art," pp. 173–87.

40. Richman, *Daniel Chester French*, pp. 71–72.

41. H. W. Janson does not believe Millmore is thus portrayed because French's rendering is out of scale with Millmore's sphinx in Mount Auburn Cemetery, and details do not match (*Nineteenth-Century Sculpture*, p. 260).

42. Richman, *Daniel Chester French*, p. 72.

43. Ibid., p. 113.

44. Dennis, *Karl Bitter*, pp. 94–96.

45. Ibid.

46. Daniel Chester French to his daughter, Margaret French Cresson, February 13, 1922, quoted in Richman, *Daniel Chester French*, p. 139.

47. Ibid., p. 133.

48. W. W. Spooner, "Heine and the Germans," *New York Times*, July 7,

1895, cited by Michelle Bogart, *Public Sculpture and the Civic Ideal in New York City, 1890–1930* (Chicago: University of Chicago Press, 1989), p. 62; see Bogart for a discussion of the monument's stormy history, pp. 61–67.

49. Reynolds, pp. 101–3.

50. Bogart, *Public Sculpture*, pp. 61–67.

51. For the chronology and a discussion of the fountain, see Victoria Donohoe, "Swann Fountain," in *Sculpture of a City: Philadelphia's Treasures in Bronze and Stone* (New York: Walker Publishing Company, 1974), pp. 230–39.

52. Ibid., p. 231.

53. Bogart, *Public Sculpture*, pp. 260–61.

54. Craven, *Sculpture in America*, pp. 422, 425–27; Reynolds, pp. 354–66, 80, 81–85, 107, 142, 288, 307, 310–11, 313, 332; Joseph Lederer, *All Around the Town* (New York: Charles Scribner's Sons, 1975), pp. 233–34, 31–32, 224–25, 87–88, 216, 212–13, 220, 47.

55. Craven, *Sculpture in America*, p. 422.

56. Bogart, *Public Sculpture*, pp. 262–64.

57. Craven, *Sculpture in America*, pp. 427–28.

58. Ibid.; Bogart, *Public Sculpture*, p. 266.

59. Ibid., p. 236.

60. Craven, *Sculpture in America*, p. 426.

61. Ibid., pp. 420–22.

62. Ibid., pp. 423–24.

63. "'Civic Virtue' Called Something Else, Might Have Stronger Appeal," A. Stirling Calder, letter to the editor, *New York Times*, July 17, 1932.

64. Ibid.

65. Craven, *Sculpture in America*, p. 428.

66. "Civic Virtue's Number Is Up," *New York Journal and American*, January 31, 1940, NSS archives.

67. "'Fat Boy' Fans Come to Aid of Harvey," *Long Island Daily Press*, March 5, 1941, NSS archives.

68. Edmondo Quattrocchi to Miss E. Mellon, NSS, February 10, 1940; Eleanor M. Mellon, Secretary to E. Quattrocchi, February 14, 1940.

69. "A Boost for 'Civic Virtue,'" *New York Daily News*, March 5, 1951, NSS archives.

70. "Sculptors Laud Harvey Defense of 'Civic Virtue,'" *Brooklyn Eagle*, March 5, 1941, p. 19, NSS archives; NSS minutes, February 11, 1941.

71. "Sculptors Praise Harvey and 'Fat Boy'—Almost," *Long Island Star-Journal*, March 5, 1941, NSS archives; "'Fat Boy' Fans"; Margaret French Casson to Hon. George U. Harvey, February 19, 1941.

72. "'Civic Virtue,'" *Long Island Star-Journal*, March 8, 1941, NSS archives.

73. The committee to confer with Mr. Harvey consisted of A. A. Weinman, Karl Gruppe, and A. F. Brinckerhoff, who met with him at 11:45 A.M. Friday, March 14, in Harvey's office (Mrs. Cresson's undated notes); George U. Harvey to Mrs. Margaret F. Cresson, October 31, 1941.

74. Reynolds, pp. 349–50.

75. Ibid., pp. 350–51.

76. Goode, *Outdoor Sculpture*, p. 136.

77. Lillie F. Kelsay, *Historic and Dedicatory Monuments in Kansas City* (Kansas City, Mo.: Board of Parks and Recreation Commissioners, 1987), p. 62.

78. Ibid., p. 16.

79. *Webster's Guide*, p. 362.

80. Ibid., p. 829.

81. James L. Reidy, *Chicago Sculpture* (Chicago: University of Illinois Press, 1981), pp. 238–39.

82. Ibid.

83. Interviews with the sculptor, May 1992.

84. Ibid.

85. The awards were established in 1973 by this group with the J. M. Kaplan Center for New York City Affairs at the New School for Social Research with a twofold purpose: to honor people who have made significant contributions to New York City and to raise funds for the center's graduate program. Those who have been been honored include David Rockefeller, Pete Seeger, Felix Rohatyn, Ada Louise Huxtable, Governor Mario Cuomo, and David Dinkins. No trophy accompanied the awards until Neil Estern was commissioned to make the LaGuardia figure (Interview with Alfred Szymanski, Associate Director of Development, Special Events, New School for Social Research, New York City, May 14, 1992).

86. Interviews with the sculptor, May 1992.

87. Todd Wilkinson, "Speaking the Universal Tongue: Kent Ullberg Builds Monuments to Nature," *Wildlife Art News*, May–June 1991, n.p.

88. Ibid.

89. Ibid.

CHAPTER 4

1. Wayne Craven, *Sculpture in America* (New York: Thomas Y. Crowell Company, 1968), p. 168 ff.

2. H. W. Janson, *Nineteenth-Century Sculpture* (New York: Harry N. Abrams, 1985), pp. 61, 65, 90–93.

3. Donald Martin Reynolds, *Monuments and Masterpieces: Histories and Views of Public Sculpture in New York City* (New York: Macmillan Publishing Co., 1988), pp. 138–39.

4. Lillie F. Kelsay, *Historic and Dedicatory Monuments in Kansas City* (Kansas City, Mo.: Board of Parks and Recreation Commissioners, 1987), p. 75.

5. Reynolds, p. 222.

6. Ibid., p. 223.

7. Ibid., pp. 129–30.

8. James M. Goode, *The Outdoor Sculpture of Washington, D.C.* (Washington, D.C.: Smithsonian Institution Press, 1974), p. 245.

9. For the history of the monument, see Richman, "Ulysses S. Grant," *Sculpture of a City*, 188–95.

10. Ibid., p. 192.

11. Ibid.

12. Goode, *Outdoor Sculpture*, p. 278.

13. Craven, *Sculpture in America*, p. 297.

14. John S. Bowman, ed., *The Civil War Almanac* (New York: Bison Books, 1983), p. 345.

15. Ibid., pp. 355–56.

16. Goode, *Outdoor Sculpture*, p. 278.

17. "The Sherman Monument," *New York Tribune*, May 31, 1896, clipping in NSS archives.

18. Ibid.

19. Ibid.

20. Maurice Rheims, *La Sculpture au XIXe* (Paris: Arts et Métiers Graphiques, 1972), p. 198.

21. James MacKay, *Western Sculptors in Bronze* (Suffolk, England: Baron Publishing, 1977), pp. 343–44.

22. Goode, *Outdoor Sculpture*, p. 131.

23. MacKay, *Western Sculptors*, p. 200.

24. Ibid., p. 350; Janson, *Nineteenth-Century Sculpture*, pp. 92–93.

25. MacKay, *Western Sculptors*, p. 210.

26. *Washington-Evening Star*, January ?, 1896, clipping, NSS archives.

27. Goode, *Outdoor Sculpture*, p. 132.

28. The following newspaper clippings in the NSS archives cover the competition and the selection process: "The Sherman Statue," *Washington Evening Star*, May 26, 1896; "The Sherman Monument," *New York Sun*, May 31, 1896; "Sherman in Statuary," *Washington Post*, May 27, 1896; "The General Sherman Monument," *New York Times*, May 28, 1896; "The Sherman Statue," *New York Recorder*, May 28, 1896; "Sherman Design Selected," *New York Herald*, May 28, 1896; "The Statue of General Sherman," *New York Sun*, May 28, 1896; "Carl Rohl-Smith's Design for the Sherman Statue Accepted," *New York Tribune*, May 28, 1896; "Wuswahl eines Modelles für das Sherman-Monument," *New York Staatszeitung*, May 28, 1896; "Artists Disappointed," *Boston Herald*, May 28, 1896.

"The Sherman Statue," *New York Times*, May 30, 1896; "The Sherman Statue," *New York Times*, May 31, 1896; "The Sherman Statue," *New York Daily News*, May 31, 1896; "The Sherman Statue," *New York Mail and Express*, May 30, 1896; "Sculptors Are Angry," *New York World*, June 1, 1896; "The Sherman Statue," *New York Evening Post*, June 1, 1896; "The Sculptors' Society and the Sherman Statue," *New York Sun*, June 1, 1896; "Sherman's Statue," *Washington Evening Star*, May 27, 1896; "The Sherman Monument," *New York Tribune*, May 31, 1896.

29. "The Sherman Statue," *New York Sun*, May 31, 1896, NSS archives.

30. "The National Sculpture Society and the Sherman Statue," *New York Evening Sun*, June 1, 1896, NSS.

31. "The General Sherman Monument," *New York Times*, May 28, 1896; untitled, *New York Times*, May 31, 1896.

32. Among the reliable discussions of Saint-Gaudens and his Sherman Monument are John H. Dryfhout, *The Works of Augustus Saint-Gaudens* (Hanover, N.H., and London: University Press of New England, 1982); Kathryn Greenthal, *Augustus Saint-Gaudens, Master Sculptor* (New York: Metropolitan Museum of Art, 1985); Burke Wilkinson, *Uncommon Clay: The Life and Work of Augustus Saint-Gaudens* (San Diego: Harcourt Brace Jovanovich, 1985); and Louise Tharp, *Saint-Gaudens and the Gilded Era* (Boston: Little, Brown, 1969).

33. Janson, *Nineteenth-Century Sculpture*, pp. 235–36, 257–59.

34. Reynolds, 72–77, 294–95.

35. For the history of the monument, see John H. Dryfhout, "Garfield Monument," *Sculpture of a City*, pp. 180–87; see also Dryfhout, *Works*, pp. 217–18.

36. Reynolds, 69–72.

37. Dryfhout, *Works*, pp. 184–85.

38. Reynolds, pp. 183–85; see also Chapter 2, n. 73.

39. For discussions of the monument, see Dryfhout, *Works*, pp. 189–93, and Greenthal, *Saint-Gaudens*, pp. 130–35; the draped figure in the Adams Memorial is an enigma. The most recent discussion of its sources is found in Patricia O'Toole's account of Henry Adams and his times in *The Five of Hearts* (New York: Clarkson Potter Publishers, 1990), p. 165.

40. Dryfhout, *Works*, p. 189.

41. Janson, *Nineteenth-Century Sculpture*, p. 257; for a chronology, discussion, and suitable illustrations, see Dryfhout, *Works*, pp. 222–29. Black servicemen were honored in 1934, when the *All Wars Memorial to the Colored Soldiers and Sailors* was erected in Philadelphia. Three life-size bronze figures on either side of its granite base represent the different branches of the Armed Forces and flank a female allegory of Justice holding in her extended hands wreaths symbolic of Honor and Reward. Crowning the group is the Torch of Life and an eternal flame surrounded by four American eagles at the four corners.

The Pennsylvania Legislature in 1927 commemorated "the colored soldiers of the Commonwealth" who had fought in all the nation's wars. Fifty thousand dollars was appropriated, and J. Otto Schweitzer was the sculptor commissioned to do the monument. Once the monument was commissioned, however, Philadelphia could not at first agree where to place it. It was finally erected on Landsdown Drive in West Fairmount Park, as if under the protection of General George Meade, whose equestrian statue by Alexander Milne Calder stands but a 100 yards away in front of Memorial Hall.

42. Ibid.

43. Ibid., p. 226.

44. Janson, *Nineteenth-Century Sculpture*, p. 90.

45. Dryfhout, *Works*, p. 238.

46. For the history and the chronology of the monument, see Lewis I. Sharp, "The Smith Monument," *Sculpture of a City*, pp. 168–79.

47. Craven, *Sculpture in America*, p. 482.

48. Ibid., p. 483.

49. "Soldiers and Sailors Civil War Monument," *Sculpture of a City*, 225; Craven 487.

50. Victoria Donohoe has paid appropriate tribute to both Meade and Alexander Milne Calder, sculptor of the Meade equestrian monument in Fairmount Park in "General Meade," *Sculpture of a City*, pp. 118–22.

51. Craven, *Sculpture in America*, pp. 545–47; Anna C. Ladd, "Anna V. Hyatt—Animal Sculptor," *Art in Progress*, November 1912, pp. 773–76; Frederick Price, "Anna Hyatt Huntington," *International Studio* 79 (August 1924): 319–23.

52. Beatrice Proske, "Joan of Arc by Anna Hyatt Huntington," *Joan of Arc* (New York: Municipal Art Society, 1987).

53. *Anna Hyatt Huntington, Sculptor of the Hispanic Society*, Hispanic Society of America, n.d., n.p.

54. *Brookgreen Journal* 18, no. 4 (1988), introduction.

55. Stephen May, "Brookgreen Gardens, Where Art and Nature Meet," *American Arts Quarterly*, Summer 1992, pp. 14–15.

56. Marilyn Newmark, "Equine Sculpture a Mixed Medium," *Morning Telegraph*, August 9, 1971, p. S14.

57. "Exhibition at Saratoga," *Thoroughbred Record,* July 31, 1976, pp. 468–69; "Marilyn Newmark's Bronze Horse," *Horse World,* June 1971.

58. Charlotte Dunwiddie's biography, NSS archives; "Charlotte Dunwiddie, *Home Furnishings Daily,* September 12, 1961, clipping, NSS archives.

59. *92nd Anniversary* (New York: Catharine Lorillard Wolfe Art Club, 1988), pp. 10–11; "National Sculpture Society Elects First Woman President," NSS release, January 14, 1982.

CHAPTER 5

1. Reynolds, p. 198. The term "doughboy" was first used in the seventeenth century by the English to describe rounded loaflike cakes of bread and boiled flour dumplings. In the nineteenth century, the term was used in the United States to describe the adobe bricks used in building houses in the Southwest, and in the Civil War, the term was applied to infantrymen's brass buttons because their shape resembled the small round doughnuts the soldiers called doughboys. The term was extended to the Civil War infantrymen themselves. A contemporary account as far back as 1854 attributes the term to infantrymen because they wore white belts, which they cleaned with dough made of pipe clay. During World War I, the term was applied universally to American soldiers. (The *Oxford English Dictionary,* 2d ed., Vol. II, Clarendon Press, Oxford, 1989, p. 986–87; *Dictionary of American Regional English,* Vol. II, The Belknap Press of Harvard University Press, Cambridge, Massachusetts, and London, England, 1991, pp. 96–97, 157–58). For further discussion of the term's use in World War I and the role of Major General William Sibert in its use, see *Encyclopedia Americana,* International ed., Vol. 9, Grolier Inc., Danbury, Connecticut, 1990, p. 307. While these sources by no means offer an exhaustive account of the complexities of the word "doughboy," they will provide the interested reader with a useful guide to its many meanings and nuances.

2. Randolph Rogers's statue, commissioned in 1863 and cast in Munich in 1865, is usually called *Sentinel,* the title inscribed on its base (Michelle Bogart, p. 324, n. 5). Rogers, however, called it "Soldier of the Line" (*Self-Guided Walking Tour of Spring Grove Cemetery,* Cincinnati, undated; Craven, *Sculpture in America* [New York: Thomas Y. Crowell Company, 1968], p. 317).

3. Cecilia Beaux, "The Spirit of War Memorials," *American Magazine of Art* 10 (May 1919): 270.

4. Fay L. Hendry, *Outdoor Sculpture in Lansing* (Okemo, Mich.: Iota Press, 1980), p. 18.

5. Lillie F. Kelsay, *Historic and Dedicatory Monuments in Kansas City* (Kansas City, Mo.: Board of Parks and Recreation Commissioners, 1986), p. 40.

6. Steve Walker and David F. Riggs, "Massachusetts," in *Vicksburg Battlefield Monuments* (Jackson, Miss., 1984), pp. 36–37.

7. "Rhode Island," in ibid., p. 55.

8. Ibid., p. 76.

9. Ibid., pp. 78–81.

10. Beaux, "War Memorials," p. 270.

11. Reynolds, pp. 199–201.

12. Ibid.

13. Ibid., pp. 206–8.

14. Ibid.

15. Charles Moore, "Memorials of the Great War," *Magazine of Art,* May 1919, p. 233; "The Permanent Monument," pp. 248–50.

16. "War's Teaching," *Magazine of Art,* May 1919, p. 251.

17. Moore, "Memorials of the Great War," p. 234.

18. Ibid., p. 239.

19. "The Problems of War Memorials," *New York Times Magazine,* May 18, 1919, p. 10.

20. "Essentials in Memorial Art," *Magazine of Art,* May 1919, p. 258; National Sculpture Society *Guidelines* circular, 1926, sent to veterans groups and other interested parties. The NSS also circulated the Radio Talk on War Memorials delivered for the AFA in 1925 by the prominent architect J. Monroe Hewlett.

21. *Records of the American Battle Monuments Commission,* Record Group 17, Washington, D.C.

22. *West Coast Memorial—East Coast Memorial* (Washington, D.C.: American Battle Monuments Commission, 1985), pp. 25–28.

23. Author's interview with architect, 1987.

24. *West Coast Memorial—East Coast Memorial,* pp. 25–28.

25. "Pennsylvania Railroad Memorial," *Sculpture of a City,* p. 295; John F. Harbeson, "Architectural Collaboration," *Sculpture Review* 23 (Spring 1974): 10.

26. Karel Ann Marling and John Wetenhall, *Iwo Jima—Monuments, Memories, and the American Hero* (Cambridge, Mass.: Harvard University Press, 1991), pp. 89–90.

27. "The Man Who Carried the Flag at Iwo Jima," *New York Times,* Letter to the Editor, October 17, 1991; Ronald Spector, "Instant Monument," *New York Times Book Review* of *Iwo Jima,* August 25, 1991, p. 10; see also "Birth of a National Icon, but an Illegitimate One," *New York Times,* October 1, 1991; Ellen K. Coughlin, "New History of Iwo Jima Monument Highlights Questions Researchers Bring to 'Public Art,'" *Chronicle of Higher Education,* October 16, 1991.

28. *The Emerging Flame: A Look at the Work and Philosophy of Sculptor Frederick E. Hart* (Northbrook, Ill.: SGL, 1989), n.p.

29. Ibid.

30. Ibid.

31. Frederick Hart, "Back to the Future," *American Art: Today and Tomorrow,* Newington-Cropsey Foundation, 1992, published remarks delivered at symposium, February 4, 1992; James F. Cooper, "Frederick Hart: Rebel with a Cause," *The World and I,* April 1992, p. 202.

32. Tom Cadwell, "Navy Memorial's 'Lone Sailor' Sculpted by World War II Whitehat," United States Navy Memorial Foundation, Washington D.C., 1987; Caldwell, "The 'Lone Sailor' on Eternal Watch at the U.S. Navy Memorial," May 9, 1991, Arlington, Va., United States Navy Memorial.

33. Barbara Lekberg, "Henry Hering Award Winner," *Sculpture Review* 39, no. 2 (1990): 16–17.

34. Ibid.

35. Beth Kissinger, "Exchange Place Monument to Recall Poland's Struggles," *Jersey Journal,* July 23, 1990, n.p.; "Avenger," *Sculpture Review* 38 (October 1989): 7.

CHAPTER 6

1. H. W. Janson, *Nineteenth-Century Sculpture* (New York: Harry N. Abrams, 1985), p. 37; moreover, it was in Houdon's conflation of the

real and the ideal that goes back to Antoine Coysevoux—whose work in the seventeenth century was influenced by Bernini and Charles Lebrun—that Houdon's strong imprint on American sculpture was made (Charles Henry Hart and Edward Biddle, *Jean-Antoine Houdon* [Philadelphia: DeVinne Press, 1911], pp. 23–27; Rudolf Wittkower, *Gianlorenzo Bernini* [London: Phaidon Press, 1966], p. 209).

2. Ibid.

3. Reynolds, 33.

4. Ibid.

5. Quoted by Albert Elsen in *Rodin* (New York, Museum of Modern Art, 1963), p. 111.

6. The art critic for the London *Art Journal* noted at the end of the nineteenth century: "Houdon joins a masterly skill in the presentation of the osseous and muscular structures of the human head and a magic power of vivifying with the Promethean spark of life To this power, Houdon adds a rare skill, for his portraits not only represent the living, breathing man, but they suggest, with a subtle truth, free from a touch of exaggeration, the human individual" (Claude Phillips, "Houdon," *Art Journal*, London, 1893, p. 80).

7. Janson, *Nineteenth-Century Sculpture*, p. 41.

8. On January 12, 1785, Jefferson wrote to Governor Benjamin Harrison of Virginia that it is "important that some one monument should be preserved of the true size as well as figure, from which all other countries, and our own, at any future day when they shall devise it, may take copies, varying them in their dimensions as may suit the particular situation in which they wish to place them" (quoted in Hart and Biddle, *Houdon*, pp. 187–88; see also "Houdon's Washington," *Harper's Weekly* 12 [1868]: 772–73).

9. In 1857, the General Assembly of Virginia authorized William J. Hubard to make casts from Houdon's statue for Lexington, Virginia; Raleigh, North Carolina; Columbia, South Carolina; St. Louis, Missouri; New York City; and Washington, D.C. (Hart and Biddle, *Houdon*, pp. 221–22); the plaster cast was sold to the United States Government in 1870 by Hubard's widow, and in 1950, it was transferred from the Capitol to the Smithsonian Institution (*Compilation of Works of Art and Other Objects in the United States Capitol*, p. 391).

10. Correspondence of William R. Stewart, treasurer of the Washington Arch Committee, and motivating force behind the project from 1892 until about 1918: letters between Stewart and Stanford White, A. Stirling Calder, Hermon MacNeil, and the Piccirilli brothers (unpublished letters in the archives of McKim, Mead & White in the New-York Historical Society); see also Frances Davis Whittemore, *George Washington in Sculpture* (Boston: Marshall Jones Co., 1933), pp. 159–66.

11. Donald Martin Reynolds, "Monuments to Neglect," *American Arts Quarterly*, Fall 1991, p. 5 (reprinted from talk delivered at First Annual Symposium on Public Monuments, March 20, 1991, in press with Gordon and Breach, Science Publishers); Reynolds, *Monuments and Masterpieces: Histories and Views of Public Sculpture in New York City* (New York: Macmillan Publishing Company, 1988), p. 40.

12. Ibid., p. 41.

13. The leading Neoclassical sculptor of the era, Antonio Canova, used Ceracchi's bust of Washington as the model for Washington's head for his seated figure of Washington for the State House in Raleigh, North Carolina, of 1820. That statue was destroyed by fire in 1830, but the original plaster is preserved in Canova's studio in Possagno, Italy (Elena Bassi, *La Gipsoteca di Possagno, Scultura e Dipinti di Antonio Canova* [Venice: Neri Pozza, 1957], p. 42; Charles Henry Hart, "Life Portraits of George Washington," *McClure's* 8 [1897]: 303; George C. Groce, and David H. Wallace, *Dictionary of Artists in America* [New Haven: Yale University Press, 1969], p. 117).

14. Reynolds, p. 39.

15. Wayne Craven, *Sculpture in America* (New York: Thomas Y. Crowell Company, 1968), p. 86.

16. Reynolds, p. 44.

17. Ibid., pp. 38–39; Hart and Biddle, *Houdon*, p. 98.

18. Reynolds, 61–63; James Holderbaum, "Portrait Sculpture," *The Romantics to Rodin* (New York: Braziller, 1980), pp. 40ff.

19. "Statues in the United States Capitol not Contributed by States," *Compilation of Works of Art and Other Objects in the United States Capitol*, p. 270.

20. For the authoritative discussion of Ward's life and work, see Lewis I. Sharp, *John Quincy Adams Ward, Dean of American Sculpture* (Newark: University of Delaware Press, 1985).

21. Ibid., pp. 72–73, 89, 234, 235, 254.

22. Reynolds, pp. 66–68.

23. Dryfhout, *Works*, pp. 173–76, 261–63; Greenthal, *Saint-Gaudens*, p. 119.

24. Albert Ten Eyck Gardner, *American Sculpture* (New York: Metropolitan Museum of Art, 1965), pp. 125–26.

25. Reynolds, pp. 85–87.

26. Craven, *Sculpture in America*, p. 498.

27. Ibid., p. 497.

28. Ibid., p. 441.

29. Ibid., pp. 439–40.

30. Interviews with the sculptor's daughter, Dorothy Grafly, 1970–71.

31. Janson, *Nineteenth-Century Sculpture*, pp. 229–30, 245–46.

32. Malvina Hoffman, *Heads and Tales* (New York: Bonanza Books, 1936), pp. 291, 240, 186, 379.

33. Lady Epstein Collection, London.

34. New-York Historical Society.

35. Fred Licht, *Sculpture: Nineteenth and Twentieth Centuries* (Greenwich, Conn.: New York Graphic Society, 1967), p. 309.

36. Ibid., p. 320.

37. Elsen, *Rodin*, p. 110.

38. Hoffman, *Heads and Tales*, p. 286.

39. Ibid., p. 66.

40. Wayne Andersen, *American Sculpture in Process, 1930–1970* (Greenwich, Conn.: New York Graphic Society, 1975), p. 15.

41. Gardner, *American Sculpture*, p. 176.

42. From a draft of "Between Sittings," in the Jo Davidson papers, Library of Congress, published by the Dial Press in 1951, quoted in Roberta K. Tarbell, "Sculpture, 1900–1940," in *The Figurative Tradition* (New York: Whitney Museum of American Art, 1980), p. 93; Gardner, *American Sculpture*, p. 146.

43. Ibid., p. 133.

44. Tarbell, "Sculpture, 1900–1940," pp. 96–97; Gardner, *American Sculpture*, p. 133.

45. Interviews with the sculptor, April–May, 1992.

46. "Native Son Is Outstanding American Sculptor," *Daily Reflector* (Greenville, N.C.), May 9, 1971, pp. 17–18.

47. "Arts Council Honors W. E. Artis," *Washington Daily News* (Washington, N.C.), June 7, 1973, p. 16; "Faculty Artist Exhibition," *Art Journal* 30 (Spring 1971): 322.

48. Tarbell, "Sculpture, 1900–1940," p. 158.

49. Janson, *Nineteenth-Century Sculpture*, p. 188.

50. *Compilation of Works of Art and Other Objects in the United States Capitol* (Washington, D.C.: United States Government Printing Office, 1965), pp. 203–4.

51. Jerry Grundfest, Theodore Morello, biographies editor assisted by Frieda T. Hliddal, "The Story of the Hall of Fame," *Great Americans, A Guide to the Hall of Fame for Great Americans* (New York: New York University Press, 1962, 1967, 1977), pp. 9–15.

52. Leland Roth, *A Monograph of the Works of McKim, Mead & White* (New York: Arno Press, 1977), pp. 32, 35.

53. Grundfest, *Guide*.

54. Ibid., pp. 162–64. In 1963, the Hall of Fame commissioned Medallic Art Company to issue bronze and silver medallions depicting each great American enshrined in the Colonnade.

55. George Washington Carver was elected to the Hall of Fame in 1973, and his bust, by black sculptor Richmond Barthé, was installed in 1977 (interview with Ralph M. Rourk, Director, Hall of Fame, June 2, 1992); interviews with the sculptor, Inge Hardison, 1989–92.

56. *Negro Giants in History* (New York: McCaden Productions, 1992); interviews with the sculptor, 1990–93.

57. Tony Brown, August 1987, syndicated column in 125 U.S. newspapers.

58. Sam Howe Verhovek, "Neglect Dulls the Glory of a Once Famous Hall," *New York Times*, March 21, 1988, p. B3.

59. Interview with Ralph M. Rourk, Director, June 2, 1992.

CHAPTER 7

1. Barbara A. Baxter, *The Beaux-Arts Medal in America* (New York: American Numismatic Society, 1987), p. 3.

2. Ibid., p. 4.

3. Ibid., p. 5.

4. Ibid., p. 6.

5. William L. Bischoff, "The United States Mint and Beaux-Arts: The Redesign of Coinage," in Baxter, *The Beaux-Arts Medal*, pp. 51–54.

6. Howard L. Adelson, *The American Numismatic Society* (New York: American Numismatic Society, 1958), pp. 128–29.

7. Ibid., pp. 152–56; Bischoff, "United States Mint," pp. 51–53.

8. Bischoff, "United States Mint," p. 52.

9. Adelson, p. 157; interview with Brenner, *New York Times*, February 24, 1907, cited in Adelson, p. 153; Baxter, *The Beaux-Arts Medal*, p. 40.

10. Adelson, p. 157.

11. Bischoff, "United States Mint," pp. 42, 53.

12. August L. Freundlich. "The Coins and Medals of James Earle Fraser," in *The Medal in America*, ed. Alan M. Stahl (New York: American Numismatic Society, Coinage of the Americas Conference, 1987), p. 189.

13. Ibid., p. 188.

14. Ibid., pp. 197–98.

15. Adelson, p. 214.

16. Saltus to Archer M. Huntington, October 22, 1913, quoted in Adelson, pp. 213–14, 341–42.

17. From the constitution and bylaws of the American Numismatic Society, adopted April 6, 1858, quoted in Adelson, p. 18.

18. Adelson, pp. 126–27, 130–32.

19. Ibid., pp. 133–34.

20. Ibid., pp. 136–37.

21. Baxter, *The Beaux-Arts Medal*, p. 74.

22. For useful discussions of the Circle, the American Numismatic Society, and the Society of Medalists, and their interrelationships, see Joseph Veach Noble, "The Society of Medalists," in *The Medal in America*, pp. 224–47; Baxter, *The Beaux-Arts Medal*, pp. 74, 82–83; and Stahl, "The American Numismatic Society and the Beaux-Arts Medal," (Baxter) pp. 86–89.

23. Noble, "Society of Medalists," pp. 224–47.

24. Ibid., p. 228.

25. Baxter, *The Beaux-Arts Medal*, pp. 82–83; Freundlich, "Coins and Medals," pp. 184–94.

26. Noble, "Society of Medalists," pp. 236–40.

27. Stahl, "The American Numismatic Society," p. 89.

28. "The 1985–1986 Brookgreen Gardens Membership Medal Created by Marcel Jovine," *Brookgreen Bulletin* 15, no. 1 (1985): n.p.

29. Alan M. Stahl, "Marcel Jovine, 32nd President, National Sculpture Society," *Sculpture Review* 41, no. 1, pp. 16–18.

30. Ed Reiter, "Reagan Taps Sculptor to be Mint Engraver," *Numismatic News*, August 1, 1981; "New Mint Engraver," *New York Times*, November 8, 1981; "Another Breakthrough for Women's Rights," *New York Times*, July 26, 1981; "U.S. Chief Engraver Jones Takes Oath," *Coin World*, November 11, 1981, pp. 1, 6.

31. Interviews with the sculptor, May 1992.

32. Judy Klemesrud, "Her Mark Is on the Coinage," *New York Times*, June 26, 1983; "Preliminary Design Sketch Provides First Glimpse of Washington Commem," *Coin World*, May 12, 1982; "Sculptor in U.S. to Fulfill Commission," *Coin World*, April 15, 1981, p. 56.

CHAPTER 8

1. See Sharp's discussion of its influence on American sculpture, pp. 36, 38, 46–47, 83, 91, 165.

2. Ibid., p. 38.

3. For a lucid and reliable account of this complex subject, see Brian M. Fagan, *The Great Journey: The Peopling of Ancient America* (London: Thames & Hudson, 1987), especially parts 3, 4, and 5, which have shaped my brief summary here.

4. Albert Ten Eyck Gardner, *American Sculpture* (New York: Metropolitan Museum of Art, 1965), pp. 40–45; Barbara A. Baxter, *The Beaux-Arts Medal in America* (New York: American Numismatic Society, 1987), pp. 26–27; Patricia Janis Broder, "Medallic Portraits of the American Indian," *Numismatist*, March 1983, pp. 462–73; see also Broder's *Bronzes of the American West* (New York: Harry Abrams, 1974), for an extended discussion of the subject.

5. Gardner, *American Sculpture*, p. 162.

6. *The National Hall of Fame for Famous American Indians* (Anadarko, Oklahoma, 1989), pp. 3–4; author's interviews with staff, 1989–93.

7. Wayne Craven, *Sculpture in America* (New York: Thomas Y. Crowell Company, 1968), p. 531.

8. Lillie F. Kelsay, *Historic and Dedicatory Monuments in Kansas City* (Kansas City, Mo.: Board of Parks and Recreation Commissioners, 1987), p. 40.

9. Craven, *Sculpture in America*, pp. 527–31.

10. Carl Waldman, *Atlas of the North American Indians* (New York: Facts on File, 1985), pp. 35–36; Harold Driver, *Indians of North America*, 2d ed., rev. (Chicago: University of Chicago Press, 1969), p. 125.

11. Craven, *Sculpture in America*, pp. 528–30.

12. Ibid.

13. Ibid., p. 493.

14. *Crazy Horse*, 40th Anniversary Commemoration Edition (Crazy Horse, S.D.: Korczak's Heritage, 1987), pp. 1–32; for the history and chronology of the monument, see also B. Drummond Ayres, Jr., "Crazy Horse, Sculptor Works on Big Scale," *New York Times*, June 9, 1970; Don Hipschman, "Crazy Horse, a Colossus in the Making," *Lufkin Line*, March–April 1962; "Night Blast Celebrates Emerging Face of Crazy Horse," *Progress* 13, no. 3 (December 1991): 4–5; author's interview with widow, February 29, 1992.

15. John R. Swanton, *The Indian Tribes of North America* (Washington, D.C.: Smithsonian Institution Press, 1984), pp. 451–52, 466–67; Gardner, *American Sculpture*, pp. 96–97.

16. Byron B. Jones, "A Dream Takes Flight," *Southwest Art*, August 1990, pp. B1–B3; Daniel Gibson, "Southwest Profile," *Magazine of New Mexico*, May 1984, pp. 6–8.

17. Ruth Underhill, *Red Man's Religion* (Chicago: University of Chicago Press, 1965), pp. 1–20.

18. Philip Kopper, *The Smithsonian Book of North American Indians* (Washington D.C.: Smithsonian Books, 1986), pp. 43–44.

19. Ibid., pp. 45–47.

20. Craven, *Sculpture in America*, pp. 526–27.

21. Gardner, *American Sculpture*, pp. 96–97.

22. Ibid. Baxter, *Beaux-Arts Medal*, pp. 81–82.

23. Chris DeRienzo of the Glenn Green Galleries, Santa Fe, N.M., to Donald Martin Reynolds, January 7, 1992; interviews with De Rienzo, 1993; interview with Houser, December 31, 1991.

24. Paula Hall, "Doug Hyde, Sculptor of the American Indian Spirit," *Gilcrease Magazine of American History and Art* 12, no. 2 (Spring 1990): 16–31.

25. Author's interview with Boomer, December 20, 1991.

26. John Villani, "Glenna Goodacre," *Southwest Art*, September 1991, special section, n.p. In 1992, Goodacre was commissioned by the Maxwell Air Force Base in Montgomery, Alabama, to do a heroic size bronze sculpture of First Lt. Karl W. Richter, a pilot in over 200 missions in Vietnam, shot down in 1967 (*National Sculpture Society Bulletin*, January 1992). In 1991, she was commissioned to honor the women who served in Vietnam. Unveiled on Veterans Day, November 11, 1993, near Maya Lin's wall in Washington, D.C., the monument consists of four figures, seven feet tall, three women in fatigues and a wounded soldier. Interviews with Daniel R. Anthony, Goodacre's manager, Santa Fe, New Mexico, June 1993.

27. George Carlson to Donald Martin Reynolds, December 27, 1991; author's interviews with curatorial staff, Eiteljorg Museum, January 2, 1992, and staff of Gerald Peters Gallery, Santa Fe, N.M., December 20, 1991.

CHAPTER 9

1. Roberta K. Tarbell, "Sculpture, 1900–1940," in *The Figurative Tradition* (New York: Whitney Museum of American Art, 1980), pp. 106–7.

2. Daniel Robbins, "Statues to Sculpture from the Nineties to the Thirties" in *Two Hundred Years of American Sculpture* (New York: Whitney Museum of American Art, 1976), pp. 133–34.

3. Albert Ten Eyck Gardner, *American Sculpture* (New York: Metropolitan Museum of Art, 1965), p. 132; Wayne Craven, *Sculpture in America* (New York: Thomas Y. Crowell Company, 1968), pp. 563–64; see also *The Artist at Ringside* (Youngstown, Ohio: The Butler Institute of American Art, 1992), catalog of the exhibition held at The Butler Institute of American Art, 1992, with "Introduction" (pp. 9–10) by Louis A. Zona, Director, and curator of the exhibition, and essay (pp. 13–21) by Steven L. Brezzo, Director of the San Diego Museum of Art.

4. Tarbell, "Sculpture, 1900–1940," p. 95; Robbins, "Statues to Sculpture," pp. 135–36.

5. Libby Seaberg and Cherene Holland, "Saul Baizerman," in *Two Hundred Years of American Sculpture* (New York: Whitney Museum of American Art, 1976), pp. 257–58.

6. Robbins, "Statues to Sculpture," p. 135; Craven, *Sculpture in America*, pp. 357–66. The beleaguered New-York Historical Society had the foresight to assemble the largest collection of Rogers Groups. Let us hope the future caretakers of the society's collections will have the foresight to preserve them.

7. "Daughter of Retired ILGer Wins Acclaim for Sculpture," *Justice*, April 15, 1978.

8. "A Tribute to Garment Workers," *Jewish Journal*, November 9, 1984; Elenore Lester, "Garment Worker Statue Is Tribute to Jewish Immigrants," *Jewish Week*, October 26, 1984, p. 4.

9. Dena Merriam, *Bruno Lucchesi* (New York: Hudson Hills Press, 1989), pp. 4, 15, 50.

10. Ibid., p. 10.

11. Craven, *Sculpture in America*, pp. 531–36; Gardner, *American Sculpture*, pp. 69–77; Harold McCracken, *The Frederic Remington Book* (Garden City, N.Y.: Doubleday & Company, Inc., 1966), pp. 9–18.

12. Cited by David Sellin in "Cowboy," *Sculpture of a City*, 196.

13. Ibid., p. 204.

14. Alexander Phimister Proctor, *Sculptor in Buckskin, an Autobiography* (Norman: University of Oklahoma Press, 1971), p. 180.

15. Ibid., pp. 184–86.

16. Ibid., pp. 186–90.

17. Dorothy Ross, *Stranger to the Desert* (London: Jarrolds, 1958), pp. 34–52.

18. Theresa Jordan, *Cowgirls: Women of the American West* (New York: Anchor Press, 1982), pp. 42–60.

19. "Richardson Petroleum Engineering Building Dedicated," *Texas Aggie*, August 1990, pp. 8–9.

20. National Sculpture Society archives; Stelzer's 25-inch-high bronze *Sundown* of 1981 in its exquisite proportions lends monumentality to the small figure of an Indian brave standing with arms folded across his chest, hair braided, clad in loincloth, and barefoot. *Doctor* was commissioned by Dell Publications for the cover of Mary Roberts Rinehart's novel *The Doctor* (1976).

21. National Sculpture Society archives.

22. NSS archives; Shahn's *Head on Stand*, 1989, in wood and painted,

is a head reclining on its side, and should be considered with this genre.

23. NSS archives.

24. "Leonda Finke to Exhibit Sculptures at Cast Iron Gallery," April 19–May 8, 1991, Cast Iron Gallery, New York, 1991; David L. Shirey, "Art: Epic Sculpture," *New York Times*, May 25, 1980, clipping in NSS archives; "Society of Medalists Issues Unusual Medal," Society of Medalists, Danbury, Conn., 1988.

25. *Recent Sculpture by Lorrie Goulet* (New York: Kennedy Galleries, 1973); *Recent Sculpture by Lorrie Goulet* (New York: Kennedy Galleries, 1986); Judith Weller, recommendation for membership to NSS, April 9, 1987.

26. Lorrie Goulet, "A Carver's Poem," 1980.

27. NSS archives.

28. Wayne Craven, "Charles Parks," NSS archives, n.d.; *The Sculpture of Charles Cropper Parks*, Wilmington, Delaware, n.d.

29. Ibid.

30. Ibid.

31. Interviews with the sculptor, May, 1992.

32. Programs in which one percent of the capital budget is used for art; popular since the 1970s, the practice has a long pedigree.

33. Interviews with the sculptor, May 1992.

34. Fred Cicetti, "Where is Homer Judson?" Publicity release, n.d., Englewood Cliffs, N.J.

35. Peter Mucha, "The Madonna Phenomenon," *Delaware Today*, November 1982, pp. 36–78.

36. "Domenico Facci's Sculpture Show," *Villager* (New York), December 27, 1962; "Hall of Fame Receives New Sculpture," *News from the Hall of Fame of the Trotter*, Winter 1981, n.p. In 1993, Facci received the National Sculpture Society's Herbert Adams Memorial Medal for outstanding achievement in American sculpture.

37. *Dedication of the Tomb of the Unknown Soldiers of the American Revolution*, Rome, N.Y., 1976.

CHAPTER 10

1. Constitution of the National Sculpture Society, founded May 30, 1893. For succinct and reliable histories of the National Sculpture Society, see Theodora Morgan, "Seventy Five Years of American Sculpture," *National Sculpture Review*, vol. 17, (Summer 1968), and Michelle Bogart, "The National Sculpture Society, Art-Search for a City Beautiful," *Public Sculpture*, pp. 47–70.

2. Albert Ten Eyck Gardner, *American Sculpture* (New York: Metropolitan Museum of Art, 1965), pp. 103–4.

3. Ibid., pp. 116–17.

4. Golden Boy was removed from its site at 195 Broadway in 1980—his armature restored, his surface regilded—and installed in the lobby of AT&T's new office at 550 Madison Avenue, New York (Reynolds, pp. 326–27). In Spring 1992, the sculpture was relocated to its present site in front of AT&T's operational headquarters in Basking Ridge, New Jersey.

5. Daniel Robbins, "Statues to Sculpture from the Nineties to the Thirties," in *Two Hundred Years of American Sculpture* (New York: Whitney Museum of American Art, 1976), p. 115.

6. Michelle Bogart, "American Garden Sculpture: A New Perspec-

tive, 1890–1930," in *Fauns and Fountains: American Garden Statuary* (Southampton, N.Y.: Parrish Museum, 1985), n.p.

7. Reynolds, pp. 417–18.

8. Janet Scudder, *Modeling My Life* (New York: Harcourt Brace and Co., 1925), pp. 292–93, quoted in Bogart, "American Garden Sculpture."

9. Adeline Adams, *The Spirit of American Sculpture*, National Sculpture Society, 1923; *American Sculpture Guide*, rev. ed., May 3, 1923.

10. *Literary Review*, November 24, 1923, National Sculpture Society archives.

11. Cornelia B. Sage Quinton and William Warren Quinton, "History of the California Palace of the Legion of Honor," unpublished manuscript, NSS archives.

12. Ibid.

13. Junius Craven, *The Argonaut*, May 4, 1929, p. 6.

14. W.C. Findlay, Findlay Galleries, to National Sculpture Society, February 15, 1929; Mrs. A. M. Simpson (NSS) to W. C. Findlay, March 7, 1929.

15. Jacob Epstein to Ulrich Elerhausen, Secretary, NSS, April 17, 1930; Mrs. Simpson to Epstein, May 5, 1930.

16. Sale of bronzes, San Francisco Exhibition, 1929, NSS archives.

17. Ibid.

18. Daniel Chester French to Robert W. de Forest, President, Metropolitan Museum of Art, February 15, 1919, quoted in Michael Richman, *Daniel Chester French: An American Sculptor* (New York: Metropolitan Museum of Art, 1976), p. 152.

19. Reynolds, p. 54.

20. *Into the Unknown*, white marble, signed, undated, Brookgreen Gardens.

21. Robbins, "Statues to Sculpture," p. 119; Barnard is remembered for his collection of medieval sculpture and architecture that became the nucleus of the Metropolitan Museum's collection at the Cloisters in Fort Tryon Park, New York.

22. Gardner, *American Sculpture*, p. 87.

23. Wayne Craven, *Sculpture in America* (New York: Thomas Y. Crowell Company, 1968), p. 445.

24. For the demise of the studio system and the new role of the artist as more independent and in some cases more introspective, see Robbins, "Statues to Sculpture," p. 122; Wayne Andersen, *American Sculpture in Process, 1930–1970* (Greenwich, Conn.: New York Graphic Society, 1975), p. 3; Roberta K. Tarbell, "Sculpture, 1900–1940," in *The Figurative Tradition* (New York: Whitney Museum of American Art, 1980), pp. 102–5.

25. Tarbell, "Sculpture, 1900–1940," p. 102. See also Tarbell, "Direct Carving," *Vanguard American Sculpture 1913–1939* (New Brunswick, N.J.: Rutgers University, 1979), pp. 45–66.

26. Andersen, *American Sculpture*, pp. 3–4; Robbins, "Statues to Sculpture," pp. 122–23.

27. Eleanor Blau, Obituary, *New York Times*, May 7, 1991.

28. Chaim Gross, *The Techniques of Wood Sculpture* (New York: Arco Publishing Co., 1957), p. 112; author's interviews with the artist, 1987.

29. Craven, *Sculpture in America*, pp. 585–86.

30. Lipton to Andersen, February 12, 1958, quoted in Andersen, *American Sculpture*, p. 38.

31. Elfriede Abee, *The Sculpture of Elfriede Abee*, privately printed, 1962.

32. Malvina Hoffman, *Heads and Tales* (New York: Bonanza Books, 1936).

33. Robbins, "Statues to Sculpture," p. 146.

34. Libby Seaberg and Cherene Holland, "Gaston Lachaise," in *Two Hundred Years of American Sculpture* (New York: Whitney Museum of American Art, 1976), p. 285.

35. Ibid., "John Storrs," pp. 313–14.

36. Tarbell, "Sculpture, 1900–1940," pp. 98–99.

37. Craven, *Sculpture in America*, pp. 591–94; Tarbell, "Sculpture, 1900–1940," p. 99; Seaberg and Holland, "Gaston Lachaise," p. 256; Robbins, "Statues to Sculpture," pp. 143–44, 154.

38. Tarbell, "Sculpture, 1900–1940," p. 105.

39. Craven, *Sculpture in America*, p. 555.

40. Ibid., p. 556.

41. Robert Silberman, "Thoroughly Modern Manship," *Art in America*, January 1986, pp. 111–14.

42. Ibid., p. 112; Jannis Conner and Joel Rosenkranz, *Rediscoveries in American Sculpture* (Austin: University of Texas Press, 1989), pp. 95–101.

43. Craven, *Sculpture in America*, pp. 568–69.

44. William Innes Homer, "The Return to Figuration: American Art After World War II," *The National Sculpture Society Celebrates the Figure* (Washington, D.C.: National Sculpture Society, 1987), pp. 30–35.

45. Andersen, *American Sculpture*, pp. 51–52.

46. Ibid., p. 54.

47. Ibid., pp. 67–71.

48. Albert Elsen, *The Partial Figure in Modern Art* (Baltimore: Baltimore Museum of Art, 1969), p. 67; Andersen, *American Sculpture*, pp. 78–79, 80; quoted from Robert Goldwater's "David Hare," *Art in America* 44, no. 4 (Winter 1956–57): 18–20.

49. Ibid., pp. 26–27, 64–65, 106–9.

50. Jacques Lipchitz with H. H. Arnason, *My Life in Sculpture* (New York: Viking Press, 1972), pp. 151–52, quoted in Tarbell, "Sculpture, 1900–1940," pp. 158–59.

51. Andersen, *American Sculpture*, pp. 59–60.

52. Tarbell, "Sculpture, 1941–1980," pp. 165–66.

53. Homer, "The Return to Figuration," p. 31.

54. Andersen, *American Sculpture*, pp. 91–92.

55. Ibid., p. 91.

56. See Homer, "The Return to Figuration," pp. 34–42, for a useful summary of these directions.

57. *Sculpture Review* 35 (Summer 1986), p. 1, and Gardner, "As the Earth Sings—Pennsylvania Dutch Family," *American Sculpture*, p. 184.

58. Martin Friedman and Graham W. J. Beal, *George Segal: Sculptures*, exhibition catalogue (Minneapolis: Walker Art Center, 1978), p. 28. Andersen, *American Sculpture*, pp. 172–75.

59. Tarbell, "Sculpture, 1941–1980," p. 162; Craven, *Sculpture in America*, p. 660.

60. Tarbell, "Sculpture, 1941–1980," p. 167.

61. Ibid., p. 166.

62. Andersen, *American Sculpture*, pp. 154–56.

63. Ibid., p. 158. Jan van der Marck, *Eight Sculptors: The Ambiguous Image* (Minneapolis: Walker Art Center, 1966), p. 30. Tarbell, "Sculpture, 1941–1980," p. 167.

64. Tarbell, "Sculpture, 1941–1980," p. 162.

65. Howard Kalish, "Interview with the Artist, Richard McDermott Miller" in *The Nude in Bronze: Twenty Years of Sculpture* (New York: Artists' Choice Museum, 1984), p. 2.

66. Ibid., p. 7.

67. Ibid., pp. 3–7.

68. Interviews with the sculptor, May 1992.

69. Donald Martin Reynolds, *The Ideal Sculpture of Hiram Powers* (New York: Garland Publishing Company, 1976), p. 112; Van Wyck Brooks, *The Dream of Arcadia* (New York: E. P. Dutton & Co., 1958), p. 186.

70. Andersen, *American Sculpture*, p. 256.

71. Matthew Katangas, "Rebirth of Venus," *Sculpture*, November–December 1990, pp. 48–55.

72. Ibid., pp. 52–53.

73. Ibid., pp. 53–54.

74. *Volupté*, 1915; Gardner, *American Sculpture*, p. 142.

75. Tarbell, "Sculpture, 1941–1980," p. 156; Andersen, *American Sculpture*, pp. 117–19.

76. Tarbell, "Sculpture in America," pp. 160–61.

77. NSS archives.

78. Interviews with the sculptor, October–November 1991.

79. *Sculpture Review* 38, no. 1 (1989): 5; Adlai S. Hardin, "Distinguished Sculptor," *Sculpture Review* 23 (Spring 1974): 8, 26; John F. Harbeson, "Architectural Collaborator," *Sculpture Review* 23 (Spring 1974): 9, 10, 26; Louise Todd Ambler, "To Celebrate Our Heroes," in *The Sculpture of Walker Hancock* (1989), p. 1.

80. Louis Untermeyer, *A Treasury of Great Poems*, (New York: Simon and Schuster, 1942), p. 1082.

81. Walker Hancock to Thea Morgan, NSS, November 20, 1989.

82. Frederick Hart, "Back to the Future," *American Art: Today and Tomorrow*, symposium, February 4, 1992, (Hastings-on-Hudson, N.Y.: Newington-Cropsey Foundation, 1992), p. 21; interviews with the sculptor.

83. Washington National Cathedral, erected with the authorization of Congress in 1893 and funds raised by the Protestant Episcopal Cathedral Foundation, was begun in 1907 and completed in 1990. It was inspired by the nation's first president and his architect Pierre L'Enfant's plan to create a national cathedral for all the people. Built in the Gothic style on plans of the English architect George Frederick Bodley, it was revised and brought to completion by architect Philip H. Frohman (Robert Jordan, "Washington Cathedral, 'House of Prayer for All,'" *National Geographic*, April 1980, pp. 552–73); "The Emerging Flame: A Look at the Work and Philosophy of Sculptor Frederick E. Hart," SGL, (Northbrook, Ill., 1989), n.p.; Michael Kernan, "Re-Casting the Creation in Just 4 Years," *Washington Post*, February 12, 1982; James F. Cooper, "Frederick Hart: Inspired by God and Beauty," *American Arts Quarterly*, Spring–Summer 1990, p. 10; Sarah Booth Conroy, "A Genesis in Stone," *Horizon*, September 1979, pp. 28–37; "Sculptor Frederick Hart Celebrates the Culmination of a 23-Year Odyssey on May 20, 1990," press release, May 15, 1990.

84. "Upcoming Millennium Inspires Unique Work of Art," press release, March 20, 1992.

85. John Donne, *Devotions Upon Emergent Occasions, Vol. XVII*, quoted in Louis Untermeyer, *Treasury*, pp. 355–56.

INDEX

PHOTOGRAPHY CREDITS